1

For a new friend in the Palo Duro Canyon

Best wishes from Palo Duro Canyon Texas!

To

Tom Hester

God bless you!

Gerald McCathern

7-15-2006

HORNS

FAIR WARNING

It was apparent that the Shadler brothers, Sam Smith and Frenchy didn't appreciate what Jim had said. The other three stopped their work and walked to Ike's side, hands resting on the gun butts which hung from their belts. The four bankers looked on as they sipped their coffee.

"You talk like a squaw man, to me," Ike said. "If the Comanches are so damned mean, why ain't you lost your scalp if you're out here living amongst them?"

When Frenchy, standing next to Ike, moved to draw on Jim, Ned's colt was out and pointing at his chest before the buffalo hunter's gun ever broke leather. Frenchy dropped the gun back in its holster and moved his hand to the front and nervously hitched his thumb in his gun belt.

Ned swung the barrel around, covering all eight men. "I'd just listen to the Colonel, boys, if you want to get back to Dodge with all your hairs still in place," Ned said slowly. The bankers continued to stand silently by the fire, the blood draining from their faces leaving them as white as a wagon sheet. They certainly hadn't bargained for a gun-fight and didn't intend to buy one now.

"We don't want any trouble with you, Shadler," Jim said. "Take your trophies and your trophy hunters back to Dodge and when you get there, tell everybody that's got a hankering to kill a buffalo, whether it's for a hide or a head, that they had better do it north of the Canadian or they may end up being a trophy themselves, hanging on a lodge pole in some Comanche's tipi. And pass the word to General Sheridan that the tribes are already having a council to protect the *Llano Estacado* from hunters. If the hunters come, it will be all-out war as far as the tribes are concerned.

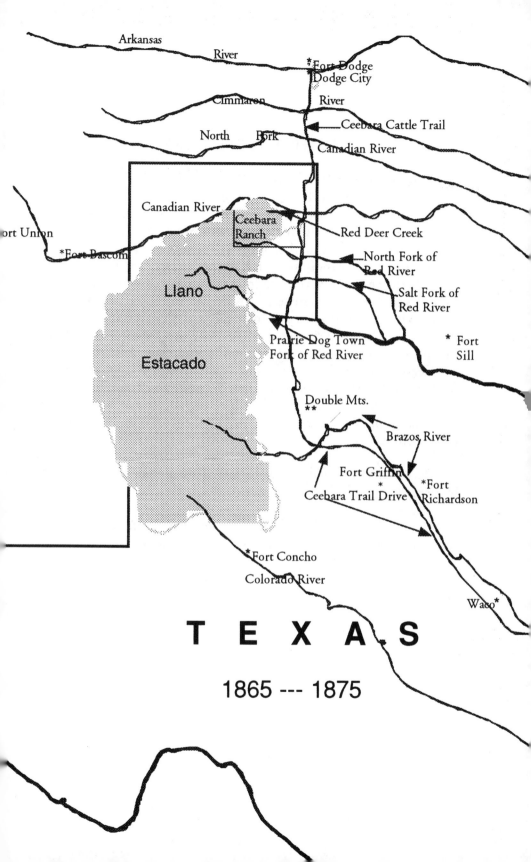

AUTHOR'S STATEMENT

Horns is a historical novel, set in far Northwest Texas during the years 1865 to 1875. Although most of the historical events referred to in the novel are factual, some liberties have been taken concerning actual dates in order to weave a fictional story around those events.

The reader will find that most characters are actual historical figures, involved in those historical events as recorded by historians through the ages. However, the four main characters of Horns: Jim Cole, Ned Armstrong, Belle and Kate McArdle, the ranch and its inhabitants are fictional. Also fictional is the establishment of the ranch on the Llano Estacado, ten years before the ferocious Plains Indians were pushed onto the reservation in present day Oklahoma.

Ceebara, the million acre ranch established by Cole and Armstrong, was located in Roberts, Gray, Wheeler and Hemphill Counties in the Texas Panhandle. Ranch headquarters was near present day Miami on Red Deer Creek. The Big Canyon is known today as Palo Duro Canyon.

Recommended reading for historical documentation of events in *Horns:*

Panhandle Pilgrimage -- by Pauline and R.L. Robertson
The Texas Panhandle Frontier -- by Frederick W. Rathjen

Other books by Gerald McCathern

From the Whitehouse to the Hoosegow

Gentle Rebels

To Kill the Goose

Line of Succession

Scheduled for Printing in 1998

QUARANTINE

Ask your bookstore or order from:

Food for Thought Publisher
419 Centre St.
Hereford Texas, 79045
806-364-2838

Horns

Gerald McCathern

ISBN 0-9656946-0-7
Library of Congress Catalog No. 97-093257
Food For Thought Publishers
419 Centre St.
Hereford, TX 79045
806-364-2838
Fax 806-364-5522

Dedicated to the memory of my parents, Emmitt and Mae McCathern and my wife's parents, Stonewall and Arispy Traweek, who saw and lived the early settling of the Llano Estacado. Their lives are a tribute to the greatness of the men and women who weathered the hardships of the western frontier.

Horns

Gerald McCathern

Food for Thought Publisher
Box 967
Hereford, Texas 79045
806-364-2838
Toll Free - 888-583-9408

Foreword

The eagle soared higher and higher on the updrafts generated by the warming day until it was a mere speck in the sky. Looking downward, it could see the sharp cliffs of the canyon walls as they came together at a point, the canyon's beginning. Stretching for as far as his eyes could see on all sides of the canyon was a vast expanse of greenish brown grass growing on an almost flat plain, broken only by a myriad of small, round dimples of water reflecting the deep blue of the West Texas sky.

The dimples were actually small *playa* lakes, some with only a few inches of water. These playas had formed as salt beds deep below the earth's surface melted away, allowing overlying formations to sink into semi-rounded depressions, which caught the sparse rains that fell over the area.

It mattered not to the eagle that it was soaring over one of the world's geologic wonders, the treeless *Llano Estacado* where the head waters of the Red, the Brazos and the Colorado rivers began in far Northwest Texas and where the Palo Duro Canyon sliced through the flat plain on either side -- nor that the vast expanse of grass was void of any civilized life on this April day in 1865. He was soaring and hunting as had his father and grandfather and their fathers before them, over a land that was occupied only by the buffalo, the prong-horned antelope, the prairie dog, the coyote, the jack rabbit and the rattlesnake.

Of course, the nomadic red man visited his domain annually,

i

hunting the shaggy buffalo for its meat and its hides, but they were so few in number that he hardly took notice of their presence. A few took refuge in the deep canyons, as did he, when the cold winter winds began to blow, and remained year round. Most, however, went south with the birds.

The white man had tamed the lands to the north, the south, the east and the west but had left the uncharted *Llano Estacado* to the animals and the red man, mistakenly believing that it was a waterless waste land, incapable of supporting life -- the Great American Desert, some said.

And so the eagle, the buffalo and the other animals had a vast area in which to roam and to hunt, undisturbed by the encroachment of Anglo Saxon civilization. This land of grass rose a thousand feet above the surrounding land and stretched for over two hundred miles north and south and a hundred miles east and west. A steep, sharp cliff-line called the caprock marked its beginning on the east and west -- the Canadian River sliced through its northern boundary -- and it dropped slowly to the south until it disappeared into low rolling hills which marked the drainage of the Colorado River.

Although the eagle could not know, others were beginning to covet his land and soon the peace and tranquility would be broken by an invasion of those who would battle for control -- the buffalo hunters, the Indian tribes, the army, and the cattlemen.

The year 1865 would mark the end of the civil war and the beginning of the war for control of the *Llano Estacado*. The end of the first and the beginning of the second both took place in Virginia as the last shots were being fired between the confederate and northern armies. Like a magnet, this vast unsettled and uncharted land of tall grass, located in the northernmost reaches of the state of Texas, would pull these four groups together and forever change the lives of those individuals who became involved.

1

Ned had heard a similar sound before. Once when he was only five years old he had disturbed a hornet's nest which was hanging from the rafters of his father's barn. Bzzz, bzzz, bzzz! Only now the sound was louder, and a different sound was intermingled, that of unseen rifle balls smashing into the protective cover of the trees.

Leaves and small branches filled the air and fell around the huddled men as they crouched in six inches of water, fear plainly showing on their dirty faces. They held their rifles at ready and peered through the low hanging limbs and water grass which obstructed their view.

In the distance they could hear a steady roar, as if a strong surf was pounding on the shore. Then a more terrible sound, a roll of thunder crashed in the distance, the air above them hissed and the top of one of the larger trees came crashing down, covering many of those who had looked for shelter under its branches.

Screams! Curses! Prayers!

Ned looked to his left and was appalled to see the man nearest him knocked backward by an unseen force. The top of his head was missing and blood had turned what was left into a crimson blob.

In the midst of this chaos, a beautiful black stallion came crashing through the swamp, carrying a man in a grey suit on his back, who was shouting, "Pull back! Pull back to the river!" The rider's uniform, that of a confederate colonel, was supplemented with twin

1

revolvers strapped to his hips, and a bright red sash which was tied around his waist.

As the rider approached the frightened line of men, his right arm, which was raised holding a shiny saber, disappeared, leaving only a bleeding stub just above the elbow. He fell into the shallow water, splashing mud and blood into Ned's face. The stallion, when his rider fell, stopped, dripping sweat and froth onto his bleeding master.

The horse was an apparition in the early morning mist of the swamp, standing tall and heaving nervously. His eyes were as black as his coat and flashed as he stood looking at the fallen officer, as if waiting for a command. Mud and dirt blotched his black coat, with spots of bright red speckled over his body, red blood from his master's wound. The saddle which was on his back was no ordinary cavalry saddle, it carried the high horn of the western cowman, a coiled rope hung from the right side of the horn and a rifle was slung in a scabbard under the rope; saddlebags and bedroll were lashed behind the seat.

In response to his order, the huddled men rose from their crouched positions, turned and began running from the sound of the thunder and the crashing surf. But as they rose, the bzzz, bzzz, thypt, thypt, which had cut the trees to shreds, now made thumping sounds as red splotches appeared in the backs of their grey coats. They were shoved forward, face down into the now red water. The air was filled with their screams of pain as bullets from their unseen enemy found their mark.

Frightened though he was, Ned Armstrong, the young confederate soldier from Kentucky, yanked the red sash from the wounded cavalry officer's waist, and tied it tightly above the bleeding arm stump. Ned grimaced as he looked at the severed arm, with the hand still clutching the saber, which lay in the shallow water next to the wounded officer. The colonel was conscious but in shock as he staggered to his feet.

Ned also stood to his feet, threw his rifle aside, and literally lifted the wounded officer onto the empty saddle. He then retrieved his rifle, grabbed the dangling bridle reins and began running to the rear, dragging the frightened stallion and the wounded officer behind him.

It was a miracle that they were able to escape the deadly barrage

of rifle lead and cannon grape as they dodged through the trees. Dead and wounded filled the swamp around them. Soon the terrible sound of battle was a din in the distance, as they were able to outdistance the range of the guns.

Ned was exhausted, but continued to run, dragging the horse and its rider through the swamp. He was now on dry ground, and was able to travel more easily. The trees opened, and a large river blocked his escape. Stopping, he looked indecisively upstream and downstream. For the first time since he started running from the field of battle, he looked back and was appalled to see the rider clutching the horn of the saddle in an effort to keep from falling. His chalk-white face graphically indicated the loss of blood which had colored the right side of his grey uniform a bright crimson red.

The rider released the horn of the saddle long enough to motion upstream and without hesitating, Ned turned and began running in the direction indicated by the wounded officer, dragging the excited stallion by the reins.

After traveling upstream less than a mile, he came to a foot path which led into the river. Looking across the river, Ned could see the path rise out of the water on the other bank, without hesitating he led the horse and wounded rider into the water and walked cautiously towards the trail on the other side. Reaching the middle of the stream, he stopped and dropped to his knees, allowing the refreshing coolness of the water to rise to his neck, relaxing his fatigued and aching body. The stallion dropped his head, lowered his nose into the stream and drank his fill. Rising, Ned reached the other side with no trouble, and continued to travel westward down the well-used foot path.

After going another two miles, he heard a crash behind him, looked back and was shocked to see the colonel lying in a heap in the middle of the trail. He stopped, tied the stallion to a nearby bush, and rushed back to help the unconscious officer, dragging him off the trail and onto a bed of leaves below the huge overhanging trees. Releasing the tourniquet for a few seconds, he was forced to retie it quickly when the blood started gushing again. Returning to the exhausted horse, he removed the canteen which was tied to the saddle, loosened the cap and wet his dirty bandana, then used it to bath the ashen face of the wounded colonel. Ned was afraid that he was dead, but was relieved when the wounded man groaned and

3

slowly opened his eyes. Holding up his head, Ned placed the spout of the canteen to the parched lips and poured a few drops into his mouth.

He then put the canteen to his own lips and gulped a large drink, and only then did he realize how extremely tired he was; his hands began to shake, his lips began to tremble, and this sixteen year old Confederate soldier began to cry uncontrollably. His body shook with great sobs as the fear and the exhaustion took over his mind.

Although only sixteen, Ned stood nearly six feet tall, and was very muscular as a result of the hard work which accompanied growing up in the mountains of Kentucky. His long blonde hair fell nearly to his shoulders under the dirty confederate cap, and eyes as blue as the sky sparkled beneath the tears which rolled down his weathered cheeks. He was a child in a man's body.

Soon, however, the sobs subsided and he took the dampened handkerchief, dried his eyes and wiped his face as he began once again to think rationally. He looked at the bleeding stump of the colonel's arm, not knowing what to do, but realizing that if something wasn't done immediately, he would have saved a dead man.

The officer, who was now conscious, spoke, though only in a whisper. "Thanks son, I owe my life to you."

"Y-y-yer welcome, sir," stammered the boy. "W-w-what are we going to do now, sir, yer bleedin to death?"

The officer looked down at his stump of an arm, grimaced and once again whispered, "You're going to have to cauterize it for me, son, that's my only chance. Build a fire of leaves and twigs and heat my Bowie knife 'till it's red hot, then you're going to have to use it to burn those bleeding arteries until they stop."

Ned didn't know if he could do it or not, but he didn't have any other ideas, for certain. Quickly, he gathered a pile of leaves and placed several small, dry twigs on top. Pulling the cork from his powder horn, he sprinkled some black powder on the leaves, and struck a spark with his flint and steel. The leaves burst into flame.

Next he pulled the large bladed Bowie knife from its sheath hanging from the officers belt and held it in the flames until the blue steel turned cherry red. Turning to the prostrate figure lying on the ground he said, "You sure this is what we need to do, sir?" His stammering had stopped but his hands still shook.

"You've got to do it, son. It's our only chance. The hot blade will stop the bleeding and keep down infection," he whispered.

Ned bit his lip as he moved the red hot blade of the knife towards the bleeding stump. With both hands trying to hold it steady, he placed it to the flesh. The sizzle of the burning was drowned out by the screams of the wounded officer. The frightened boy jumped back, dropping the knife.

The screaming stopped as the wounded officer fainted from the pain. Ned, sucking the blood from his bitten lip, put the blade of the knife back in the flames of the fire and held it until it once again turned red. This time, as he placed the hot blade on the wound, the unconscious officer only groaned as the flow of blood slowed to a trickle, then stopped completely. Ned removed the sash which was tied above the wound and was thankful that no blood flowed from the cauterized blood vessels.

The task completed, he dropped the knife and rushed into the woods where he sank to his knees and began to retch and vomit. His body shook and the tears once again began to flow. The excitement and the pressure had been too much on this young Kentucky farm boy who had thought that going to war was going to be something glorious.

Crawling back to the side of the unconscious officer, he too, was unable to stay awake. Ned did not know how long he slept, but was awakened by someone shaking his shoulder. It was the wounded officer. "I believe I can ride a ways now, boy. We better put tracks between us and them yankees. It looks like we're the only ones what made it acrost the river, and they'll be sending scouts to see if anyone escaped."

Ned helped the colonel to his feet, and thought that he was going to faint again. However, after he stood awhile, the color began to return to his face. Lifting the officer into the saddle, Ned mounted behind him to make certain that he did not fall again, and urged the horse down the trail.

The big black stallion was rested and moved out at a brisk pace. After traveling for an hour down the narrow trail, they came to a wagon road which was filled with a rag-tag band of wounded and disorganized grey clad soldiers, moving south and west away from the field of battle.

After another hour, slowly moving through this sea of defeated

confederates, the officer told Ned that he could go no further. Ned, seeing a deserted barn through the trees, turned the horse off the road and headed for its shelter. Dismounting, he helped his new friend to the ground, then led the stallion into the barn, removed the saddle and placed him in a dilapidated stall. There was hay for the horse, and enough for them to bed down on for the night.

The officer was made as comfortable as possible by his young friend and Ned was grateful when the colonel fell into deep sleep, knowing that at least for awhile he would be free of the pain.

The next morning the colonel awoke to the smell of meat cooking over an open fire. Ned had killed a rabbit with a rock when it strayed into the barn, removed its skin and placed it on a spit over a small fire he had built on the dirt floor of the barn. The Bowie knife was used to cut it in half, and it was quickly consumed by the two famished soldiers.

Although the pain was still almost more than the officer could bear, he was much better after the night's sleep and hot breakfast. Ned refilled the canteen from a nearby stream and washed the wound as clean as possible. After washing the sash which had been used as a tourniquet, he wrapped the stub, thankful that no infection seemed to be present.

The officer told Ned, while he was dressing the wound, that his name was Jim Cole, and that he was from Texas, having come with a group of cavalry volunteers to fight with General Lee. He had fought at Harper's Ferry and Gettysburg without injury, although many of his friends had been killed when their company had been caught in a crossfire while rushing Cemetery Hill. General Lee had personally promoted him to Colonel after Gettysburg. He had been leading Ned's group of infantry into battle when the Yankees overran his position and he lost his arm to cannon grape.

"Seems to me we've lost the war, Ned," he said. "Grant's got Richmond surrounded and its just a matter of time before Lee's going to be forced to surrender. He's out of food and nearly out of ammunition. Our best bet is to circle Richmond and try to rejoin Lee's main group if he breaks out.

Ned saddled the stallion, helped Colonel Cole to mount, climbed behind him and headed the big black back towards the road where they joined the wounded and broken as they moved

slowly towards the smoke of the burning city of Richmond.

2

The smoke of the burning city convinced Colonel Cole that they should try to find a field hospital elsewhere. He instructed Ned to head the horse north by northwest since the Yankees had overrun the area between Richmond and the sea. Following the Pamunkey River, they reached the Hanover Ford, where they crossed and turned south by southwest.

By late afternoon, the big black stallion had carried them northwest of Richmond, where they became a part of a mass of humanity fleeing the burning city. Thousands of soldiers, dressed in their tattered grey uniforms, some wounded and some just dazed and scared, mixed with the thousands of civilians who were trying to save what few possessions they could from the ravages of war. They saw no organized movement of troops nor any officers who seemed to be in command. When they stopped for the night on the banks of the James River, the colonel fell exhausted from the back of the horse. Once again his face was ashen, and Ned was afraid that he would die before morning.

Ned stretched the colonel's blankets on a bed of leaves beneath the branches of a large oak tree and helped the wounded man to the bed before staking out the stallion in some lush grass along the river bank. There were many civilians scattered along the river bank and two elderly white women, accompanied by an old slave couple,

were camped a few hundred feet downstream. They had fled the burning city in a buckboard drawn by a team of dappled geldings, trailing a beautiful bay mare behind. The buckboard was loaded with many items including sheets, dishes, cooking utensils, and food. One of the women, observing the young confederate soldier attempting to tend the wounds of his comrade, asked if she could be of help.

"I'd be much obliged," Ned said as he looked up from his duties. "There ain't much we can do though, because we don't have any medicine or bandages."

She was aghast at the sight which filled her eyes when Ned removed the blood stained sash from the stump of an arm. Rushing back to the buckboard, she returned with an arm full of torn sheets and a bottle of whiskey . Pushing Ned aside, she said gently, "Let me do it, son."

Making a swab from the torn sheets, she soaked it in some of the drinking whiskey, and gently began to bathe the wound. The sting from the alcohol brought a moan from the unconscious colonel, and he opened his eyes to see the gray haired lady tending his arm. After the dirt and dried blood had been removed, she began to wrap the wound in a clean, white bandage, tying the ends of the strips of sheet around Colonel Cole's neck. She then placed her arm under his head, raised him to a sitting position and held the bottle of bourbon to his lips. He let the liquid fill his mouth and could feel the warm fluid flow down his throat as he swallowed.

The slave couple approached the camp, carrying a large pail of cooked broth, made from chicken and grain and wild onions which they gave to the two famished soldiers.

After their meal, Ned and the colonel were given blankets and were instructed by the two women to remove their filthy clothes. Wrapped in the blankets, the men watched as the slaves carried their uniforms to the waters edge and began washing them. The clothes were strung on the low bushes to dry in the late evening sun and before night closed in, they were once again dressed in their tattered but clean uniforms.

The women who were in their early sixties, Mrs. Scott and Mrs. Renfro, were wives of shop owners in Richmond. They had left their husbands in the city to try to protect their shops from the fires. They had brought the elderly slave couple, property of Mrs.

Scott, to tend to their needs.

They informed Colonel Cole that the confederate lines had completely collapsed east of the city. General Lee was trying to re-group his troops in the area around Appomattox but no one had much hopes that he would be successful. It was now only a matter of time before Grant's troops would be able to completely encircle the disorganized southern army.

Their prophecy was correct, for at dusk, a young confederate officer, riding a winded and sweating horse, came through their camp and told them excitedly that General Lee had been surround-ed at Appomattox, and would probably surrender the next day. The southern ladies could not restrain their tears, and cried un-ashamedly at this news.

This information convinced Colonel Cole that they should make a run due west the next morning, and try to reach the foot-hills of the Blue Ridge Mountains before they too would become prisoners of the encircling Yankees. At daylight the next morning as they prepared to leave, they were surprised as the two ladies and the slave couple approached their camp, leading the saddled mare. They had made a bed roll of blankets, tied on provisions of food, coffee, and bandages, and had filled two extra canteens with the contents of the bottle of whiskey.

"We thought that you could use the mare much better than us," said Mrs. Scott, then added, smiling, "The whiskey is for medicinal purposes, use it accordingly. We will go no further. The damn Yankees will probably find us today, and they would only take the mare and what provisions we have. Take her as a gift of apprecia-tion for doing your best to save the South. God Bless you and pro-tect you."

Tenderly kissing the ladies on their cheeks, Colonel Cole thanked them for their kindness. With Ned's help, he mounted the big black stallion and urged him into the shallow crossing of the James River, splashed across and disappeared into the forest on the other side. Ned mounted the mare and followed close behind.

3

Traveling westward during the morning, they observed several columns of blue clad soldiers in the distance but luckily remained unnoticed by the northern troops. Reaching the foothills of the **Blue** **Ridge** Mountains at Massie's Mill, they started the steep climb to the top, picking their way through the trees and rocks.

Once on top, they stopped, dismounted their horses and looked back to the east to see if they were being followed. They could see smoke several miles in the distance, but observed no activity on their immediate trail.

Colonel Cole removed a canteen of whiskey and took a long swallow, hoping that it would dull the ache in the stub of his missing limb, while Ned began to search through the sacked provisions for something with which to prepare a cold meal. He settled for a piece of salt pork and dry bread. The long hard ride had taken its toll, and they ate in silence as their bodies soaked up the warmth of the sun, all the while looking back down the steep Blue Ridge in the direction from which they had come.

After completing their snack, Colonel Cole finally spoke. "You've done well, Ned," he said. This was the first time he had called Ned by name, heretofore it had been only boy or son. Ned acknowledged the comment with an embarrassed grin and a nod of his head.

"Looks as if we gave them Yanks the slip. We should be able to

keep heading west without too much worry, because I don't think they're going to bother too much about folks west of these mountains. If they've got General Lee and Richmond, they ain't gonna be too anxious to capture anymore mouths to feed. With Lee captured, it's all over 'ceptin the shout'n, you can bet your hat on that!" he said, adding, "Where you from, Ned?"

"Kaintucky," answered Ned in his slow southern drawl. "Bowlin Green. Folks had a farm there, where we raised cotton and 'backer 'till the war come. Pa left soon's the shootin' started but he didn't last long. Caught a musket ball in the head at Bull Run. My two older brothers lit out for the war soon's they heard about Pa. Tom got his at Harper's Ferry, and Shannon took a bayonet at Chanclerville. When ma heard about Shannon, it was more than she could stand. She took to ailin' and didn't last more'n a month. Well, I signed on the next day after the funeral and they sent me to help hold the line below Richmond. I only been gone from home a little over six months." He stopped talking, looked at the one-armed officer, and asked. "How about you, Colonel, where you hail from?"

"Texas," responded Cole. "Came up soon as I heard General Lee was having trouble at Manassas. "Took awhile though; it's a fur piece from Texas to Virginia. There was forty-five of us put together a cavalry regiment and hightailed it north. Were'nt many of us made it all the way through the war. Guess them Yankees got a better target when they can sight down a man on a horse."

He stopped talking, looked at his young friend thoughtfully, then continued.

"When I was just a little greener than you, I left my home in Tennessee and followed Colonel Davey Crockett to Texas. Got caught in a war there, too. I guess you heard what happened at the Alamo?"

"Yes sir, I heard."

"Well, I was there. Right there with old Davey, Colonel Travis, and Jim Bowie." He pulled the Bowie knife from its sheath and held it up fondly. "Jim Bowie gave me this knife, personally, just before they put me on the best horse inside the Alamo and slipped me out the back door to carry a message to General Sam Houston. Next day they was all killed when the Mexicans stormed the walls." He was quiet for several minutes as he stared at the knife, reflecting. Sighing, which was almost a sob, he returned the knife to its scab-

12

bard, looked out across the trail below, and said, "We better be gettin' on our way Ned. We should be able to make camp on the Shenandoah tonight."

Ned saddled the two horses and they headed down the western slope of the Blue Ridge Mountains, with no particular final goal in mind, just put as much distance as possible between them and the Yankee army.

Before dark, they reached the bottom of the valley, crossed the Shenandoah River, and camped on the west bank of the river in a clump of aspens which offered protection from observation. They built a small fire and cooked a hot meal of beans, dried beef, and coffee. The horses grazed on the lush grass along the river's edge.

As they lay on their bedrolls, looking at the twinkling stars shining through the budding tree limbs, Colonel Cole announced his intentions. "Ned, I'm headin' back to Texas. General Sam Houston gave me a parcel of land up north on the *Llano Estacado* before Texas joined the Union in '45. I was gettin ready to go up and stake my claim when the war started. I ain't never seen it, but they tell me there's grass up to a horse's belly, buffalo by the millions and plenty of fresh creek water. 'Course, there's a few Indians, too, that don't cotton too much to pale faces. I'd consider it a honor if you'd agree to go along and kinda take care of this one-armed old cripple."

"Don't reckon I got anything back in Kaintuck to go home to, Colonel, what with all my kin gone. Besides, looks like you're gonna need someone with two good hands for awhile till you kinda get used to operatin' with one arm," Ned replied.

The night of April 12, 1865, they slept fitfully, not knowing that in surrendering, General Lee had negotiated amnesty for his defeated men. They need not run from the prison, for they were now declared free to return to their homes, with the blessings of President Abraham Lincoln.

* * * * * * * *

April 12, 1865, the Kwahadi Comanche tribe, led by old Chief Nocona, began to break camp in preparation to begin their westward migration to the spring buffalo grounds on the *Llano Estacado*. They were in no hurry because it was still several weeks before the buffalo would arrive on the Staked Plains from their wintering

grounds along the Concho and Pecos rivers.

The Comanches had spent their winter on the Canadian River in Indian Territory, a week's walk from the high plains, known to the Indians as the Land of No Trees. The Land of No Trees had been granted to the Comanche, Cherokee, and Kiowa nations by the United States government with the signing of the Medicine Lodge Treaty, and was reserved for the Indian tribes to harvest the buffalo without interference from white settlers, buffalo hunters or the U.S. army. However, unknown to Nocona's Kwahadi tribe, hunters had already begun to encroach on the very northern reaches of their hunting grounds along the Arkansas River and were beginning to covet the huge herds between the Arkansas and the Canadian.

There had been a few small herds of buffalo wintering on the eastern reaches of the Canadian as well as an abundant supply of mule deer and antelope, however, the Comanches had about exhausted the deer and antelope herds and were being forced to hunt further and further away from their camp in order to supply their tribal needs.

"We will move two days to the west for better hunting," Chief Nocona told his young son, Quanah. "We will camp there where we found many deer last spring. If the deer are plentiful, we will remain for one moon, until the cold winds cease to blow on the buffalo grounds, then we will take our people above the high rocks for the summer hunt."

It was a large encampment, the Kwahadis being the largest group of the Comanche tribe, and many tipi's must be taken down and packed on the travois for the move. The travois, two long slender poles cut from trees along the river bank with buffalo skins laced firmly on each side, were fastened to the sides of gentle horses and dragged like sleds, loaded with the meager possessions of the Indians. These were nomadic Indians, moving wherever the game was plentiful, and their worldly possessions included only the necessities of life, a few earthen pots, their tipis, animal skins and robes, hunting and skinning implements, bows and arrows and a few rifles stolen or taken from white settlers in sporadic raids on settlements far to the south.

Tribal hunters had left early this day, to scout ahead and locate the best deer herds and determine the best location to set up camp for the next thirty days, while they waited for the return of the huge

buffalo herds to the plains. Quanah, nineteen year old son of Noco-
na, led the group of young hunters upstream on the Canadian River,
seeing few deer and antelope the first day, but the sign became
more plentiful the second day and by the time the tribe arrived two
days later, they had several large mule deer gutted and hung in the
cottonwood trees, ready for the women of the tribe to skin and pro-
cess into jerky and pemmican.

The Comanches were content and happy with no thought that
soon their peace would be violently interrupted by others who
would invade their hunting grounds.

4

The big black stallion carried his load easily, and set a fast pace for the smaller bay mare, but she was tough and managed to match his pace. Traveling southeast, they paralleled the Blue Ridge range on the east and the Allegheny range on the west. It was the third day before they met up with another group of grey clad soldiers heading south. It was then that they learned that what they suspected was true, General Lee had surrendered, the war was over, and the southern army had been disbanded. Although there was little joy in the hearts of the beaten southerners, they were glad that the war was over and that amnesty had been granted allowing them to return to their homes.

"We'll be able to make better time now that we don't have to worry about the damned Yankees," Colonel Cole told Ned, with a note of bitterness in his voice.

They crossed over the Allegheny range and followed the Cumberland Gap wagon trail west. After they passed through the Cumberland Gap, travel became easier for both the men and their horses. The beautiful rolling hills of Kentucky made Colonel Cole question his choice of Texas for a home.

"Won't be long now, Colonel," Ned said as they made camp. "Cain't be more'n two days to our farm. It ain't much but it'll beat sleeping out in the open and you'll be able to mend up some while I get my belongings together."

The trail weary travelers reached Ned's home at Bowling Green ten days after leaving the field of battle at Richmond and Ned immediately visited his mother's grave, placing a small bouquet of wild flowers on the rock headstone. "Ma," he silently said, "Pa and the boys are all gone, they's just me left now. I hate to go off and leave you here alone, but I know you're alright now. There ain't nothing left for me here, anymore, so I'm going to Texas with Colonel Cole. He needs my help, and I know you'll understand." After saying goodbye, he got up and walked to the house, wiping the tears from his eyes.

They spent two weeks resting and cleaning their bodies and clothing. The colonel's arm was healing miraculously, although it continued to give him much pain when he rode. Ned caught the one remaining mule from the creek pasture, loaded his packsaddle with the best of his mother's meager possessions and some of the smaller work tools from the barn, tied him behind the bay mare, and they once again headed west.

The roadways were full of wandering bands of soldiers, civilians, and freed slaves. The countryside offered little subsistence for these homeless relics of war, and the colonel became concerned that some of the more desperate might decide to divide their needs with these two more fortunate travelers.

His worries were warranted, for as they were making camp the first night after leaving Bowling Green, a band of drifters walked into their camp, uninvited. There was seven of them, and they appeared to be neither north or south soldiers, for they were dressed in an array of uniform mixtures. Some had on confederate trousers and Yankee coats, others with Yankee trousers and confederate coats, and some were dressed in tattered civilian clothes. Colonel Cole surmised that they were deserters from both sides of the line, living off what they could steal or take with force.

The intruders looked the campsite over, as if they were trying to determine the best way to overpower them and take their horses and provisions. The leader of the group, dressed in a dirty union coat and confederate trousers, smiled cruelly and said, "Look what we got here, boys, a fuzz-faced kid and a one armed old man. Looks to me like these folks came out of the war with way too much property. I reckon they ain't goin' to mind sharing a little of their good fortune with us poor souls, now, are they?"

17

Colonel Cole, who had been bending over the fire and preparing to pour a cup of hot coffee, straightened. He looked at the band of cutthroats, smiled kindly, and said, "You're welcome to share our grub with us, boys, but I'm afraid we can't get along without our other property. We've got a long way to go to get to Texas, and we're going to need it all." As he spoke, he bent back to the fire and continued pouring his coffee.

"Texas?", the leader said. "Hear that, boys? These fellers got enough stuff to take 'em all the way to Texas. Looks like we done hit us a bonanza!" He motioned for the group to start moving in. Each one carried a broken branch for a club, and took a couple of menacing steps toward Ned and the Colonel. The tough looking leader pulled a revolver from his waistband as he moved forward.

However, before the intruders knew what had happened, Colonel Cole had replaced the coffee pot with one of the matched forty-fives in his good left hand, it belched smoke and flame and the noise of the shot echoed back through the trees. The leader of the renegades looked down at a bleeding hand which had been holding the gun, screamed in pain, and fell to his knees. The others stopped in their tracks.

The forty-five was still smoking as the colonel calmly spoke, pointing the long barrel at first one and then the other. "Looks like you boys got a little too greedy and ain't even going to get to share our grub. Now, you've got about thirty seconds to get your friend up and hightail it out of here. If I so much as see a hair on your head again, the next shot will be right between both ears."

The mangy band of deserters grabbed their leader and started running back in the direction from which they came. Ned still stood with the skillet in his hands, looking as astonished as the departing renegades.

"You sure know how to use that gun, colonel, and left-handed, too! Before I could bat an eye you had it out and fired," he said excitedly. He looked at the backs of the departing strangers and asked nervously, "Reckon they'll be back?"

"No, Ned, we've seen the last of them cowards. They'll be looking for easier pickins. I don't think they are going to want to tangle with this forty-five again." He put the gun back in its holster and reached once again for the steaming coffee pot.

Before they went to sleep, however, Colonel Cole handed one

of the revolvers to Ned, saying, "you might ought to keep it under your blanket, just for insurance."

They reached the Ohio River after two more days of hard riding and found a small farmer's ferry which carried them across to the western bank, then turned their horses northwesterly, heading for St. Louis where they would be able to purchase provisions and secure passage across the Mississippi.

After three more days, they rode into the bustling frontier town on the banks of the muddy river. St. Louis in 1865 was a sight to behold. It was the jumping-off point to the west, sod busters going to Kansas and Oregon, cattlemen going to Texas, and gold prospectors going to Colorado, Nevada, and California.

There were blue clad soldiers from the north mixing with the gray clad soldiers from the south. Freed slaves were seen everywhere, not knowing exactly what to do since it was the first time in their lives that they didn't have someone to give them orders. Some were dancing in the street to the music of a harmonica or banjo, begging for pennies from the passing throngs. Indians and half-breeds were helping to outfit wagon trains and tending to the horses and oxen. Hawkers lined every street peddling their wares.

"Now ain't that a sight to behold, Colonel." Ned said as his eyes took it all in.

The tinkling sound of honky-tonk music could be heard coming from several of the saloons which dominated the buildings. Pretty ladies with painted faces peered from the doorways, beautiful women with long skirts and parasols to protect them from the sun walked the board walks. Horseback riders, buggies, wagons, and pedestrians filled the streets as the teeming masses moved in every direction. The air was filled with a fine dust which rose from the dirt streets.

No one seemed to notice the congestion and the dust. Everyone seemed to be going somewhere in a hurry, with only one purpose in mind, and were oblivious to those around them.

Colonel Jim Cole and Ned Armstrong rode slowly down the main street, leading their pack laden mule behind. They feasted their eyes on the many sights on both sides and in the middle of the street. As they approached a louder than normal saloon, a body came crashing out the swinging doors and landed in the street in front of them. As they pulled their horses to a stop, another body

came hurtling out of the bar and landed with a thud on top of the first. A lady with too much rouge and lipstick appeared in the doorway and shouted obscenities at the two as they fought in the middle of the street for her favor. Both were so inebriated that neither was able to do much damage to the other, and they soon crawled to the shade of one of the buildings and ignored each other, trying to regain their breath. Ned and the Colonel laughed at the spectacle and continued down the street.

The street ended on the banks of the Mississippi, where barges and sailing ships were tied at anchor. They dismounted and stared with awe at the huge body of water which was moving slowly to the south. "I never in my life saw anything like that before," Ned said in amazement.

"Yep, she's quite a river, boy. Big enough for sailing ships to come all the way up here from the ocean. Sometimes she gets pretty mean, too, after winter snows start to melt and spring rains start to come. We're lucky she ain't running no bigger than what she is."

They turned back towards the center of town, found a livery stable which was close by the River Bend Hotel, and made a deal to leave their horses and mule in the care of the stable manager for a couple of days. They threw their saddlebags and bedrolls over their shoulders and walked across the street to the hotel. A hot bath and a tasty meal were the two foremost thoughts on their minds as they climbed the stairs to their room.

5

Dusk had fallen when Ned and the Colonel stepped out of the hotel onto the boardwalk. There seemed to be more traffic, more people, and more noise than during the day. Lanterns were lit along the street corners and others illuminated the windows in each of the buildings along the street. The music from the saloons was louder and there was more laughing and shouting as the whiskey began to affect the attitude of the drinkers.

Walking across the street to the livery stable, they checked their animals and were pleased to see that the proprietor had rubbed their horses down and had put out a large portion of hay and grain. Leaving the stable, Ned said, "Colonel, I'm so hungry I could eat the north end of a south bound skunk!"

Laughing, Jim replied, "I 'spect it'd be hard to find any part of a skunk to eat in this metropolis, son, but my nose tells me that there's catfish cooking in this here establishment," as he guided Ned into the open door of a building which had a sign painted on the window which proclaimed it was "Cajun Joe's Bar and Restaurant."

An hour later and a dollar poorer, they exited the crowded restaurant, stuffed with the best catfish either had ever eaten.

Seeing the sights of St. Louis after dark was another exercise in discovery, especially for Ned who had never been more than thirty miles from his home until he went off to war. He had taken only a dozen steps out of Cajun Joe's when a beautiful lady, wearing a low

cut dress which was held in place by her ample breasts, gently took his arm and started walking beside him. Her perfume was so strong and sweet he thought he was going to drown in its fragrance.

"Well, now ain't you some Johnny Reb," she said, as she squeezed his arm a little tighter. "So big and handsome and strong. I bet you have to fight the girls away with a stick."

Ned, blushing, looked embarrassed at the colonel, who was smiling knowingly at the scene which was taking place. He didn't offer Ned any assistance, however, in his apparent loss of words.

"What's the matter, soldier boy, cat got your tongue?" she said.

"N-n-no m-ma'am," Ned stammered. "You just kinda took me unawares, is all."

"Well, now that you see that I'm no Indian looking to scalp you, do you suppose you might buy me a drink and tell me all about why you're in St. Louie?" she asked coyly.

"I'm sorry ma'am," replied Ned, "I don't drink and besides, I ain't got any money."

Her demeanor changed immediately and her voice became rough and raspy as she said, "You don't have to drink to buy me one, Reb, but you sure as hell need some money to get what I've got." She released her hold on his arm and swung her hips back down the street to find another suitor.

Colonel Cole laughed loudly at Ned's embarrassment, and after he regained his composure, he chided the sixteen-year old. "I bet that's the first time you ever been propositioned, hey boy?"

"Yes sir, if that's what she was doing, it sure is," Ned said with a sheepish grin.

"Well, I can guarantee it won't be the last time, Ned. These frontier towns are going to be full of pretty ladies just itching to get your money and other things. Hell, sometimes I think they're more dangerous than those highwaymen that we had to take care of back down the road. They's one thing you ought to know, though, son. I got a money belt under my shirt that's got some gold coins stashed in it that I brought all the way from Texas. It's half your's any time you find something you feel like you'd like to buy. I owe you, boy, and I intend to pay my debts."

Ned, surprised, said, "I shore didn't know you had any money, Colonel. I thought we was as pore as old Job's turkey. But I thank you for the offer. No sir! I sure ain't aiming to get hooked up with

any of them floosies. My pa warned me about them before he went off to war and got hisself killed. I guess I need lots of things worse than I need me one of them painted up ladies."

Jim placed his left arm on Ned's shoulder, patted it a couple of times and said, "That's the way I like to hear you talk son, sounds like you must have had a pretty straight thinking pa. It looks to me like I got me a helluva pardner. I'm proud of you."

Ned dropped his head, not knowing quite how to take this compliment, but liking it just the same. They walked slowly down the street, turning into a few of the bars just to look at the sights. Pushing their way up to one of the bars, Jim bought a couple of shots of bourbon and Ned drank a sarsaparilla while they watched the mountain men, the cowboys, and the river gamblers dance with the honky-tonk girls. Ned was so excited when they returned to their room for the night that he had a hard time going to sleep.

"Did you ever see such goings on, Colonel? I tell you, I ain't never seen the likes of this St. Looie. Why, I bet there's ten thousand people out there and everyone of them is going somewhere besides here. Did you see that big mountain man with the bright red beard. I bet he weighed three hundred pounds. He told me he just brought in his winter catch of furs all the way from Oregon. Fetched him four hundred dollars, can you imagine that, four hundred dollars for just one winter's work! Said he's heading back up to the Missouri tomorrow, too. Don't like these big cities and all these people."

Ned was interrupted by the solid snores of the colonel in deep sleep. He stopped talking but lay looking out the window and listening to the sound on the streets for half the night before he finally was able to close his eyes and drop off into a fitful sleep.

Ned was awakened the next morning by a dog barking below his window. He raised up quickly in bed, not able to gain his bearings. At first he thought he was at home in his old bed, but a quick look around the room dispelled this thought. Then, as he became fully awake, realized that he was in a hotel room in St. Louis with a one-armed colonel who he had saved in battle and nursed back to health.

At the movement, Jim opened his eyes and looked at Ned who was sitting on the side of the bed. "Well, boy, did you finally decide to go to sleep last night? Last I remember you was still yapping

like a jaybird."

"Yes sir, I finally got some sleep, but I swear, Colonel, I don't ever remember seeing so many sights as I seen yesterday. And all them things just kept going round and round in my mind after I went to bed. It shore was some day!"

"Well, today may be more exciting than yesterday, boy. We got lots of things we got to get done. First thing after breakfast we're going to get rid of these Johnny Reb uniforms and get us some clothes that will be more fittin' once't we cross that old river. Then the next thing we got to do is load that mule of your's down with black powder and lead, cause where we're going they ain't going to be no corner mercantile. Then I guess we're going to have to figure out how to get us and them critters of ours acrost that river."

Ned was already up and slipping on his trousers. The excitement shown in his face as he said, "Well get out from under them blankets, Colonel, we dang sure ain't going to get it all done burning sunlight up here in this room."

Breakfast was shared in a boarding house which joined the hotel. An elderly lady who everybody called "Ma," was the proprietor and cook. For two bits apiece, they had all of the biscuits, gravy, ham, eggs, and grits they could eat.

"Beats that rabbit we ate in the swamps of Virginny, don't it boy?" Colonel Cole, smiling, asked Ned. Ned replied by shaking his head since his mouth was so full of gravy and biscuits that he couldn't speak.

They found a mercantile down the street that had everything from nails, tools, guns, and ammunition, to canned goods, flour, coffee, beans, and clothing. Their first stop was the clothing area which was permeated by the strong, musky smell of fresh tanned leather.

The colonel pointed out some soft buckskins, both breeches and shirt. "These will do us right handy where we're going, Ned. They will protect us from the weather and won't wear or tear. We'll get us some of them woolen longjohns to wear under them in the winter which ought to cut those icy winds that I hear tell get pretty bad on the *Llano Estacado*."

Heavy handmade boots were five dollars a pair. They bought two pair then headed for the hat rack and after trying on several, settled for two felt ones with very wide brims. After pulling them

firmly down on their heads, they looked at each other and laughed. Their appearance changed considerably to what it had been with the tattered confederate caps on their heads.

Next Jim led the way to the gun and ammunition section. To Ned's surprise, he picked up a long, cumbersome looking rifle, hefted it and sighted down the hexagon barrel. "Takes a fair size ball to knock a buffalo down, Ned. And where we're going, the buffalo is thicker than flies on a sorghum lick. Besides, a buffalo hide fetches a pretty good penny back here in St. Looie. Smiling, he added, "We might just try buffalo hunting for a spell."

Well, the thought of hunting buffalo set Ned's heart to pounding. This was something which he hadn't really thought about. It sounded like Texas was going to be just the place for this Kentucky farm boy who would rather hunt squirrel than plow behind a mule any day.

Jim bought several pounds of black powder and lead for the two fifty caliber Sharps rifles, several hundred rounds of ammunition for the two forty-five caliber revolvers, and ammunition for the Winchester which he carried on his saddle and the one he chose for Ned. He picked up a large bone-handled Bowie knife and tossed it, handle first to Ned. "You might need to cauterize another arm someday, boy. Stick that in your belt," he said with a grin.

"Looks like you boys are planning on making a war with someone," the shopkeeper said, as he started adding up their bill.

"No sir," Jim replied, "just aim to protect and feed ourselves for the next twelve months. Don't want to have to come a thousand miles back to St. Looie just to load our guns."

The proprietor smiled and said, "That'll be one hundred and fifty three dollars, mister. And that's a bargain if I do say so myself."

The colonel pulled out three fifty dollar gold coins and some smaller coins to make the change. They thanked the shopkeeper, walked out burdened down with the weight of their purchases and headed for their room, where they immediately shed their worn army clothes and donned their new buckskins.

Jim tucked the empty sleeve of the buckskin shirt under his belt, glanced proudly at Ned and said, "You look a heap better, son. Better be careful or them painted-up ladies will be paying you for spending a little time in their back rooms."

Ned laughed.

Their next job was to locate a ferry or boat which would carry them to the other side of the Mississippi River. On the western edge of the city they found a small ferry which was pulled across the river by a team of horses on the other side. A winch rolled out a rope on the east side as the ferry was pulled across to the west side. This rope was then hitched to a team on the east side and the ferry was pulled back across. For this service, the ferry operator charged a dollar a head per person and for each horse. Wagons were five dollars each. "Glad we ain't taking no wagon train," the colonel told the ferry operator.

They made a deal and informed him they would be back at daybreak the next morning then headed back to town.

Upon reaching town, they stopped by the livery stable to enquire about another mule, since they now had more supplies than one could carry. Luckily the stable owner had one nearly identical to Ned's which he offered to sell for forty dollars and said he'd throw in a packsaddle and a set of harness. They paid for the mule and the board for the horses and informed the stable owner that they would be leaving at daybreak in order that he could feed the animals early.

* * * * * * * *

Lee's surrender at Appomattox had ended the Civil War, but it did not end the problems of the United States Army. General of the Army Ulysses S. Grant recognized that another war was waging in the west, mostly as a result of the war in the east. While the war between the states was being fought, army units were pulled away from the frontier and placed on the battlefront in the east, leaving the western frontier at the mercy of marauding bands of Indians who were determined to push the white man out of their territory. Grant dispatched several regiments to the area to put down the Indian uprisings, many of them black *buffalo* soldiers, so named by the Indians because their coarse curly black hair resembled the hair on the plains buffalos. These troops were commanded by white officers.

General Grant appointed General William Tecumseh Sherman as commander of the Department of Missouri and Sherman moved

his military headquarters to St. Louis in preparation for fighting the Indian wars. General Sheridan assumed command of the Fifth Military District, headquartered at Ft. Leavenworth, Kansas and made plans to bring peace in the area, either through treaty or by force. The Indians, however, were not his only problem.

Not all members of the army recognized the surrender of Lee at Appomattox to be the end of hostilities. Colonel Quantrill, who had led a band of confederate guerilla fighters during the war, refused to disband his troop, and continued to raid, plunder and rape across the Kansas and Missouri frontier, more as a bandit than as a soldier. Sheridan vowed to put an end to the lawlessness perpetrated by Quantrill and his ruthless raiders.

As Colonel Jim Cole and Ned Armstrong finalized their plans to travel across Missouri to Ft. Smith on the eastern edge of the Indian Territory, Quantrill was planning yet another foray against the citizens of a small frontier community in that state to rid them of their hard earned cash, stored in the local bank.

6

Before the sun broke the horizon, Jim and Ned had finished breakfast and were loading the packsaddles on the mules. They mounted their horses and headed for the ferry, each leading a mule.

The ferry was made of rough logs, cut from the nearby forest. The logs were laced together with large ropes and were floored with two by eight timbers which were secured with steel spikes. It was sound enough, but the animals wanted no part of this floating contraption sitting on top of the water. It required the strength of Ned, the Colonel, and the ferry operator to drag them on and snub them to metal rings which were attached to the floor.

A white flag was hoisted to inform the driver of the team on the opposite side of the river that they were ready to cast off. The ferry started moving slowly towards the middle of the river. The flow of the muddy water carried the ferry and its occupants downstream at first, but soon the ropes on either side tightened, and the ferry took a straight course across the river.

Reaching the other side without incident, the horses and mules were released and the Texas bound travelers mounted and headed west at a brisk pace, the black stallion leading the way. The ferry operator shouted to them and they stopped and turned back.

"I'd be a mite careful," he said as he rolled a jaw full of tobacco around in his mouth and spit a brown stream at the feet of Ned's mare, "that bastard Quantrill has been raising hell across Missouri. Claims to be a vigilante but ain't nothing but a damned outlaw if

you ask me. They say those James and Younger boys have been riding with him and they might just take a liking to those mules and supplies if you were to meet up with them."

"I appreciate that, friend," Jim answered, "may be the same Quantrill I rode with for awhile back in Virginia when we was fighting the Yankees. I considered him a friend back then, maybe he'll consider me a friend now."

The trail to Ft. Smith was not as well traveled as the other trails leading away from the ferry, since most of the travelers were heading for the new prairie homesteads in Kansas or farther west up the Oregon Trail. Traveling across the Indian Nation was considered too dangerous, and the *Llano Estacado* (Staked Plains) was known as the Great American Desert, encouraging most western travelers to take a more northerly route.

After traveling most of the day alone, Jim and Ned overtook a small column of Union Cavalry going to Ft. Smith to relieve some of the soldiers at that outpost. The officer in charge of the contingent had no objections to the two civilians traveling along with the troop, so they dropped in behind, feeling safer with the protection of the soldiers.

Approaching a small settlement in the Ozark Mountains, the leader of the Union contingent halted his troops, listening. Gunfire could be heard coming from the direction of the settlement.

Jim and Ned pulled up to the front of the cavalry company, stopping next to Captain Newman. "Sounds like a small war taking place up ahead," he said to the captain. "Them's army rifles making that noise."

"I think you're right, Mr. Cole," Newman answered. "I was instructed to keep a sharp eye out for that bastard Quantrill and his cutthroats, he's been reported in this area and I'll bet my hat that he's behind whatever is going on out there."

"Lieutenant! Form your troops in a battle line then move them out at a canter. Sounds like them folks need some help." Looking to Jim, he said, "You two wait here, there's not much you can do dragging them pack mules. We should be able to take care of this problem in a hurry."

Jim and Ned pulled their pack mules out of the way as the cavalry unit prepared to rush the town.

The gunfire was concentrated around the small bank in the set-

tlement and it appeared that local citizens had control of the bank and the raiders were trying to convince them to give it up. Captain Newman held his fire until they were nearly on the unsuspecting raiders then gave orders to open fire. Hearing the firing from his rear, Quantrill turned and shouted orders for his men to direct their fire into the charging cavalry. In the first volley, several of the mounted horsemen were knocked from their saddles.

Pandemonium resulted as the cavalry charged through the line of raiders with both battle lines being broken. Quantrill shouted orders to mount up and he led his men away from the bank in the direction from whence Newman's group had attacked, while Newman ordered his men to dismount and form a battle line between the raiders and the bank. As the distance between the two groups increased, firing ceased.

The Colonel and Ned were waiting on the trail, when suddenly the raiders topped the hill and they were caught up in their midst. Quantrill pulled up beside them, looked them over then cast his eyes on the two heavily loaded pack animals. Turning to one of his lieutenants, he shouted, "Shoot these two and bring the mules and their horses!"

"Hold on, Billy," Jim shouted. "Don't you recognize me? Jim Cole, Texas Cavalry, Virginia!"

"Hold it!" Quantrill ordered his lieutenant as he took a second look at the one-armed, buckskin clad rider. Recognizing the huge black stallion he realized it was the Texan with whom he had rode in '63.

"Damned if it ain't, Jim! What the hell happened to your arm?"

Looking back towards the town and without waiting for an answer, he said, "We'll talk about it tonight. Get them mules in gear, them damned Yankees may decide to follow us and they got more fire power than we've got."

He didn't give them an opportunity to object, as he grabbed the lead rope on Jim's mule and kicked his long-legged bay back down the trail away from the town. Jim followed, he wasn't about to lose possession of his mule and half their supplies. Ned's mare followed the black stallion dragging the other mule behind.

They rode for the remainder of the afternoon, turning off the main trail, ascending into the heavily wooded foothills of the Ozark Mountains. Two hours before sundown, Quantrill called a halt next

to a small clear stream and gave orders to make camp for the night. He sent two of his men back about a mile to a high, rocky point where they could see for a great distance down the trail with orders to shout a warning if they spied the soldiers following.

Quantrill motioned for Jim and Ned to join him under a large pine tree where they dismounted and started pitching their camp. Ned began removing the packsaddles from the mules and the saddles from the horses as Jim sat down and leaned against the tree, totally exhausted from the hard ride.

Quantrill sat down beside him, pulled a long black cigar from his pocket and offered one to Jim. He lit Jim's, then his, took a long drag and slowly blew the smoke before he spoke. "I almost blowed your head off back there, Cole. What in hell you doing out here in the middle of Missouri?"

"Me and the button is headed back to Texas -- North Texas, that is. Got me a parcel of land up there on the head of the Red River, and we was figuring on proving up on it. Figured we'd have some Indian trouble but wasn't expecting to get my head blowed off by an old friend before I ever got there."

Quantrill laughed. "Not many people out in these parts call me friend. I was sent out here by Lee to raise hell before the war ended, and we did some things that folks ain't apt to forget, most of them might even like to stretch my neck from the nearest oak tree. Since I'd kinda like to keep my neck, we just decided we'd keep on doing what we do best. Besides, nobody ever asked me if I was ready to surrender to the damned Yankees."

Staring at the empty sleeve, he once again asked, "What the hell happened to your arm, last time I seed you, you was slashing right and left with a bloody saber with that there arm and hand?"

Jim related what had happened east of Richmond and how he and Ned had met on the field of battle. Quantrill listened attentively and when Jim had finished his story, he said, "Looks to me like you was lucky as hell, you'd be lying dead back there in that swamp with the rest of them rebels if it hadn't been for the kid."

Jim agreed and smiled at Ned, who had returned from watering the horses and mules. "Might have been the other way around," Ned said, hearing Quantrill's statement, "If the Colonel hadn't showed up and told us to head for the river, I'd probably be a pile of bones back there in Virginny. Maybe we both owe each other."

Back at the town, Captain Newman decided he had lost enough of his unit, three dead and six wounded. He left Quantrill's future up to General Sheridan in Ft. Leavenworth, satisfied that he had at least saved the town's money from the raiders. The thankful citizens put the soldiers up for the night, tended to the wounded and wined and dined the survivors.

Jim Cole and William Quantrill shared a bottle under the huge pine tree and spent most of the night reliving their experiences together fighting the Yankees for the past four years. "The war's over, Billy, you ought to lay down your arms and turn yourself in, amnesty has been declared and you wouldn't have to stand trial for your raids during the war," Jim said.

"Ain't no way, Jim. It's not what we did during the war, it's what we've done since it ended that'll hang me. No sir, I got me some good men and we're making a good living, taking from the rich and giving to the poor -- the poor being *us!*"Maybe someday, but not now."

The next morning, Jim and Ned said goodbye to the outlaws and headed their mounts in the direction of Ft. Smith as Quantrill led his raiders towards the Kansas line, saying they had some unfinished business to take care of concerning a gold shipment on the Atchison, Topeka and the Santa Fe.

The weather turned wet and they traveled the last two days through heavy thunderstorms and blowing rain. Lightning illuminated the outlines of the fort as they rounded a bend in the road as darkness closed around them. Ned wiped the rain from his face and announced with a smile, "Hallelujah, Colonel, I was about to think you had me lost forever but I guess you knew where we was all along."

After a hot bath and a good night's rest in the only hotel in the small settlement adjoining the fort, Jim and Ned paid a visit to the commandant of the fort, Colonel John Traxler. The two colonels soon discovered that they had much in common. Colonel Traxler had been commanding the Union lines of cannon on Cemetery Hill at Gettysburg when Colonel Cole's Texas Cavalry charged his positions. They were soon engrossed in a lively discussion about that fateful day when so many brave Americans on both sides of the battle were killed.

When asked about the trail across the Indian Territory, Colonel

Traxler responded, "Pretty dangerous, boys," he said. "Buffalo hunters been taking too many buffalos from their western hunting grounds and the Comanches, Cherokees, and Kiowa are pretty upset. They might just decide to try to lift your scalps if you try to cross their country alone. I'd advise you to wait until we have some troops going in that direction."

"How long might that be, Colonel?" asked Cole.

"Don't rightly know," replied Traxler. "Our orders at this time are to secure this part of the country and not start any confrontation with the redskins in their territory. If the Indians and the buffalo hunters get into a fracas, we might get orders to go in and calm things down, but that ain't no guarantee."

"Where's the nearest fort to the *Llano Estacado*, Colonel. That's where we're headed and we might go around the Indian Territory if there's a safer or better way?" Jim asked.

"There isn't any between here and the Plains. Ft. Bascom is on the other side, with Ft. Leavenworth to the north and Ft. Concho to the south. The trail to Santa Fe is the closest and best route, but like I said, them redskins ain't looking too kindly on us white folks these days," Colonel Traxler answered.

"What do you think, Ned? Do you want to wait?" Jim asked.

"I'm with you, Colonel. I don't see much in this place to wait around for, and if you think we can make it, then I'm willing to take our chances." Ned said.

"Well, I fought a few Indians down in Texas and still got my hair. I say let's give it a try. We got lots of work to do on our spread before winter blows in, and we sure as hell ain't going to get it done toasting our toes in this place," Jim said with a grin.

They shook hands with Traxler and left the fort. Dawn found them following the well-worn ruts of the Fort Smith - Santa Fe Trail, made during the gold rush of '49. Colonel Traxler said he thought they probably wouldn't have any trouble for a couple of days, since most of the Indians had moved further west with spring, to intersect the migrating buffalo herds.

As they rode westward, Ned asked, inquisitively. "How come General Houston gave you all this land, Colonel, if they ain't no white folks living up there?"

"I guess he kinda took a liking to me, Ned, after all my friends got killed in the Alamo. I stayed with him till he whipped ole Santa

Anna at San Jacinto, and when he was made President of the Re-
public of Texas, he kept me around, kinda like an aide. Me and his
son, Temple, was about the same age and ran together. Course, I
wasn't very old and he treated me like I was kin. He always told
me that someday, that high, flat country at the head of the Red
River would be the best part of Texas and wanted me to have a part
of it. No one else was very interested in it, so it wasn't no problem
for him to get the legislature to make me a grant. Most of the state
was divided up into Spanish land grants, anyways." Jim reached
into his saddlebags as he was talking and took out a roll of papers,
stopping the big black stallion as Ned rode up beside him.

He unrolled the papers and showed Ned the signature of Presi-
dent Sam Houston on a legal looking document which said in ef-
fect that Jim Cole, a citizen of the Republic of Texas, was hereby
granted a parcel of land, yet unsurveyed, which has as its boundaries
the Canadian River on the north, the North Fork of the Red River
on the South, the head of the Sweetwater Creek on the east, and a
north-south line from the head of the Red to the Canadian on the
west. A crude map was attached to the document indicating the
approximate location of this area, referring to land marks attested
to by Josiah Gregg, a trader who had made several trips across this
area. The map indicated that a portion of the land was located on
top of the northeast thumb of the *Llano Estacado,* while the balance
lay along the Canadian River bottom and below the escarpment
along the eastern boundaries.

"My title to the land is on record at the capitol in Austin," Jim
continued, "so if there are any squatters on the land, we won't have
any problem proving ownership. Don't reckon we need to worry
about anyone wanting it 'ceptin buffalo hunters and redskins,
though. There's another thing I didn't tell you, Ned. After the war
with the Mexicans, I was able to save my money working for the
General and put together a right smart piece of property in the hill
country of Texas. I sold it just before the war with the Yankees,
and was fixin' to buy a herd of longhorns and head 'em north to my
grant. The war kinda interfered with my plans for a spell, but I still
got the gold from selling that property in a bank down in Austin.
When we get our ranch staked out, we're going south and buy them
cows, just like I planned to do before the war."

Excitement could be seen in the young boy's face as the colonel

laid out his plans for the future. Buying cattle and driving them north, now that would be an experience!

They traveled slowly west during the day, seeing plenty of Indian sign, but no Indians, and camped along a small stream for the night. Staking out their horses a short distance from their campsite in a patch of lush grass, they decided that while one slept, the other would stand watch for any roving band of Indians that might have their eyes on the horses and supplies. Ned took the first watch.

About midnight, under a bright moon, Ned was startled to hear a sharp, screaming nicker from the direction of the horses. Then the sound of horses thrashing around in the grass, as if someone was trying to stampede them. He heard the grunting whinny of the mare as he shook the colonel awake. They grabbed their guns and dashed towards the horses.

There in the clearing, with the moon reflecting off the slick black coat of the colonel's stallion, stood the horses, the stallion was still mounted on the buttocks of the mare. But his moonlight courtship was complete, and the mare stood contentedly, holding up her suitor. In twelve months, the colt which would be born from this union would be the first of many which would be fathered by the black stallion, building a herd of the finest horse flesh west of the Mississippi.

They returned to their bedrolls, laughing at their mistake, but happy with their good fortune.

The next day they continued their journey along Josiah Gregg's old Santa Fe Trail which paralleled the Canadian River. They saw a few Indian hunting parties in the distance, but never made contact. However, the third day a party of twelve braves blocked the trail as they topped a hill. The colonel slowly pulled his Winchester from its saddle boot, laid it across the saddle horn, and rode up to the Indians before stopping. Ned kept his hand on the butt of the colt hanging from his hip.

The colonel held up his hand in a sign of friendship. One of the braves returned the sign. They were Kiowas, on a hunting mission, the leader told the colonel. It was difficult for Jim to communicate, because the Indian dialect which he had learned in Texas was different than the Kiowa language, however, he was able to tell the hunting party that they traveled in peace, and were heading for a land many days to the west and were only passing through their

land.

He reached into his saddlebag and brought out a few of the beads and trinkets, which he had purchased in St. Louis for just such an emergency and handed them to the young brave who was leading the group. The Kiowa brave took them, laughing as he held them up for the others to see. He said something in Kiowa, and the braves moved their horses out of the trail and motioned for the colonel and Ned to go in peace. The Indians were still laughing and talking about their gifts when the two riders disappeared over the next ridge and continued their journey west.

They passed numerous relics of the '49 gold rush. Abandoned wagons which had broken down or had been burned out by raiding Indian war-parties. On the fifth day out of Ft. Smith, while passing close to the Canadian River bank, they came upon a lone Indian brave who, along with his pony, was bogged down in quicksand approximately thirty feet from shore. The pony was buried to his belly and was unable to move; the young brave, approximately nineteen years old, had sunk up to his armpits in the shallow water and quicksand, a look of panic on his face.

Jim untied his mule and handed the lead rope to Ned who dismounted and tied the two mules to a nearby willow. The colonel loosened his lariat, made a loop and tossed it accurately over the floundering brave. He then made a dally around his saddle-horn and backed the stallion slowly away from the river bank. The Indian held tight to the rope and was easily pulled from the sand. He lay exhausted on the grass as Ned removed the rope and Jim made a new loop. He threw it over the head of the frightened pony and this time turned the stallion away from the river and tightened the rope. The Indian pony, frightened, began to thrash about in the sand and was able to get his front legs free. The stallion pulled with all his strength and the trapped pony,s rear legs were freed and he came thrashing to the bank and stood shivering but unhurt next to his rescuers.

Ned then turned his attention to the young brave who continued to lie on the grass. The rope had left a raw welt around his chest and under his armpits. He had regained his wind, and was trying to get up, at the same time drawing a knife from the belt which held his breech-cloth in place. Ned, seeing the move, grabbed the boy's wrist and wrestled the knife from his hand.

Colonel Cole spoke in the Comanche dialect, telling the Indian that they were friends and meant him no harm. The Indian relaxed, and the fear in his eyes disappeared. Ned, looking into the Indians eyes, was amazed, for the boy's eyes were nearly as blue as his own!

7

Jim, who had dismounted and approached the two young men, said, "They sure as hell are, boy! And look at his features, he's near as white as you are, if it weren't for all that dirt and grease on his body."

Looking into the Indian's eyes, the colonel spoke softly, as if talking to a frightened animal, "Do you understand English, Indian?"

There was no response, only a look of confusion as the Indian returned the stare.

Once again the colonel spoke, this time in the guttural language of the Comanches. "What's your name, blue eyes?"

The brave replied, "Quanah, son of Nocona, chief of the Noconi." He stood proudly erect and threw out his chest when he introduced himself, as the son of a chief should do.

Colonel Cole, acknowledging the boy's statement, said, "My name is Jim and this is Ned," as he placed his left hand on Ned's shoulder. "We are traveling west to the land of no trees and wish to go as friends of your people," he held up his hand in the Indian sign of peace.

Quanah nodded his head in understanding and extended his arm towards the colonel who took it in a grip around the wrist. Quanah also gripped the colonel's wrist, indicating brothers. He then turned to Ned and offered his hand in the same manner. Ned looked at Colonel Cole, who nodded his head for him to accept the

offer of friendship from the young Indian brave.

The two boys, identical in size and approximately the same age, gripped each other's arms and stared into each others eyes, saying nothing but leaving the impression that a bond was formed which would not be easily broken.

Quanah stepped to his pony and agilely jumped to his back, turned and motioned for the two to follow him. They retrieved their horses and mules and took a position behind the young brave as he turned his pony west down the ruts of the Santa Fe Trail.

Quanah told them as they traveled that he had been out on a hunting party with two friends, when they had jumped a buck deer along the river. He became separated from his friends as he trailed the deer, and while trying to cross the river, became mired in the quicksand.

After traveling along the river bank for an hour, they came to a grove of cottonwood trees in a flat valley dissected by the river. Smoke could be seen rising above the trees. As they came closer, the sound of barking dogs and screaming kids could be heard, and they could make out many tipis scattered through the trees.

Quanah led them into the camp, calming the excited braves by telling them that these were friends who had saved his life. Stopping before a tipi, located in the center of the village, they dismounted as the flap of the tipi was thrown back and a huge Indian stepped out, dressed in buckskins and wearing a flowing warbonnet of feathers and animal tails.

"Why do you bring these *white-eyes* into our village," he asked angrily?

The young brave listened respectfully at this tirade from Chief Nocona and after he had finished, Quanah spoke, "I owe my life to these men you call *white-eyes*. When the sand of the river had captured me and my pony and was ready to swallow us, these men pulled me out. Without their help I would have died."

Upon hearing this news, Chief Nocona relaxed, turned to the two intruders and raised his hand in peace. He thanked them for saving his son's life and informed them that they would be welcome and safe in his village.

After dismounting, the chief instructed two nearby braves to tend their horses and mules. The braves responded quickly, removing the saddles from the horses and the packsaddles from the mules. They carried the saddles and supplies into a nearby tipi

which he designated as the home of Quanah's friends while they were visiting his village.

Ned, having never been around Indians before, was nervous at this turn of events. After traveling halfway across the continent, finding himself in the company of such ferocious looking savages was rather unnerving, to say the least.

"Colonel," he said as they ducked into the dim interior of the tipi, "It 'pears to me that we got ourselves into a helluva predicament by saving that buck from the quicksand. Ain't no way we can get out of here with our hair if they decide they want our horses and supplies more than they want our friendship."

Jim laughed. "I 'spect you're right, son, but I know Comanches. They respect friendship and bravery above all other things and their word is their honor. The Chief has spoken and said we are welcome so we don't have anything to worry about. "

After refreshing themselves with water carried from the river by two of the women, they joined Chief Nocona in a meal of buffalo meat broiled over the open fires. The meat was delicious, if not the most sanitary. They ate their fill, and sat relaxed next to a large campfire, as other braves came to join Chief Nocona and Quanah around the fire. Soon there was a circle of fierce looking, half naked Comanches completely encircling the fire. The chief was handed a long, clay pipe by one of his squaws, which was filled with a coarse tobacco poured from a leather pouch which he lit with an ember from the fire, took a couple of long drags, and handed the pipe to Jim as he exhaled the smoke. Jim also took two long drags and handed the pipe to Quanah who did likewise, and then passed it to Ned who took one puff and began to cough and sputter uncontrollably. Tears welled in his eyes from the strong smoke, as he tried to regain control of his breathing. The braves around the campfire began to laugh and yell loudly at Ned's embarrassment.

The pipe continued around the campfire, each brave taking his turn at puffing, inhaling, and blowing out the smoke and grunting their approval of Quanah's friends. After the pipe had made the complete circle, Nocona spoke.

"My people are very angry with the Tejanos from the south. They continue to move their settlements further north into our buffalo range and plow the grass. They make war on our people and force us to move further north. This country was given to the Indians by the Great White Father in the east, yet your people continue

40

to travel through our land without permission and shoot our buffalo for their hides. Someday the Great White Father will say that this land is no longer Indian land, then where will the Indian go?"

"I understand your anger, great chief Nocona. I promise you that my friend and I wish to live with your people in peace and friendship. The Great White Father has given me a parcel of land which lies at the beginning of the *Llano* and reaches to the west for two day's travel. We wish to live on it without fear of your people. We will not plow the grass but use it only to feed our cattle. We promise to give you and your people free travel across our land, and our lodge will be your lodge when you follow the buffalo across our land, and when there are no buffalo to feed your people, we will share our beeves with you."

The chief replied, "Because you have saved my son's life, I will always respect your land and your property. I will instruct all my people that you and your land will be treated as a brother's."

It was now young Quanah's turn to speak. "I owe my life to these men who have treated me with respect and accepted me as a friend. I wish to make them my blood brothers so that our people will always know that if they harm them in any way, they will answer to me, their brother."

Upon saying that, he removed the knife which he had previously pulled in anger, cut a small gash in his wrist, then handed the knife to Ned. Ned took the knife and did the same, then cut the outstretched wrist of the Colonel, and they each touched their wrists together, letting the dripping blood commingle. The braves around the fire grunted their approval, stood up and each of them marched by Jim and Ned and shook their hands, Indian fashion, in friendship.

"How is it your son has blue eyes like his new brother, Chief Nocona," Jim asked when the ritual was completed.

"Many moons ago," answered the chief, when the Tejanos were at war with the Mexicans, my people joined the Mexicans to keep the white man out of the land of the buffalo. During a battle with the whites at Parker's fort, we took captives. One of the captives was a beautiful white maiden who became one of our people. I took her as my bride when she became of age. She had yellow hair and blue eyes. She was Quanah's mother."

"I remember the incident. Her name was Cynthia Ann Parker," Colonel Cole said. "I have seen no woman here who appears white.

Where is she now?"

"Five years ago, the Long Knives attacked one of my villages on the Pease River and killed all of my people who were curing buffalo hides and meat which we had killed. My braves and I were on the hunt, chasing the buffalo herd. I have been told that the Long Knives took my squaw and my daughter captive. I do not know if that is true or not, perhaps she is dead," Chief Nocona said sadly.

With that statement, the Chief stood and entered his tipi. The meeting broke up, Ned and the colonel went to their tipi where they found buffalo robes on the floor for their beds. Once again, Ned was too excited with the days events to be able to sleep. He lived over and over in his mind the days events, and it was almost dawn before he finally fell into a restless sleep, content that he would be able to keep his hair, after all.

The sounds of the camp activity awakened them and they walked outside the tipi where the women of the camp had a meal of buffalo meat and beans prepared. They ate, retrieved their horses and mules from the Indian remuda, packed their belongings and mounted to leave.

Chief Nocona and Quanah bade them farewell and told them to go in peace. Colonel Cole said in parting, "When you follow the buffalo onto the high llano you will find us. You will be as welcome in our home as you have made us welcome in yours. Good-bye good friends."

They rode out of the Indian village, followed by yapping dogs and excited children.

* * * * * * *

One hundred and fifty miles north and west of Chief Nocona's camp, an army post was being erected on the Arkansas River near the remains of old Fort Atkinson. The new fort was to be named after Major General Greenville Dodge who was commanding officer of the Department of Missouri, before Sheridan took command.

Buffalo hunters, who had discovered a new market for buffalo hides in Europe, were quick to use Fort Dodge as a gathering point for hunting the buffalo herds north of the Arkansas and would soon begin invading the hunting grounds south of the river, land given to the Indian tribes by treaty in 1853.

Although it was forbidden by treaty, when General Dodge was

asked by the buffalo hunters for permission to hunt south of the Arkansas, Dodge replied, "Boys, if I were a buffalo hunter, I would hunt where the buffalo are."

This was an open invitation for the hunters to flood the area a-round Fort Dodge and soon a lawless town sprung up next to the Fort -- Dodge City.

Two of the newly arrived hunters were Billy Dixon and Bat Masterson, former employees of the Atchison, Topeka and Santa Fe railroad which was plodding slowly westward towards Dodge City. While they were waiting for the buffalo lands to be opened to hunt-ers, Bat was hired, temporarily, to act as town marshall. "I ain't no lawman," he told the store and saloon owners, but I'll try to keep the killings down until me and Billy head south after the shaggies."

8

The big black stallion continued to move briskly up the Canadian River, as if he knew he was getting close to home. They traveled for two days after leaving Chief Nocona's village before intersecting a large stream bed on the south side of the river. According to the rough map, the stream was known to the Indians as Red Deer Creek, because of the numerous mule deer which inhabited the cottonwood groves along the stream bed.

They followed the stream away from the Canadian for a day, before Jim called a halt, looked around proudly, and announced to Ned that they were now on Cole-Armstrong property. A short distance further west, the escarpment of the *Llano Estacado* could be seen rising from the floor of the valley.

They were in a large grove of cottonwoods, with plum thickets and hackberry trees scattered about and a small clear stream flowed into the creek from somewhere higher in the foothills. They turned their horses up this small stream and followed it for about a half mile until they found a large, clear spring, bubbling at the base of

the hill, which was surrounded by huge cottonwood trees. Looking back, they could see down to the floor of the valley, and in both directions up and down the creek. A vertical cliff rose steeply from the pool's edge, ascending for nearly two hundred feet to the top of the escarpment.

"This will do us fine until we can ride out our property and see what we've got," the colonel told Ned.

Unloading their horses and mules, they began preparing a semi-permanent camp. After the animals were staked in the lush grass along the spring, Ned set about gathering fire wood and stacking it next to a large boulder which lay at the base of the cliff. Soon he had a fire going with fire-irons in place on either side and a big black coffee pot hung from the spit over the fire. The pleasant aroma of boiling coffee filled the air, bringing Colonel Cole back from a short scouting trip around the perimeter of the cottonwood grove.

Ned poured a couple of tin cups full of the boiling coffee, and they sat down by the water's edge and silently contemplated their new domain. As they drank the dark brew, they both saw the cloud of dust at the same time, rising from the rim of the caprock across the valley, probably two miles in the distance. Then they could see the black objects as the dust cloud continued to flow down a cut in the cliff's face.

"Buffalo!" Jim said in amazement, as hundreds of the shaggy animals poured from the plains down to the valley's floor. They watched as the hundreds turned into thousands and the stream bed turned black as if covered with ants. And still, they came. Neither Ned nor the colonel had ever seen anything to equal this phenomenon.

Ned finally spoke, "Ain't that the damndest sight you ever seen in your life, Colonel? I knowed there must be lots of buffalos after listening to Chief Nocona, but I never dreamt that they'd be that many."

Even the older man was amazed at the sight. "They must be five thousand in that one bunch, boy. No telling how many is scattered over the plains. That's probably just a drop in the bucket! Tomorrow we're going to get up on top and see just how many of those black devils is on this Cole-Armstrong ranch."

Some of the herd had now grazed to within a mile of their camp. Ned picked up the Winchester and told the colonel he was going to see if he couldn't get close enough to kill them one of the

45

yearlings for camp meat. He struck off on foot towards the milling herd. Fifteen minutes later Jim heard the sharp crack of the rifle and saw the herd start moving back upstream; another fifteen minutes and a smiling Ned walked back into camp and announced that they wouldn't go hungry for a spell. The balance of the herd moved only a short distance up the valley before stopping to graze and drink.

Ned saddled one of the mules and led him back down the hillside to the downed buffalo, loaded it on the mule and brought it back to camp. He swung the young gutted calf to a low hanging branch from one of the nearby cottonwoods, and started skinning out the carcass. By dusk, a large buffalo roast was being turned slowly on the spit over the flames of their campfire.

The dreams which filled their minds on this night would be far from the realities of hardship which would face them in the years to come as they set about to build a cattle dynasty in this harsh land of the *Llano Estacado.*

The next morning, while eating a hearty breakfast of fresh buffalo, beans, and sourdough biscuits, they discussed their immediate plans. "We will use this camp as a base," Jim suggested, "and ride half a day in one direction, then spend the other half backtracking to camp. That way, we can get acquainted with the terrain, and see if there are better places to set up headquarters. We best not venture too far from camp 'till we determine just how many redskins is about. The Comanches may accept our presence, but the Cheyennes and Apaches might just take a hankering to our hair."

"Sound's like a smart idee, to me, colonel," Ned mumbled through a mouthful of beans and meat. Any plan would have been a good plan to Ned in his excitement. He just wanted to get started looking the country over and seeing how many buffalo, deer, and wild turkey there was going to be for him to sight down on. He would soon realize that there were many more than he ever thought existed in the world.

They loaded their horses with light grub, a bedroll, and slickers and climbed the hill behind their camp, heading north to see how much land lay between the camp and the Canadian River. When they reached the top of the escarpment, they were surprised to see that a broad, flat prairie stretched to the north. Looking to the west and south, they could see that they were at the same height as the land from which the buffalo had come the previous day and Red

Deer Creek was only a small cut carved through the flat table-top of the plains. The Indians had named it well, Land of No Trees, for there was not a tree in sight for as far as the eye could see.

The tales which General Houston had told Jim Cole were true, the grass was near up to the bellies of the horses and was moving in the wind, much as waves on the ocean. The day was clear, except for a few scattered clouds, and it was no problem to keep their direction due northerly by keeping the early morning sun over their right shoulders. After going only a short distance they looked back and could see nothing but miles of grass with large herds of buffalo grazing in the distance, the valley of the Red Deer Creek had disappeared on the horizon and they were in an ocean of grass with no landmarks to be seen in any direction.

Stopping, they discussed the phenomenon. "I can see why old Coronado had to put up stakes to find his way back," Jim said. Noticing a questioning look in Ned's eyes, he explained. "Coronado was the first white man to ever cross these plains. He came up from the south in Mexico, about three hundred years ago, searching for a city of gold, some say. The story is that when he got up on top of the plains he had his men to drive stakes and build mounds of rock ever so often so's they could find their way back to their base camp. *Llano Estacado,* that's 'staked plains' in Spanish. If we was going to be gone for two or three days, guess we'd need do the same thing cause once that grass raises back up where the horses walked, we sure wouldn't be able to stay on the same trail."

Ned nodded in agreement as they turned their horses and continued their journey to the north.

After going only four or five miles, the land started dropping and became rougher and more rolling. Soon they came to another escarpment which dropped off into the broad valley of the Canadian River that they had followed for many days across the Indian Territory. Finding an animal trail leading down from the escarpment, they followed it to the water in the Canadian River where they watered their horses, dismounted and stretched their legs.

Ned walked over to a large cottonwood at the edge of the river, took out his Bowie knife and carved a "C _ A" in the tree. Underneath he painstakingly carved, "North Line 1865". The colonel smiled in agreement.

"Seems to me that 'C bar A' makes a pretty good brand, and a good name for our ranch. From here on, this here ranch is going to

47

be known as Ceebara, property of Jim Cole and Ned Armstrong," the Colonel said.

Ned looked up proudly from his carving on the tree and repeated the name, "Ceebara -- that's got a good ring to it, Colonel, suits me fine."

After resting the horses and eating a cold lunch, they remounted and rode back up the canyon of the Canadian. On top once more, they put the evening sun over their right shoulders and retraced the faint trail back to the Cottonwood Springs camp.

9

The following morning at sunrise, the black stallion and the bay mare carried Ned and the Colonel up the slope of the caprock where they had previously seen the thousands of buffalo descending to water. Reaching the top they put the sun to their backs and headed due west at a brisk pace. The grass, though still lush, had been trampled by the migrating herd of buffalo, however, after traveling only a short distance away from the edge of the escarpment, the damage was hardly noticeable, and the prairie swallowed up any sign of the migrating herd.

Their map indicated that they were now heading into the broad expanses of the plains, with nothing ahead for several days travel except plains, no river beds, no streams, only playa depressions and buffalo wallows to break the monotony of the flat prairies. The dry grass from the previous year was much taller than the new green grass which was only now coming through. This gave the prairies a golden brown color.

"The Great American Desert! Now I see why Colonel Marcy called it a desert after he made his trip in '45. The grass looks like sand in the distance, doesn't it Ned," Jim said?

"Yes sir, it sure does. And we've come a pretty good distance and there ain't no running water; just what's in these shallow lakes. I bet when it turns dry and these lakes dry up a person would think he was in a desert if he was to get lost out here," Ned responded.

As they rode, their eyes continued to circle the horizon, looking for some change in topography or an identifiable landmark, but

nothing interrupted the smooth, level division of sky and grass to the right, to the left and straight ahead. But suddenly, the prairie dropped into a large shallow playa depression, probably one mile across and fifty feet lower than the surrounding plains. A shallow lake formed the bottom of the playa, and the lake was filled with drinking buffalo, standing in mud and water up to their bellies. Around the edges of the lake, many of the black shaggy beasts were rolling in the mud and water, for protection from the heat and the millions of flies which accompanied the herd.

Several hundred antelope grazed around the edge of the playa, oblivious to the two riders who were looking over the scene from the lip of the prairie. Some of the buffalo who were nearest to the intruders, raised their heads and looked inquisitively at the two men, but made no move to run. They sat their horses and watched in amazement at this mass of wild animals which seemed to have materialized out of nowhere.

"I've heard tell that a man can lay a couple hundred yards away from a herd and down as many as a hundred without ever stampeding them," Jim told Ned.

Ned nodded his head in agreement, "No more scairt than they are of us setting here watching them, I believe it, Colonel!"

They slowly rode around the rim of the playa and continued their journey, anxious to travel as far as possible before noon. After only a few minutes, they looked back and no sign of the playa or the animals was apparent. It was as if they had ridden up on a mirage, and the mirage had now disappeared.

The terrain had not changed since they left the rim of the caprock and they had been traveling west for nearly six hours. The sun was now high over head. Pulling up, the colonel once again took out the crude map.

"The way I figure it, Ned, we are a good day's ride from the west edge of Ceebara, and a day or more from the head of the Red River on the south. The Canadian may not be over a half day's ride to the north, if this map is anyways near right. It's going to take us a long while just to scout our boundaries, but we sure as hell can't do it all today. We better turn these critters around and head back to camp or we'll be spending the night up here with the buffalo and coyotes."

With that, they turned and started back east, looking across a prairie with no apparent end. The horses followed their original

trail without any urging from the riders, knowing that once again they were heading home.

"Colonel," Ned said after riding for a couple of hours, "My eyes are plumb wore out looking for something to see. It seems to me you can see forever but nothing comes bouncing back to yer eyeballs."

Jim laughed. "That's a helluva a way to put it Ned, but you're sure right about it. We're gonna change that, someday, and they's gonna be longhorn cattle bouncing back to your eyeballs just anywhere you want to look."

As dusk began to settle over the prairie, they found the cut in the caprock and descended once again to their camp in the cottonwood grove.

Their journey to the south the following day was made across rolling hills and small dry creek beds which lay below the caprock. They were never further from the cliffs of the *Llano Estacado* that they could not see them rising in the distance to the west.

After a couple of hours, they dropped into a larger than normal dry creek which the colonel surmised was the head of the Washita. There were small pools of water along the river's banks but no running water. They rested their horses and watered at one of the pools before proceeding to the south.

Ned was the first to notice the tracks around the pool. Intermingled with the tracks of deer and antelope were the clear imprints of several horses. "Colonel, looks like we got Indian visitors on our property," he said, pointing at the hoof prints.

The tracks were fresh as witnessed by a small mound of horse manure a short distance from the pool. "Let's ride to the top of the creek bank for a better view and maybe we can spot them. They can't be very far away," Jim suggested.

Upon reaching the top of the sandy bank, they spotted a large herd of horses grazing about five hundred yards up stream. It was apparent that there were no Indians around, only wild horses. Upon seeing the two riders, the horses galloped out of sight around a bend in the river.

"Well, what do you know about that, boy? Looks like we got us a herd of wild horses to go along with this ranch. They'll come in right handy if we can figure out a way to catch them," Jim said. "They ain't going to move too far away from this water, we'll leave them be and come back after we get some corrals up, and see if we

can't add them to our remuda."

After two more hours they reached a small clear stream, "This must be the Sweetwater, Ned," Jim said. "This could be our east line, but the map shows the Red River to be another three or four hour ride to the south. We best turn around and head back to camp."

Ned nodded agreement, but quickly dismounted under a large cottonwood which grew along the creek bank. He slipped his Bowie knife from the scabbard and began carving, as the colonel watched bemused. 'C _ A' appeared in rough lettering as the bowie knife made the brand in the tree. Below he carved, "East Line, 1865".

Ned returned the knife to its sheath, and without saying a word, remounted his mare and walked her up the creek bank and headed north. Jim smiled his approval as he allowed the big black stallion to follow.

"Colonel," Ned said after riding silently for several minutes, "This is a helluva big country, ain't it?"

"You're right, boy, it sure is," replied Jim. "I been doing some calcalatin' and it appears to me it must be nigh onto thirty or forty miles from the Canadian to the Red River, and maybe fifty miles from this east line to the west line of Ceebara. It's hard to believe that it all belongs to us."

"Back in Kaintuck," Ned responded, "my pa just owned 160 acres. That ain't a drop in the bucket to what this ranch is."

Jim nodded in agreement, "General Houston told me he wanted me to have a million acres, and looks like we just about got it. A million acres of this grass is going to run one helluva big herd of cattle once we get it stocked."

They rode the remainder of the afternoon discussing the magnitude of their property, how they could have their summer range on the plains and their winter range in this rough country below the cap, and where they should locate their permanent headquarters.

"Seems to me we couldn't find a better place for a headquarters than right where we made our first camp, Colonel," Ned said.

"I think you're right, son. We've got to have fresh water, and the trees will give us protection in the summer from the heat, and the hills behind the camp should knock off some of the winter winds. It's a little too far from the western part of the ranch, but we can build a summer headquarters later on, up on top of the plains," Jim

replied.

The mules, seeing the horses coming in the distance, welcomed them home with a loud piercing bray.

10

During the night, a thunderstorm blew in and dumped an inch of rain on their camp. They pulled the large tarpaulin which had covered their packsaddles over their bedrolls and continued to sleep. By morning the storm had blown over and the sun rose above the mists which blanketed the valley, forming a bright new rainbow. A beautiful day to start their cattle dynasty.

"Catch the mules, boy, and get 'em harnessed up, we got work to do," Jim said after they had finished breakfast.

A sturdy branch from a hackberry tree was cut and formed into a double-tree and hitched behind the mules. They then drove the team to a smaller grove of hackberry trees, where they cut several straight trees for posts. The posts were tied in bundles and dragged to the base of the hill where holes were dug with a sharp ended steel bar and a fence was erected from the base of the cliff towards the creek bottom.

After proceeding in a straight line for a quarter of a mile, they turned the fence at right angles and proceeded another four hundred yards, turned once again at right angles and built the fence back to the base of the cliff.

As the days went by, their hard work began to pay off. Cutting smaller straight trees and trimming the branches, poles were made which were tied to the buried posts. They now had a pasture which would hold their horses and mules and prevent them from wandering off, if left unattended.

Next they built a strong pole corral in the corner of the pasture which was at the base of the cliff, large enough to hold several animals. Close by the corral and next to the spring, they dug into the side of the cliff for several feet, carving out a large room. More poles were cut and were used to fashion a log front to the dugout, with a ten foot porch which overhung the front.

The porch would give them protection from the sun and prevent rain from running into their living quarters. It was very crude but would be cool in the summer and warm in the winter. A rock fireplace was fashioned at the end of the porch which would serve for heating and cooking.

Time passed quickly, and after two weeks of work, they were almost finished.

"We'll kill some buffalo and dry their hides and close the porch in before winter," Colonel Cole told Ned, as they stepped back and looked at their handiwork.

Hearing a slight noise behind them, they turned and were surprised to see Quanah Parker and several braves quietly observing them. They were embarrassed that they had allowed the Indians to slip up on them without their knowledge.

Quanah held up his hand in greeting and spoke in Comanche. "My white brothers have been busy since leaving my village. You have chosen well. This place of spring water will supply your needs well."

Both Jim and Ned held up their hands and returned his greetings. Jim spoke, "Join us, my brother, around our fire. We have fresh buffalo to fill your bellies."

The Indians dismounted and led their ponies into the corral, then inquisitively inspected the newly completed dugout in the hillside, grunting their approval.

Ned stoked the fire and cut several large slabs of buffalo steaks, sticking them on the spit above the fire. As they ate, Quanah explained that Chief Nocona and the other members of the tribe were not far behind, on their way to a summer camp on the plains where they would hunt the migrating buffalo.

When the colonel told him about the huge herd which they had seen around the playa only a few days before, Quanah became very excited. "I know the place," he said, "We have camped there many times on our hunts."

He explained that they would kill many buffalo, dry the meat

and cure the hides, then they would move southwest to the big canyon where they would have fresh water, trees, firewood, and protection from the blizzards of winter.

"Quanah, my brother," spoke the colonel. "We must travel south to the country of the longhorns, to buy many cattle which we wish to bring to this land of grass and buffalo. You have traveled this country many times and are wise in its ways. Could you tell us the best direction to follow for good grass and fresh water?"

"Best direction for Indian is Indian trail to Elm Creek Fort on river called Brazos by white man. But for white man with many ponies and many cattle, best trail is south many suns to Two Mountains, then east to river called Brazos. Indian is on warpath with Tejanos, and Indian trail very dangerous now for Quanah's friends. Long knives and Tejanos killed many Comanches and Kiowas at Elm Creek and Pease River many moons ago, when Chief Nocona's squaw, my mother, was killed. Maybe Kiowas take One Arm's scalp on Elm Creek, better go to Two Mountains," answered the young chief.

While he was talking, he drew a rough map on the sandy ground, showing many rivers which they would cross while traveling south. A rough line running nearly due north and south was drawn from top to bottom of his map which he described as the "high rocks", then pointed to the caprock in the distance. Two circles denoted the Two Mountains of which he spoke. Two rivers, one on each side of the mountains, joined east of the mountains into one even larger river which he indicated as being the Brazos. He scribed the Brazos both north and south of this point, indicating a fort north of their proposed route which he said was Elm Creek (Fort Belknap).

"Many longhorns in this country," he said, as he indicated a large area south of Fort Belknap.

Before he left, Quanah removed two round, hide covered ornaments from his horse's neck. They were approximately eight inches across, and had turkey feathers and fox tails tied around the edges. The tanned leather had Indian signs painted on the surface. "Tie one of these on the post of your house, and the other on the fence down by the creek," he said. "They will tell all Indians who pass this place that you are friends of Chief Nocona and Quanah Parker and you and your ponies will be safe."

"Thank you, my friend," Jim replied. "Your people will always

56

be welcome when you pass this way."

The Indians retrieved their ponies and raced out of the campground, kicking up clouds of dust as their shouts echoed back from the cliff's walls. Soon Ned and the colonel could see them climbing the steep cut in the caprock and watched as they disappeared over the horizon.

The following week their time was spent reinforcing their pasture and corral fences and adding to their dugout and lean-to. Ridge poles were added to the room which had been dug into the hillside. Pegs were attached to the ridge pole and their supplies were hung from the pole. Bunks were fashioned along the back wall from small tree branches which would later be stretched with buffalo hides.

Jim could see that Ned was becoming impatient with the drudgery of continual work on the headquarters. "I think it's time we see how our buffalo guns are going to work, boy. What do you think about us taking a little trip up on the plains tomorrow and see if we can't get those hides that we need to finish our bunk house?"

Ned's response was, "Hallelujah!" as he grabbed one of the Sharp's fifty-caliber from the corner, held it up and sighted down the barrel as if he had a buffalo in his sights.

The mules were caught and fitted with the trees of the packsaddles, leaving off the pack bags. They would roll the buffalo hides and tie them to the trees, each mule carrying three hides. They followed the trail left by Quanah and his tribe only a few days before.

When they reached the crest of the large playa, they looked down on a beehive of activity. The Comanche village was set up around the shores of the lake, the bright tipis shining in the noonday sun. Fires of buffalo chips smoked lazily around the village and the smell of cooking meat mixed with the stench of curing hides and emptied buffalo entrails. It was apparent that the Indians had had a successful hunt.

Squaws were cutting meat into strips and hanging it to dry on racks made from willow trees. Some of the younger women and children of the village were scraping and pounding the hides, converting the stiff skins into smooth and pliable leather.

As they rode into the village and dismounted in front of Chief Nocona's tipi, they were greeted by the chief, Quanah, and many of the braves who gathered around to learn the reason for this visit.

"We need hides and are seeking the herd," Jim said in answer to Quanah's question.

"There are many buffalo one hour's ride to the north," Quanah said as he pointed northward. "I will take you," and he instructed one of the boys to bring his horse.

After an hour's ride, they crested a small ridge which began the breaks into the Canadian River, and observed the herd slowly grazing towards the river.

Quanah instructed them to ride back out of view of the herd where they dismounted and picketed the horses and mule. Crawling quietly, they moved back to the crest of the ridge and lay on their stomachs as they watched the herd, no more than four hundred yards upwind.

Quanah removed a forked tree limb from his waist which was no larger than a rifle barrel and only eight inches in length. The single end was sharpened which he pushed into the ground, making a cradle for the rifle barrel. He then instructed Ned to lie on his stomach and place his rifle in the fork. He pointed out a large black cow, which he described as the leader of the herd.

"Shoot cow first," Quanah said, "other buffalo no run."

Ned took careful aim with the big Sharps and slowly squeezed the trigger. The roar of the shot was deafening in the shallow depression and smoke curled up from the end of the barrel.

The cow fell dead in her tracks, shot through the heart by the fifty caliber rifle ball. The other animals, startled, at first began to run but seeing the huge cow lying motionless on the grass, began circling her and smelling of the fresh blood.

Jim passed the other rifle to Ned as he reloaded the one which had been fired. Even though his heart was racing with excitement, Ned calmly took aim and downed a large bull which fell close to the cow. He continued this procedure until he had downed six of the largest buffalo, all falling within thirty yards of each other. Only when the three hunters stood did the herd panic and start stampeding towards the river.

Quanah smiled his respect for the young Kentuckian's marksmanship and slapped him on the shoulder as the three men walked the four hundred yards to the downed animals. Each was shot cleanly through the heart, the big Sharps leaving a large hole where the bullet had entered and exited on the opposite side. They removed their Bowie knives and started skinning the shaggy beasts,

then rolled the skins and tied them to the packsaddles. Squaws would be sent after the meat, Quanah said. Within four hours after leaving the Comanche village, they returned, with their hides and stories of Ned's great accuracy with the huge buffalo gun.

A bright moon was just rising over the eastern horizon as they descended from the plains to Red Deer Creek, lighting the trail as they returned to their camp.

The next morning as Ned was preparing breakfast, he said, "Colonel, we just about forgot those wild mustangs we seen over on the Washita. Do you reckon they're still there?"

"I 'spect they are, boy," Jim replied. "Guess we haven't got anything better to do than take a look and find out for sure."

The mules were loaded once again with rope, axes and camping supplies and tied behind the black stallion and bay mare. Ned kicked out the campfire and mounted up, following Jim down the trail to the creek.

By mid-morning they were looking down on the wide, flat valley of the Washita and the narrow stream bed which meandered out of the foothills.

Just as the colonel had predicted, the mustangs had not moved very far from the water hole where they had been seen before. After watching them from a distance of about half a mile, the two riders turned away from the grazing ponies and headed up the Washita, looking for a place which would make a good trap.

Two miles up the river, they discovered a smaller dry creek bed dropping out of the steeply climbing hills, and followed it for nearly a mile, with its banks rising sharply on each side. Rounding a bend in the creek bed, they were stopped by a vertical cliff at the head of the stream which formed a small boxed canyon.

Following Jim's instructions, Ned went to work cutting cedar posts from trees along the creek bank while the colonel hitched the mules to the posts and dragged them to a narrow point in the creek bed. Soon they had constructed a six foot high fence, funneling into the boxed canyon from each side of the creek bank and a large gate which they concealed in the brush along the edge of the dry stream bed.

Leaving Ned to turn the herd a short distance up the Washita from its junction with the dry creek bed, Jim circled the herd then maneuvered them towards the trap. As they approached Ned's position, he rode out of hiding and waved his rain slicker at the run-

ning horses. The mustangs turned up the creek bed as he had hoped, and headed quickly into the boxed canyon. Riding hard in their dust, Ned pushed them on, and when they reached the hidden gate, he quickly dismounted and closed the trap. Tieing their sweating horses and the mules on the outside of the fence, they watched as the nervous mustangs circled the inside perimeter of the natural trap until they decided that there was no way out, then rested in a bunch at the base of the cliff, watching their captors through frightened eyes.

The herd was led by a beautiful buckskin stallion, not as large as the colonel's black, but well proportioned and stout. He had a harem of twenty-three mares, ten yearling fillies and eight young studs which were every color imaginable but mostly spotted paints.

"We sure made us a haul this time, didn't we colonel," Ned said breathlessly.

"We sure did, boy," Jim responded with pride in his voice. "These bang-tails are going to come in right handy on Ceebara, once we get our cattle up. We'll let them settle down till morning, then we'll see how good you can throw a rope, Ned. I think we can catch the stud and two or three of the lead mares and the others will follow us back to camp.

First thing the next morning, they cut one of the largest cedars they could find, peeled the bark and buried it three feet deep in the creek bed, leaving five feet above ground. This would be their snubbing post once an animal was roped.

Ned picked the buckskin stallion for his first throw, missed a couple of loops but on the third try the rope fell neatly over the stallion's head and settled around his neck.

As the rope tightened, all hell broke loose! The buckskin began rearing, snorting, running, and bucking trying to shake the snake from his neck. Ned hung on, setting the heels of his boots in the sand. The stallion dragged him around the pen, his boots making two deep furrows in the soft sand. As he went by the snubbing post the second time, he loosened some slack on the rope and quickly threw a dally around the post. By holding the end of the rope, he was able to pull out the slack each time the stallion came a little closer to the post. Soon the buckskin made a dash towards the post and Ned ran backwards as fast as he could, pulling out the slack as he went. When the stud reached the snubbing post, the slack was all gone and his head was pulled up tightly against the smooth ce-

dar.

Jim, who had been standing by the gate and shouting encouragement to Ned, now ran to the post and with his one good hand, held the rope while Ned made a half hitch around the post. The buckskin continued to pull, snort and paw but was unable to free himself.

Talking to him softly, Jim began stroking his neck and forehead and soon the stud had calmed down and stood trembling, snubbed tightly against the post. A strong rope halter was slipped over his nose and around his ears, and a second lariat was tied to the halter. One of the mules was brought into the pen and the lariat was tied to the mule's neck leaving about four feet of slack between the two animals. Ned quickly removed the lariat from the stud's neck and stepped back to watch the action.

As the now haltered stud tried to turn away from the mule, the slack in the rope tightened, the mule set his feet, and the stud's head was jerked around where he was once again facing the mule. He tried several times to turn back into the herd and each time the mule set his feet and the mustang was jerked around. Now the mule began to slowly move back towards the gate and the other mule. The stud was forced to follow.

The procedure was begun again, this time with the boss mare. After a similar struggle, she was snubbed to the other mule, and Ned roped another. The black stallion was brought in and she was tied to the saddle horn and Jim led her out of the corral.

Ned tied his lariat to the two mules and to the horn of his saddle, opened the gate and started moving slowly down the sandy creek bed. At first the wild horses did not want to follow but the mules were persistent, jerking, kicking and biting when they tried to go any direction except in the direction which the mules were being led. Thirty minutes later, as they left the bed of the Washita, the mustangs were leading docilely, while their mates were following a short distance behind.

Three hours later they rode into camp, forty-one head richer than when they left the previous day.

The following week was spent training their new remuda to lead by tying each to a mule and leading them around inside the pasture. Hay was cut from the lush grass along the edge of the spring and carried to the horses in the corral, and by the end of the week they were as gentle as domestic animals, although far from being

broke.

"That buckskin stallion will make you a good cow horse, Ned, once he's broke but we won't try to saddle break any of them now. We can't afford for you to get a broken arm or leg out here in this country. A one armed old man and a crippled boy might have a hard time making a go of it," he said smiling.

11

Quanah and the Kwahadi Comanches had a good hunt around the big playa, filling their tipis with much dried jerky and many hides. The hunt completed, they made preparations to move to the big canyon for the coming winter. However, their preparations were interrupted by a group of five warriors from the Kiowa-Apache tribe of Chief Dohasan, or Little Big Mountain as he was called by his people.

As they rode into the Comanche village, they held their hands up in the sign of peace even though their faces, bodies and ponies were marked with war paint. Quanah and Nocona's warriors watched, rifles and bows ready, as they dismounted.

Chief Nocona reluctantly invited them to share his campfire and smoke the pipe of peace when they informed him that they brought a message from Chief Dohasan and many of the other chiefs of the plains Indian tribes.

"We come from a great war council being held at the old post on the Canadian," Howling Wolf, who was spokesman for the group, said. "Little Big Mountain, our Chief, asks that the Kwahadis join us in putting together a great army to push the *white-eyes* back from our hunting grounds."

"What is this great war council you speak of?" Nocona said. "I have heard nothing of a council."

"The Kiowa-Apaches, the Arapahoes and the Cheyennes from north of the river have come together to make war on all whites who

travel across our land or who hunt and kill our buffalo," Howling Wolf replied. "There are over two thousand warriors and their families making council on the river, less than a day's ride from here."

"We will go and see if what you say is true," Nocona said. "If you speak falsely, then we will cut out your tongue."

Howling Wolf scowled at this insinuation that he might lie, stood and beat his breast. "I am Howling Wolf and I do not lie," he said angrily as he turned and vaulted onto his pony's back. The other warriors followed.

The young Comanche braves, tired of the women's work of preparing meat and hides for the coming winter, were eager to join the other tribes in war against the whites. They talked of the many scalps they would take as trophies and the many horses they would add to their herds.

"You must remember," cautioned Chief Nocona, "that the Kiowas and the Cheyennes have taken many Comanche scalps and stolen our women and our horses in the past. We must be careful that they do not intend to do it again. We will go but we will keep our eyes open and our guns loaded."

The tribe of Kwahadi Comanches moved slowly west and north, leaving the flat prairies for the rolling breaks of the Canadian River. By late afternoon, they topped a hill and looked down upon hundreds of tipis scattered along the edge of the river. Several thousand head of horses were being herded in the tall grass and cedars by hundreds of Indian children. The air was filled with the smoke of cooking campfires and the aroma of roasting buffalo and deer meat mingled with the pungent odor of the burning cedar and mesquite.

A steady din of noise filled the valley -- barking dogs, screaming children, yelling squaws and the many varied sounds which accompany an Indian campground. For several minutes the Comanches stood along the top of the hill and looked in awe at the huge gathering below. Never in their life had they witnessed such a large group of Indians camped together.

Howling Wolf's tongue had been straight! There were over two thousand warriors in the camp besides the many thousands of women and children.

Calling Quanah to his side, Chief Nocona said, "My son, we must be cautious. The Kiowas may want our ponies more than they want our help. Make camp on that high hill which rises from the riv-

er's bank. We will be able to see in all directions and will know if anyone tries to approach our camp, day or night! It is far enough away from the other camps that we can prepare to protect ourselves if danger approaches."

Quanah nodded his head in agreement, turned his pony and quickly gave orders to the others. The women went quickly to work setting up tipis and making camp. The children took charge of the horse remuda, leading them to the river's edge for water and grass, while others began gathering dried mesquite and driftwood for the evening fires. Before the sun settled behind the buttes in the west, the smell of cooking buffalo meat filled the campground as twilight settled on the new addition to the war council.

Before their meal was finished, a warrior from Chief Dohasan's camp brought a message that a war council would be held in his village when the moon rose in the east.

Nocona, Quanah, and the other braves ate their fill and then dressed in their finest Comanche regalia in preparation for joining Chief Dohasan and the other warriors around the war council campfire. They mounted their best ponies and rode the short distance to the meeting.

Chief Dohasan welcomed Chief Nocona and his braves, introducing them to the other chiefs around the campfire. Quanah's warriors stood together a short distance behind him, holding their ponies as if ready for a quick retreat if trouble arose.

After the pipe had been passed to all of the seated Chief's and Sub-chiefs, Chief Dohasan stood and stepped to the middle of the circle and spoke.

"My brothers, the Kiowas have decided to make war against all whites who are crossing our hunting grounds and stealing our buffalo. Many wagons have been coming from the East carrying the *white-eyes* along the white man's Santa Fe trail. Buffalo hunters have moved south of the Arkansas and have been slaughtering our herds. Soon they will be chasing the herds south of the Canadian, and with them will come the settlers who will plow the grass and the Indian will no longer have a home or food."

A rumble of agreement could be heard from the darkness surrounding the huge council fire.

Chief Dohasan, in his deep baritone voice, continued, "The white man has pushed us from our homes many times and taken our lands. Now he is trying to force us to live on the reservations in

a land where there is no buffalo, only starvation. This land of tall grass and buffalo is the last place where we Indians will be able to live in freedom. The Kiowa would rather die defending our land than to live in disgrace on the reservations and watch our families starve. I ask for your help in ridding the plains of these white dogs forever."

Removing a belt of fresh bloody scalps from his waist, he held it high for all to see. "We have stopped many wagons, took many scalps and captured many horses this moon," he said. "The long-knives and yellow-legs will hear and will come. We must prepare for a great battle and we must win!"

The other chiefs nodded in agreement, their feathers reflecting the orange glow of the huge campfire. A thunderous roar of approval arose from the darkness behind the circle of chiefs as the young warriors sent up a war cry.

Drum beaters were called forward and their tom-toms began to beat out the war dance as, one after the other, the braves moved in from the shadows and joined the war dance around the campfire. Medicine men joined the dancers, shaking their rattles and sprinkling their secret powders of protection on the braves. The silhouettes of the dancing men caught the orange glow from the campfires and cast strange and elongated shadows into the blackness which rimmed the camp.

The war dance and parley lasted until the early morning hours before the chiefs and their braves returned to their own tipis for sleep, where they would dream of victory in the coming battles and count a great number of scalps hanging from their lodge poles. However, they would not have slept so soundly had they known the danger which was approaching in the night.

Thirty miles to the west, a long line of army wagons rumbled noisily through the foothills adjoining the Canadian River. The column was being led by the noted Indian fighter, Colonel Kit Carson.

Carson had left Fort Bascom three days before, on orders from General Sheridan to search out and destroy the Indians who had been raiding wagon trains on the Santa Fe Trail. Ute scouts reported that a large Indian encampment was located at the old ruins of Bent's Trading Post and Colonel Carson was pushing his column unmercifully in order to make contact with the Indians before they were alerted to his presence.

They intersected the river three miles above the Indian council

at daybreak, and reached the first Indian village at sunup. The crisp morning air was broken by the shrill sound of the bugle as an advance column of mounted cavalry rode through the sleeping village shooting everything that moved.

The Cheyenne braves rushed from their tipis, shouldering their rifles and stretching their bows. Their accurate fire knocked several of the charging cavalry from their horses.

Women and children dashed from their tipis and headed for the protection of the mesquite and tall grass adjoining the village. The braves who escaped the deadly fire of the soldiers vaulted to the backs of their tethered horses and quickly disappeared down river to warn the other tribes of the impending danger.

The Comanche campground was the farthest down river, and Chief Nocona's foresight of making camp on the highest hilltop gave them a good view of the activities upriver. A guard who had been posted for the night gave the early morning alarm as the battle began to wage in the Cheyenne village. Quanah and his warriors rushed from their tipis and quickly gathered their war ponies while Chief Nocona instructed the squaws and children to hide in the nearby canyons.

Quanah led his braves to the scene of battle, staying on high ground in order to gain the advantage. Reaching the Cheyenne village, they rode their ponies between the retreating Indians and the advancing cavalry, setting up a deadly barrage of rifle fire, turning the cavalry towards the river.

Upon reaching the high ground, Chief Dohasan surveyed the battle between Quanah's horsemen and the cavalry unit and noted the column of wagons and infantry rushing up from the river's edge. He motioned with his battle lance and Chief Nocona, Chief Iron Shirt, Chief Satanta, and Chief Stumbling Bear joined him on the crest of the hill. Their mounted warriors followed close behind, three thousand strong -- a formidable sight to Colonel Carson and his soldiers.

The bright feathers of their war bonnets and their bronzed muscular bodies glistened in the early morning sunlight as they lined up on the crest of the hill. Their war ponies reared and pranced in excitement, raising clouds of dust which drifted lazily back towards the floor of the valley. The form of Chief Iron Shirt stood out in their midst, as he set his dappled pony, wearing the bright metal Spanish Conquistador vest which had been a gift to his great grand-

father by the noted explorer, Coronado.

Leaving his wagons at the river's edge, Colonel Carson advanced, seemingly unconcerned about the huge numbers of Indians staring down on him from the hill's crest. Dragging his two cannons into position in front of his infantry, he gave the order to fire. The thunder from the cannons reverberated up and down the floor of the valley as the balls struck the midst of the waiting Indians. The explosions knocked several horses from their feet and the remaining Indians, as if in fear, moved back from the horizon. However, Chief Dohasan as guide for the army in the past, had previously experienced cannon fire and was not retreating, only luring the soldiers into a pincher trap. His ruse worked, and as the soldiers charged up the hill, Quanah led his mounted warriors to the right behind the protection of the hill while Chief Iron Shirt led his horsemen to the left.

The hillside exploded with charging Indians, riding low on their horses necks, making poor targets for the bewildered soldiers. Quanah led his horsemen into the soldiers midst, firing his carbine which was held in one hand and guiding his horse with the other. The soldiers panicked and began retreating back down the hill, with Indians in front and rear.

The mounted cavalry, which had taken up positions to the right and left of the attacking infantry, were overrun by the charging Indians and pushed back down the hill. Colonel Carson was unable to fire his cannons into their midst for fear of hitting his own men.

But then, when it looked as if Carson's troops were doomed, as Iron Shirt's warriors attacked from the left, the Cheyenne chief fell from his horse, mortally wounded with a rifle slug through the neck just above the protective steel vest. Two of his braves, riding as fast as their ponies would carry them, bent low from their horse's backs and grabbed Iron Shirt by each arm and dragged him back towards the crest of the hill. His other braves followed them, allowing the soldiers to rush back to the bottom of the hill and to the protection of the crumbling adobe walls of the old trading post.

When the last of his cavalry reached the walls, Colonel Carson ordered the cannons to once again fire into the main body of the Indians. Chief Nocona was caught in the cannon fire and fell dead from his horse. The remaining chiefs and their warriors disappeared once again behind the protection of the hill.

Colonel Carson, realizing that he was hopelessly outnumbered,

ordered his troops to withdraw from the protection of the crumbling walls and instructed the cavalry to set fire to the Indian tipis while his wagons and foot soldiers retreated upriver. The Ute Indian guides quickly removed the scalps from many of the fallen Cheyenne braves who had been killed in the attack on the first village, tying the bloody trophies to their belts before following the retreating soldiers.

Chief Dohasan, respecting the power of the soldier's cannons, followed at a distance, harassing and pushing the retreating soldiers farther upstream. After they were well away from the burning village, Quanah and his braves, carrying torches fired from the burning tipis, set fire to the dry grass between them and Carson's column. The southerly wind quickly turned the grass into a roaring prairie fire which raced towards the retreating wagons.

The soldiers were forced into the stream bed in order to escape the fire, where some of their wagons and the two cannons became mired in the quicksand and were abandoned. They continued their retreat back towards Fort Bascom. Indian fighter Kit Carson knew when he had had enough.

Quanah and his braves retrieved the body of their fallen Chief Nocona and carried him back to their abandoned village. The women and children appeared from the tall grass and canyons and began ministering to the wounded and extinguishing the fires.

Chief Nocona's body was placed in the middle of the camp, cleaned and dressed in his finest clothing, wrapped in soft buffalo robes and then carried to a deep cut in the caprock where he was buried and covered with rocks.

Although the battle had lasted only a short time, it had been very costly to both sides. It had also increased the determination of the Indians to get revenge for the death of their two chiefs, Iron Shirt and Nocona. The war had begun. Quanah Parker, son of fallen Chief Nocona and blood brother of Colonel Jim Cole and Ned Armstrong, was now elevated to Chief of the Kwahadi Comanches. He would lead them as they joined the other tribes in their battle to rid the plains of those who killed their buffalo, their warriors and their women and children.

Returning scouts who had followed the retreating soldiers at a distance, reported that the long knives and yellow-legs continued to retreat towards Fort Bascom, with no indication of regrouping and returning to continue the battle.

Upon hearing this news, Chief Dohasan posted guards upriver for security, then called the five tribes together for a victory celebration. For hours, the Canadian River valley resounded to the noise of the dancing and screaming warriors and the wail of the Indian squaws who had lost their men in battle. Bloody scalps of the slaughtered soldiers were brought forward and displayed by the dancing throngs. The dead bodies of their vanquished foes were dragged into the center of the circle and each warrior was allowed to vent his vengeance upon the dead soldiers by mutilation. Eyes were plucked out, tongues cut out, genitals slashed off and bodies ripped open.

Young Chief Quanah was led to the center of the group and Chief Dohasan praised his bravery and courage to the members of all the tribes. "The victory belongs to Quanah," he said as he placed both hands on Quanah's shoulders. "For his courage I have prepared him a gift so that all will know that he is also a chief of the Kiowa."

Motioning to an aged squaw, he said, "Bring Morning Star."

The squaw disappeared inside Chief Dohasan's tipi, and quickly reappeared leading a beautiful dark-haired, brown-skinned maiden. Her face was that of a child but her body was that of a woman. Her long black hair fell in ringlets on her shoulders and her smooth brown face was chiseled with fine features, highlighted by almond shaped smiling eyes that looked straight at Quanah as she walked slowly towards him.

Her tall slender body was carried straight with shoulders back, which caused her ample breasts to move tauntingly beneath the soft, tan buckskin dress which hung loosely from her shoulders. The looseness of her dress, however, could not hide the fullness of her hips as she followed the old squaw.

Quanah was taken by her beauty, the most beautiful girl he had ever seen. It was apparent she was not Indian, but it was also just as apparent that she was not white, like his mother.

"Quanah, this is my daughter, Morning Star," Chief Dohasan said. "I took her captive when she was very small, and have raised her as my own. Her mother and father were killed when we raided their village on the Mexican border many years ago. Her blood is Mexican but her mind and her heart are Kiowa. She is one of my most precious possessions and I give her to you to seal our friendship. She will make you a good wife."

Morning Star looked proudly into Quanah's eyes and smiled,

holding her hand out for him to take. It was Quanah who felt embarrassed by such a gift -- embarrassed but proud. He took her hand as the surrounding throngs of Indians shouted their approval. Surely the Kiowas and Comanches would long honor this pact.

Another squaw appeared, leading a beautiful spotted mare which Chief Dohasan explained was Morning Star's pony. Thrown over her back was a large bundle which was filled with the Indian maiden's belongings. Morning Star took the horse and led her out of the Kiowa camp and towards the Comanche camp, where she tied it in front of Quanah's tipi and disappeared inside, content that this man who was chief of the Kwahadi Comanches would be her husband for life.

Quanah remained at the Chief's circle until plans were completed for their war against the whites. He told the story of his friendship with the two white men, Cole and Armstrong, and asked that the other tribes would honor his blood brothers and their land. This request was accepted with a rumble of discontent.

But Quanah's heart was not in the war plans, he was thinking about the beautiful Indian maiden who was waiting for him in his buffalo hide tipi.

He was filled with pride as he left the meeting, his bronze skin, naked to the waist, glistened in the light of the campfires. Copper bands adorned his arms and his father's war-bonnet of black and white eagle feathers trailed down his back. A brightly painted breech cloth and soft buckskin leggings covered his lower body. A bow and quiver of arrows were slung across his back and he carried a repeating Winchester rifle loosely in his right hand. He was now, truly, a chief of the plains tribes.

As he pulled the flap of the tipi back and stepped inside, he was struck once more by the beauty of the girl who stood waiting inside, silhouetted by the small fire which lit the inside of the tent. She had brushed her long hair which now fell loosely across her shoulders and onto her breasts. Quanah placed his rifle, bow and arrows along the side of the tipi, removed his war-bonnet, then stepped to the waiting Morning Star who stood motionless in the center of the lodge. He held out both hands which she took in hers. They stood this way for a long while, saying nothing as they looked into each other's eyes.

Quanah spoke. "I knew only one woman as beautiful as you and she was my mother. She always told me that someday the Great

Spirit would send me a mate which would surpass all others for beauty. I have waited because I knew the Great Spirit would not fail me. My patience has been rewarded."

As he spoke, he gently felt of her soft black hair, brushed her cheek with the back of his hand and let it fall to the smooth skin of her shoulder. His fingers found the buckskin straps which held her dress, pulled, and the loose buckskin fell in a crumpled heap at her feet. She smiled at his reaction to her nakedness, not ashamed that she stood before this man who only hours before had been a stranger, but was now her husband for life.

Reaching out, Quanah took her hand and urgently pulled her to the bed of buffalo robes next to the glowing embers of the fire. Morning Star did not resist.

12

"I 'spect it's time to head south, hire us a crew and see if we can't put together a herd of 'horns for this here Ceebara ranch," Jim said as they sat around their campfire, unaware of the recent battle which had taken place no more than thirty miles to the north.

"It's the middle of August, and it'll take us a couple of weeks to reach the Brazos. I ain't hankering to break new trail after the northers start blowing so we best pack up and get going, boy," he continued. "It'll probably take most of the winter just to put together a crew and get our cattle located and marked."

Just as General Houston had always called him "boy", even after he was a grown man, Jim was bestowing this title on his young protege. It was not his intent to use the name facetiously, but more as a symbol of affection, for Ned had become like a son to him.

"Yes sir," Ned replied, " 'peers to me that the sooner we get started the sooner we're going to get Ceebara to producing beef. I've been wanting to see what the Red River looks like, and I reckon we'll have to go right acrost it on our way south." Smiling slyly in the campfire's glow, he added, "Besides, I'd like to cast these eyes on something with skirts on for a change. Your old ugly face is gettin' mighty hard to look at."

Jim laughed and replied, "Guess you're right, boy. If I don't get you out of here pronto, you may try to trade some of them bang-tails we captured for one of them black-eyed squaws in Quanah's camp."

Ned blushed at the thought.

Three days later, after burying most of their lead and powder in the floor of the dugout, and hanging much of their surplus supplies in the branches of the largest cottonwood, they loaded their mules, tied the buckskin stallion and boss mare behind the mules, and headed south. The other horses followed meekly behind.

Their plans were to travel due south, keeping the caprock in view if possible, until they reached the Two Mountains Quanah had talked about, then turn east until they intersected the Brazos. The colonel gave Ned the responsibility of mapping the most prominent landmarks and water holes as they made their way slowly south.

After crossing the Sweetwater, the country became very sandy, with sand hills covered with grass, sage, and shinery oak dominant. The terrain dropped gradually until they reached the North Fork of the Red River, the south line of Ceebara. While they rested in the shade of a huge cottonwood, Ned once again marked the boundary with his Bowie knife in the bark of the tree. "C _ A, South Line, 1865."

The caprock had disappeared in the west, but as they continued to move south, it would reappear occasionally, indicating the uneven line of the escarpment.

Reaching a small live stream by nightfall, they made camp along its banks, and while Jim gathered wood for fire, Ned walked a short distance down stream and surprised a flock of turkeys which were drinking from a pool. One of the largest gobblers was soon roasting over the coals of a glowing campfire.

The next day they crossed a larger semi-dry river, similar to the Canadian in size which the colonel surmised was the Salt Fork of the Red River, as indicated on the map that General Houston had given him. They were able to travel another fifteen miles before nightfall and camped on a small creek which was fed by spring water.

The caprock of the plains was once again close to their route of travel as they crossed several more small streams, with only a small trickle of water flowing in each. The grass along their route was beginning to turn brown in the hot sun, however, it had good growth and would offer sufficient grazing for the cattle when they trailed them back in the spring. They stopped for the night on the banks of the Prairie Dog Town Fork of the Red River. The cliffs of the caprock had once again disappeared in the West.

As they continued southward, the faint outline of two large peaks could be seen rising in the distance. Their route took them to the west of the peaks and to the east of the caprock. They traveled for hours with the peaks always remaining in the distance. Ned marked them on his map as the "Double Mountains", because they were almost identical, and very close together.

As they approached the peaks, they were surprised to see that the mountains were not really mountains, at all, but two buttes which were remnants of the caprock. The flatness of the country had made it possible for them to view the peaks from a very great distance.

"Colonel, Quanah was sure right about this being the safest route to the south, we ain't seen hide nor hair of any Indians since we left the plains," Ned said as he looked up at the strange looking peaks.

His comment had no more than left his lips when suddenly, their peaceful journey was interrupted by the sharp crack of a rifle shot, and a small geyser of sand was kicked up at the foot of the mules as the bullet ricocheted into the mesquite. Six Indians on horseback appeared on the horizon to the west, approximately one mile away. Seeing the two riders trailing the large herd of horses, they kicked their ponies into a run, intent upon securing fresh scalps and many ponies. Ned could hear their war cries as they approached and saw the smoke from one of the rifles before he heard the shot and watched as one of their wild mustangs fell dead in his tracks.

"We can't outrun them without leaving the mules and ponies," Jim shouted as he kicked the black stallion into a run. "We best find cover fast!"

A small arroyo offered some cover as they quickly dismounted in the sandy bottom. Ned grabbed one of the buffalo guns from the mules pack saddle and rested the long barrel on a branch of a small mesquite tree on the bank of the arroyo. The Indians were now within half a mile and coming fast as he sighted the big Sharps on the lead Indian's breast and slowly squeezed the trigger. The brave was blown backwards off his horse when the huge slug passed through his heart.

Colonel Cole handed Ned the other Sharps as he took the previously fired rifle to reload. *Just like buffalo hunting*, Ned thought. He sighted quickly and once more pulled the trigger and another

Indian was knocked from his pony, blood covering his chest.

This was too much for the remaining braves. Seeing the accuracy of the big buffalo gun, they grabbed the two riderless horses, turned and disappeared back towards the caprock as quickly as they appeared. Ned turned to look at the colonel, smiled and wiped his forehead, pushing his hat to the back of his head as he did so.

" Damn, that was a close 'un, Colonel. Them Indians had hair on their minds!"

"You're right on that one, boy. They thought they was horse rich when they saw all these horses and just the two of us trailin' em. I'll say one thing for you, son. You sure did learn how to shoot back in them Kentucky mountains. Why, I'll bet them redskins was at least eight hundred yards away, maybe more'n that, when you popped the first one."

Ned, embarrassed at the compliment, said, "Shoot, colonel, we used to knock the eyeballs out of a squirrel's head further than that."

"Well, them redskins don't want no more of that fifty caliber and that kind of shooting, Jim said, "I don't think we have to worry about being bothered by them anymore."

They remounted their horses and once again headed south, keeping a sharp eye ahead and behind, to make certain that the Indians didn't try again. Reaching the river on the south side of the Double Mountains, they followed the stream bed east for a short distance, until it turned sharply to the northeast. Leaving the river, they rode across the mesquite flats due east, following the directions which Quanah had given.

The following day, as they rode slowly under a scorching sun, they observed dust in the distance to the north. The dust cloud continued to grow and soon they could see that a group of riders, riding hard in their direction, was responsible for its origin. It was apparent that this was no band of Indians, but Ned and the colonel pulled their Winchesters from the saddle boots and levered shells into the chambers, prepared for the worst. They were relieved to see the blue uniforms of the U.S. Cavalry as the riders bore down on them.

A young lieutenant who was leading the column, held up his hand to command the soldiers to halt. Removing his hat to wipe the sweat from his brow, he addressed the two civilians.

"Thought you folks were redskins, mister," he said addressing Jim. "We been on patrol from Fort Graham trying to run some ren-

egades back up on the plains. When we saw all your horses we thought we'd found a band of the horse thieving Comanches. Where you heading?"

"We're heading for Waco on the Brazos to put together a herd of longhorns to take back up north. Don't rightly know just where we are but figured we'd run into someone like you who might set us straight," Jim replied, smiling.

The lieutenant, pointing to the northeast, said, "You're in luck, mister. Fort Belknap is just over that ridge to the north about thirty miles. There's a good wagon road from the fort down the Brazos to Waco. You ain't more'n ten miles west of the wagon road now."

"We're shore obliged, Lieutenant. We was beginning to think that we wasn't ever going to see civilization again," Ned said. "We been up on the plains all summer and all we seen is Indians since we left Fort Smith in May."

The lieutenant looked surprised. "How in hell did you keep your scalps? Those damn redskins been on the warpath from here north for the past year. Most of the settlers have moved their families out for safety. Ain't been much white folks from here north for the past four years, leastwise since the beginning of the Civil War. We've had orders to try to push the savages back up to the Indian territory so folks can come back to their homesteads."

"Guess we was lucky, " Jim answered. "We made friends with the Comanches up on the Canadian and they didn't give us any problem. Six braves tried to take a liking to our horses just yesterday, but Ned's sharp eye must have discouraged them after he knocked two of them off their horses with this big buffalo gun. They hightailed it back up towards the plains."

"You must be carrying a rabbit's foot, mister," the lieutenant said. "They been taking more scalps the past year than ever before because they're all riled up at the buffalo hunters. If you're looking for longhorns, you'll find plenty scattered along the Brazos and Colorado Rivers. Ain't nobody been looking after them since the war started and there's thousands just running wild with no brands. Guess they belong to the first man that catches them and puts on his mark." Placing a fresh cut of tobacco in his mouth, he added, "Don't know why anyone would want to go to the trouble, though; they ain't worth a damn, and even if they was, no one's got any money to buy with." He handed the tobacco to Jim who cut a plug and gave it back.

"Ain't going to be that way forever, lieutenant. One of these days folks back east are going to be willing to pay good money for beef-steak. When they do, me and Ned intend to have plenty to sell," Jim said as he placed the tobacco in his mouth.

"You may be right, mister, but right now me and my troop got more things to worry about than whether people are going to be willing to buy those mangy critters. We've got to head back west and see if we can find those thieving redskins that's been stealing our horses." With that, he raised his hand and signaled for his cavalry to move out.

13

After spending the summer on the plains, Waco was a lovely sight to Ned. In actuality, however, it was no better or no worse than any of the hundreds of small communities which marked the western frontier, a village of approximately eight hundred hardy souls, many who had been forced into the town by raiding bands of Indians. Its dirt streets, false-fronted buildings, and wooden sidewalks were typical of most settlements which had sprung up as civilization moved west.

The town had its share of saloons, livery stables, and hotels. Horses lined the one main street, tied to the hitching rails, swishing flies with their tails while waiting for their riders to complete their shopping, drinking, or gambling. As in St. Louis, the tinkling sound of a honky-tonk piano could be heard above the other sounds of barking dogs, screaming kids and scolding mothers.

They rode slowly down the narrow street, the hooves of the horses kicking up small clouds of fine dust. When they stopped at the hitching rail in front of the livery stable, the mustangs crowded around the other horses, trying to get as close as possible to the buckskin stallion and the boss mare for protection.

"We best get these critters in a corral before they stampede on us and end up back on Red Deer Creek," Jim told Ned. Ned, nodding his head in agreement, remained with the horses while the colonel stepped inside the livery stable and made arrangements for a corral in back. He and the stable owner reappeared and helped Ned

lead the remuda to the rear. They locked the mustangs in a pole corral and led their mounts and the mules inside the barn where they were given the luxury of stables, fresh hay and oats.

The two dusty riders then carried their bedrolls and saddlebags to the hotel next door and asked for a room. "Looks like you fellers been traveling quite a spell," said the friendly hosteler. "Where'd you come from?"

"Up north, on the *Llano Estacado,*" replied Colonel Cole. "Been up there since spring, settin' up a ranch."

The desk clerk looked surprised, "You must be kidding, mister. How in hell did you keep from losing your scalps to the injuns? They been raiding all the way down here to Waco for the past two years, stealing horses and taking scalps from the settlers who haven't moved into town. Up north a ways, around Fort Belknap, they just about wiped out the settlers. Folks say its old Chief Nocona and his Comanches, taking revenge for the rangers killing his folks and capturing his white squaw. Anyways, I sure wouldn't want to try to start no ranch up in that injun country."

"Well, it ain't going to be Indian country forever, mister, and we intend to have a part of it when it ain't," Ned said. "Right now, though, I just hope you got a bathtub in this here place. I need to get about six months of dirt off'n my skin."

The clerk smiled and nodded, "You sure ain't lying there, mister. I'll have the maid start heatin' some water and the tub will be in the room at the end of the hall. Should be ready in about thirty minutes."

Ned and the colonel thanked him, and carried their belongings upstairs. An hour later they both came down, bathed and shaved with clean buckskins covering their bodies. Smiling, the hotel owner said, "Ain't it amazing what a little soap and water will do for a man's looks."

Both men smiled and nodded in agreement as Jim asked, "What we need now is a good meal and directions to your local banker."

"Saloon next door to both of your questions," he grinned. "Mr. Tompkins owns just about all the businesses in Waco. He runs the bank during the day, and spends most of his evenings in his Longhorn Saloon and Restaurant. Sign says 'Best Food and Whiskey in Texas,' so I ain't going to argue the point." As an afterthought, he added with a wink, "Some say the gals is the prettiest this side of

New Orleans, but I 'spect you'd best pass judgement on that yourselves."

Ned laughed and replied, "If they're just the prettiest this side of Fort Belknap, I'll be happy."

They stepped out the front door of the hotel, walked about ten paces down the boardwalk and turned through the swinging doors of the Longhorn Saloon and Restaurant. Three cowboys were sipping their beers at the bar and looked up unconcerned as the swinging doors flapped behind them.

"What'll it be, gents," the bartender asked as he wiped a puddle from the bar?

"First, we'd like for you to point out Mr. Tompkins to us, and then we'd like a bottle of your best drinking whiskey," replied the colonel. We need to wash about six months of dust out of our throats."

The bartender reached behind him and took a bottle of Kentucky bourbon off the shelf, setting it down on the counter, he pointed to a well dressed man who was eating at a table in the corner. "That's Mr. Tompkins and that'll be two bucks for the whiskey, information's free," he winked with a smile.

Ned picked up the bottle and the two glasses, pretending he had been drinking all his life. He followed the colonel to Tompkin's table and stood to the side while Jim introduced them.

"Mr. Tompkins, my name is Jim Cole but most folks call me 'Colonel', and this here's my pardner, Ned Armstrong. We been traveling for more days than I can remember, and we got a mighty hankering for one of your good steaks and a chance to bend your ears a mite.. Mind if we sit down with you and talk a little business while we eat?"

Tompkins looked the two over, his eyes moving from one to the other and from their boots to their hats. Shrugging, he said, "Why not? Have a seat and speak your piece." He motioned to the two empty chairs at the table while raising his other hand to get the bartender's attention.

They sat down and Ned opened the bourbon and poured the colonel a stiff drink. He hesitated, looking at both men as he nervously poured a small amount in the other glass.

"Ned's pa used to make the stuff back in Kentucky but his ma kinda frowned on him using it," smiled the colonel as he noticed Ned's hesitation. "Ain't no bigger man this side of the Mississippi as

far as I'm concerned, though, and he don't have to prove nothing to me.. How about you, sir. Will you join us in a drink to celebrate the beginning of the biggest cow ranch in the State of Texas?"

Tompkins pushed his empty glass to Ned's hand without answering, keeping his eyes inquisitively on the colonel's.

The bartender interrupted the conversation and Tompkins said, "Bring these gent's a couple of our best steaks," adding, "it looks like they ain't ate a decent meal in a spell." After he disappeared into the kitchen, Jim and Ned raised their glasses towards the banker. Hesitating, he raised his glass to theirs and drank with them.

Ned took only a sip, holding his breath as the whiskey began to burn his throat as it traveled to his stomach. Tears brimmed in his eyes and no matter how hard he tried, he couldn't keep from coughing. The two men laughed good naturedly at his embarrassment.

When he finally got his breath, he said, "Ma was right, it's got to be made by the devil!"

"Now, what's this about the biggest ranch in Texas? That's saying quite a mouthful, Colonel," Tompkins said.

Jim then related his story about his experience at the Alamo, how his friend General Sam Houston had gotten the legislature to make him the grant of land in the north, and how he and Ned had met in battle then traveled together from the east to the Canadian River.

"That's quite a story, Colonel," responded the banker, "but why tell me? Seems to me you must be figuring that I can help you some way. Guess you better tell me what you got in mind and I hope you ain't aiming to ask me for a loan. They ain't enough money in these parts to grubstake a prospector, much less bankroll a ranch."

Having finished his steak, Jim picked up the bottle of bourbon with his left hand and removed the cork with his teeth, then poured himself and Tompkins another drink. Ned shook his head *no* when he started to pour some more in his glass. He replaced the cork and set the bottle on the table.

"It's not so much as to how you can help us, sir, but how we can help you," Jim replied. "You see, I was able to put together a pretty good spread down by San Antonio before the war. I sold it, *lock, stock, and barrel*, just before joining up with General Lee, and put the money in the bank at Austin. I got me twenty thousand gold dollars in that bank and I intend to use them to buy cattle and out-

fit our ranch. I'd like for you to handle the money for us and pay for the cattle, for a fee, of course. I can pick up the money when I go to visit General Houston."

The banker took a deep breath when he heard the figure. Twenty thousand dollars was more money than he had in his bank, altogether. "Guess you ain't heard that the General died last year," he said after catching his breath.

Jim looked surprised, then sad. Tears welled up in his eyes at the news. Finally he said, "The General was like a daddy to me. Guess he was one of the best friends I ever had. I sure hate to hear that he's dead."

"We got a stage runs from Waco to Austin every week. If you can show proof who you are and proof that you got that money in the bank, we can have it here inside of a week and you won't even have to go to Austin," Tompkins said after Cole had regained his composure.

"You'll have the proof in the morning, sir," replied the Colonel. "There's a couple of other things we're gonna be needin'. I would like to set up an office for cattle buyin', and we need a place with good grass and water that's big enough to hold about five thousand head of horns and hides 'till spring."

"The first request is no problem. There's an empty building joining the bank which belongs to me. It's yours. The second may take a little doings, though. Five thousand head of longhorns is gonna need a lot of territory. Better let me sleep on that one," Tompkins said with a glint in his eye.

He pushed his chair back and got to his feet. "Guess you boys will have to excuse me now. There's a little game going on in the back room that I'm late for. I'd hate for someone to win all these cowhand's money without giving me a shot at it," he said .

Jim smiled and said they would see him in the morning. The saloon was beginning to fill with drifters and local cowboys as a baldheaded gent with silk shirt and red suspenders, holding up black and white stripped trousers, sat down at the old dilapidated piano and started playing a honky-tonk tune. Several scantily dressed girls, cheeks and lips painted, descended the stairs and began circulating among the men. Ned just couldn't get enough looking. The bodice of their dresses were cut so low, and their sashes were tied so tight, that it looked as if their breasts would spill out any minute.

The colonel poured them each another drink from the half empty bourbon bottle as he smiled and said, "Well son, looks to me like your wish done come true. You said you shore would be glad when you could find something with skirts on to look at instead of this old homely face. Seems to me, Mr. Tompkins got him a passle of the best-lookin' skirt wearers this side of St. Looie."

Ned blushed, realizing that he had been staring at the pretty girls. Subconsciously, he reached for the newly poured drink and turned it up without thinking. Half of it was in his stomach before he realized what he had done. His face reddened, his eyes watered and his lips formed a circle as he blew to try to cool the flame. When he regained his breath, he said, "That didn't taste half bad, Colonel. With a little practice I might get to where I liked it."

Jim laughed, as one of the girls came to their table and asked Ned if he would like to dance. Not much older than Ned, she was the prettiest girl in the saloon, with blonde hair and big blue eyes. When Ned could get his eyes to raise from her bodice, surprisingly he heard himself say, "I shore would."

She grabbed him by the hand and before he realized what was happening, she had pulled him into the throng of pushing and shoving cowboys and dancehall girls who were doing everything except dancing.

Now, there wasn't much to do back in the hills of Kentucky except hunt squirrels and listen to mountain music. Ned had been brought up on clogging and square dancing since he was big enough to walk. The whiskey was beginning to have its effect on his timidness, and he began to swing his blonde-headed lady friend to the beat of the baldheaded gent's piano pounding. The other dancers stepped back and watched, clapping their hands to the rhythm, as the two young people danced around the saloon.

Jim watched flabbergasted. Ned sure hadn't told him everything that he could do. He began to tap his toe and pat the top of the table with his left hand, keeping time to the music.

Ned and the girl, returned to the table, laughing and winded. "Colonel, this here's Jeannie Boudreaux -- Jeannie, this here's Colonel Jim Cole, the only survivor of the Alamo.'" Ned said as they sat down.

Jim could see that the whiskey was having its effect on this usually quiet young man. He smiled and thought, *what the hell, he deserves a little fun, all he's had for the past two years has been war and*

killing, fighting injuns, and working his tail off." He asked for another glass and poured three more glasses of bourbon. Petite little Jeannie turned her's up and downed it without batting an eye. Ned held his breath and took a small sip.

Jeannie jumped up and grabbed Ned's hand, "Come on cowboy," she said, with a slow Louisiana drawl. "I ain't had no one could dance like you since I left New Orleans two years ago." She dragged Ned to the dance floor and they disappeared in the crowd. Ned's head began to swim but he felt so good it made him dance all the better. Jeannie pulled him close to her and he became very aware of the sweet smell of her perfume. *Gosh,* he thought, *after all those months of smelling Indians, buffalo hides and sweating horses, this is like walking in the spring flowers on old bald mountain back in Kaintuck.*

Before the music stopped, Jeannie had guided him to the base of the stairway and was leading him up the stairs away from the crowd. Ned followed meekly as they came to a door which she opened and pulled him in.

A coal oil lamp glowed softly on a small table and a yellow cat was curled asleep on the bed. She shoved the cat to the floor and pushed Ned on to the bed's edge. Taking both his cheeks in her hands she kissed him warmly on his lips. His head was whirling even more now, and he couldn't have resisted even if he had wanted to -- but somehow he didn't seem to want to.

She took off his boots, unbuttoned his shirt, loosened his belt and pulled the shirt and trousers from his body. The yellow cat jumped nimbly from the floor to a cane-bottomed chair in the corner and watched knowingly as it smoothed the fur on its foot with its tongue.

An hour later, they returned to the Colonel's table. The bottle of bourbon was almost empty and Jim had a drowsy look on his face. He smiled as the two sat down, knowing that tonight his young protege had grown into a man. He reached into his pocket and pulled out a five dollar gold coin and laid it in Jeannie's palm.

"Thanks, little lady, for a deed well done," he said as he observed the look of contentment on Ned's face.

Jeannie smiled, thanked him for his generosity, grabbed a stray cowboy who was walking by and led him to the dance floor.

14

Mr. Tompkins was waiting for them in the bank the next morning. Jim handed over the papers which proved that the legislature had granted him the land in north Texas, the deposit slip showing twenty thousand dollars in gold on deposit at the Republic National Bank in Austin, and his commission as a captain in the Texas Cavalry, signed by General Houston, himself.

Mr. Tompkins nodded his head and said, "Looks like you've got everything you need. I'll dispatch a messenger to Austin tomorrow and get your money transferred. Look's like we're in business."

They walked from the bank to the empty building next door and Mr. Tompkins showed them through the four rooms. It was ideal for their needs, with a large front room which they could use as an office, a smaller room that had cabinets and stove for a kitchen, and two more rooms at the rear which would serve as their bedrooms.

While they were looking, two men carrying a large roll-top desk came into the office. "We wasn't using it at the bank and I figured you needed it worse than me," the banker said.

Pointing down the street, he added, "Joe Schluter is a painter and I told him you'd be needing a sign. What you going to call this *biggest* ranch in Texas?"

Ned spoke first, "Ceebara -- C, Bar, A. That's what she's gonna be. Just make the sign say 'Ceebara Cattle Company'."

Tompkins looked at the Colonel who nodded his head and smiled. Last night sure had changed Ned's outlook on life, he thought. But it's all for the best, the boy was just too danged timid for his own good.

They went to work cleaning the building and getting their office established. Joe Schluter began painting the sign over their front door, and crowds began to gather in the dirt street to watch the activity. A little round Mexican lady appeared at the door carrying a mop, a broom, some rags and a bucket of water. "Senor, I am your new cook and housekeeper. Senor Tompkins said that I should start to work pronto, so please *vamanos* from the back rooms until I tell you to come." With a rustle of petticoats she disappeared through the door, announcing over her shoulder, "My name is Maria Garcia."

When it appeared by the sounds from the back room that Maria was nearly finished with her cleaning, Jim stuck his head in the door and said, "Maria, when you finish, you may go to the mercantile and buy what you will need for cooking and for beds for Ned and myself. Tell the clerk to charge it to Ceebara Cattle Company.

"Si, Senor," came the reply. What Jim didn't know was that Maria intended to make these four rooms home for him and Ned, and didn't intend to spare any expense to do so. Of course much of the refurbishing she intended to make herself; curtains, rugs, table linens, etc. But it would be a comfortable home which they could enjoy for the next six months. And Maria intended that the young man whose name was Ned, would put some meat on his bones, he was just entirely too thin. She had the remedy for that; enchiladas, tacos, frijoles, with lots of hot peppers prepared only the way that Maria could prepare them!

By night, she had completed her work and had prepared a steaming hot meal for her new *muchachos*. They could not imagine the changes which had taken place in the drab back rooms. Bright colored rugs were on the floor, curtains on the windows, and beds which she had instructed her husband to build, with mattresses filled with corn shucks and leaves. Colorful Mexican style spreads covered the beds, and even wild flowers in a glass jar were set in the middle of the dining table.

When Jim complimented her on her handiwork, she giggled proudly, and smoothed the white apron which covered her ample stomach.

The next morning, standing beneath the still wet sign, stood a woman nearly as tall as Jim Cole, waiting for the men to open their office. There was a look of elegance about her, although she was dressed in a buckskin skirt which stopped at the knees, a denim blouse which was open at the neck, cowhide boots which came half-way to her knees, and a fringed doeskin jacket which hung comfortably from her shoulders.

Her hair was pulled back and tied in a ponytail and was covered with a large flat brimmed felt hat pulled low over her eyes. She wore soft leather gloves which held a repeating carbine rifle, resting loosely in the crook of her arm. Her face, neck and throat were a weathered tan from too much sun, and even dressed as she was, it was not hard to see that she was much of a woman, with all the curves and valleys in just the right places. There was a touch of grey showing in her copper red hair.

"My name is Belle McArdle," she said, matter-of-factly as she slowly removed her gloves. "I hear tell ya'll are looking to buy some cows. I got me some to sell."

She looked Jim straight in the eye as she made her statement, and he could see that the eyes were ice-blue and calculating.

"That's right, Ma'am. Name's Cole -- Jim Cole. This here's my pardner Ned Armstrong, and we are in the market," Jim replied. "How many head you got."

"Depends on how much you're paying," Belle answered, smiling. "Got five hundred head if the price is right, ain't got none if the price ain't right."

Jim smiled. He admired this woman's bluntness. Got a business head on her, too. Wonder why she is here instead of her husband? He could see the wide gold band on her third finger, left hand.

"Well, Ma'am, why don't you come in and set a spell and we'll see if my dollars fit your cattle," he said.

She came in, leaned her rifle against the wall, removed her jacket and hat and sat down, holding her gloves in her left hand.

Looking at her with respect, Jim said, "We're paying two dollars, gold, for all grown cows, Ma'am, three dollars for cows with yearling calves by their side, and two dollars for two year old bulls and heifers. Don't want no cows with babies by their side next spring. We're gonna be driving them a fur piece and can't be bothered with babies."

"Sounds fair enough, Mr. Cole. You can figure on five hundred head of cows more or less, from me, and half again as many grown calves. Mr. Tompkins said ya'll are looking for a place to run your herd till next spring. You might be interested in my spread; ain't very big, but ain't no one joins me on the north. Just wide open free range. And we got plenty good corrals, river water and grass runnin' out our ears. You're welcome to use it if you're a mind to," she said.

"How about your husband, reckon he'll agree to that," Jim said, inquisitively.

"Husband's dead. Killed in the war. Just me and Kate and Sonny. Reckon we'll be leaving the place anyways after we get rid of the cattle. It's just too much of a chore to try to keep it going since Buck's gone."

"Sorry, Ma'am," Jim replied, then added. "Sounds like you got just what we're looking for, Ma'am. If you'll just give us directions to get to it, we'll ride out first thing in the morning and look it over."

"Ain't no problem to find," Belle said. "Just take the north road out of town, three miles out it curves around the bend in the river and that's where my property begins. Ranch house and corrals are located another half mile up river, setting in a large grove of live-oak. Our land stretches another five miles up river, then they ain't nothing but injuns and jack rabbits clean to Fort Belknap. All the settlers have moved out trying to save their scalps."

"Just one more thing, Mrs. McArdle. I ain't particular what color your cows are, but I don't want any cows with more'n one brand on them. That ways I don't have to argue with no one about where I bought them. I understand there's thousands of horns out in the timber that ain't never been fired with any man's brand and belong to the first one that puts an iron to them. If you put your brand on them, I'll take all you can catch."

"Thanks, Mr. Cole. I'll keep that in mind. I'll be looking for you in the morning." Saying that, she put on her hat and gloves, picked up her Winchester and walked out the door.

"Oh, Mrs. McArdle," Jim said as she turned. "Name's *Jim*, hope I can call you *Belle*. She smiled and said, "Sure, Jim. I'd appreciate that."

Sunup the next morning found Ned and the Colonel rounding the bend in the road, with the river just a short distance to their right. A smaller road cut out into the timber from the main road,

and they turned their horses onto this little used trail. A half mile farther and they came upon a log cabin nestled beneath the oak trees. Large pole corrals trailed off behind the house and half a dozen horses could be seen lazily swishing flies with their tails in the nearest pen.

The smell of fresh coffee greeted them as they knocked on the door. Belle, her buckskins covered with a white apron, opened the door and asked them in. The large front room of the cabin was immaculate. Buffalo and deer hide rugs were scattered around the floor. A large hand hewn dining table with benches on two sides sat in the middle of the room. On one side was some rough cabinets and a small wood-burning cook stove. On the other wall was a huge fireplace and a large stack of fire wood. A back door was ajar, revealing two bedrooms in the rear.

A tall, sandy haired boy entered behind them, carrying a bucket of water. As he placed it on the cabinet, Belle said, "This here's my boy, Sonny. He turned fourteen last month. Guess he's the man of the house now that his pa's gone."

They shook hands with Sonny, who stood almost as tall as Ned. His grip was strong, a result of the hard work required to keep the ranch in workable condition. Jim noticed that Sonny was staring at his missing arm. "Lost it to a cannon ball in Virginny," he said to the unasked question. Sonny's face reddened, embarrassed that he had been unable to take his eyes from the arm stump.

His embarrassment was interrupted when a lovely young lady entered from the back room. She walked over to her mother's side and Belle placed her arm around the girl's waist. "And this is my daughter Kate. She's sixteen," she said.

The two men bowed slightly and said as how they were proud to meet her. Kate smiled brightly, looking them both over appraisingly. It was apparent from her reaction that she liked what she saw. It was also apparent that the timidness of Sonny did not run in the family. His sister was as bubbling with excitement as Sonny was shy and quiet.

Ned was stricken with her loveliness. She was her mother made over, from the tall, elegant frame to the copper hair and piercing blue eyes.

Belle asked the men to set awhile as Kate poured hot coffee and set a large plate of fresh-baked cookies on the table. The men ate the cookies and drank the coffee as they told their new friends

about their land on the *Llano Estacado* and their plans to make it into a great cattle ranch. Sonny was spellbound with the story, especially about their experiences with the Indians, rescuing Quanah from the quicksand and the ritual of cutting their wrists and becoming blood brothers with a Comanche chief.

"Belle," the Colonel said, "If the rest of your ranch is even close to being as good as what we've already seen, it is going to serve our purpose perfectly. We may have to build some more holding and working pens, but there seems to be plenty of cedar for that. We sure aim to pay you for the use."

"I appreciate that, Jim. Just name your price and its yours. Ain't going to be no use to me and the kids, anyways, once the cows are sold," she said. "Kate will show you to the north pastures. Me and Sonny are going into town and rustle up some cowhands to help with our sorting and branding."

Jim and Ned got up from the table and started for the door. Kate said, "I'll be ready soon as I get my hat and coat."

She returned from the bedroom shortly, putting on a large felt hat and buckskin jacket. Ned noticed that she had strapped a gunbelt with a Colt revolver to her waist. She took a rifle from the gunrack before motioning for them to follow her. Sonny had disappeared out the door, and when they reached the hitching rail, he came out of the barn leading a saddled roan mare. Kate took the reins and easily swung into the saddle, shoved the rifle deep into a saddle boot, turned the mare and started riding north, kicking the mare into a slow trot. The two men followed.

They rode until midmorning through grazing longhorns, fat and slick from the lush grass growing along the river bottom. "No need to waste any more time, Kate," Jim said as he pulled the big black stallion to a halt. "We couldn't find a better herd if we searched from here to Laredo. Let's head back in."

Upon returning to the office shortly after noon, they found a large group of men waiting. Word had spread about the price they were willing to pay for cattle, including the mavericks which roamed unbranded around the countryside.

Most of the men who were waiting owned nothing more than their horse and saddle, the clothes on their backs and a six-gun which hung at their side. They were out of work, broke and ready to earn some money. The war had just about drained all of the money out of the state and with it the jobs which they so desperate-

ly needed. They wanted to know if it was true that Ceebara was willing to pay for rounding up the mavericks.

"Sure it's true, boys," Jim said to the group. "Two dollars a head for cows, bulls and heifers, two year old or older. Three dollars for cows with yearling calves by their side. We don't want anything with more'n one brand on 'em." Smiling, he added, "Just to be safe, I'd say that brand ought to be your own."

A dark-bearded cowboy they called Slim, who seemed to be spokesman for the group, said, "Where do we have to deliver these critters to get our pay, Colonel?"

"Out to the McArdle spread," answered Jim. "We will have pens set up where you can hold 'em 'till you get 'em marked. After we check them to see that we ain't buying someone else's cows, we'll pay. If you're a mind to bring 'em in unbranded, we'll pay two-bits more if you just burn our brand instead of yours."

The cowboys began to talk among themselves, nodding their heads in agreement. Slim turned to the colonel and said, "Me and the boys would like to have a shot at supplying you with what you need, Colonel. We ain't got nothing better to do than chase around through the prickly pear and mesquite looking for mavericks. They's damn sure enough of 'em out there if we can just catch the wild bastards."

"Good enough, boys. We'll give you first shot at it, but if it looks like you ain't going to pen enough for our needs, we'll have to make other arrangements," Jim answered. As an afterthought, he added, "Stop in at the mercantile and pick up what supplies you'll be needing and charge it to me. You can pay for it when we settle up."

The cowboys disappeared down the dirt street, slapping each other on the back and laughing about their good fortune. Their leather chaps flopped and their bright metal spurs jingled as they walked towards their horses.

"Ned, you're a damn good shot with a gun, pretty good fence builder and mountain man, but I just bet you don't know a danged thing about herding cows or swinging a rope. Why don't you gather your things and go out to Belle's and help them gather their herd. The experience will do you good, and I'm sure they could use the help," Jim said as they sat down to the evening meal which Maria had prepared.

Ned's hand stopped halfway to his mouth with a fork full of en-

chilada, and his eyes brightened. He had been thinking about Kate every since they had left the ranch and wondered when he'd get to see her again.

"I'd shore like that, Colonel. But what about you? You're going to need my help around here," Ned said excitedly.

"Looks to me like we got most everything in pretty good shape here," Jim replied, "If any of the local ranchers come in wanting to sell their herds, I can take care of that. About all I've got to do now is start putting together a list of supplies we're going to be needing next spring when we head back north. Besides, I bet there ain't a better teacher this side of San Antonio than Belle, when it comes to knowing cows. You ought to be able to learn a heap if you can keep your mind off of that gal long enough at one time."

Ned ducked his head, blushing, realizing that Jim was reading his mind. He shook his head in agreement as he pushed the fork-full of enchilada into his open mouth.

The next morning Ned saddled his mare, gathered the mules and mustangs and headed out to the McArdle ranch, trailing his re-muda behind him. Jim and Maria stood in the doorway and watched him disappear around the corner.

"Maria," Jim said proudly, "that's a fine young man and I'm proud to have him as a friend."

The little Mexican lady nodded in agreement.

Turning back into the office, he asked, "Do you know some-one who is good with his hands at building things?"

"Si, Senor Cole, I know one man. Ramon can build anything, he is the best," Maria answered, then laughing added, "I should know because he is the father of my six children."

Smiling, Jim said, "Well, tell Ramon I need to talk to him."

"Si, senor Cole," Maria said as she bustled out the door to fetch her husband.

Soon the two returned and Jim invited the small, elderly Mexi-can to set down in the office. "Ramon," he said, "I'm going to need a good man to look after our equipment. Maria tells me you are good with your hands at making and fixing. I'd be obliged if you would go to work for me."

The little Mexican smiled proudly. "*Gracias*, Senor Cole," he said. "You honor me with the privilege. What would you have me to do?"

"First, we are going to need three good wagons which will be

strong enough to carry a heavy load of supplies on the cattle drive. We will need extra parts for breakdowns, and the right tools for repairs. We will need a chuck wagon which is completely outfitted with pots, pans, cooking and eating utensils; barrels for water, flour, sugar and coffee; several hundred feet of lariat rope, nails, hammers, axes, blacksmith tools and shovels," Jim listed.

"We'll also need three more sets of harness to outfit some of those mustangs that Ned and I brought down from the plains." As an afterthought, Jim added, "If you're any good at breaking work stock, guess you'll have to take the harness to McArdle's ranch and spend some time breaking those wild *cayuses* to harness."

"Si, Senor Cole. I have broke many *cabayas* to work the plow and pull the wagon. I will make your wild ponies into gentle babies," Ramon answered with a smile.

With the addition of Ramon and Maria Garcia, the Ceebara family had grown to four; there would need to be many more added before they would be ready to head five thousand head of wild longhorns north to the *Llano Estacado* in the spring.

15

Sonny's dog, Shep, welcomed Ned and his string of ponies to the McArdle headquarters with loud barking and a few nips at the horses' feet. Sonny appeared in the barn door and called the excited dog to his side. He was visibly glad to see Ned and rushed to open the gate in one of the larger corrals behind the barn.

Ned dismounted and greeted the boy. "Thanks, Sonny. The colonel thought I should come and stay a spell with ya'll and help with your roundup."

Belle had appeared from the house and smiled approvingly when she heard the news. "We're rightly obliged, Ned. We can shore use the help. Sonny and I was only able to pick up three hands in town. Seems all the cowboys joined up with Slim to try to bring in the mavericks. Can't say I'm right proud of the three we got. Don't know how much we can trust them, but they'll have to do. I just hope they stick with us 'till we get finished," she said.

Sonny removed the saddle from the bay mare and carried it to the tack room as Belle led Ned, carrying his bedroll and belongings, to the bunkhouse.

The three new cowboys were already in, washing for supper. Belle introduced them, "Ned, this is Bob Sharp, Jesse Adams and Frank Jones. This here's Ned Armstrong, boys. He's going to help us with our roundup."

The three men looked disapprovingly at Ned, but shook his hand when he offered it. They were a motley looking crew. Bob was a big, barrel-chested man with coarse, ruddy features. His face

95

was highlighted by a broad flat nose with distended nostrils, sur-
rounded by a week's stubble of uncut whiskers. On the other hand,
Jesse was a small, thin man with squinched, piercing eyes. His hair
was long, almost blonde, tied in a pony tail which hung past his
shoulders. His lips were stretched tight across his teeth, as if he had
never smiled in his life. Frank was a half-breed, half white and half
Apache, short-legged and muscular. A heavy fold of stomach hung
over his belt, indicating too much time at the bar. His black hair
was held in place by a rawhide band which was tied tightly around
his head. He smelled of liquor.

Speaking to Ned but addressing the four of them, Belle said,
"Supper will be ready in about thirty minutes. Just come on up to
the house when you're ready."

Ned was anxious to see Kate again. She greeted him at the
door, wearing a gingham dress and a clean white apron. A smudge
of flour was on her left cheek and a ringlet of copper hair fell across
her brow. Her smile was just as fetching as Ned had remembered,
and his heart skipped a beat as he took her hand which she offered.

"Supper's on the table," she said as she turned and removed a
pan of hot biscuits from the Dutch oven. The men entered and sat
down at the large dining table. Belle, Kate and Sonny joined them.

Belle led the conversation during the meal, explaining her plans
for gathering the herd and getting it ready for the colonel's inspec-
tion. "The pens are a mess," she said, " and won't hold a jack-rab-
bit. You'll find tools in the shed and at first light tomorrow you
boys will need to start putting them back into shape. Soon as you
get them repaired, we'll head up north and start pushing the herd
down river. It's going to be quiet a chore with no more help than
we've got, but we'll make do."

Ned noticed that the three rough-looking cowhands kept cast-
ing furtive glances at Belle and Kate as Belle talked. He didn't like
the feeling that he got while watching them. They were far too in-
terested in the ladies' bodies instead of listening to the instructions
which Belle was giving. He told himself that he had best keep his
guard up around these three, they could not be trusted.

The next week was spent doing hard manual labor -- replacing
posts, splitting rails, and repairing gates. However, the ranch was in
pretty good repair when they started and it didn't take long before
Belle passed judgement that the fences and corrals would stop and
hold the wildest longhorn.

Before daylight the next morning they were riding towards the north pasture; Belle, Kate, Sonny and Ned leading the way and the three cowhands bringing up the rear. Ned was leading one of the mules which was loaded with light camping gear, since bringing the cattle out of the river timber would require more than one days riding.

They reached the north boundary of the ranch by mid-morning and tethered the mule in a grassy meadow at the river's edge, unloading the packsaddle beneath the spreading branches of a large oak tree. They then proceeded upriver another four miles before spreading out and starting their drive back southward.

The river bottom was full of grazing longhorns, most with the "Slash M" brand; but many with no brand at all or carrying the brand of settlers long gone from the area. When the riders would approach a grazing herd, the majestic animals would hold their heads high, smelling the air like some wild animal then bolt for shelter in the nearest grove of trees. It was a slow process, riding back and forth along the river bottom, pushing the herds downriver towards the ranch house.

An hour by sun they reached the area where they had tethered the mule, unsaddled their horses, hobbled them and turned them loose to graze on the tall grass in the meadow. Ned and Sonny began gathering driftwood for the campfire while Belle and Kate started preparing beans and bacon for supper. Bob, Jesse and Frank sat down a short distance from the camp area and watched the ladies at work, now and then laughing at some rude remark that one of them made about his prowess with the opposite sex.

Their discussion was kept so low that Belle and Kate could not hear their remarks, but they were aware that they were the brunt of the conversation. Belle realized she had made a mistake in hiring the men and cautioned Kate to be alert to any kind of meanness they might try to pull. "Just keep your gun handy and don't be afraid to use it if they try to take advantage of you," she said.

The meal of beans, bacon and hardtack was eaten without incident, an ample supply of wood was thrown on the fire and the tired wranglers stretched out on their bedrolls under the stars, knowing that tomorrow would be another busy day.

Sunup the next morning found breakfast completed, the mule loaded and the group once again mounted and ready for the drive down river. Ned noticed that the three wranglers, off to one side

by themselves, seemed to be planning something. As he approached the trio, Bob cast a menacing look at him and with his hand on his Colt, said harshly, "Mind your own business, kid, and keep out of our way if you know what's good for you!"

Ned ignored the threat and rode on by, taking his position in the line of drive. Kate had taken the river's edge, with Ned between her and Bob. Jesse was next in line, and Frank took the position between Belle and Sonny, who was sweeping the edge of the low hills which rose from the floor of the valley.

The herd had now become large enough that the cattle were staying pretty well together, moving slowly south. The day turned hot and muggy and about noon Kate decided to rest her horse near a quiet pool along the river's edge. The temptation of the cool water was too great, and she shed her clothes and dived in, savoring the cool freshness of the water while her horse drank its fill. Her revolver was placed on top of her buckskins and her rifle remained in the holster on the saddle. As she swam back to the river bank and stepped out of the water ten feet from her clothes, she was startled by a dark shape which moved quickly out of the bushes between her and her buckskins.

Before she could scream, Bob had thrown a sweaty arm around her body and placed a dirty hand over her mouth. She struggled to get free, but another pair of hands now had her by the feet and she was thrown to her back on the sandy bank of the river. Looking up, she recognized Jesse, on his knees and holding tightly to her ankles.

Bob now had one hand on her chest, a knee pushing hard against her shoulder, and his big hand still covered her mouth. Frank rode up and dismounted, hurrying to help his friends subdue Kate who was struggling to free herself. He grabbed her free arm and the three of them pinned her roughly to the ground.

"Now what do you think about that, boys," Bob said as he stared greedily at the helpless girl. "Didn't I tell you what a great body was hid beneath them buckskins?"

As he spoke, he relaxed the hand which was covering her mouth, engrossed in the other parts of her body. Kate opened her mouth and bit hard on his little finger.

Cursing her, he jerked his bleeding finger from her teeth and slapped her across her face. With her mouth free, she screamed as loudly as she could before Bob once again covered it with his hand. Jesse pulled his bandana from around his neck and pushed it into

her mouth and tied it at the back of her head.

"Now, let's hear you scream," Bob laughed as he ran his hand up and down her chest and stomach, dripping blood on her white skin from his bleeding finger. She could only look at him with hate-filled eyes as she realized what was about to take place.

With the bandana tied tightly across her mouth, Frank pulled her hands above her head and held them roughly while Jesse gripped her ankles and shoved them into the sand. Bob stepped back and admired her lovely body as he began unbuckling his gun-belt.

He removed his chaps, unbuttoned his trousers and let them fall around his knees as he said, "Hold her tight, boys. I'm gonna ride her first and see if'n I cain't take some of the buck out of her. She'll be saddle-broke by the time ---".

Before he could finish his sentence, a heavy object hit him in the back and he sailed over the outstretched body of Kate and the other two abductors and landed on his face in the water of the pool.

Ned, having heard Kate's scream had ridden into the clearing at full gallop, leaped from his running horse and crashed into the middle of Bob's back. Quickly jumping to his feet, he placed a well aimed boot to the chin of the half-breed, Frank.

Frank loosened his grip on Kate's hands as he was knocked backwards. Ned was like a wild man as he jumped across Kate's outstretched body and landed in the middle of Jesse. They rolled across the sand to the water's edge as Kate struggled to her feet.

Jesse had pulled his knife from its sheath on his belt and slashed at Ned's throat. Ned nimbly dodged the knife and grabbed the wrist of the knife hand and pushed it backwards to the sand. His other fist made an arc and caught Jesse in the temple, making a loud cracking sound. Jesse's body went limp.

As Ned rose to his knees, his ears were deafened by the explosion of a gun close to his head. Almost immediately another explosion went off and a bullet tore into the skin of his left arm. He rolled to the ground and turned where he could see the form of Bob standing, bowed slightly, with his trousers around his ankles and a smoking revolver dangling loosely in his hand. A look of astonishment was on his face as he slowly fell forward, blood gushing from a large hole in his chest.

Looking to his right, Ned saw Kate standing above her pile of clothes, with a smoking Colt held tightly in both hands which was

still pointed in the direction of the prostrate form of her would be rapist.

Bob, having reached the river's bank had retrieved his gun about the same time Kate had reached hers. As he squeezed the trigger, aiming at Ned's back, Kate had fired. Her bullet had struck him just as he fired, causing his shot to be pulled just a little to the left which had saved Ned's life.

From the corner of his eye, Ned saw a slight movement from the crumpled form of the half-breed which lay at the river's edge. His instincts told him that the movement was a hand pulling a gun from a gun-belt. As the hand came around, he could see the barrel swinging towards Kate. Still on his knees, he quickly pulled his holstered revolver and fired, knocking the prostrate half-breed backwards into the shallow water. Blood gushing from the hole in his neck turned the clear, blue water to a bright red.

Ned rose to his feet, turning his eyes once again to the frightened girl who still stood motionless with the dirty bandana tied across her mouth. He moved to her side, removed the bandana, and took her in his arms, holding her tightly as she began to sob uncontrollably. Blood from the wound in Ned's arm ran down her side and legs and formed a small red pool in the sand at her feet.

They were standing in this fashion when Belle rode up, having heard the gunfire. She dismounted and rushed to Kate's side. It was only then that Ned realized that Kate was naked. Embarrassed, he released her and she fell into her mother's arms who consoled her soothingly until she stopped sobbing.

Belle picked up Kate's crumpled buckskins and helped her dress while Ned turned his back and kept his eyes on the unconscious form of Jesse, who was beginning to show signs of recovery.

It wasn't Jesse who was moving, but Ned's head which had begun to swim due to his loss of blood. As the trees and river began to whirl around his head, he fell silently to the ground.

When he awoke, his head was resting in Kate's lap and Belle was wiping his forehead with a wet bandana. The sleeve from his shirt had been torn away and a compress was tied tightly over the gunshot wound in his arm. Sonny was kneeling on the back of Jesse, tieing a rawhide cord around his wrists which had been pulled to his back.

Ned looked at Kate, who was now fully dressed, and could see the remnants of tears shining in her deep blue eyes.

Belle spoke first. "Seems to me you're gonna live, Ned," she said kindly. "You're shore in a lot better shape than that damned side winder that shot you. Kate's pa would be right proud of her marksmanship. He spent many an hour teaching her how to handle that '45'."

Ned was beginning to remember what had happened as Belle washed and dressed his wound. "Yes Ma'am," he said. She sure knows how to use a gun. Guess I'd be a gonner if she'd been a second slower."

"And I'd be a gonner if you'd been a second slower," Kate interrupted, as she ran her fingers through his hair. "Not only that, but if you hadn't come running the way you did, I guess there'd have been a lot worse things happen to me than a gunshot wound in the arm. I'm much obliged to you, Ned Armstrong."

Ned winced as he struggled to set up, the pain nearly more than he could bear. Belle and Kate helped him to his feet and he noticed the two dead drifters were still laying where they had been shot. His horse was standing grazing a few yards away and the mule, which he had released when he came to Kate's rescue, was standing at the water's edge, drinking his fill.

"If you feel like riding, Ned, we may as well load these drifters on their horses and carry them into Waco to the sheriff. Ain't no way we can get these cows into the corrals by ourselves, anyways," Belle said.

Sonny retrieved the horses and he, Kate and Belle loaded and tied the two dead men to their saddles, then lifted Jesse onto his horse. Ned walked to his horse and mounted with Sonny's help, although he was still weak from the loss of blood.

Sonny remained at the ranch to tend to the stock and Ned and the ladies rode into Waco, leading the three horses which were carrying their sad looking relics of crime. As they rode slowly down the main street, a crowd followed them to the sheriff's office. Jim was one of the first to reach the jail as they approached.

He rushed to Ned's side to see how badly he was wounded and was relieved to see that it was merely a flesh wound.

Belle explained to the sheriff and the crowd the events of the day and how Ned had prevented a terrible crime from taking place. The town's folks gathered around Ned and showered him with congratulations for being so brave. As usual, he was very embarrassed by the compliments, but proud all the same.

16

After turning the two dead men and Jesse over to the sheriff, Ned, Belle and Kate joined Jim in the Ceebara office. They rehashed the day's events, filling the colonel in on all the finer points of the battle at the river's edge. Their discussion then turned to the cows which they had left milling in the river bottom.

"You're going to need more help to pen the critters," Jim said to Belle. "Ramon and I will join you at the ranch in the morning and help before they all head north again."

"Thanks, Jim," Belle replied. "Guess I got no choice but to impose on your friendship. Ain't no more cowboys to be had between here and San Antonio."

Maria entered the office with hot coffee for everyone. Hearing the conversation, she spoke. "Senor Cole, I will have nothing to do here with all of you gone and Senora McArdle will need help with the food. I will go with you."

Looking at the little Mexican lady, Jim realized that she was not making a request but announcing a decision. He smiled and nodded his head in agreement.

Daylight was just breaking when Jim and the Garcias arrived at the ranch house. Lights from the coal-oil lamps cast a soft orange glow from the doorway as they dismounted and were greeted by the wagging tail of Shep. Belle appeared in the doorway and asked them in for breakfast.

Jim could not help but marvel at the beauty of this frontier

lady, dressed in the rough work buckskins which she had hand made from the skins of deer which she had shot along the river bottom. Her hair was brushed neatly, tied in the pony-tail knot behind her head, and the clean white apron was draped across her front. *Quite a lady,* he thought to himself.

Kate was pouring hot coffee when they entered the room and the table was set with a huge breakfast of eggs and venison, hot biscuits and gravy. "A breakfast fit for a king," Jim said, as he heaped his plate with the food.

Sonny and Ned, their breakfast complete, headed for the barn to saddle the horses while Maria began cleaning the table. Belle and Kate removed their aprons and replaced them with gun-belts, filled with the bone-handled Colts which was a part of their daily dress. The six of them mounted their horses and headed north, telling Maria that they would probably be back before dark. Maria waved from the doorway as they disappeared in the early morning fog.

The cattle had been pushed to within two miles of the ranch house the day before, but had wandered back upstream another mile. When Belle had determined that they were past the grazing herds, she instructed the others to spread out in the fashion of the day before, slowly pushing the herd closer to the wing fences which would funnel the longhorns into the pole corrals.

The day passed without incident, and the cattle were much less nervous and easier to drive since they were now accustomed to the presence of the cowboys and horses. By four o'clock in the afternoon, they reached the wing fences and the cattle began to be pushed closer and closer together, crowding as they moved towards the corrals. The noise of their bawling was deafening and the fine dust which now filled the river bottom was stifling. The clackety-clack sound of the huge horns of the older cattle could be heard as they were hit by other horns due to the crowded condition as they entered the funnel and flowed into the corrals. Ned dismounted and closed the gate and watched as the cattle began drinking from the small spring which flowed through the middle of the large holding pen.

As they stood leaning against the cross-rails of the corral, Ned said, almost reverently, "Colonel, ain't that a pretty sight. I can just see 'em now, climbing up that cut in the caprock and spreadin' out across Ceebara's plains. We'll damn sure have something to rest our eyes on now. But we ain't got more'n seven hundred head

penned up here -- what in hell we going to do with five thousand?"

The enormity of the size of their herd had now penetrated his mind and he realized what a tremendous task lay before them, getting them all shaped up and branded and ready for the trail. And moving them five hundred miles north! "Ain't no way possible," he thought out loud!

Jim laughed. "You're right, son. Them's fine looking cattle and they'll do us well. But don't worry about getting five thousand head ready. We got all winter and Belle's got plenty grass to hold 'em till spring. And I'm betting my hat that Slim and the boys know their business. Things are going to work fine. Only thing we got to worry about is getting this bunch marked and branded and back in the north pasture before Slim and the boys get here with their first herd."

By the time they had unsaddled and fed and watered their horses, Maria appeared on the front porch of the ranch house and began pounding the large steel triangle hanging from the rafters. The clanging of steel against steel echoed down through the river bottom, announcing that the evening meal was prepared.

And so were the weary wranglers, having had nothing to eat since breakfast. They walked briskly from the barn to the house, smelling the highly seasoned enchiladas, tacos, chili and beans for which Maria was famous. There would be nothing left but empty plates when they finished gorging themselves around the huge dining table.

The next day was spent cutting the cattle into different pens , one pen for "Slash M" cattle, another for cattle carrying a different brand, and still another for cattle with no brand at all.

There were very few cattle which had brands other than the McArdle mark, probably a hundred head which were carrying no brand at all and the remainder, about five hundred head, had the big "Slash M" on the left shoulder.

Jim rode slowly through the herd, looking for blemishes which would make them unacceptable for the long drive north. He found only twenty-nine head which had either bad eyes or feet, the others he announced would do for the "C bar A" brand.

The culls and the cattle belonging to other ranchers were turned down-river and driven a couple of miles away from the ranch house. The others were turned back into the large holding pen until morning, when they would be worked and branded and driven back to

the north pasture.

Ned could hardly wait until the branding began and spent a sleepless night thinking about the coming activities. His arm ached but was usable and he was anxious to learn all there was to know about headin' and heelin', castrating, earmarking and branding. The only cattle he had ever been around were two old jersey milk cows which his pa had back on their Kentucky farm. Now that he was half owner in a million acre ranch which would have five thousand head of longhorn beeves as a foundation herd, he guessed he'd better start learning a little more about the cow business.

Ned would have good teachers. Jim Cole was one of the best, even with just one arm with which to work. There were a lot of things he couldn't do because of his handicap, but there was one thing for damned certain, thought Ned, he sure knows *how* to do everything.

Then there was Belle. She knew those longhorn cattle like the back of her hand. And when she mounted a horse, it was as if they became one, cutting and turning, outsmarting the wildest steer. She seemed to have nerves of steel, with no fear of even the largest longhorn bulls. Ned was amazed at her ability to throw a lariat. Watching her perform was a sight to behold, whether she needed to throw a barn-sized loop around a six feet spread of horns or whether the need was to snag both hind legs of a steer running full speed, she seemed to never miss.

And Kate was almost as accurate, setting her horse as easily as any man and throwing her loops with deadly accuracy. Sonny was learning and knew what to do, he just hadn't yet learned the precision which was exhibited by his mother and sister.

Belle and Kate took the first hitch at heading and heeling the cattle for branding. Ramon prepared the branding fire with a large bed of hot coals and heated the irons until they were cherry-red. Ned and Jim would run the branding irons, and Sonny would work the gates.

When everything was ready, Belle mounted her horse, a big roan, and made her loop. She chose the nearest cow and spurted her horse in quick pursuit, smoothly casting her loop which sailed neatly over the cow's horns. As the loop tightened and the cow's head began to turn, Kate swung past on her horse, twirling her lariat over head and let it fly beneath the cow's belly. The cow's two rear legs stepped into the loop as she slid her horse to a stop. Kate's

horse quickly began to back away, tightening the rope around the cow's rear feet. At the same instant, Belle's big roan slid to a stop and began to move backwards. The cow, stretched between the two horses with both rear legs in the air, fell to her side, stretched out and unable to move. The entire episode took only fifteen seconds!

Jim was at her side before the dust had settled, carrying the red-hot "C" branding iron in his one good hand. He pushed it hard into the cow's hide, high on the left hip. As the hair and hide began to smoke and burn, the cow let out a loud beller, announcing her disagreement to the pain. Jim held the iron in place until he was convinced that he had burned through the thick mat of hair and into the tough hide.

As he relaxed the iron and stepped back, Ned immediately stepped forward, as instructed, with the "bar" iron in one hand and the "A" iron in the other. He pushed them both into the hair at once, the "bar" in front of the "A" but behind the "C", holding them long enough that the brand was burned well into the hide. The smell of burned hair and hide was pungent as smoke curled from the cow's hip. He stepped back and admired his handiwork. Ramon stepped forward and cut a deep "V" in the cow's right ear with his Bowie knife. The first cow in the Ceebara herd was now earmarked and branded.

Ned and Jim smiled proudly as they handed the irons to Ramon who replaced them in the fire.

Now the ropes had to be removed from the cow which was no easy task. Ned grabbed one of the huge horns and held the cow's head to the ground as Kate moved forward on her horse, loosening the rope around the cows horns. Jim eased the rope from around the horn and dropped it to the ground. Before Ned could release the horn, the cow realized that she was no longer being held with the rope and swung her head around, trying to get up. Ned sailed through the air and landed in a heap in a pile of fresh cow manure.

Kate moved forward with her horse, and as the cow kicked her rear legs the rope fell easily from her feet. She was quickly on all fours, mad as hell, and looking for something to direct her anger towards. Her eyes fell on Ned who was struggling to his feet. Letting out a beller which would have scared the hell out of all the devil's angels, she made a lunge at Ned! He didn't know much about cows, but he knew she wasn't running towards him in jest. In two

leaps he was on top of the top rail of the corral as the cow's horn passed within inches of his backside.

Belle and Kate were laughing hysterically from the safety of their saddles, as Ramon and Jim headed for higher places to get away from the angry cow. They turned their horses to the rear of the cow and drove her out the gate which Sonny had swung open.

Everyone was laughing at the turn of events except Ned. Somehow he just couldn't see any humor at all as he scraped the cow manure from his buckskins and retrieved his fallen hat.

"That's a good lesson for you to remember, son," Jim said as Ned brushed the dust from his hat. "There's an old saying that 'hell hath no fury like a woman scorned' which holds true for any old cow which has just had her backsides burned by a hot branding iron."

The next cow received a little more respect from the Kentucky mountain boy. After he released the rope from her horns, Kate held her rope tight until the men were able to get a little farther away from the angry critter, removing any danger of a two-foot horn coming to rest inside a six-foot cowboy.

After branding a dozen or so head, the team began to work with precision, requiring very little time to brand and earmark. Jim had determined that he would not castrate any of the bulls for fear of infection and screwworms, since the weather had not cooled sufficiently to rid the country of flies.

After lunch, Ned decided he would like to try his hand at roping. Belle stepped down from her horse and handed him the reins, giving a minimum of instructions on how to throw his loop. Ned had been watching her all morning and she made it look so easy that he felt he knew just what to do.

But it wasn't as easy as it looked! He threw four loops at the first cow before finally succeeding in getting the rope around one horn and the cow's nose. Then he turned his horse the wrong direction and tangled the rope around his leg. He was able to free his leg just in time as Kate jerked the cow's rear legs from under her and she fell flat. Belle's horse, being smarter than Ned, immediately backed into the proper position, holding the cow stretched out on the ground.

By evening however, he was throwing a pretty good loop, and was completing a high percentage of his throws. Over supper they all congratulated him on his improvement. "Tomorrow," Belle

said, " we'll give you the other end of the cow and teach you the hard part, throwing the loop under the cow's belly and snagging both rear feet while riding at full speed."

Three days later, all of the "Slash M" cattle had been converted to "C bar A" cattle and driven back upriver to the north pasture. They would remain in that vicinity until spring when all the newly purchased cattle would once again be rounded up and headed north on the five-hundred-mile trail drive.

The branding of the McArdle herd was finished none too soon, for on the morning of the fourth day, two riders were observed approaching from the west. They were covered with dust from the trail and were wearing two-week old beards, but under all this grime, the colonel recognized Slim and Waddy who he had hired to gather mavericks from the countryside.

"Howdy, Colonel," Slim said as he slowly dismounted from his horse. Waddy continued to set his horse, resting his arms across his saddle horn.

"Howdy, Slim," Jim replied. "Tie your horses and come in and set a spell. Belle makes a mighty good cup of coffee."

"Thanks, Colonel," Slim drawled as he started tieing his horse to the hitching rail. Waddy slowly swung to the ground and tied his horse then followed Jim into the house and took a seat at the big table. Belle and Maria were cleaning the breakfast dishes, Kate, Ned and Sonny were in the barn tending to chores.

As Maria poured four cups of coffee, Slim spoke. "Colonel, me and the boys are bringing nigh onto a thousand head of them ornery critters you call cows down from the hills to the west. We rode out to the Colorado River bottom and spread out over about five miles and started sweeping the brush and hills back this way, pushing the cattle in front of us. Lots of 'em got by us, but we damned sure got us a bunch that you're gonna be proud of. Driving 'em that far, we kinda got 'em tamed down to where they ain't no wilder than a buffalo," he said with a smile.

Jim and Belle listened attentively as Slim and Waddy explained how they had gathered small herds, cut out the branded cattle, then pushed them into larger herds until they now had one huge herd which had been held on the Bosque River the previous night, no more than fifteen miles from the ranch. They should be reaching the McArdle ranch before nightfall, Slim said.

"Most of 'em are two to three year olds, Colonel, and fat

108

enough to butcher. Got one old red bull that acts like he knows he's heading for the plains. We just head him up in the morning and he takes off in the direction we point him, leading that whole damn herd like they was his harem. The others seem to be satisfied that he's the boss and foller along like puppies. We named him "Big Red" and he shore has made our job a heap easier," he added.

"Sounds good, Slim," Jim said as he pushed his chair back. "When you finish your coffee I'll ride out with you and show you where you need to come into the river bottom north of the corrals. Belle's got some wing fences which makes penning them a simple matter."

Slim and Waddy stood up, turned to the ladies and thanked them politely for the coffee, then followed Jim out the door. They walked to the barn where Ned had just finished saddling the horses. Ned and Sonny joined them and they rode out, heading north to the point where the wing fences began, then turned west and rode up a small creek away from the Brazos river bottom. Soon they reached higher ground and rolling hills covered with sparse live oak trees and mesquite. After a couple of hours, they spotted a huge dust cloud rising in the distance which seemed to be moving slowly in their direction. They waited on one of the higher hills and watched as the herd came into view.

It was a beautiful sight. The herd widened from the point where the one big red bull was alone, until it was over a hundred yards wide, and then stretched back over and behind the nearest hill. The cattle flowed over the hill and into the shallow draw like a crest of water flowing down an angry river. The wave flowed a-round trees and rocks, into the draw and up the other side with no change in speed.

Two cowboys rode parallel to "Big Red", keeping him pointed in the right direction, other cowboys rode at evenly spaced intervals along each side of the herd, and three cowboys brought up the rear, urging the stragglers onward.

As the herd approached, the sounds of the drive could be heard -- a steady bawling of cows separated from their calves, cowboys shouting and whistling, horses whinnying, and the ever present 'clackety-clack' of horns against horns. Dust rose from the midst of all this movement, shrouding the cows and cowboys in a veil of fine dirt which left the allusion that the sight was being viewed through frosted glass.

Slim rode down to meet the lead trail-hands, approaching the herd slowly, cautious not to frighten them and cause a stampede. Jim and the others fanned out and joined the herd as it passed. By mid-afternoon they had reached the river bottom and turned the herd south into the mouth of the funnel formed by the wing fences. Big Red moved through the gate into the holding pen with no sign of excitement, as if this was just an every day occasion. He moved to the backside of the corral before stopping, raised his head high and watched contentedly as *his* herd slowly filled the huge corral.

"Well, Colonel," Ned said, "there's another thousand head penned and ready for the Ceebara mark."

With more hands to work, the marking and branding of this herd was quickly completed. Slim's boys put three teams of headers and healers in the pen, and as fast as the branding crews finished with one cow, another was stretched out and awaiting the hot irons. Jim and Ned were kept busy making certain that no cow was carrying someone else's brand. It was necessary for Belle and Kate to assist Maria with the cooking for the thirty-three new cowboys which had swelled their ranks. Ramon and Sonny worked continually keeping branding and cooking fires hot.

Three days later, the work was complete and the thousand head were moved north to join the other Ceebara stock. Ramon built some sturdy side racks on a wagon and Big Red was loaded up and hauled behind the mules back to the Colorado River, twenty five miles farther north of the original drive, where he once again became the point of the next drive, leading the stray mavericks to the Brazos River bottom.

By February, the last roundup had been made and Ceebara's cattle numbers had swelled to over five thousand head. The McArdle ranch was overflowing with fresh-branded longhorns and some had to be pushed farther upriver in the free-range country. They were safe from marauding bands of Indians until the weather warmed in the spring.

Payday was a big day for Waco. The cattle averaged just a little over two dollars a head and Slim and his thirty-two cowhands split the take equally, with each sharing in nearly three hundred dollars apiece; more money than any of them had ever seen at one time.

After payment had been made and most of the cowboys had headed noisily for the Longhorn Saloon and Restaurant, Jim called

Slim aside and told him he would like to talk to him in his office. They were joined by Ned as they left the bank and entered the Ceebara office next door.

"Slim, I want you to know how much we appreciate the good job you and the boys did for us," Jim said.

"Thanks, Colonel," Slim answered. "We appreciate your fairness. Me and the boys were hard up for work and you've been more than fair on your end of the bargain. I think I can speak for the boys when I say that any time you need our help, just holler and we'll come a runnin'."

"That's what I want to talk to you about, Slim," Jim answered. "Me and Ned are going to need some help trailing that herd up to the plains and would shore appreciate it if you would hire on as trail boss and put together a crew."

"Count it done, Colonel," Slim said as he reached out his weathered hand to seal the bargain.

17

During March, Ramon was kept busy breaking the wild ponies to harness and outfitting the chuck and supply wagons. Slim took on the job as trail boss and hired fifteen of the best cowboys who had helped bring in the strays and mavericks. They moved their horses and bedrolls to the McArdle ranch and spent their time herding the five thousand head of longhorns along the Brazos River bottom, making certain they did not roam too far upriver nor out of the valley.

Maria, besides keeping house for Jim and Ned as well as her own household, was given the responsibility of putting together the essentials needed on the trail drive and the bare necessities for setting up housekeeping in the yet-to-be built ranch house on the *Llano Estacado*.

Jim, with the assistance of a local carpenter, drew up a sketch for the ranch house which would take shape from the existing cliff side lean-to at the cottonwood springs location. He then purchased the materials and tools which would be needed to start the house once they reached the Red Deer Creek headquarters. It would be nothing fancy, but would offer protection from the heat of summer and the cold of winter. Nails, hammers, saws, axes, shovels and a hundred other small items were added to his list of necessities, since there would be no place to purchase them on the plains. Building

materials would come from the native rock, cottonwoods, hackberrys, grass and adobe. The list became so long that another wagon was added just to carry the excess.

Ned's bay mare was getting heavy with foal and he realized that he would need to replace her for the drive. Early one frosty morning, while everyone else was still asleep, he removed his lariat from his saddle and climbed into the horse corral. The buckskin mustang eyed him from the corner of the pen, and pawed the ground as Ned approached.

The lariat snaked out of Ned's hand and settled neatly around the mustang's neck, and he quickly looped it around the snubbing post and pulled the stallion's head up tight against the post. He rubbed the horse gently between the ears, along the neck and across the back, speaking softly and soothingly while he slipped a strong rope halter over the stallion's nose and around his ears then pulled his bandana from around his neck and tied it across the horse's eyes, blindfolding him. After a few minutes, the line-backed stallion became almost calm and Ned placed his saddle gently on its back, pulled the cinch tight and swung his six foot frame into the seat.

The buckskin trembled at the unexpected feel of the cowboy's weight, but remained still, with his feet slightly extended to each side. Ned leaned forward and jerked the slipknot loose on the snubbing post and with his other hand pulled the neckerchief from around the horses eyes. The buckskin rolled his eyes, turned his head and looked at the cowboy who was now seated on his back -- then all hell broke loose!

Ned was prepared for the worse but didn't realize that the worse was going to be so bad. The buckskin lowered his head between his front legs, bowed his back, and kicked his hind feet about twelve feet into the sky. He turned, he rolled, he jumped -- and about four jumps later Ned was looking down at the six foot high corral fence as he arched upward with nothing under him except his hat which had been lost on the third jump.

He hit the ground in a crumpled heap, and rolled in a cloud of dust to the pen's edge. The stallion stood looking at him from the corner, trembling and sweating from the brief ordeal.

Ned picked himself up, looked in all directions to see if anyone had seen his embarrassing moment, picked up his hat and used it to beat the dust off his buckskins and shirt, placed it squarely on his head, pulled it down over his ears, and once again approached the

stallion lariat in hand.

Three times he mounted the mustang and three times he picked himself up off the ground. The fourth time the bronc had only about three bucks left in him and began running around the corral. Ned continued to spur him until both horse and rider were too exhausted to move. He slackened the halter rope, and the horse dropped his head in defeat, with sides heaving and sweat dropping in puddles around his feet.

Ned dismounted and once again rubbed the horse's ears and neck and spoke softly to him. "That's one for both of us, Washita," he said. "You're the first bronc I ever rode and I'm the first cowboy you ever throwed." The horse seemed to understand and rubbed the side of his head against Ned's chest as if to say, "O.K., let's call a truce."

Unknown to Ned, Kate witnessed the whole affair from her bedroom window, and her heart beat with pride at his courage, even if his success was accomplished with a lack of finesse.

The first day of April, departure date, was quickly approaching. Everyone was working frantically to make certain that nothing was left undone. Jim was up early, going over the many lists on his desk, with only two weeks left to finalize their preparation, he couldn't afford to forget anything.

Hearing a movement at the door, he looked up from his work to see Belle, standing as she was the first day he had met her, with her hat pulled low over her eyes, buckskin skirt and boots, six shooter strapped to her waist, and her Winchester resting easily in the crook of her arm. She was looking intently at him with the traces of a smile beginning to show at the corners of her mouth.

"Jim Cole," she said, "I've been waiting all winter for you to make a move, and all you can do is pour over them lists and records and worry and fret about getting them five thousand head of mangy horns and hides up to that *Llano Estacado*. Well, I've decided if'n you ain't going to make a move, then I am. I'm telling you right now, I'm going with you and you can either take me dishonest or you can make me honest by marryin' me."

Jim's face turned as red as Belle's hair, he coughed and felt sweat pop out on his brow. He jumped up from his chair and stood clumsily looking at this lovely lady, not believing what he had heard her say. Slowly it dawned upon him that he had not been imagining things, Belle was standing in the doorway and she had just pro-

posed to him. He took two quick steps to the door and swung his one good arm around her waist and pulled her tightly, although roughly, against him. His lips found hers as she tilted her head back. The Winchester made a loud crash as it fell to the floor when she dropped it to wrap both arms around the back of Jim's neck. They stood pressing against each other with lips locked, oblivious to the crowd of passersby who stopped to watch this show of affection displayed by these two friends -turned-lovers.

When they could get their breath, still holding tightly to her waist, Jim said, "I've wanted to ask you ever since the first day I met you, Belle, but I just couldn't bring myself to ask you to weather the hardships and danger that's going to come with making Ceebara a cow ranch. I would never forgive myself if I asked you to go with me, and something happened to harm you."

"You ain't asking, Colonel," she smiled, "You're accepting! Me and the kids have weathered a lot of hardships and dangers before, life would be pretty dull without them. So if'n your willing, I'm willing. And I'll do my very best to make you a good wife and a good home, wherever its at."

The crowd which had been witness to this proposal cheered, and crowded into the office to congratulate them and wish them well.

The whole town turned out for the wedding, which was held three days later. Mr. Thompson arranged for a big barbecue and street dance to climax the affair, and everyone was still celebrating when the newlyweds slipped out of town in Bell's buckboard and headed for the deserted ranch.

They felt like kids on their first date as they rode the moonlit path to the river bottom ranch, a little tipsy from drinking toasts with their friends. Jim pulled the buckboard up to the ranch house hitching rail, jumped down and took Belle in his good arm, kicked the door open and carried her into the bedroom. The moonlight shined brightly through the window, casting a dull, yellow glow a-round the room.

Belle was kissing him gently on his cheeks, his forehead, his neck and his lips as he held her with her arms locked around his neck. He released her and her feet touched the floor. Clumsily, his hand rose to the buttons on the back of her gingham dress, and as they stood with bodies pressing against each other, he slowly unbuttoned each button, then pulled the loosened gingham from her shoulders, allowing it to fall to the floor. With only slight help from Jim, the

petticoat fell on top of the dress. Belle stepped from the crumpled heap and stood in pale moonlight with all her beauty displayed before this toughened frontiersman. He reached out slowly and gently touched her naked shoulder, feeling the shiver which shook her body as she savored the pleasure of his tenderness. Jim guided her to the bed and they once again found each other's lips as they slowly fell into its folds.

18

After the wedding, Slim and his crew began bunching the long-horns in an area along the northern line of the McArdle ranch in preparation for the drive north. Sonny, who Jim had given the job of horse wrangler, called on Manuel, Maria's son, to help him get the remuda moved from the corrals to the north pasture. Shep was in-valuable to the two boys as he kept the horses in a tight bunch by nipping at any stragglers' heels.

Jim purchased another large wagon and loaded it with his new bride's possessions. Everything was packed and ready by the evening of the thirty-first day of March, and the wagons had been moved to the north line of the McArdle ranch where the cattle were being held in a tight bunch along the banks of the Brazos River. Everyone was anxious for tomorrow, the day that would be the beginning of a new life and a new adventure for these twenty-six hardy souls.

Daylight came on the first of April enshrouded in a dense low hanging fog. The Brazos River bottom was one of unbelievable beauty as breakfast was cooked by Maria and Belle and served by Kate and Maria's pretty sixteen year-old daughter, Juanita. The younger cowboys were ill-at-ease around the two pretty girls who filled their plates and poured their coffee, casting furtive glances at them when they thought no one was looking.

"I'll bet my hat that this is the first cattle drive in history with the prettiest cooks this side of St. Looie," Bo said to Laredo as they looked at the girls over their plates of beans and bacon.

The green grass of spring was pushing through the tall dead grass from the previous year, and the shapes of the five-thousand head of longhorns were silhouetted to the south of the campground with their heads down, grazing lazily on the young tender grass, their forms fading into the dense fog.

"O.K., let's move 'em out, boys," Slim yelled as the lead wagon began rolling northward, followed by the other wagons, the horse remuda and Big Red taking the point of the herd.

As they followed the dim trail out of the floor of the valley, the herd disappeared into the low hanging fog as they began rising into the rolling hills above the river. Ned, who was several hundred yards out front, was the first to break out into bright sunlight. As he looked back, he was stricken with awe as the wagons, one by one began to materialize out of the depths of the fog, followed by the horses, the longhorns and the trail riders. Moisture from the fog clung to the curved horns and glistened in the bright morning sunlight while the many hued colors of the hides of the large animals contrasted sharply with the blue sky above, the green grass below and the bright white covers of the wagons.

He was also amazed at the sounds which accompanied the huge caravan which trailed behind him. The creaking and squeaking of the wagons, the steel rims of the wheels clanging as they rolled over the rocks, the rattle of pots and pans, the whinnying of the horses, the bawling of the cattle, the barking of Sonny's dog and the ever present "clackity-clack" of horns against horns as the cattle crowded against one another.

Now that they were out of the damp river bottom, a fine cloud of dust began to rise around the herd as it moved slowly north and west, and would accompany them for the next eight weeks.

On this first day of the drive, good fortune was with them, with no major problems with the wagons or equipment. However, the cowboys were kept busy keeping the cattle bunched and moving in the proper direction. The job would have been even more difficult had it not been for Big Red breaking trail, head down as if sniffing the tracks left by Slim's horse which was fifty yards ahead, and Shep's uncanny ability to nip the heels of the strays and head them back into the herd.

The trail roughly paralleled the course of the Brazos River and camp was made in early afternoon on a small clear creek only five miles from the river and fifteen miles from their starting point.

There was an abundance of grass and water and by nightfall the cattle were full of both, content to rest and chew their cud after the hard day's drive. Big Red, as if he realized that he was something special, kept to himself thirty or forty yards away from the main body of the herd, watching and listening.

Sonny and Manuel grazed their remuda a short distance upstream from the cow herd, and erected a large rope corral between trees next to the waters edge, which would hold the horses after nightfall.

The freight wagons and chuck wagon had gone ahead of the herd and a comfortable camp had been made before the cattle had arrived in the small lush valley. The ladies were cooking over a large campfire and the smell of hot coffee and roasting meat filled the evening air as the cowboys rode into camp, one or two at a time, dismounted and waited anxiously for their share of the steak, beans and hardtack. They ate ravenously of the superbly cooked meal and gorged themselves on the sugar-sweet cinnamon rolls which Maria had brought along for this first night's meal on the trail. If there had been any doubt as to Jim's choice of a camp cook, it was dispelled by this night's meal.

Talk around the fire after the meal was a rehash of the days events -- the herd of deer which was jumped, wild turkeys which spooked some of the longhorns on the right wing of the herd, almost resulting in a stampede, poking fun at Boots who failed to see a low hanging branch while chasing a cow back into the herd and was knocked from his horse leaving a sizable bump on the top of his head.

No one had seen any Indian sign although they had all been watching closely. Jim cautioned them that the farther north they traveled the greater the danger and to always keep a sharp eye out. "I don't want anyone firing on an Indian unless the Indian shoots first. We're going to have enough problems on this drive without creating an Indian war," he instructed.

As darkness settled over the cow herd, the stars filled the night sky with sparkling diamonds. Pointing to one of the brightest, Jim spoke to Ramon. "That's the North Star, Ramon, and it will be our guidepost. I want you to to take a bearing on it each night and point the tongue of the chuck wagon directly towards it, so we'll always know our direction in the mornings, no matter what the weather might be."

Slim posted his nighthawks, with three riders continually circling the herd throughout the night. Each team of three would ride for three hours and then be relieved by the next team. The fire was allowed to fade into embers as each tired trail-driver curled up in his bedroll and dropped off into an exhausted sleep.

The sounds of the night riders, softly singing, could be heard mingling with the other night sounds -- a cow bawling after her lost calf, crickets chirping, whippoorwill calling, and coyotes yelping as they patiently patrolled the outside rim of the herd.

Waddy's clear, baritone voice carried above the other sounds as he rode along the rim of the herd and softly sang,

"While I was out riding one morning for pleasure, I spied a young cowboy a'riding along; his hat was throwed back and his spurs was a'jingling, and as he approached me he was singing this song.

"Whoppie-tie-yi-yo, git along little doggie, it's your misfortune and none of my own. Whoppie-tie-yi-yo, git along little doggie, for you know that West Texas will be your new home."

His voice faded as he rode on down the line of restless longhorns, but it was soon replaced by Bo's high tenor voice as he approached the camp from the other end of the herd.

"With my ten dollar hoss and forty dollar saddle, I'm going to punching Texas cattle, Come a tie-yi-yippee-yippee-yea, yippee-yea, Come a tie-yi-yippee-yippee-yea.

"It's beans and bacon most every day, I'd as soon be a'eating prairie hay, come a tie-yi-yippie-yippie-yea, yippie-yea, come a tie-yi-yippie, yippee-yea."

As Bo's voice faded in the distance, Curley could be heard approaching the camp from the opposite direction. "Oh, give me a home where the buffalo roam, and the deer and the antelope play. Where seldom is heard a discouraging word and the skies are not cloudy all day.

"Home, home on the range, where the deer and the antelope play, where seldom is heard, a discouraging word and the skies are not cloudy all day."

As his voice trailed off in the distance, his words came drifting back softly, "How often at night, when the heavens are bright with the light of the glittering stars, have I stood there amazed and asked as I gazed, if their glory exceeds that of ours."

The purpose of the singing was not to just break the monotony

of the job but to also calm the cattle and keep them from spooking to other night sounds.

Each day the drive became easier. The cattle became accustomed to the slow but steady movement north and west and ceased their straying away from the main herd. The cowboys changed positions on the herd each day, from swing, to flank to drag. Drag was the worst position to ride, because the riders were continually riding in the fine dust which was kicked up by twenty thousand hooves grinding the grass into the sand as the five thousand cattle walked along.

Ned, referring to his crude map which he had drawn on the trip down, rode ahead of Slim, marking the trail for the wagons and the herd. Jim seemed to be everywhere during the day, riding at Ned's side or eating dirt with the drag riders in the rear.

The days passed slowly and monotonously, and it soon appeared that the cowboys should be more concerned with the weather than with the prospect of Indians. Large thunderheads could be seen building in the west, and each day they built a little closer. Lightning and thunder could be seen and heard in the distance.

The cattle sensed that a change in weather was in store, as they became more nervous and discontent. On the evening of the eighth day, the path of the storm clouds crossed the path of the Ceebara herd. As darkness closed in, the wind from the oncoming storm began to lash the hurriedly made camp. Jim declared an emergency and ordered all men to mount up and ride to the perimeter of the herd, trying to hold the cattle together. Over his protests, Belle and Kate joined the cowboys, riding their two roan mares.

Their efforts were to no avail as the clouds started pouring a deluge of cold rain and hail amidst the roaring of thunder and the sharp crackling of lightning. Balls of static electricity began to cast an eerie light on the huge horns of the cattle, bouncing from one horn to the next as the cattle began to mill about nervously. The cattle in the rear began pushing and shoving the cattle to the front, and soon the herd was moving, first in a walk, then a trot - and finally frightened by a tremendous bolt of lightning which split the trunk of a large oak tree, they began to stampede out of control!

The cowboys in the front moved to the side and the herd rushed past, making ghostly images as the night was lighted by the quick flashes of lightning, and the horns glowed as if they had been coated with phosphorous. The dust had turned to mud, and in the

darkness, cows slipped and fell and were trampled by the thousands coming from behind. The cowboys knew there was nothing they could do to stop the mad stampede, and tried only to keep out of their way and keep them all moving in the same direction hoping that after a few miles of running, they would become winded and stop on their own.

The storm raged for four hours, and for four hours the cowboys rode wildly through the night, shouting and circling the herd. Once the storm had passed, each cowboy remained with that portion of the herd which he could see, and allowed the cows to remain where they stopped until morning.

There was no way to analyze the damage until daylight, nor to determine if any of the crew had been hurt. At first light of dawn, Jim began moving up and down the crooked trail left by the stampeding herd. Dead cattle, covered with mud and blood, were scattered along the route of the stampede. Coyotes had already appeared and were devouring the meat of the fallen longhorns. One by one, he came across his cowhands -- Boots with 300 head resting in a shallow draw; Bo and Laredo with over a thousand head grazing on an open hillside; Slim and Hondo with another thousand bunched in a clump of liveoaks. By mid-morning, every one was accounted for except Belle and Kate.

Ned joined Jim in the search, but with no luck. They became frantic, as they rode the high ridges and the low valleys calling and searching to no avail -- nothing!

Finally, as Ned rounded a low hill, he spotted Kate's roan horse grazing in an open area and heard Kate calling his name. He spurred the buckskin towards the direction of the sound, and was appalled to see several of the huge longhorns piled dead in a small depression, the tail and buttocks of Belle's dead roan mare extended from beneath the pile.

He fired his colt three times in the air as he reigned his horse and dismounted on the run. Stumbling over the dead cattle, to his amazement he saw Kate and Belle, huddled beneath the outstretched legs of a huge dead bull. Bell's bleeding head lay in Kate's lap and a muddy Winchester was leaning against the dead bull's shoulder. Mud plastered the two women from head to foot, making it impossible to tell if they were alive or dead. Ned fell to his knees and threw one arm around Kate's shoulder as he took Belle's wrist to feel for a pulse.

He was relieved that her pulse felt normal, then looking into Belle's dirty face, he could see that her eyes were open and traces of a weak smile was showing through the mud and blood. Tears had washed the mud away in tiny rivulets down Kate's cheeks, and she was now sobbing uncontrollably as Ned wrapped his strong arms around her shoulders.

Jim, hearing the shots, had spurred the big black stallion in a wild run towards the sound. Sliding to a stop, he hit the ground running, slipping and falling as he reached the huddled trio. Because of the mud, there was no way to tell how badly Belle was injured, but in response to Jim's questions, she was able to tell them that the gash on her forehead seemed to be the only damage.

Maria, who had also heard the shots, appeared over the crest of the ridge in the supply wagon. She reigned up beside the pile of dead cattle and the four muddy people. Ned lifted Belle out of the mud and placed her in the rear of the wagon on a bed of saddle blankets, while Maria filled a bucket with water from the barrel lashed to the wagon's side and began washing the mud and blood from Belle's face.

They were all relieved to see that the cut was only superficial, although a large bruised area was beginning to form around the swollen area of the cut. As Maria continued to wash the mud from Belle's face, neck, arms and hands, Kate related what had happened during the night.

She and her mother had been caught in front of the herd when they spooked, she said, and no matter which way they turned, it seemed the cattle would follow. It seemed they ran for miles and as they had topped the ridge, Belle's mare stumbled in the shallow depression and fell, knocking her unconscious in the fall. Kate, seeing her mother's danger, jumped from her horse as she pulled her rifle from the saddle boot and quickly shot the injured mare and pulled her mother behind the horse's corpse.

As the herd arrived, she started shooting the lead animals which fell virtually on top of them. She continued firing into the oncoming mass until the pile of dead cattle was so high that the herd was forced to split, rushing past them on either side. Belle had remained unconscious throughout most of the night and Kate had remained in the mud, cradling her mother's head in her lap until Ned had found them.

The Colonel placed his arm around his step-daughter's shoulder

and squeezed hard, "You did well, Kate, and I'm proud of you," he said as tears of relief rolled down his weathered cheeks.

19

Fifty-six head of longhorns were killed in the stampede, including the ten head shot by Kate. The cattle were scattered over a five mile area and required two days to regroup but luckily, no wagons were damaged and Sonny and Manuel were able to contain the horse remuda during the night. On the third day after the stampede, the drive resumed.

Ned could now see the Double Mountains looming in the distance and felt a sense of pride in the fact that he was right on course. Remembering the Indian attack on the back side of the mountains, he became more alert for trouble, riding to the highest points of the terrain in order to see greater distances.

The grass became shorter, and water more scarce. The dust cloud of the moving herd rose higher in the heat of the day and could be seen for several miles. This added to the chances that roving bands of Indians might become inquisitive and be drawn to the herd like a moth is drawn to a flame.

The herd, now moving westerly, passed to the south of the Double Mountains and then turned northward, passing between the two peaks and the caprock which loomed on the horizon. Ned, who had ridden half way up the slope of the nearest peak, spotted a small whiff of smoke several miles to the west. He was convinced it was a band of Indians and rode down to the herd and reported his sighting to the Colonel.

"We'll just keep moving north," Jim said, "and put more riders

on the west side of the herd. We better swing the wagons around to the east side for better protection in case of an attack. We can regroup the cattle easier than we can replace the wagons and supplies."

Riding up to Slim, who was on point in front of Big Red, Jim instructed that word of the sighting be sent to the rear and for every one to make certain that rifles and six-guns were loaded. In case of an attack, the fifteen trail riders were ordered to take positions between the Indians and the wagons, and the wagons, even though few in number, were to circle.

The day passed without incident and camp was made on the banks of a wide, shallow river, with only a trickle of water meandering along its sandy bottom. There were, however, enough pools for the cattle to get their fill.

Jim and Ned rode to the top of a nearby low-lying hill after dark and spotted the campfire of what they presumed to be Indians, no more than two miles upriver. "We best scout them out, boy, and see how many we're up against. No sense in us getting too excited if it's just a small hunting party," Jim said. Ned could tell the Colonel was worried, because he always called him "boy" when he was in deep thought.

They headed their horses in the direction of the campfire, and after riding for nearly two miles, stopped, tied the two stallions to a mesquite bush in a small arroyo, removed their spurs and continued their journey on foot.

Crawling on their bellies, they carefully looked over the top of a ridge in the direction of the light from a huge campfire. There along the banks of the riverbed was a half dozen rickety wagons, many horses and fifteen or twenty oddly dressed men. Huddled at the edge of the wagons and away from the campfire were several women. The light from the campfire disclosed that the women were mostly brown skinned and black haired, although three of them appeared to be white. Several more women were standing around the huddled group, as if guarding them.

The men, also, were of mixed origin, some appearing to be Indian, some Mexican, some white and one huge black man. They were all talking and laughing loudly, and Ned could see that each was holding a whiskey bottle, getting very drunk from the contents.

"Comancheros," the Colonel whispered. "Looks like they been down south raiding and stealing and are heading to the plains to

trade their plunder and women to the Indians. They know we are camped down river and I'll bet my hat they will pay us a visit tomorrow."

As they watched, the one who appeared to be the leader of the band, a half-breed who was dressed in buckskin leggings, fringed jacket, and a wide beaded headband securing his long black hair, walked over to the huddled women and grabbed a long-haired Mexican girl by the wrist and dragged her nearer the fire.

Holding the whiskey in one hand and the girl's waist in the other, he kissed her roughly on the mouth. The other men yelled their approval. When the girl twisted and tried to pull free, he dropped the whiskey bottle and grabbed the girl's frayed blouse and pulled it from her shoulders. She tried to cover her nakedness with her hands, but to no avail. The half-breed twisted one arm behind her back and tore her skirt from her waist. The girl screamed in pain and stopped struggling.

Lifting her from her feet, the drunk Comanchero carried the naked girl to the edge of the shadows and dropped her onto his blanket. This seemed to be a signal to the other filthy men of the group, and they each grabbed a woman and pulled her into the shadows surrounding the fire. The screams of the women and laughter and curses of the men could be heard echoing down the river bottom as Jim and Ned slipped quietly away and headed back to their own camp. To have tried to do more would only have endangered themselves, their crew and the herd.

"If they come tomorrow, we'll be ready," Jim said as they rode back to their camp.

The next day, as Jim had prophesied, twelve of the Comancheros, bristling with guns and bandoleros draped across their chests, approached the Ceebara herd. They stopped approximately two hundred yards from the camp and the half-breed Indian rode forward, holding his hand up in the sign of friendship with a wide, toothy grin showing under his scraggly beard. The Colonel rode out to meet him.

"*Buenos Dias, Amigo*," the half-breed said. "I am Huereto, and these are my *compadres*. You are lost and far from home in a dangerous land. Perhaps you need our protection, no?"

"No," replied Jim, who had stopped ten paces in front of the half-breed. "We are not lost, and we are very capable of taking care of ourselves. We do not wish for trouble, but if trouble comes, we

are prepared," he said as he stared coldly into the eyes of the bandit.

A nervous twitch appeared in the corner of Huereto's mouth as he looked past this one-armed cowboy for signs of hidden strength. He found it in the dark, round muzzles of several rifles protruding below the wagon sheets aimed at his heart!

"We want no trouble, *senor*," he said. "For ten horses and twenty cattle, we will leave you in peace."

"We have no horses or cattle for the likes of you bastards," Cole said firmly." He pointed to the ridge to the left, where a longhorn had strayed from the herd, nearly half a mile away. "You see that spotted bull? If I ever see you or any of your men any closer to this herd than that bull, this is what will happen."

He lowered his arm, a sharp crack reverberated from the hillside behind the wagons, and the bull fell dead in his tracks. The half-breed turned pale with astonishment as Jim, quick as a flash, drew his revolver and pointed it at the half-breed's belly.

"My men can all shoot just as straight. Your greed will gain you only holes in your bellies. So *vamanos*! And keep your distance from my herd!", he said as he turned and rode slowly back to the wagons.

The half-breed, convinced that a few horses and cattle were not worth losing his life, turned his horse and led the band of Comancheros in a wild run back towards their camp upriver.

Ned appeared from behind a mesquite bush, high above the level of the riverbed, carrying one of the long barreled Sharp's fifty caliber buffalo guns, smiling at his accuracy. The Colonel certainly knew what he was doing when he stationed him up there before daylight, with instructions to shoot the stray 'horn when he lowered his arm, Ned mused.

As the herd moved out, Jim joined Ned who had ridden several hundred yards out front. "They'll be back, boy," he said, "but on their terms, not ours. Keep a sharp eye out for anything that looks suspicious. I'd sooner meet up with a bunch of Quanah's braves on the warpath than them thieving, dry-gulching murderers. There ain't no one out here to look after you except your own eyeballs, and I ain't hankering to run Ceebara all by myself. You take care, boy, and if you see anything unusual, come high-tailing it back to the herd, you hear?"

"Yes sir," Ned said as Jim turned and loped slowly back to the

herd.

The trail was relatively easy as Ned picked his way slowly northward. He recognized the numerous landmarks which he had made on his rough map on the trip south. As he topped a ridge which rose above a deep arroyo, the buckskin stallion stopped dead in his tracks, his ears shot forward, and he snorted as his eyes searched the area towards the arroyo. Ned's hand dropped to the butt of his revolver as he looked in the direction indicated by the excited horse. A slight glint of steel reflecting the sun's rays flashed momentarily behind a low lying mesquite bush.

Ned's colt broke leather instantly and his finger squeezed off a shot only seconds before he saw a flash of fire and heard the accompanying sound of a shot coming from behind the mesquite. He heard a scream and saw the form of a man rise and fall backwards as his own hat was jerked from his head when the bullet from his assailants gun tore through its crown. He wheeled the buckskin and disappeared quickly below the crest of the ridge as he heard other shots being fired.

Slim and the Colonel, hearing the shots, rushed forward and joined Ned as he pointed out the positions of the hidden bushwhackers. As Ned dismounted and crawled to the top of the ridge, Slim rode around the east side of the hill and Jim rode around the west side. Ned fired a couple of shots in the direction of the hidden gunmen to gain their attention as Slim and the Colonel circled around behind them.

Five horses could be seen tethered in the bottom of the arroyo and the body of a dead Comanchero lay sprawled on the sandy floor of the dry creek bed, witness to the accuracy of Ned's shot. The others were untieing their horses and attempting to mount when Jim and his trail boss appeared from either side, riding hard as if in a cavalry charge, firing as they rode.

Two of the renegades fell at their horses feet, while the other two were able to mount their horses and disappear around a sharp bend in the arroyo. When Ned and Slim spurred their horses in the direction of the disappearing Comancheros, Jim stopped them.

"Let them go, boys," he said, "They'll carry the message back to that half-breed that this herd ain't no easy pickin' and I don't think we'll see hide nor hair of them again."

The Comancheros apparently were convinced that Colonel Cole meant business, leaving their dead to the buzzards as they

headed their small band of wagons away from the line of travel of the herd. As Ned slowly led the herd northward, he watched as a small dust cloud indicated the retreat of the renegades towards safety of the caprock.

The last days of April came and passed, as the trail herd moved closer and closer to its final destination with only minor problems -- a busted wheel on Belle's wagon, the chuck wagon overturned and spilled its contents while crossing a dry arroyo, one of the horse remuda stepped in a gopher hole resulting in a broken leg and had to be shot, and a few arguments were settled by roughhouse brawls in the dust of the herd when tempers became shorter as the trail grew longer.

The spring weather once again turned nasty, and most of the dry stream beds came to life as rushing water cascaded down the canyons along the caprock. The herd had become accustomed to the drive, and were not nearly as easy to spook as on the night of the big stampede, however, the rains caused more than a few problems.

The worst came when the herd reached the banks of the Prairie Dog Town Fork of the Red River. The river was running bank to bank, although not over four feet deep at any point. After waiting for two days for the water to recede, Jim decided to go ahead and cross since storm clouds continued to rear their ugly heads on the horizon to the west.

Slim and Ned rode their horses up and down the raging belly-deep waters until they found the shallowest spot with the most firm bottom, then motioned for those waiting on the bank of the river to follow them across.

Three cowboys tied their lariats to each wagon bed and rode upstream from the wagons as they crossed, holding the ropes tight to prevent the wagons from overturning or floating downstream. One of the team pulling the supply wagon fell in the swift waters, and was almost swept away before regaining its footing. After two hours of hard work, the five wagons, drenched but safe, reached the other side.

Next, the horse remuda was pushed into the waters, and crossed easily with Sonny in front and Manuel bringing up the rear.

Big Red, following the remuda, waded into the waters without looking back and the remainder of the herd followed faithfully. The river, nearly four hundred yards across, was a solid mass of

horns and hides bobbing in an uneven line to the opposite side. When about half of them had crossed, Bo's horse, one of the more nervous mustangs, reared when the sharp tip of one of the horns grazed his flank, and Bo was thrown into the water. Before Hondo, who was close by, could help him, the swift waters had pulled him into the teeming mass of swimming cattle.

His body was found four hours later nearly a mile downstream from the crossing.

It was a sad day as the cowboys dug a shallow grave along the banks of the river and buried the young cowboy in the tracks of the herd which he had learned to love. As they all stood around the grave, hats in hand, mourning the loss of a friend, Colonel Cole said, "We can all be proud for having known Bo these past few months. He was a quiet and proud man who valued friendship more than anything else in the world. He did his job well, and asked no man to carry his load. I expect Saint Peter is going to find it easy to please Bo. All he will ask is that they furnish him a good horse and saddle and a mangy herd of longhorns to drive across the valleys and prairies of the sky."

When he had finished, Hondo pulled out his harmonica and began blowing a sad dirge which Waddy, in his sweet tenor voice, put to words.

"Oh bury me not on the lone prairie. These words came low and mournfully, from the pallid lips of a youth who lay, on his dying bed at the close of day.

"He had wailed in pain till o'er his brow, death's shadows fast were gathering now; he thought of his home and his loved ones nigh, as the cowboys gathered to see him die.

"Oh, bury me not on the lone prairie, where the coyotes howl and the wind blows free. In a narrow grave just six by three, oh bury me not on the lone prairie.

"I've always wished to be laid when I died, in the little churchyard on the green hillside. By my father's grave, there let mine be, and bury me not on the lone prairie.

As Waddy sadly sang, each of the cowboys walked by the grave and threw a few shovels of dirt on the body of their dead friend.

Waddy continued to sing as the others mounted up and rode silently away.

"Oh bury me not on the lone prairie, in a narrow grave just six by three. Where the buzzard waits and the wind blows free; then

bury me not on the lone prairie.

"Oh we buried him there on the lone prairie, where the wild rose blooms and the wind blows free; oh his pale young face nevermore to see; for we buried him there on the lone prairie."

The herd moved slowly north, and Ned was seeing more and more fresh Indian sign. Two days after the death of Bo, he spotted a large cloud of dust on the horizon, and determined that what ever was making the dust was moving in the direction of the herd. He kicked the buckskin into a run back to the herd and reported his sighting to the Colonel.

Jim ordered the trail hands to bunch the herd along the east side of a rather narrow but deep arroyo and pulled the wagons into a tight circle. They waited anxiously for the arrival of the approaching dust cloud.

The crest of the ridge to their west, almost as if by magic, became lined with the feathered forms of several dozen Indians, setting proudly on their painted war ponies. Jim instructed Laredo and Ned to cut out ten of the nearest 'horns and the three of them drove the cattle across the arroyo and towards the line of Indians, then he rode out front and stopped no more than fifty yards from the painted warriors. Holding up his hand, he spoke in the dialect of the Comanche.

"We come in peace to your land of the buffalo," he said. "We offer these beeves to you as a gift for peaceful passage across your lands."

One of the Indians, with a large flowing war-bonnet of eagle feathers, raised his lance and came charging down the hill towards the three cowboys. Laredo's heart rose into his throat as his hand went instinctively to the gun strapped to his side. Ned, seeing the movement, grabbed his hand before the gun could break leather, and Laredo quickly replaced his hand to the horn of his saddle.

As the Indian pony slid to a halt in front of Jim's horse, the rider was quickly on the ground, followed by Jim and Ned as they rushed forward and clasped the hand of their blood-brother, Quanah.

Quanah had seen the missing arm and recognized the Colonel, cautioning his braves to remain calm as he rushed down the hillside. The crew across the arroyo believed they had seen the last of the three cowboys, and gazed in disbelief as the Indian chief and Jim and Ned, instead of being locked in mortal combat were shaking

hands and laughing as if they were old friends.

An early camp was made and Quanah and his braves were invited to share a freshly butchered beef, roasted by the ladies over a large campfire. After eating their fill, the trail hands and Indians sat around the campfire, Indian fashion, and shared in the smoking of strong, black cigars which Jim had brought for just such an occasion, an act which would cement the friendship between these red and white men as the first herd of longhorns trailed onto the *Llano Estacado.*

The Indians departed at dawn, carrying with them many gifts of colored beads, yards of calico, sewing needles and threads and a small mirror which Belle presented to Quanah for his woman to enjoy.

Crossing the North Fork of the Red River four days later, in water only eight inches deep, the five thousand head of longhorns followed Big Red past the cottonwood tree where Ned had carved "South Line, C bar A Ranch, 1865," nearly twelve months before.

A rebel yell echoed up and down the Red River Valley when Jim informed the crew that they were now on Ceebara land and the drive was nearly over.

The final three days were uneventful, as the huge herd moved leisurely across the low sand hills, around scattered shinery groves and into the rolling grasslands along the headwaters of the Washita. By the middle of the afternoon of the third day after setting foot on Ceebara land, the herd dropped down into the small valley of Red Deer Creek and were allowed to spread out and graze as the trail crew followed Ned and the Colonel to the headquarters site at Cottonwood Springs.

Jim broke out the whiskey and the whole crew drank a toast to their successful cattle drive and to the future of Ceebara, the first cattle ranch in Texas north of the Red River. "This is not the end," he said, looking back down on the thousands of contented longhorns grazing along the creek's banks, "but the beginning of a new era for Texas."

20

After a few day's rest, Colonel Cole instructed Slim and the cowhands to move the cattle to the *Llano Estacado,* where they would be kept for the summer. After the long drive northward, it was a simple matter to move the now gentle longhorns up the buffalo trail and through the cut in the caprock to the broad, flat expanses of the plains. They were then divided into herds of five hundred head each and driven to playa lakes which would offer sufficient water during the hot summer months. Thousands of acres of lush grass surrounded each small lake, and would serve the cattle well, adding tallow and weight to the large frames of the rangy longhorns.

The shaggy-haired buffalo continued to graze leisurely among the cattle, making a sharp contrast with their dark hides, huge humps and short curved horns. Although the buffalo bulls bellered and pawed at the intrusion of their domain by this strange-looking animal, they soon learned to respect the huge horns of the cattle. It appeared that nature would allow the two breeds to live together in peace, with the longhorns content to remain where the cowboys left them, while the buffalo were continually moving slowly northward.

Leaving the cattle in the virgin area to fend for themselves, Slim and his cowboys returned to the valley to help with the building of the headquarters. There were trees to be cut into logs, rocks to be hauled from the rim of the caprock, adobe bricks to be molded

from the clay, and sod to be cut for the roofs. Each person was given a responsibility, and the valley buzzed with the activities of turning the Cottonwood Springs area into a ranch headquarters. Jim became the architect, choosing the sites for each building and laying off the dimensions while Ramon was the "expert" for the actual building, making the decisions on cutting rocks for the foundation, logs for the frames and adobe for the bricks, and meticulously seeing that each was placed in its proper place.

Jim and Belle had little time to enjoy each other on the cattle drive, but now were able to take long rides across the sweeping plains, exploring their *Eden*, and keeping a close watch on the grazing 'horns'. On some of their excursions, they would be gone for several days, riding across the grass-covered plains by day, and sleeping under the stars at night, sharing each other's thoughts and enjoying each other's bodies, planning a future for this, the first ranch on the *Llano Estacado*. Their love grew with each passing day.

On many occasions, as they rode, the prairie would suddenly drop into a round playa lake, and they would find a small band of Indians camped along its shores, harvesting the bountiful supplies of buffalo and antelope. Word had moved through the Indian villages that the "one-armed *white-eye*" was a friend and blood brother of Chief Quanah, thus each village would welcome, and even feel honored to share their food and shelter with One Arm and his woman.

On one such trip, they traveled to the southwest, looking for the "Big Canyon" of the Red River, which the Indians seemed to hold in awe. After riding for two days, with no change in the flat terrain, they were about ready to turn back, for they could see for miles in any direction and there was no sign of a canyon. On the third day, Jim said, "We'll ride until noon, and if we haven't found it, we'll head back to the ranch." Belle nodded in agreement.

Suddenly, to their amazement, the prairie opened before them and their eyes gazed on the most beautiful sight they had ever seen. A deep canyon, which appeared to be several thousand feet deep and three or four miles across lay before them. It looked as if a huge slice of the prairie had been cut away, leaving a sharp, deep valley with a small stream winding along its floor. They could see across the chasm and the extension of the flat terrain on the other side.

The cliffs which lined the canyon walls reflected virtually every color of the rainbow, yellows of the sandstones, whites of the gyp-

sums, and reds and grays of the clays and shales. The cliffs fell into a lush green carpet of grass and mesquite trees along the floor of the valley, ending at the stream's edge where large cottonwood trees shaded its banks. Wild plum thickets were dotted along the streams edge, and far below they could see huge herds of deer nibbling on the leaves of the thickets. Scattered buffalo grazed contentedly along the valley floor and wallowed in the cool clear waters of the stream. They watched as a half dozen eagles soared on the air currents rising from the valley's floor, their white heads and tails reflecting the brightness of the morning sun.

They rode along the rim of the canyon for several hours seeking a trail to the bottom. When none could be found, they made camp. As the sun dropped slowly beyond the horizon and twilight fell, they stood together in silence and watched the canyon change colors a hundred times as darkness slowly engulfed the deep chasm, each experiencing a sense of total fulfillment from sharing this sight together.

The next day they turned their horses towards home, anxious to tell those at the ranch of their experiences and of the beautiful canyon which they had seen.

By the end of summer, the huge ranch house and its surrounding out buildings began to take shape. Nestled in the shade of the spreading cottonwood trees, it was the perfect picture of a comfortable and safe wilderness compound. Colonel Cole was ever mindful to construct each dwelling, the ranch house, the bunk house and the Garcia house, on the banks of the small stream which was formed by the spring.

The work was hard and tedious, but before the cool autumn winds began to blow, the buildings were complete, with an eight foot rock fence surrounding the compound on three sides, and the steep cliff forming the fourth. Gun ports were molded into the rock walls for protection, and a huge log gate was constructed which could be closed quickly in case of danger.

"The Comanches are our friends today, but who knows what might happen tomorrow," the Colonel said, as he admired the finished compound.

During the summer work, Kate and Ned were always at each other's side, cutting logs together, hauling rocks together, building fence together, and talking and laughing together. But Kate could not understand why Ned always treated her as a sister, never offer-

ing to show any signs of endearment, or indicating that he would like to touch her or hold her. She carried her heartaches to Maria, who had become her confidant during her mother's long absences.

"Sometimes a man cannot see because he is blind," said Maria, with her soft Spanish accent. "Perhaps Senor Ned's eyes can be opened if he thinks someone else may share your pleasures," she said with a wink and a sly smile. "The other caballeros adore you, and would welcome a small amount of your attention and I would bet that Senor Ned would discover that you are much more than a sister to him."

The cool autumn winds had begun to blow and the Colonel decided it was time to move the longhorns from the plains before the snows started falling. Kate, taking Maria's advice, began to ride with the other cowboys as the cattle were gathered and headed back to the winter pastures below the caprock. Ned, surprised, at first acted unconcerned, as if it did not matter to him. But as the days passed, Kate rode first with Waddy, then Slim and next with Hondo and as each of the cowboys glowed with pride at their good fortune, Ned became more and more irritated and jealousy began to show in his eyes.

On the third evening, as they rode into camp and dismounted next to the chuck wagon, Hondo gallantly offered his hand to Kate as she dismounted. As her boot touched the ground, she stepped into a gopher hole and lost her balance, falling into Hondo's arms. Their cheeks touched, and Hondo could not pass up the opportunity and planted a playful kiss to Kate's lips.

This was too much for Ned, who looked up from loosening his saddle girth just as Hondo planted the kiss. Growling in anger, he leaped towards the pair and jerked Hondo's arms from around Kate, smashing him in the mouth with his fist. Hondo fell to the ground, blood flowing from a cut in his lip. Ned was immediately on top of him as they wrestled under the horse's legs and against the wheel of the chuckwagon. As they stood to their feet, Hondo lowered his head and lunged at Ned, catching him in the stomach with a powerful blow. Ned's legs buckled and he crashed to the ground, gasping for breath. Hondo's fist smashed into Ned's nose when he came to his feet and the blood gushed forth as they both, once again fell to the ground, rolling, swinging and gouging. Blood from Ned's nose was mingling with blood from Hondo's cut lip, making them fight even harder.

As they pulled themselves once again off the ground, swinging ineffectively, they were confronted with a screaming red-headed woman standing between them, hands on hips and feet spread apart. "Stop it! Stop it!" Kate shouted. "You should both be ashamed of yourselves, friends fighting friends."

Ned and Hondo hung their heads, grinned embarrassedly, and began knocking the dust from their clothing while wiping the blood from their faces with their neckerchiefs. Kate stepped from between them, and they hesitantly shook hands and quietly offered apologies. Kate turned and walked away, smiling. *So Ned does care, after all!* she said to herself.

A thousand head of the herd was left in the tall grass along the Red Deer Creek, while the balance were driven south, with another thousand left in the Washita River pasture. Another thousand head were dropped off along the Sweetwater Creek and its tributaries, and the remainder were taken farther south to the North Fork of the Red River.

The grass was tall and plentiful, and would be sufficient to carry the herd through the winter with little supervision from the cowboys. However, a small crew was left with each herd, to make certain that they did not wander too far in any direction. Supplies were left with each crew, and tools with which to construct small *line-shacks* from the scattered cottonwood and hackberry trees along the creek banks. They were to return to Ceebara headquarters at the end of two weeks.

"Remember," Jim said in parting, "Every Indian is not your friend, and there is no way to tell on sight which is and which isn't. If you do come into contact with any of the tribes, treat them with respect, and if that doesn't work, use your legs instead of your guns and come hightailing it back to the compound. I don't want anyone losing his hair just for a few head of cattle.

At the end of two weeks, Pete and two of the hands who had been left in charge of the Sweetwater herd failed to show up at the ranch house. Showing concern, Jim instructed Ned to saddle their horses and load a mule with enough supplies to last at least ten days. As he and Ned rode out of the compound, Belle and Kate stood on the veranda of the ranch house and watched, nervously, not knowing what sort of trouble they might encounter.

They found the herd grazing contentedly along the banks of the Sweetwater but no cowboys. After searching downstream a short

distance, Ned soon found the remains of their campsite which showed signs of a gun battle, blood on the sand and a trail which seemed to have been made by something being dragged. All of their supplies were missing including horses and saddles. Following the trail for a couple hundred yards over the sandy hills, he found the remains of the three cowhands, their hands tied behind their backs and bullet holes in each of their foreheads!

"My God!" Jim cried, as he looked down on the remains of the cowboys, unable to believe what he was seeing. He turned his head away from the bloody scene and wiped the tears from his eyes. These were not only his cowhands, they were his friends.

"Who in hell could have done such a thing, Colonel?" Ned said angrily as he dismounted, then added another question, "Quanah's braves?"

"No, son, this is not the work of Indians. If they had been responsible these boys would not still be wearing their hair," Jim answered, "I can't believe that any white man would go to these extremes, though, just to steal a few horses and grub. Whoever did this took pleasure in seeing these boys suffer."

Ned removed a shovel from the pack mule and began digging a grave in silence for his three friends, stopping several times to shake his head in disbelief and wipe the tears from his eyes. Jim followed the trail of several horses over the next sand hill and around a shinery grove. There he discovered tracks where the horses had been tethered and two wagons had been hidden. The tracks led away from the shinery grove to the southwest.

He spurred the big black into a lope back to where Ned was covering the bodies of the cowboys in the shallow grave which he had dug.

"Comancheros," Jim said as he pulled up and dismounted. "And I'll bet my hat it was that damned Huereto that we had the run in with back at Double Mountains."

Ned looked up from his gruesome work and said with determination, "Then I say we find them and string that dry-gulching *hombre* up to the nearest cottonwood, Colonel!"

Jim nodded in agreement, removed his hat and said a few words over the grave of their friends. They both mounted their horses and turned onto the trail left by the bushwhackers, urging their mounts into a steady lope.

After a dry camp in the sand hills for the night, they left at day-

break and by noon reached the North Fork of the Red River at its intersection with a large tributary coming from the southwest. Ned dismounted at the remains of a large campfire on the river's bank, felt of the ashes and said, "They're still warm, Colonel. Must have camped here last night."

Looking up the creek towards the southwest, Jim could see the wagon tracks following the sandy shoreline. "They're heading for the Big Canyon, Ned. It should be southwest of here another two days. Probably going to trade our horses and rigging to the Indians. Slow as they're traveling we should be able to catch up to them before nightfall. We're going to have to be careful, though, they've got us outnumbered four to one."

"Yes sir," Ned replied, "but if we can get in range of this buffalo gun I'll cut those odds down a mite!"

They followed the trail for another two hours before Jim pulled up and said, "I been thinking, Ned. They're staying right along the edge of this creek and I suspect they'll be camping on it somewheres before night. Let's pull out a ways and see if we can't outflank them, get ahead of them and pick us out a place where we'll have the advantage instead of them."

"Them's my thoughts, exactly, Colonel," Ned replied. Pointing to some fresh horse manure in the trail he added, "By the looks of those horse apples in the trail they can't be more'n an hour ahead of us at the most and they're going to be thinking about making camp pretty soon."

Ned turned the buckskin to the right and climbed the steep banks of the creek, dragging the mule behind him. Jim followed on the black. They made a wide circle to the northwest then turned west and rode for an hour before turning back to the south to intersect the stream. Several groves of cottonwoods were growing along its banks as they reentered the streambed. There was no sign of the wagon tracks.

"We outflanked 'em, boy," Jim said as he searched for tracks which would indicate that they had already passed this point.

The sun was slowly settling towards the horizon in the west as they crossed the stream and climbed the rock-strewn hillside on the other side. A huge boulder offered cover on top of the small hill and gave a good view above the cottonwoods and downstream. To Ned's surprise, the Comancheros were in the process of making camp around a sharp bend in the stream no more than three

hundred yards downstream from their vantage point.

"We're in luck, Ned," Jim said as he surveyed the camp through his binoculars. "If we'd been a quarter mile farther east we'd of run smack into the middle of the bushwhacking murderers."

Looking upstream, he could see a small arroyo leading back into the hills from the streambed. Motioning to Ned, he led the way to the arroyo then up it for a half mile before stopping.

"We'll make camp here for the night so's this mule won't have the urge to give our position away with one of his wild brays," Jim explained. "Before daylight we'll walk back down and set up behind that boulder where we'll have a clean shot when they come around the bend in the creek."

Ned nodded his head in agreement without comment as he dug into the saddlebags for some dried jerky and hardtack. He wasn't concerned about the odds of eight to two, he was just anxious to get a bead with his big buffalo gun on the bushwhackers that had killed his friends. He pulled the bedrolls from behind their saddles and threw them on the ground where they would have one more dry camp before he would get his revenge. The horses remained saddled, tied to a nearby mesquite as a precaution against their plans going awry. "We might need to get out of here in a hurry," Jim explained.

As darkness settled in, they curled up in their blankets for a fitful sleep until morning.

Ned was startled as he came awake to the pressure of a hand on his shoulder, he jerked upright and had his Colt in his hand before realizing it was only the Colonel awakening him. "It's time, boy," he said, "Grab those two Sharps and strap your Winchester around your shoulder, we're going skunk hunting."

Leaving the horses and mule tied to the mesquite, they filled their pockets with extra ammunition and headed back down the arroyo, Jim leading the way carrying a Winchester. A bright full moon lit their way as they reached the creek bed and climbed once again to their vantage point behind the boulder. Now it would be watch and wait. "I hope they don't decide to spend the day before moving on," Jim whispered softly.

As daylight broke, activity could be heard at the Comanchero campsite as the men began to awaken and relieve themselves. Soon, the sound of wood being chopped for the morning cook fire and pots rattling indicated that breakfast would soon be completed. Jim

watched through his binoculars as two of the men began harnessing the horses and hitching them to the wagons.

"It's Huereto, alright," he said as he located the big half-breed fastening his gunbelt around his waist. "I don't see but four women so they must have already traded the others to the Indians for horses," Jim said as he continued to look through the binoculars, "There's only eight of them and they've got a string of about thirty horses including ours and looks like there's going to be one driver in each wagon and the others plan on leading a string of horses each. We'll wait until they get around the corner and in that open stretch of sand before we open fire. You take the two wagon drivers with your Winchester and I'll take the horseback riders, then you can help clean up what I miss. If any of them get away and get out of range of our Winchesters, use those big Sharps on 'em."

Ned nodded in agreement as he positioned himself with his rifle resting on a flat rock. "They're going to know what a bushwhacking is like when we get through with 'em, Colonel. I owe them one for that hole they put in my hat down at Double Mountains."

The sand was deep and the wagons heavily loaded as the horses struggled to pull their loads upstream. They were moving very slow when Jim whispered, "Now!" The air was filled with the sharp crack of the rifles as both men opened fire.

Ned shouted as he pulled the trigger on the first wagon driver, "This is for Pete, you bastard!" He quickly turned the rifle to the driver in the next wagon and put a hole in his chest. Moving his line of vision back to the other riders he could see that two of them were bleeding on the ground from Jim's shots and the others were still struggling to calm their horses and get their Colts out of their holsters. He levered another round into the chamber and knocked the big black man out of the saddle as Jim cut down on the one in the rear.

Six down and two to go, he thought. But the other two had dropped the lead ropes to the horses and were spurring their mounts downstream. The bend in the streambed covered their escape for a short time and he couldn't draw a bead on them. He dropped the Winchester and picked up one of the big Sharps and waited. They were nearly a quarter mile downstream when they again appeared in his sights. He squeezed the trigger slowly and watched as his target was blown from the saddle. Quickly he picked

up the other gun but the last rider was no where in sight!

"Damn," Jim shouted, "We got 'em all but Huereto, that was him on the big gray!"

But Ned had not given up. As he watched below the cottonwood grove he saw Huereto break out into the open a half mile down the creek bed, running the gray as fast as it would go. He pulled the barrel of the big gun around, lined up his sights and squeezed the trigger. Because of the distance it appeared that he had missed. He held his breath and waited as smoke curled from the end of the rifle and then almost two heartbeats later he saw the bullet hit and knock the Comanchero leader from the saddle.

"You did it, boy," Jim shouted as he jumped to his feet.

The scene below them was pandemonium. The two wagons, driverless, were being dragged by their teams in a circle across the deep sand. One overturned, spilling its load as the team tried to climb the creek bank. The thirty horses which were tied together were raring and kicking, with each trying but unable to go its own way. The four women were huddled behind the overturned wagon and the six men lay scattered about the creek bottom in their own blood. The riderless saddle horses trotted to the creek bank and began nibbling on the tall grass.

Downstream, Huereto and the other Comanchero could be seen lying in a heap as their horses trotted back to the remuda around the wagons.

Ned and Jim stood up from behind the protection of the big boulder and began reloading their guns before descending to the creek bed. They walked to each downed Comanchero to make certain they were dead then turned their attention to the women who were cowering nervously behind the wagon.

All four appeared to be young Mexican girls in their late teens or early twenties. They were dirty and disheveled with numerous cuts and bruises on their faces, necks and arms, an indication of the cruel treatment they had suffered at the hands of Huereto and his cutthroats.

Jim spoke to them in Spanish, assuring them that he and Ned meant them no harm. In response to his questions, the oldest told him that they were sisters, taken by the bandits in a raid on their father's ranchero in Chihuahua when their mother and father and two brothers had been murdered. She said that Huereto had already sold ten women to the Apaches on the Canadian river and was

headed for a rendezvous with the Cheyennes in the Big Canyon where he intended to trade her and her sisters for more horses.

The women were instructed to assist Ned in digging shallow graves in the sandy creek bed for the eight dead Comancheros, where they were dumped and covered. The overturned wagon was righted, the remuda gathered and the group headed back to the Ceebara headquarters with two of the women driving the teams and two helping trail the horse herd.

* * * * * * * *

The weather turned to *Indian Summer* during the latter days of October, with temperatures in the nineties and very little wind. They were days to enjoy, and Ned asked Kate to join him in riding to the Washita pasture to see how the construction of the line-shack was progressing.

They packed the lunch which Maria had prepared for them, saddled the buckskin and roan, swung into their saddles and rode south, crossing the Red Deer below the ranch house and disappeared over the low rolling hills which rose from the sandy creek bottom.

The Colonel and Belle watched them go. "Guess I'm going to have to have a talk with the boy," Jim said with a grin. "It 'peers to me those two ought to be thinking about getting hitched, as much as they seem to like each other."

"Nothing would make me happier," responded Belle. "But I quess they've got their whole life ahead of them; and they're certainly old enough to make their own decisions. I've got a feeling that Kate don't need any prodding, but that boy is just too timid," she laughed softly. Turning to Jim, she continued, "Maybe I need to 'splain to her how you chased me until I caught you, Colonel!"

Jim laughed!

Ned and Kate rode slowly south, laughing and talking, enjoying the weather and each other's company. They had no reason to look back to the north, otherwise they probably would have turned back to the ranch. This land of sudden weather was in for a drastic change. A bank of low-hanging, fluffy clouds was rolling in from the north, reaching from the eastern horizon to the west. With the warm autumn sun beating down on their bodies, they were unaware of the weather change until suddenly, the still, warm air was shat-

tered by a blast of cold north wind, hitting them in the back. Startled, they turned in their saddles and were amazed to see the fast moving cold front bearing down on them.

Dismounting, they quickly untied their rain slickers from behind their saddles and hurriedly put them on, remounted and turned their horses back towards the ranch house. However, it was too late, cold rain started pelting them in the face as the wind became stronger and stronger.

Ned yelled to Kate, over the howling of the wind, that they had better turn around and try to find shelter along the Washita River. Kate nodded in agreement. They rode south for more than an hour, hoping to dissect the small river bottom. The rain turned to sleet, and then to large wet snowflakes, as the temperature continued to fall and the wind blew harder and harder.

By the time they dropped into the semi-dry stream bed, the ground was covered with three inches of the wet snow, and the flakes were so thick that they could hardly see each other when the space between their horses was more than three feet. Ned remembered that this should be about the area where he and the colonel had captured the wild mustangs, and decided to ride upstream, hoping to find a bluff or small canyon which would shelter them from the fierceness of the cold wet wind.

The horses picked their way slowly upstream, hardly able to see as the snow stuck to the hair around their eyes. For another hour they rode, slowly groping their way, unable to find enough shelter to block the wind. Suddenly, the horses stopped and refused to go farther. Looking through the snow, Ned could see that something was blocking their path. He dismounted and walked in front of the horses, discovering that a thick stand of small willows along the stream's edge had stopped their progress. Listening, he heard a strange sound coming from beyond the willows, a sound which was muffled by the roaring of the wind.

Leading the buckskin, he waded through the six inches of wet snow, picking his way slowly. Kate followed close behind.

To his surprise, just beyond the small trees, Ned could see the huge, dark shapes of six buffalo, huddled next to the low creek bank. He motioned for Kate to dismount and hold the horses. Removing the Winchester from his saddle boot, he pumped a shell into the chamber and aimed at the shoulder of the nearest animal, slowly squeezing the trigger. The dark hulk of the buffalo fell in its

tracks.

The roar of the wind carried the sound of the shot away from the small herd, which stood no more than twenty feet away from the end of Ned's rifle. The others did not move.

Ned pumped another shell into the chamber, and dropped another bull, then another, until three shots later, all six animals lay dead at the edge of the stand of willows.

The two shivering riders tied their horses on the south side of the willow stand, and Ned shouted instructions into Kate's ear. The snow continued to get heavier as they removed their Bowie knives from their belts and began skinning the downed buffalo. It was cold, wet work, but they soon had the skins of all six animals rolled next to the carcasses. The body heat from the skinned carcasses and rolled hides sent clouds of steam boiling upwards into the whiteness of the falling snow.

Ned motioned for Kate to follow, and they moved back inside the stand of willows, and, using their knives as axes, began cutting the willows within a six foot circle. After clearing everything within that circle, Ned pulled the surrounding willows together at the top and tied them with a short length of his lariat which he had cut for that purpose.

The small, limber saplings became the brace poles for a crude tipi. Next, he and Kate dragged one of the steaming hides into the circle and unrolled it with the hair up. Another was placed on top of the first with the hair down, after first brushing all of the snow from the hair. By using more pieces of his lariat, Ned laboriously lashed the other four around the outside perimeter of the willow poles, with the hair of the hides turned inside. His fingers were so cold that he could hardly tie the rope.

He retied the horses on the south side of the tipi, which offered some protection from the blowing snow, and then joined Kate inside the hide hut. Their buckskin clothing was now soaked beneath their slickers, and their bodies were shivering from the wetness and cold. They removed their slickers and crawled between the two buffalo skins.

However, they continued to shake and shiver and were unable to get warm because of the wet buckskins. Ned realized they would never get their body temperatures back to normal as long as they remained wet. "We're going to have to get these wet clothes off," he chattered, "if we ever expect to warm up."

146

Kate nodded her head in response and began removing her buckskins. Ned turned his head in embarrassment, remembering the day along the Brazos when the three cowhands had attempted to rape her.

Reaching out her hand, Kate touched his shoulder and said softly, "It's alright, Ned."

He quickly removed his soaked clothing and they once again crawled between the buffalo skins. Modesty disappeared as they began rubbing each other's frozen bodies, trying to speed up circulation. The thick, warm hair of the hides soon warmed their bodies, and the vigorous massaging turned to a gentle touching -- from an act of necessity to one of pleasure and desire.

In one accord, their lips met in the darkness between the hides, and their bodies strained against one another and neither was anxious to pull away.

The coming of dawn brought a stilling of the winds, and the weather changed as quickly to warmth as it had changed to cold. The sun was able to break through the clouds and bask the lone tipi in spring-like warmth. Snow was piled almost a foot deep as Ned, dressed only in his rain slicker and boots, stepped from the tipi and hung their wet and frozen clothing on the willows to dry. The horses remained where he had left them, suffering no ill effects from the blizzard.

He quickly removed his saddlebag and hurried back inside the crude hut, crawling between the skins to the girl and the warmth he had left. They hungrily shared a cold breakfast from the food which Maria had packed, while lying in each others arms.

Neither was anxious to leave the comfort of their bed, and for two more hours they shared each others love before finally breaking away and retrieving their cold but dry buckskins. As they rode back to the ranch house across the broad expanse of whiteness, only the tracks of their horses gave evidence that man had once again won a battle against the hardships of this harsh and wild country.

21

"I now pronounce you man and wife."

The huge cottonwoods cast a protective shadow over the small wedding party which was gathered to unite Ned and Kate in marriage. In the absence of an official ordained minister, Colonel Jim Cole, performed the ceremony just as he had conducted the burial ceremony of Bo on the banks of the Red River.

Kate was radiant, if not somewhat uncomfortable, in her blue and white gingham dress. Her long copper hair fell in ringlets across her shoulders, and her happiness reflected from the smooth, weathered features of her lovely face. She held a small bouquet of autumn wildflowers firmly in her hands, while Jaunita, Belle, and Maria stood at her side, smiling proudly.

Ned, dressed in buckskins, stood tall and straight, his blue eyes sparkling brightly under his long, sun-bleached hair. He tried hard to hide his embarrassment, but his hands gave him away, as he was unable to find a position where they would be comfortable. He finally settled for resting his right hand on his gun butt, with his left thumb tucked under his holster belt. Hondo stood as his best man, with the other men of the ranch forming a circle around the group.

"Kiss the bride", they all shouted as the Colonel said the final words. Ned's face turned crimson as he bent slightly and placed a quick kiss to Kate's lips. Not satisfied, Kate dropped the flowers and threw her arms around his neck and pulled his lips to hers in a

long and passionate kiss. The cowboys cheered her on, and when she finally released Ned for air, they all threw their hats into the air with one final rebel yell, then crowded into line, pushing and shoving to be the first to get to kiss the bride.

As fall settled into winter, ranch life slowed to an easy pace for the newlyweds. There was little for them to do except share their happiness together. On days when the weather was permissible they would take long rides across the rolling hills below the caprock, hunting deer and turkey for Maria's kitchen. Ned was very proud of the fact that Kate was as accurate with the Winchester as he, and could stop a running buck at four hundred yards.

A few of the hands kept close watch on the herds which were now nearer to home while others were given time off to return to Waco to visit family and friends and to bring supplies when they returned in the spring. The remaining cowboys were kept busy repairing and mending everything from fences to work harnesses and adding to the corrals which would be needed to work the cattle in the spring.

It became apparent as the months passed that Kate would be adding to the family before long. As her stomach grew, it became more and more difficult for her to ride, and she soon was forced to stop riding altogether. "If you don't have twins, it'll be a surprise to me," Belle said proudly as they sat sewing blankets and baby clothes.

February and March passed and about the middle of April, when the first prairie flowers began to blossom, Quanah and his tribe arrived in the valley, on their annual trek to the buffalo grounds on the high plains.

They camped on the river below the ranch house, and Quanah took time to dress in his finest regalia before riding the remaining distance to visit his white brothers. Morning Star accompanied him, riding close behind his larger buckskin on her beautiful spotted mare. He was truly a prince of the prairies, with his long, flowing war bonnet of eagle feathers, brightly painted buckskin leggings, silver bracelets on his wrists, and a bear's-claw necklace around his neck.

And if Quanah was a prince, then Morning Star was surely a princess. She was dressed in a white doe-skin dress, with beads and seashells lining the fringes. Her long, black hair dropped around her shoulders and was held in place with a white buckskin thong drawn

tightly around her forehead. Tied to her back was a cradle-board, and peeking out of the brightly colored Indian blankets was the round brown face of a baby boy.

They rode through the huge gate and up to the ranch house porch where Jim, Ned, Belle and Kate stood waiting. The Garcia family and the cowhands who were not out on the range, stood in the shade of the huge cottonwoods watching the procession. Jim and Ned stepped forward and held up their hands in welcome. Quanah dropped easily to the ground and offered his hand, first to Jim and then to Ned. Turning proudly, he motioned for Morning Star to dismount and come forward.

She removed the cradle-board from her back and handed it to Quanah, who in turn, handed it to Jim. Speaking in broken English, he said, "My son, Jim Bold Eagle, for my friend One Arm."

For an Indian to name his first born son after a white man was indeed an honor. Jim accepted the honor with a smile, took the child and looked into his round Indian face, and was pleased to see that he had the same blue eyes as his father.

"Some day he will be a great warrior and hunter like his father, Quanah," he said. Belle and Kate had now joined the group in front of the ranch house and were eager to hold the small papoose. Morning Star looked on with pride beaming from her beautiful face.

"My lodge is your lodge," the Colonel said to Quanah, as he motioned for them to come into the ranch house. Slim, Ramon and three of the ranch hands followed them into the huge living room, where several buffalo robes had been placed in a circle around the center of the room. Belle, Kate and Maria led Morning Star into the kitchen as the men sat Indian fashion, in a circle on the buffalo robes.

Jim, using an ember from the fireplace, lit one of the black cigars, took a long puff and blew the smoke upward, handing the cigar to Quanah. Quanah did the same and passed the cigar around, each man taking a long draw and passing it on.

After the ritual, the Colonel spoke. "My heart is troubled for my friend Quanah and his people. You war with the whites from the south, raiding their homes, taking scalps and stealing horses. To continue will result in many long-knives being sent by the Great White Father to kill you and your people. If we can live as brothers in peace, why is it that you cannot do the same with the Texans in

the south?"

Quanah thought for a moment, then replied. "My brother One Arm and his people are different. You leave the grass and the buffalo for the Indian. Your cattle with the long horns do not destroy the grass nor the buffalo. The *white-eyes* in the south do not like the grass, they kill it with the plow and leave nothing for the buffalo to eat. Then they kill the buffalo and leave them to rot so the Indian has nothing to eat, no skins for clothes and lodges, and the Indian must travel far to find food. They wish to move farther and farther into the Indian's lands and plow more grass, soon there will be no grass for Comanche's buffalo or One Arm's longhorns. The iron plows will starve us both. There is no other place for Indian to go, the land of no trees will be our home or our graves. We must fight and raid and scalp to keep the white-eyes out."

"Maybe the Comanche can smoke the peace pipe with the Great White Father and he will agree to let the Comanche keep the land of no trees for the buffalo, and little Jim Bold Eagle can grow to be a great chief of many people, without waring and killing," Jim replied.

"We cannot trust the Great White Father and his peace treaties," Quanah said sadly. "For many years Indians have signed treaties in good faith, and each time the white man has broken the treaties and forced us to move further west. My father, great Chief Nocona, once thought that the white people of the south could be trusted. He traded with the people of the forts until one day after trading many things with the *white-eyes* at Parker's fort, while my father and his braves were unarmed, the people of the fort opened fire with their guns and killed many of my father's people. My father escaped and came back later with many braves and killed the people who betrayed him and took captives. One of those captives was a young girl who grew into a beautiful yellow-haired Indian maiden who my father took as a wife, and who became my mother. Since that day, the Kwahadi Comanche does not trust the white-eyes. Only you, my brother, who has proven to be honest, can be trusted."

"It is my hope that peace between you and the long-knives can be made, my brother," the Colonel replied. "But, whatever happens, you know you will always have a friend here on Ceebara range. Our herds are getting large and soon we must take many of the long-horns north to the railroad where we will sell them for much gold.

To get to the railroad we must cross the land of the Kiowa and the Cheyenne but we do not want to have trouble with Chief Little Big Mountain and his people. Can you help?"

"Yes, I can help. Chief Little Big Mountain is the father of Morning Star, and he will honor my friendship with you. But there are other tribes along the Cimarron who may not listen to me or Chief Little Big Mountain. It will be difficult to move many long horns across that land. When you are ready, send word to me and I will help."

With that, Quanah stood and walked to the door. Morning Star appeared from the kitchen and joined him, carrying several presents of steel spoons, forks and glassware which Belle had given her. They mounted their horses and rode slowly out of the ranch compound.

Cole Armstrong, son of Ned and Kate, was born on a hot July day, the summer of 1867, after thirty hours of labor on his mother's part, and near death from heart failure on his father's part. "Grandfather" Jim Cole broke out the liquor and the members of the ranch family drank a toast, and several more, to the future of young Cole and the Ceebara Ranch. The sounds of celebration could be heard echoing down the Red Deer Valley throughout the night.

22

Shep announced the presence of the wagons long before they appeared coming up the trail to the ranch house. There were three of them, two Conestogas with covers and one large flat-bed freight wagon pulled by mules, each carrying two men, with one man on horseback leading the way and two more on horseback following. The flat-bed freight wagon was half loaded with smelly buffalo hides.

It was a motley looking crew, dirty and disheveled, and smelling as bad as they looked. Shep continued to bark as Jim and Belle stepped out onto the veranda of the ranch house. The leader, a large, heavy-shouldered man with flowing black beard rode up to the hitching rail and tipped his weathered hat.

"Howdy," he said with a drawl.

"Howdy," answered Jim. Belle nodded politely. There was several days dust clinging to his dirty buckskins, and under the dust were splotches of what appeared to be dried blood. His gun belt was fastened tightly over the hip-long fringed jacket, with a long-barreled forty-four filling the holster. Hanging on the other hip was a sheath holding a large skinning knife.

"Names Dixon; Billy Dixon. Me and the boys is buffaler hunters from Dodge City. Been hunting up on the Arkansas, but too many hunters and not enough buffaler to suit us. Heard tell they was thick as flies along the Canadian so we decided to see for ourselves," he said as he spat a long, brown stream into the sand at

the edge of the porch.

Jim stepped down from the porch and walked the short distance to Dixon's horse, reached his left hand up and shook the outstretched hand of the buffalo hunter.

"Jim Cole," he said with a smile. "Most folks call me Colonel." Looking back at Belle he continued. "This here's my wife, Belle."

Looking around at the neat compound, almost in awe, Dixon said, "Indians said they was a ranch built up here but I didn't believe it. How in hell you folks manage to put this together and still keep your scalps?"

"It's a long story, Dixon," Jim smiled, "Step down and come in, and we'll talk about it over a cup of coffee."

"Thanks, Colonel, but me and the boys would like to make camp before dark. We'd be much obliged if we could camp on the spring down below your ranch house. We need to scrape some of this dirt off'n our hides before we track up your wife's floor," Dixon replied.

"You're more than welcome," Jim said. "When you've finished making camp and cleaned up, come on back up. We need to talk about hunting on our range." Although he was still smiling, the tone of his voice implied that there would be no hides taken from Ceebara range.

Dixon spat, squinted his dark eyes at Jim as he nodded his head. He shifted his eyes from Jim to Belle, touched the brim of his hat with his index finger, turned his horse and led the crew of hunters and skinners out the gate.

Just before dark, Billy Dixon returned alone, washed and neatly dressed in clean buckskins. Belle asked him to join them for supper and he politely accepted. Jim introduced him to Ned and Kate, who had returned from checking cows which were calving in the Canadian River pasture north of the ranch house. They all gathered around the huge dining table and were served beef steaks and beans by Maria.

"My compliments, ladies," Dixon said, as he pushed his chair back from the table after consuming the huge steak. "Sure beats hell out of buffalo meat cooked over a campfire."

Belle and Maria nodded their appreciation of the compliment. Ned stepped into the other room and returned with three of the long black cigars as Kate appeared with a half-empty bottle of bourbon. She poured the men a drink before disappearing back

into the kitchen to help Kate and Maria with the dishes.

"How about telling me that *long story* about how you folks can live in this Indian country without losing your scalps, Colonel," Dixon said as he lit the cigar.

Jim smiled, nodded, and began to relate how he and Ned had saved Quanah from the quicksand and had been accepted by the tribe and made blood brothers. "We have smoked the peace pipe with the Comanches and have promised to respect their buffalo range. They have agreed to allow us to run our longhorns and we have agreed to kill no more buffalo than is needed for our own use. When the buffalo move out, they take only the beeves they need for food. They respect our wishes and we respect theirs. There is enough grass for everyone."

Pausing, Jim swallowed a sip of the bourbon, then continued, this time speaking very precisely. "The buffalo on Ceebara's range belong to the Comanches. We will not allow them to be slaughtered for their hides. We cannot prevent you from hunting in other areas, but on our property," he handed Dixon the papers signifying their legislative grant, "the buffalo are not to be bothered."

Dixon looked the papers over, as well as the rough map which indicated the boundaries of the Ceebara range. Rolling his glass in his fingers, he returned the Colonel's stare. He swallowed the remaining bourbon before speaking.

"The Kiowas and Apaches weren't too fond of us taking hides along the Arkansas, either Colonel, but they wasn't able to stop us. Sure, we had a few skirmishes with them, but the army out of Fort Dodge kept them on the run while we did our killing and skinning. The army will do the same thing with your friend Quanah and the Comanches, if he tries to stop us south of the Canadian. Me and the boys are just a few of the hunters that will be coming down once they hear about the size of these herds, you can bet your hat on that," Dixon said.

Taking a long drag on the cigar, he slowly blew the smoke towards the ceiling. "I hear tell that General Sherman has been given command of the western troops and has put out the word that he intends to run all the redskins back onto the reservations, one way or another and he's probably going to use us buffaler hunters to help get the job done."

"That may be so," Jim replied, "but until the army gets involved, me and Ned intend to live up to our word. We can't stop

you from hunting other areas, but we will do whatever is necessary to see that you don't take buffalo from Ceebara ranges."

To emphasize his point, he gently placed his hand on the butt of the revolver hanging from his hip.

Dixon stood up, smiling nervously, and said. "O.K. Colonel, I'm sure the Llano Estacado is large enough for you to run your 'horns and for me to hunt hides. We'll do our hunting off your range, but there'll be other hunters who won't be so agreeable. You may as well be prepared, the hide hunters are coming."

He bowed to Belle and Kate, who stood listening at the kitchen door, retrieved his hat and stepped out into the night

A few days after Dixon had left the ranch compound, Jim and Belle were riding the range west of Ceebara headquarters, checking the condition of the herd which had been brought up from the winter pastures below the caprock. The cattle were scattered over an area of fifty thousand acres of the lush Gramma and Buffalo grass, with three or four hundred head in each group. Multicolored spring calves were frolicking around the edges of the herds and made a lovely contrast on the background of dark green grass. The late spring sunshine reflected off the polished horns of the older cattle, and their sleek coats indicated the layer of fat which they had put on since the new grass had pushed through last years carpet of brown.

"Ain't that a sight to behold," Jim said to Belle as they slowly circled one of the larger groups of cows and calves. Off to the left, a herd of dark brown, shaggy buffalo were grazing slowly northward, their winter hair hanging in clumps of reddish brown and now and then, one of the shaggy beasts would lay down and roll in the grass, leaving some of the loose hair lying in the wallow.

Belle pointed to the horizon where a large herd of white and tan antelope bounced to a stop and looked back at the two riders who had disturbed their evening meal. "They must have eyes like an eagle, Jim. Seems we can't get within a half mile of them before they are off like a rabbit, heading for the highest ridge around."

Jim nodded in agreement as his gaze took in all of the beauty of the moment. The flash of several black specks hanging in the sky just to the right of the antelope herd caught his attention. Looking closer, he could see that the black specks were moving in a slow circle, probably two or three miles on the other side of the cow herd.

"Buzzards," he said, leaving a slight question in his comment.

"Must be something dead over that way," as he turned his horse in the direction of the circling specks.

Belle followed as he kicked the black stallion into a slow gallop. As they neared the birds, he could see another group circling in the sky two miles farther north. Topping the ridge, they were amazed to see the naked carcasses of thirty or forty buffalo lying in the bloodstained grass. A quarter of a mile off to the left was the carcasses of nine head of longhorns, hide still on them, with only a large chunk of meat cut out of the muscle in the hind quarter. Hundreds more buzzards were tearing at the exposed flesh of the slaughtered animals, and several coyotes were gorging themselves and nipping at the buzzards, selfishly trying to keep all of the carcasses for themselves.

"Indians?," Belle asked as she looked at the bloody scene lying before them.

"Afraid not," Jim answered. "Indians would have killed only what they needed and would have used the whole animal. 'Peers to me that only the hides and tongues have been taken from the buffalo and some prime steaks cut off of the cattle. Looks as if we got some hide hunters poaching on Ceebara range."

"Surely it's not Billy Dixon and his crew," Belle said as Jim dismounted and kicked some of the feeding buzzards away from one of the carcasses.

"No," Jim answered. "Dixon wouldn't have killed the cattle. And I'm certain he meant it when he promised he'd stay off of Ceebara range."

Grabbing one of the horns of the animal, he lifted the head and dropped it. "Can't be more than a few hours since it was shot," he said. "Ain't even stiff yet."

Pulling himself easily back into the saddle, he turned the stallion towards the next flock of buzzards circling two miles to the north. They were now following the tracks made by two wagons and three or four horses. The same scene confronted them as they topped a small rise and several buffalo carcasses lay almost hidden in the tall grass of a shallow depression.

Belle could see that Jim was getting angrier by the minute as he rode past the fresh carcasses without stopping or speaking. He kicked the black into a gallop down the fresh wagon tracks and pulled his Winchester from its boot, held the lever action between his fingers and threw the rifle away from him. When he jerked it

back, a fresh cartridge slipped easily into the chamber. Belle did the same, using both her hands to flip the lever.

Before traveling two miles, they topped a rise and looked down upon a large playa lake, where another twenty carcasses lay shining in the late evening sunlight along the edge of the lake. Two men were busy rolling a freshly-skinned hide into a tight bundle and two more were loading a hide in a flat-bedded wagon. The wagon was piled high with several more hides.

The fifth man was making camp, blowing on a buffalo-chip campfire from which was curling a small column of smoke. The men all looked up with surprise as Jim and Belle rode towards their camp. They dropped what they were doing and retrieved their rifles which were leaning against the wagon bed, pointing the guns loosely towards the two riders as they pulled their horses to a halt, thirty feet away.

The stink coming from the men and the wagons was overbearing, and the men themselves were covered with dried blood from head to foot. Their buckskins were slick with several days of the bloody gore of skinning and loading the hides. Even their long, unkempt beards and hair were matted with the grime. They seemed to relax when they saw that one of the riders was a woman.

The smaller of the skinners, a young man about eighteen years old, punched the older fat man next to him with his elbow, and uttered a high-pitched giggle as he stared towards the beautiful woman who set so straight in the saddle, the smooth skin of her leg showing an inch above her knees. The fat man wiped a dirty forearm across a foolish grin and nodded his head in agreement to the young man's reason for excitement.

The tall, slender man who seemed to be a little cleaner than the rest and who was holding a large Sharp's fifty caliber buffalo gun, took a couple of steps forward and spoke.

"Howdy, folks. Me and the boys sure as hell wasn't 'specting no company out here in this God-forsaken country, leastwise if they weren't redskins. We was just about ready to throw a little lead your ways, afore we saw you was white folks. Where at in hell did you'uns come from? Ain't no settlements 'tween here and Dodge, that's for dammed sure," he said. His eager eyes moved from Jim's stump of an arm to the cocked Winchester, then across to Belle, and her well proportioned body. They darted back to the cocked Winchester which she held before returning to meet the Colonel's

cold stare.

The sun was now dropping below the horizon as Jim returned the hunter's stare. "We didn't come from nowhere's," he said slowly. "We live here. You're standing on our property, the Ceebara ranch, and you're killing our cattle and the Comanche's buffalo. And neither one of us is too fond of people who shoot cows and buffalos. My advice to you is to load up your damned wagons and git back north of the Canadian before daybreak or you will have me and the Comanches both to contend with," he said.

"Now, ain't no reason to get all riled," the tall one said. "We got us a paper here signed by General Sherman himself saying that the army wants buffaler killed all the ways from the Arkansas to the Concho, and he didn't say nothing about no Cee--baree ranch being smack-dab in the middle of it." He leaned the long-barreled buffalo gun against the wagon wheel and stepped towards Jim's horse, pulling a paper from his shirt pocket as he spoke. He glanced towards the young skinner and winked as he moved.

Reaching up, he handed Jim the paper, which was tightly folded. Belle had taken her eyes off of the two skinners who were standing to her left and did not see the young man begin to slip slowly towards her horse. As Jim released the rifle and laid it across the saddle to take the folded paper, the tall man's hand darted to his wrist, and before he knew what had happened, he was jerked from his horse and fell onto a long bladed skinning knife which the hunter had pulled from his belt with his left hand. The knife blade sank to its hilt in Jim's shoulder just above his heart. As he rolled to the grass the tall hunter pulled the blade from the wound and blood immediately covered Jim's chest.

Belle, having relaxed her grip on her rifle, dropped the reins and raised the gun to shoot. The sudden movement caused the roan mare to jump and the bullet hit the ground two inches from the tall hunter's boot. She felt a hand grab her long red hair which hung below her hat, and another hand latched firmly onto the barrel of the Winchester. A quick jerk and she was dragged from the saddle, landing on her back and looking into the grinning face of the young hide skinner. He landed solidly on top of her and wrestled the rifle from her hands. Two of the other three skinners were now on their knees on each side of her and had her wrists pinned to the ground.

As the hunter slipped the knife from Jim's shoulder, he came forward with his right foot and caught Jim in the ear with the toe of

his boot. A flash of brightly colored lights blurred Jim's vision as he lapsed into unconsciousness.

A red glow filled the evening sky as the sun disappeared below the horizon, casting an eerie glare on the struggling bodies. Belle was no match for the four foul-smelling men as they pulled her towards the wagon. The fifth man had reached into the wagon and pulled out several small strips of rawhide which he used to tie her wrists to the spokes of the wagon wheel as the others held her against its hub. While the young man held her legs, the other tied each ankle to the bottom rim of the wheel.

Thus she stood, looking down helplessly at Jim's crumpled body and the small puddle of blood which was beginning to form in the grass under his arm.

"You bastards," she screamed through clenched teeth, "do something, can't you see he's bleeding to death?"

"Now don't fret yourself, pretty lady," the tall one said, grinning cruelly. "He ain't feelin' no pain and you got we'uns to look out after you now. We ain't aimin' to let no redskins or wild coyotes to bother you none."

As the hunter spoke, the fat man was rubbing his grimy hand over her body, feeling of the softness which was covered by her buckskins. The tall man swung a looping right hand and caught the fat skinner in the mouth, knocking him sprawling to the ground.

"Now, what did you go and do that for," the fat one whined as he got to his knees and tried to wipe the blood that was flowing from a cut in his lip.

"Cause I want you to keep your greasy paws off'n her until we decide what we're going to do," the hunter said. "We can't all have her to once't, and since this here is my riggin', I'm going to have her first."

Reaching down he pulled a handful of the long stemmed grass and broke off four different lengths, throwing the rest away. He held out the stems to the four skinners and said, "Whichever gets the longest gets first after me, and whichever gets the shortest is last."

They each pulled a grass stem as Belle watched silently, tugging on her bonds trying to get free.

The tall man, grinning hungrily, stood at arm's length from her and pulled his skinning knife, which was still red from Jim's blood, and stuck it under her chin, with the blade beneath her jacket, sharp

edge turned out. He moved it slowly downward and she could hear the soft buckskins being parted by the blade. As the blade reached the bottom of the jacket, it fell open, and the young man, seeing the white flesh beneath her jacket, let out a wild yell, "Lawsey, look at that!" he screamed.

The knife blade slipped beneath her skirt, and with a quick jerk, the skirt split and fell around her ankles.

One of the other skinners, unable to contain his lust any longer, lunged between the hunter and Belle, only to be felled with a blow from the butt end of the heavy-handled hunting knife to his right temple. He fell unconscious at her feet. The fat skinner dragged his prostrate body away as the tall hunter proceeded to take his pleasure with the now crying and screaming Belle.

Laughing and cavorting, each man took his turn with the helpless woman tied to the wagon wheel. Unable to do anything else, Belle spit in the face of the second rapist who reacted by smashing her in the face with his dirty fist. Her mind went blank as she fell into unconsciousness and was spared further knowledge of the degradation which was being inflicted on her body.

Nor was she conscious to witness the stiffening of the young skinners body, as he was preparing once more to take his turn with her. There was the sound of a sharp thud as his body was slammed into hers, air rushing from his open and grinning mouth. His fingers released their hold on her shoulders and the grin turned to a silent scream as his knees buckled and he slid slowly to the ground.

The others looked in astonishment at the smooth, feather tipped shaft which was protruding between his shoulder blades as he lay prostrate on his stomach. Before they could move, the sound of several more shafts whistled through the air and found identical lodging places between each of their shoulders. As the shafts struck, a loud war-hoop rang out and echoed across the silent prairies, and a dozen bronze-skinned Comanche warriors, clad only in breechcloths and leggings rose from the tall grass and ran into the dimly lit camp.

Sharp knives replaced the bows in their hands and as each of the hide hunters turned their frightened eyes on their attackers, they could feel the sharp knives circling their scalps as the braves took their battle trophies.

The sharp blade of the young leader of the group quickly slashed the rawhide thongs which bound the unconscious Belle to

the wagon wheel and the strong arms of Quanah, chief of the Comanches, picked her up gently and laid her on one of the freshly skinned buffalo hides.

Other warriors quickly carried the unconscious form of Quanah's friend, One Arm, and laid him on the hide beside Belle, and began to dress the knife wound and stop the flow of blood. Quanah was pleased to see that his friend was still alive, although on the verge of death.

After tending to Jim's wounds and dressing the unconscious Belle, Quanah instructed his braves to lift them into the wagon which was loaded with buffalo hides, and with a brave on either side of the team they led the wagon away from this scene of rape and death. They would travel for most of the night, trailing the extra horses, before reaching the Comanche village which was camped on the stream called White Earth, west of the deep canyon.

Belle was conscious only of the fact that no longer was her body being ravaged by the hide hunters. She could not, however, control her sobbing which racked her body throughout the long night's journey.

She awoke to the sound of dogs barking and kids yelling as the camp came to life at daybreak. At first, she was disoriented, in the semi-darkness of the Comanche tipi. Lying on her back on a soft buffalo robe, she could see a small patch of blue sky at the apex of the hide-covered tent.

Her eyes adjusted to the semi-darkness surrounding her and she recognized the one-armed form of the Colonel lying next to her. His shallow breathing caused a sense of relief to pass through her body, since her last recollection had been that he lay dead in the bloodstained grass next to the hide-hunters camp.

She sat up, too quickly, and was unable to contain a sharp cry as her bruised and battered body, was filled with pain from head to foot. Crawling on her knees, she reached Jim's body and gently lifted his head into her lap, "Thank God you're not dead!", she said to the unconscious form.

His buckskin shirt had been removed and the knife wound had been dressed and seemed to have some kind of poultice tied over it with a soft antelope-skin bandage. The flap of the tipi opened, and she could see the form of an Indian squaw filling the opening.

Morning Star entered, carrying a steaming bowl of buffalo broth, and kneeled next to Belle and Jim. She said something which

Belle could not understand, but recognized by her movements that she wished to help get some of the hot broth into Jim's mouth.

Belle held up his head up to keep him from strangling as Morning Star slowly fed the broth into his mouth. As the warm liquid reached the back of his mouth, he swallowed and to Belle's joy, his eyes flickered and opened slightly. They were able to get him to swallow several spoonfulls before he closed his eyes once more and dropped off into deep sleep.

Belle ate the remainder of the broth while Morning Star looked on with compassion, knowing the pain that her friend was feeling, both physical and emotional. Quanah had told her of the degradation that Belle had suffered at the hands of the hide hunters, and although she was a Comanche, taught to show no emotion, tears filled her dark eyes and ran down her cheeks as she quietly ministered to their needs.

Belle reached out and took the hands of the lovely, raven-haired squaw in her own, and gently squeezed them indicating her gratitude for what Morning Star was doing for her.

About mid-morning, the flap of the tipi was thrown back and Chief Quanah entered and stood over Belle and the sleeping form of his one-armed friend. Speaking in guttural English, which he had learned from the Colonel, he said, "Bad mens dead," and held out two freshly cut human scalps which hung at his belt. "One Arm now better, he live."

Jim, hearing the deep voice of Quanah, opened his eyes and looked up at the towering figure standing above him. His eyes moved to Belle's face, who was still cradling his head in her lap.

Quanah smiled and reached down to take Jim's hand when he saw that his friend was awake. "White brother much strong," he said as he indicated on his own breast where the knife had penetrated Jim's chest. Then, in Comanche dialect, he told Jim how he and his braves had been hunting when they saw the circling buzzards, found the slaughtered buffalo, trailed the wagons and arrived at the hide-hunters camp shortly after sundown. Telling of the accuracy of his braves' arrows, he proudly held the bloody scalps for Jim to see.

When Jim seemed to be confused as to the events that took place before the arrival of the Comanches, Belle explained how she had been tied and raped after he had been knifed and knocked unconscious.

163

"God! Such scum!" he cried when she told what had happened.

"Thank you, Quanah, my brother," he said after he had regained his composure. "Thank you for killing the white dogs who did not deserve to live and for saving my woman and me from certain death."

Quanah smiled and said, "I owe you my life, now I have repaid, you owe me your life," turned, and walked out of the lodge.

After two weeks of rest and healing, the Colonel and Belle bade their Indian friends goodbye, mounted their horses and struck out in the direction indicated by Quanah, towards the Cottonwood Springs ranch house. Two days later, they rode into the compound to be welcomed by a distraught and worried frontier family.

"We had given you up for dead," Kate said tearfully, as she held her mother close. "Some of the men are still out searching, but we had just about given up hope of ever seeing you again."

23

The shoulder wound healed promptly since the knife had missed all vital organs and Jim was soon participating in normal ranch activities. He had been thinking for several months that the cattle herd had now grown to such a large number that they must try to find a market for the largest and oldest members of the herd.

The grass had been good this spring of 1869, and the cattle were as fat as he had ever seen them. His decision was made, Dodge City was only a hundred and twenty-five miles to the north which was about ten to twelve trail-days away, and Billy Dixon had said the railroad was there and buyers were anxious for cattle to ship to the eastern markets. They would be able to make a drive and arrive at the railroad in good condition if they were not pushed too hard.

The first day of July he gave orders to round up the cattle on the plains and bring them down to the Cottonwood Springs corrals where they would be shaped up for the drive north.

"We need to be ready to move out by the first of August with all of the old moss-back steers which we brought up from Waco and the two and three-year old steers which we've grown here on the plains. Near as I can tell there should be about four thousand head ready for market," Jim said as he gave Slim orders for the roundup. "That should leave us about ten thousand head of mama cows, bulls, yearlings and calves for seed stock."

Turning to Ned, Jim added, "We'll all help move the herd across the Canadian, then you and Ramon and a couple of the

hands can return to the ranch and stay with the women until we get back."

Ned was disappointed, but agreed, not wishing to leave Kate and young Cole in Indian country without his protection.

While the others began work on shaping up the herd, Ned saddled his buckskin and rode onto the plains in search of Quanah's camp. He found them camped on the shores of the large playa lake, a days ride to the west of the ranch house, where they were completing the drying of hides and jerky from several buffalo which their hunters had killed. When he explained to the Comanche chief that preparations were being made to move the herd to market, and they would probably start north in a couple of weeks, Quanah promised his help.

"We will make camp in the cottonwoods below your ranch and my people can continue their work while me and my braves lead you to the railroad," he explained.

After two weeks of preparation, the wagons were loaded and ready, the cattle had been cut out of the herd, and Big Red was headed down the Red Deer Creek, leading the huge herd to its junction with the Canadian, twenty miles to the northeast.

The huge bull, with his enormous horns shining in the early morning sunlight, seemed to know that time was of the essence as he broke into a slow trot, anxious to begin this new adventure. His hooves fell into the tracks left by the mounts of Quanah and his six braves who were leading the way. Jim, mounted on his great black stallion, sat on the crest of one of the small rolling hills rising from the floor of the valley and surveyed the sight with pride.

From his vantage point, he could see the ranch house, the large Indian encampment a half mile below the house, the huge herd kicking up dust as it snaked after the disappearing form of Big Red and the Indian scouts, and the twenty cowboys who were scattered along the fringes of the herd. The two wagons were waiting below the hill for his signal to move out.

Ned rode up in a gallop, pulling up in a cloud of dust. "Shore wish I was going with you, Colonel," he said as he leaned on his crossed arms which rested on the saddle horn and gazed at the sight below.

"You'll have your chance, son," Jim said. "There'll be a lot more of these drives before we get a railroad of our own. Besides, I'll rest a lot easier knowing you're here to look after our family."

They both kicked their horses into a gallop, went around the waiting wagons and motioned for them to move out.

By sundown, Big Red had led the herd to the banks of the Canadian, where camp was made and the herd was allowed to rest and graze in the lush grass along the river's edge.

The next morning, Quanah found a crossing where there was a minimum of quicksand, and the herd was urged across. Try as they would, the cowhands were unable to keep all of the herd within the boundaries of the narrow crossing and several of the larger cattle became mired in the dangerous quicksand. Lariats were uncoiled from the saddles and were looped over the massive horns. With two horses struggling and pulling on each animal, the river was soon cleared of the floundering herd. The only damage was to Slim's pride, when the girth to his saddle snapped while he was struggling to free one of the 'horns. Slim and the saddle landed in the knee deep water while his horse bolted to the opposite bank. Shouts of laughter echoed down the river, as cowboys and Indians alike poked fun at Slim's dilemma.

Quanah and his braves turned their course due north and led the herd up the rolling sandhills which bordered the river's north bank. Ned and Ramon and the two cowhands watched the last drag rider disappear over the horizon before turning their mounts back across the river and heading back to the ranch headquarters. He wondered if maybe they weren't placing too much trust in Quanah, and also in the safety of the ranch with such a large number of Indians camped within a stone's throw of the compound.

The sand hills fell away to broad expanses of flat prairie land which made progress easier, and after only six days, the herd took its fill of river water which Quanah explained was the north fork of the Canadian. No Kiowas or Cheyennes had been seen to this point, however, there was fresh sign along the banks of the river.

Jim joined Quanah and his braves as Quanah looked closely at the signs of the abandoned Indian camp, "Apaches," he announced. "Many braves, no squaws. Camp only one day old. Apaches mean big trouble," he said matter-of-factly.

Jim nodded in agreement as he turned his horse back to the main body of the herd. Slim joined him as he rode up.

"Quanah says Apaches are close by," Jim said with a scowl. "Better let the boys know and tell them to keep a sharp eye out for anything that looks suspicious. If we come under attack, I want all

hands to leave their positions with the herd and come hell-bent-for-leather to the point of attack. Make certain every gun is loaded and ready and issue six Sharp's fifties to our best marksmen. If the Apaches attack, I want to see six dead Indians before they get within a half-mile of our positions. That might make them reconsider," he said with a grin.

"What about Quanah and his braves, Colonel," Slim asked as he pulled off his hat and wiped the sweat from his brow. "Are they going to take the side of the Apaches or will they fight with us?"

"Apaches and Comanches don't like each other," Jim said. "They was enemies a long time before they decided they didn't like whites. I think we can depend on Quanah's boys to be trying to get a few Apache scalps to add to their collection. You'd best keep your eyes open though, just in case."

The herd was pushed across the river and up onto the flat prairies, still on a due north course. Quanah explained that another river lay not more than a day's drive to the north called the Cimarron. He expected that the Apaches would have seen their dust by now and that if an attack were to come, it would take place between the two rivers.

His suspicions were accurate. Fifty semi-naked horsemen suddenly appeared on the horizon, a mile to the west of the herd, riding hard and holding new repeating rifles high over their heads. Quanah turned his scouts back to the herd as Jim fired three quick shots signaling the approaching danger. The cowhands to the rear left their positions and came riding hard in the direction of the shots.

As the Apaches closed the distance to three-quarters of a mile, most of the trail hands pulled their winded and sweating horses up next to the Colonel. Jim wasted no time in shouting orders. The six marksmen dismounted and took prone positions in the grass, sighting down the long barrels of the buffalo guns. Four more of the cowboys were ordered to kill several of the closest of the now milling herd, and drag them into a line which would act as a barrier on the open prairie and offer protection from the Apache guns. The wagons were lined up behind the dead cattle, and the saddle horses were picketed behind the wagons.

The Indians were now within a half a mile of the herd and coming on fast. "Ready!" Jim shouted, "Aim -- fire!"

The six buffalo guns went off at the same time, roaring like a

cannon. Six of the Apaches were knocked backward from their horses. Six loaded guns were passed to the marksmen as they handed back the smoking Sharps. Now the leading Indians were within a quarter of a mile, as the six long-barreled rifles roared again. Six more of the Indian ponies were left riderless. Now the other cowboys, lying behind the dead longhorns, opened fire with their repeating Winchesters. The line of charging Indians became a line of riderless horses and those Indians in the rear turned their mounts and rushed to get safely out of range of the deadly fire.

Glancing to his left, Jim could see the smoking rifles of the seven Comanches as they kneeled in the open and pumped lead at the retreating Apaches. They jumped on their ponies and yelling their victory chant, rushed to the area where the wounded and dead Apaches lay in the grass. They made quick work of pulling a handful of hair up and slicing the scalp from the defeated warriors.

Tying the bloody trophies to their belts, they remounted and began rounding up the grazing ponies which stood nearby. When they returned to the herd, each was leading four Apache war horses, a great prize to carry back to their tribe.

The trail hands continued to lie in the grass, their rifles pointed in the direction of the departed war party. Quanah dismounted and proudly told the Colonel that he need not worry further about the Apaches. Losing more than half of their braves in such a short exchange of fire, while inflicting no casualties on the trail drivers would be enough to convince the Apaches that this was one herd which could pass through their land without further harassment.

"Apaches will return for their dead after we leave, but will not bother us again," Quanah said.

Jim gave the orders to gather the herd which had bolted only a few hundred yards before stopping to graze on the lush grass, and to once again move out. He wished to reach the shelter of the Cimarron River breaks before dark where they could circle the herd and find a little more protection if, by chance, Quanah was wrong.

However, the Apaches had had enough and did not return. The remainder of the drive passed uneventfully, and Jim allowed the herd to move at a slower pace as they approached their destination, giving the cattle a chance to fill their bellies on the tall dry grass of the Kansas prairie.

Five days later a buckboard accompanied by two horseback riders approached from the northeast. The group proved to be repre-

sentatives of the Great Western Livestock Company of Chicago, coming to make first contact with the Ceebara herd.

"Howdy," Jim said as the group rode up. "Sure is good to see some friendly faces for a change."

"Hello," came the reply from a large, round-faced gentlemen in the buckboard. He was dressed in a pinstriped suit complete with bow tie, celluloid collar and derby hat. He held the stub of a dead cigar between his fingers as he stiffly stepped down from the seat of the buggy.

Jim dismounted and approached the stranger, extending his hand in greeting.

"Heard there was a large herd coming in from the south and thought I'd best come out and see for myself. Name's Abercrombie, Vince Abercrombie, with the Great Western Livestock Company of Chicago. We pay top dollar for cattle and looks like you might have lots of cattle for sale," he said with a twinkle in his eye.

Jim returned the smile and replied, "Jim Cole, Mr. Abercrombie. Kinda got used to being called Colonel by my friends, and I suspect you're right about one thing, we got a passel of 'horns for sale if the price is right."

He glanced at the two horseback riders who had accompanied Abercrombie's buckboard and noticed that one of the men was wearing a badge. The man dismounted, knocked the dust from his denims with his hat and walked towards Jim. Reaching out his hand he introduced himself as Bat Masterson, temporary sheriff of Dodge City.

"We want you boys to know that you're welcome in Dodge," he said slowly. "Just make sure you keep your celebratin' in a friendly way. Some of those Texas drovers that's been coming up with the herds seem to think they got to fight and shoot to have fun. And we got a town full of buffalo hunters that's meaner than a room full of rattlesnakes just itchin' for a battle. Ain't no use in any of your hands ending up in jail or worse yet, in Boot Hill. Dodge ain't no straight-laced city, but it also ain't a town without no law 'atall. Hell, I like a good card game, a jug of liquor or a joust with the ladies as well as the next man. Just pass the word to your drovers that we got lots of things to help 'em rest up from the trail, but just keep the shootin' and rough-housing to a minimum and I'll be much obliged."

"Thank you, sheriff," Jim replied. "I don't 'spect you'll be having

much trouble with my boys cause we don't intend to stay no long-
er'n it takes to get these 'horns sold." Looking at Abercrombie, he
added, "And if Mr. Abercrombie is as easy to get along with as he
makes out to be, that ain't apt to be very long."

Turning back to Abercrombie, he asked, "How far are we from
Dodge?"

The easterner looked back over his shoulder to the northeast
and said as how he allowed it must be another seven or eight miles.
"If I was you, Colonel, I'd come in about two miles upriver from
Dodge where you'd have running water and plenty of grass. Those
other herds coming up the Chisolm Trail just about got the best of
the grass east and south of town.

"I'm much obliged, Mr. Abercrombie," Jim said as he looked up
at the sun, which was nearly straight overhead, turned to Slim and
said, "Head ole Red in that direction for another five hours and
we'll make camp early enough that the boys can ride into town and
wash some of that trail dust out of their gullets."

Turning back to the sheriff, he said, "I'd be much obliged, sher-
iff, if you'd tell the bar-keeps that the drinks are on me, tonight,
and I'll pick up the tabs soon as we sell these 'horns."

Masterson nodded his head as he turned his horse and started
back across the unmarked prairie. Abercrombie and the buckboard
followed. Big Red, sensing the end of the trail, trotted after the
buckboard.

It didn't take Slim and the cowhands long to splash the dirt off
their bodies in the Arkansas River and ride into town after the cattle
were circled on the south banks of the river. It wasn't much of a
town, with a dozen or so clapboard buildings setting on the north
side of the railroad, surrounded by numerous tents of all shapes and
sizes which housed temporary businesses, buffalo hunters, prosti-
tutes and railroad workers.

Saloon's dominated Front Street's business establishments; be-
sides the Longbranch, there was Hoover and MacDonalds, Pea-
cock's, Hanrahan's and the Dodge House, with several of the tents
being marked with crude signs indicating bar and women inside.

The other buildings housed Webster's Grocery, Fringer's Drug
Store, Young's Harness Shop, Zimmerman's hardware, and Rath's
General store.

The dusty street had nothing but the railroad on the south side
with its unfinished end pointing grotesquely to the west, as if saying

that this was only a temporary stop in its journey to the Pacific. Buffalo hides were piled high next to the railroad, awaiting the arrival of the next train which would carry them east.

The cowboys rode wildly into town, their horses kicking up clouds of dust as they raced to the stockyards at the east end of the street, turned and raced back to the hitching post in front of the Longbranch Saloon. They pulled their horses to a sliding stop, all the while yelling like a band of attacking Indians and firing their six-shooters into the air.

This display of their arrival was successful in emptying the saloons as the ladies lined the boardwalk in front of their establishments, shouting and waving for the cowboys to join them inside.

The sun was just dropping behind the hills to the west as they dismounted and crowded into the Longbranch, joining the hide-hunters, railroad workers and soldiers as they began their night of celebration on ending the cattle drive. However, the other saloons would receive their fair share of the drover's hard-earned money before morning as the cowboys proceeded to patronize the ladies and try to drink the town dry.

Slim did his best to keep the younger cowboys out of trouble, but as the night wore on and the liquor swelled their egos, trouble began to brew. The dance-hall girls were anxious to garner the favors of the free-spending cowboys, leaving the mostly broke hide-hunters to nurse their wounded pride with more liquor.

Gotch-eye Webster, a six-foot, two-hundred pound hide-hunter who had laid claim to Squirrel Tooth Alice's favors for the night, objected when Alice started dancing with Shorty, one of the younger Ceebara trail hands who had allowed the effects of the whiskey to increase his courage beyond the limits of his ability. Gotch-eye, a name bestowed on him because one eye gazed off at a crazy angle, grabbed Alice by the hair and pulled her from the arms of the inebriated Shorty. Shorty proceeded to double Gotch-eye over in pain with a hard kick to the groin.

The dance-hall floor cleared, with the cowboys taking one side and the hide-hunters taking the other, urging the two on with loud curses and shouting. Slim, seeing that the situation could get serious, rushed into the street in search of the Colonel.

He found him next door at the Dodge House eating a steak and they both rushed back to the Longbranch where Shorty was being mauled by the huge buffalo hunter. As the two brawlers rolled

on the floor, the hunter's hand went to the huge skinning knife which hung from his belt, and he plunged it into Shorty's chest just as Jim pushed through the screaming crowds. With the bloody knife still held in his hand, Gotch-eye picked himself up from the floor and turned snarling on Jim. Jim stepped nimbly aside as the hide-hunter lunged, kicked his hand, and sent the knife clattering across the floor.

Seeing the bleeding, prostrate body of Shorty lying on the floor, the crowd hushed as the buffalo hunter's hand reached for the Colt at his side. As his hand came up with the gun, Jim's hand was a blur as it snatched his gun from its holster and fired. The bullet caught the hunter squarely in the chest, knocking him backwards into the crowd as he squeezed off his dying shot which pounded harmlessly into the ceiling as he fell to the floor.

Sheriff Masterson rushed into the saloon just as Gotch-eye pulled his gun, and was standing by Jim's side with both pistols held firmly in his hands, pointed at the other hunters who stood next to the wall. No one made a move to pursue the argument further.

"Seems to me this here argument has been settled," the sheriff said as he looked at the the two bodies lying on the floor. Slowly casting his gaze on each of the persons standing around the saloon, swinging his guns as he did so, he added, "Now git them bodies out of here and go on with your partying. Anyone else wants to cause more trouble, I'll put a hole in him, myself."

After seeing to the bodies of the two dead men, and taking time for the blood to be wiped from the dance floor, the crowd continued its wild celebration until dawn. The morning found the beds of Alice, Big Emma, Big Nose Kate, Lillian Handie and the other dance hall girls,shared by the Texas trail hands.

Jim, anxious to get his men out of town before more trouble began, had breakfast with Abercrombie, after determining that the Great Western Livestock Company was the only buyer in Dodge City that had gold coin enough to pay cash for his herd.

"You saw the herd," Jim said, "And I think you'll agree that no other has reached market in as good a condition. Only ten days on the trail, and the grass was knee-deep and water was in good supply. You're going to find plenty of taller under those hides and steaks as tender as a young girl's kisses. I'll be expecting top dollar if you want your brand stamped on 'em."

Abercrombie smiled. "I told you we pay top dollar and I'm cal-

culating that top dollar for those mangy old moss-backs is three cents -- maybe three and a half and no more."

Jim looked disappointed and moved his chair back to leave the table. "You disappoint me, Mr. Abercrombie. I was told last night that the McCoy herd that was trailed all the way from South Texas into Abilene brought four and a half cents last month and they weren't nothing but skin and bones. Guess I'll just have to see what the Chicago Cattle Company is willing to pay."

Before he could get to his feet, Abercrombie, flushing, grabbed his hand and said, "Now hold on, Colonel there's not any reason in being too hasty. Set back down and let's talk about this a mite. I could've made a mistake. Those cattle of yours is probably worth more than I first thought. Maybe you ought to tell me what you got in mind they're worth."

Jim knew he had Abercrombie on the defensive and he also knew that if he could get even a half a cent more it would mean at least another five dollars a head, or twenty thousand dollars more on the total.

Sitting down, he said, "I'm thinking that five and a half would be a steal for you, Mr. Abercrombie, considering how much flesh my steers has got on 'em. After all, you're paying for meat, not bones."

"Ain't no way in hell I can pay that kind of money, Colonel. The folks back in Chicago would hang and quarter me on the spot, if I did. But you're right about one thing, you got a mighty good bunch of steers. I'll go four and three quarters, loaded on the railcar and that's a quarter more than the McCoy herd brought."

"I still think you're stealing 'em, Mr. Abercrombie, but you just bought the first herd of Ceebara cattle. I'll be looking to sell you many more in the future," Jim said as he stuck his hand out for a handshake to seal the deal. "I'll be wanting fifty thousand in gold coin, and the balance deposited in the Bank of Kansas City to the account of the Ceebara Cattle Company," Jim added as he stood up.

Loading the four thousand head of longhorns into the empty cattle cars proved to be a slow job. Some of the older steers' horns were so long that the cowboys would have to turn their heads sideways to get them into the cars. While one cowboy worked on the steer's head, another would poke him from behind with a long pole, urging him forward. Jim, good-naturedly, called the men in the

rear *cowpokes,* a name which wou!d be passed down through the ages.

When the cattle were all weighed and loaded, Mr. Abercrombie counted out fifty thousand dollars in gold coin and gave Jim a bank deposit for another one hundred and five thousand dollars on the Bank of Kansas City, a little less than forty dollars a head.

He gave each of his trail hands one hundred dollars bonus for the successful drive which they immediately spent for new hats, boots, shirts and trousers as well as additional amenities at the local saloons.

Jim purchased a large assortment of blankets, knives, beads and trinkets for Quanah and his braves, as well as six bright new Sharps buffalo rifles which they would carry back to their village with much pride.

24

After the cattle had been loaded in boxcars and Abercrombie had made payment, a courier from Fort Dodge delivered a message to Jim as he was preparing to leave on his return journey to Texas. The message was from General Sheridan, who was in command of the Military Division of the Missouri.

"Mr. Cole, you are cordially invited to join me and members of my staff for dinner tonight at 8 p.m. in the officer's mess at Fort Dodge. It is very imperative that I discuss a matter of utmost importance with you before you return to Texas. -- General of the Army Phillip H. Sheridan, Commandant of the Military Division of the Missouri," the message read.

Jim was puzzled, however honored, that General Sheridan would wish to meet with him. He was also pleased that he would have an opportunity to visit with the General about his problem with the buffalo hunters, a problem which would result in pushing the Comanches onto the warpath if not resolved immediately.

Fort Dodge was a beehive of activity as Jim rode through the gates. Tents were being erected around the parade grounds to take care of an apparent influx of new recruits. Indian tipis were scattered along the river's edge where scouts and their families had taken up residence, and troopers were involved in dozens of odd jobs, from currying horses and polishing harnesses to repairing wagons and cleaning guns.

Jim dismounted in front of the Officer's Mess where a young

private took his mount and disappeared behind the building. A corporal, who stood waiting by the door, motioned for him to follow and entered the mess. Jim was ushered into the dining room where a long table had been formally set with the heavy white porcelain army dishes sparkling on bright white table linen. A group of officers were engaged in an informal discussion at the opposite end of the room, each holding a half-empty glass of the General's best Irish whiskey.

General Sheridan, seeing Jim enter, stepped forward with an outstretched hand and greeted him with a smile. "Thank you, Colonel, for coming," he said as he awkwardly shook Jim's left hand. "I would like to introduce you to my staff -- Colonel Sulley -- Colonel Custer -- Colonel Crawford -- Major Evans -- and my chief scout, Bill Cody." As the introductions were made, each man came forward and shook Jim's hand.

Jim was surprised at Sheridan's appearance. He was dressed in a rumpled uniform, dress jacket and field trousers. His long arms extended from the ends of the jackets sleeves revealing hairy wrists. Although the smallest man in the room, he evoked an air of authority. Sharp, piercing eyes were set deep below a pronounced forehead, which itself was topped with short black hair. His beard and mustache , also a deep black, was immaculately trimmed. Jim noticed he was extremely muscular, square set and easy on his feet. *Bet he was a helluva boxer in his younger days,* Jim thought. Sheridan's smile made one feel instantly at ease.

Custer was quiet a contrast to Sheridan. Nearly six feet tall, he stood arrow straight, his long yellow hair dropping in curls across his shoulders. His eyes were a deep blue, made even more blue by his red complexion. His sharp nose was framed by high cheek bones and a drooping, nearly red mustache. He wore a buckskin jacket trimmed with fringes, and field trousers tucked in black riding boots. Although battle hardened, his boyish features indicated his true age of 28 years.

Standing at the edge of the group, William Cody, "Buffalo Bill", was dressed very similar to Jim, in soft buckskins, both jacket and trousers. His long blonde hair was tied in a pony-tail with a buckskin thong. As he stepped forward to shake hands, Jim noticed he carried a bone-handled colt on each hip and a long Bowie knife hung from his belt in the rear.

Sulley, Crawford and Evans were typical cavalry officers,

dressed in field blues which looked the worse for wear in this frontier fort where neatness was not the most outstanding attribute of its occupants.

At a word from the General, they all moved to the table. Sheridan indicated that Jim was to take the seat next to his right, and Colonel Custer took the seat to the General's left. Smiling, he said, "At long-last we meet, Colonel Cole. I have admired your bravery from a distance for quiet some time. Once, at Five Forks, just above Richmond, we almost met under an entirely different set of circumstances when a band of wild-eyed Texans who were led by a lean scoundrel on a huge black stallion overran my position. Had it not been for Custer, that day, it might have been Phil Sheridan instead of Jim Cole who sports an empty sleeve. At that time, as I remember, your right arm was still intact and was very handy with a battle saber."

Jim returned the smile, saying,"And as I remember, General, we busted open a beehive that day and was lucky to get out without being stung!"

"I am certain you are wondering why I requested your presence, Colonel, but for the moment let us just say that we wish to share our hospitality with you," Sheridan said. He nodded to one of the waiting orderlies and others appeared with steaming platters of steaks, potatoes and beans.

The conversation during the meal centered around the hostilities which had dominated the area for the past four years, and battles which had been fought with different tribes. Buffalo Bill Cody was the only one who didn't seem to harbor a hatred against the redskins. Jim listened intently and spoke only when a question was directed to him.

After the meal, cigars were passed around the table and more of the fine Irish whiskey was poured. Sheridan leaned back, belched, lit his cigar and spoke.

"I'll get right to the point, Cole, we are planning a winter offensive against the plains tribes. They refuse to remain on the reservations and continue to raid and plunder, killing and scalping settlers in Texas, Kansas and Colorado. Cody tells me that their winter campgrounds are along the Canadian, Washita and Red River, and apparently you are familiar with that area." Looking incredulously at Jim, he paused and shook his head in disbelief and added, "How in hell could you bring a herd of mangy long-horns across

177

that country without losing your scalp?"

Jim smiled and replied, "I didn't bring them across that country, General, I brought them *out* of that country! My ranch is just south of the Canadian, and the Washita and Red begin on my property."

"Your property! My God, man, that's Indian country. Few white men have ever been across those plains and lived to tell about it, much less to own and operate a ranch!" Sheridan said in disbelief.

"You're mistaken, General," Jim replied, looking Sheridan squarely in the eye. "General Houston and the Texas Legislature granted me a million acres in that country, and I've got over ten thousand head of cattle grazing on them today, not to mention the four thousand head I just delivered to the Great Western Livestock Company. As for the Indians, they have given me no problem, I respect them and they respect me."

Custer interrupted and almost spat the words, "Respect! How in hell can you respect those thieving, murdering savages. They can't be trusted no further than I can throw a buffalo by the tail, and anyone who does will end up with his scalp hanging from one of their trophy belts!"

Jim, not intimidated by Custer's outburst, looked at him with cool, calculating eyes and calmly replied, "You seem to forget, Colonel, that we're the trespassers in this land. These so-called 'savages' owned this land long before you and I ever thought about it existing. And if you walked in their moccasins for a year or two, and had to deal with us, you could understand why they think we are the thieving, murdering savages who can't be trusted. We've pushed them back, killed their buffalo and plowed their grass until they've got no place else to go. We've made promises and broken them and signed treaties that we never intended to keep, so it's no wonder that they steal and kill and scalp."

Looking around the table at the startled officers, Jim continued. "I made a covenant with the tribes to live in peace with them -- to leave their buffalo be and to share my beeves when they are hungry. But I seem to be in the minority, settlers move closer and closer to their lands, plowing the grass as they come; and hunters are coveting their buffalo herds and move farther south each year into the territory which was strictly forbidden by the Medicine Lodge treaty. I have broken no promises to them and they have broken no

promises to me. If problems between me and my friends develop, it will be because of what the army and the buffalo hunters do, not because of any broken promises on my part. They are my friends and until they prove otherwise, I will treat them no differently."

Custer flushed, and as anger flashed from his eyes, made a move to stand and challenge Jim. Sheridan's hand reached out and gripped him by the shoulder and pushed him firmly back into his chair. Turning to Jim, he smiled and said, "Friend or foe, we need your help. President Grant has determined that we can no longer tolerate the lack of cooperation on the part of the tribes. They also have broken the terms of the Medicine Lodge treaty, refusing to remain on the reservations in the Indian Territory. General Sherman has ordered that we push them back onto the reservations at all costs, and to see that they remain there. They will either go or they will be destroyed."

With a touch of kindness in his voice, he added, "So you see, Jim, it is to their benefit if they go peaceably."

Jim, seeing the futility of argument, and realizing that no matter what he believed, the die had been cast. The decision was not his to stop nor was it General Sheridan's to begin, it was the policy of the nation.

"There'll be more bloodshed than you'll want to see, General," he said. " *The Llano Estacado* is a natural fortress for the tribes, and they know it like the palm of their hands. They know where every creek and gulley's located, every water hole and playa lake, and they've got their own commissary, the buffalo. You can't find 'em to drive them out, and you can't surround them and starve 'em out. It'll take the blood of a lot of good soldier boys if you try to push them out."

"I know that Jim, and that's why I asked you here today. I need to know all you know about that God-forsaken country and I need you to take a message to the tribes and tell them they've got until winter to get out or we'll be coming after them."

Jim stood to leave, slowly moving his eyes around the table to each of the officers, and said, "I'll carry your message, gentlemen, but I'll not betray my friends. I believe that each of you would do no less." With that, he turned and walked from the room.

25

The autumn weather had turned to winter early this year on the plains. The Cheyenne village was blanketed by a heavy snowfall and a light north wind whistled through the branches of the protective cottonwoods that surrounded the tipis, keeping the smoke which curled from the lodges close to the ground.

Chief Black Kettle, wrapped warmly in a coat of buffalo hide, walked nervously from one end of the village to the other followed by a pack of mangy Indian dogs, their tails tucked between their hind legs for protection against the wind. He passed the horse remuda where two teen-age boys were standing guard, bundled in their long buffalo coats, and as he reached the edge of the winter campground, Black Kettle stopped and strained his eyes through the swirling snow towards the low hills which surrounded the village. The late evening sun was trying to break through the low hanging clouds, casting an orange glow on the western horizon.

For four years he had followed this same ritual just before dusk, looking and listening, straining his eyes and his ears for a movement or a sound that he hoped would never come again. The sound of bugles and thundering hooves; the roar of cannon and the chatter of Gatling guns; the sharp crack of rifles; and the screaming of women and children -- his people, as they fell before the onslaught of hundreds of long-knives.

Reminiscing, he would never understand why the long-knives

came that late November morning, just a few weeks after he had met with the Territory of Colorado's Governor Evans at Camp Weld, a short distance from Denver, and agreed to take his tribe to Fort Lyon for a peaceful surrender and to live on a reservation designated by the Governor. As if it were only yesterday, he remembered how he had led his people to Fort Lyon where his tribe was given a few rations and instructed by the post commander to move the 40 miles to Sand Creek. There, game was abundant and they would be able to provide for themselves.

Black Kettle was satisfied that peace had finally been won, so satisfied, in fact, that he no longer posted guards at night around the camp nor with their horse herd. He would forever remember that mistake.

On that terrible morning, four years ago, he was awakened by the sharp strains of a bugle sounding the cavalry charge and before he could throw back the flap of his tipi and look out, the roar of the cannon and the sharp crack of rifles filled the air. As he rushed from his lodge only half-dressed into the winter chill, he could see the first wave of cavalry charging down the slopes of the creekbank and the bright flashes coming from the barrels of their rifles. His friend, Chief White Antelope, now seventy years old, rushed to meet the charging cavalry, waving his hands and shouting in English for them to stop, that the tribe was under the protection of the U.S. Army. He fell dead as a hail of bullets riddled his body.

Black Kettle quickly hoisted his American flag up a lodge pole with a white flag immediately below it to inform the invaders that this was a peaceful tribe, living under the protection of the army. The flag had been presented to him personally by President Abraham Lincoln when he and many more chiefs had traveled to Washington to talk of peace. It did no good. The cavalry was now inside the perimeter of the camp, and his people who had rushed from the warmth of their lodges were being cut down unmercifully by the charging blue coats.

Most of his warriors were in hunting camps fifty miles away, with only old people, women and children left in the village. He shouted for them to find shelter in the sand hills along the banks of the creek when he realized that there was no stopping the slaughter. But the soldiers continued to pursue, slashing with sabers and firing at close range with their revolvers. The snow was littered with the bodies of his people, turning the white snow a bright red where each

fell.

Looking back as he too ran for shelter, he could see the dismounted cavalrymen committing atrocities on the wounded, scalping, disemboweling and shooting those who were still alive. Even to an old warrior like Black Kettle, it was almost more than he could bear as he watched one trooper cut the belly of a pregnant squaw with his saber and pull the unborn infant out. Another cut the scrotum from his fallen friend, White Antelope, and held it high for other troopers to see.

Although it made no difference, Black Kettle was unaware that this was not an ordinary troop of cavalry but a group of Colorado militia being led by a self-proclaimed general who wished to make a name for himself in his quest for the position of Territorial Governor of Colorado.

The volunteers killed ninety-eight women and children and twenty-five men of his tribe four years ago and the memory still haunted him day and night.

Black Kettle, Chief of the Cheyenne Nation, had recognized many years ago that the Indian was no match for the guns and the cannon of the *white-eyes*. He had fought them and he had beaten them in many battles, but always there were more to take their place, and less of his braves to fight the next battle. And Sand Creek had taught him that the *white-eyes* could be vicious in victory.

That is why he agreed to try one more time, just eleven months ago, to seek peace when a message was sent that the *white-eyes* were sending emissaries to once again offer a peace proposal. He led his tribe to the designated site at Medicine Lodge where Kiowas, Comanches and Arapahoes joined them. The peace commission came with a huge wagon train of supplies as gifts and after two weeks of negotiating, a settlement was reached. Under the leadership of Black Kettle, the Indian tribes agreed to remain within the boundaries of a designated reservation; except during the hunting season and the commission agreed that the U.S. government would supply them throughout the year with needed supplies of food, clothing, rations, housing and vocational training. However, the agreed-upon supplies never materialized and the tribes were forced to leave the reservations or starve. The treaty had been broken by both sides.

Black Kettle knew that someday the horse soldiers would be

back and the war would begin again. Quanah's friend, One Arm, had warned the tribes only two moons ago that the soldiers would come if they refused to go back to the reservations, but he felt secure on the Washita with over a foot of snow on the ground. He returned to the warm fire within his tipi where his squaw had prepared his evening meal of roast venison. Later, curled in his bed of warm skins with his squaw by his side, he forgot about Sand Creek and dreamed of the coming spring when he would join the younger braves in chasing the buffalo across the plains.

It would be the last dream of the old warrior, for about the same time that he dropped off to sleep in his bed of buffalo robes on the Washita, Lieutenant Colonel George Armstrong Custer, the officer the Indians called Yellow Hair, was crossing the icy Canadian River with 800 mounted 7th Cavalrymen, only a few hours ride to the north.

Custer had left Camp Supply four days earlier during the midst of a driving snowstorm with orders from General Sheridan to "kill or hang all warriors and capture all women and children." Sheridan had determined that the only way to successfully fight the plains Indians was to fight them in the winter when they were confined to their lodges because of the weather. He could have picked no worse weather to start his campaign. Custer marched his men unmercifully through the blizzard, sometimes unable to see the scouts ahead. The snow stopped during the night and the temperature dropped to below zero and remained below freezing for the next three days.

Upon reaching the Canadian, Custer sent Major Joel Elliot with a small scouting party upriver to search for sign. A short while later, a messenger returned from Elliot's scouting-party saying they had crossed a fresh Indian trail leading south.

Custer and his main party caught up with Elliot about nine p.m. in a protected creek bottom where he rested the troops and allowed them to build some small fires and brew some coffee. They ate a meal of hardtack while waiting for the moon to rise. The sky had cleared and the moon was bright and offered light enough to follow the Indian trail in the snow.

Before dawn, the contingent of freezing cavalrymen topped a ridge above the Washita River and looked down upon the sleeping village of Black Kettle's tribe, no more than a mile away, bathed in the brightness of the winter moon. They moved back behind the protection of the hill where Custer divided his command so that at

dawn it could attack from all four quarters, leaving no escape route for the unsuspecting Indians. They quietly took their positions and waited through the freezing night for daylight.

Custer did not know who was in the village, nor did he care. They were savages who should have remained on the reservation and he intended to make an example of them. If he was ever to regain his general's brevets, he needed a victory over the recalcitrants, and this was his opportunity for that victory.

By dawn, a heavy fog had settled across the river bottom which offered additional cover as the four groups of cavalry converged on the encampment. There was no way for 800 mounted soldiers to move quietly, packs rattled, harnesses jingled and rifles banged against saddles, but the village continued to sleep until the troop was within firing distance.

Custer gave the order, the bugler sounded *charge*, and the horses broke into a gallop as the soldiers yelled their battle cry. A lone Indian awoke the camp with a rifle shot as the sounds of the bugle echoed through the fog-filled valley.

Black Kettle awakened with a start, sweat breaking out on his forehead. He thought he must have been having another one of his nightmares of the Sand Creek massacre. Then he heard the yells of the soldiers, the muffled thunder of hooves rushing through deep snow, and the rifles blasting as frozen fingers squeezed icy triggers.

"It can't be happening again," the old chief shouted as he grabbed his rifle and leaped out of his tipi into the early morning light. But it was happening! His eyes were filled with charging horses coming from every direction out of the fog and his ears were deafened by the sound of eight hundred rifles which seemed to fire as one. He raised his own rifle and fired at the nearest rider and watched as the trooper disappeared from the horses back, spreading a crimson stain on the snow as he fell.

Other braves leaped from their tipis, kneeling in the snow, some with bows and arrows, some with rifles, all firing at the charging soldiers. Women and children rushed from the lodges and ran for cover in the surrounding trees. But soldiers were everywhere and there was no place to hide. Sighting down the barrel of his Winchester, Black Kettle could see another soldier charging out of the fog. He hesitated, for this one had on a coat of buckskin and long, yellow hair flowing from beneath his hat. Rather than a rifle, he held a revolver in his hand, and the revolver was pointed at Black

Kettle's chest. As Black Kettle slowly squeezed the trigger, he could see an orange flame belch from the muzzle of the cavalryman's revolver and felt the weight of a thousand buffalo pounding on his chest. His rifle fired and as he fell backwards, the last thing he saw was a round dark hole appear in the hat of the yellow-haired horse soldier. "Too high," he whispered as darkness closed in on his mind.

In a matter of minutes Black Kettle and his wife lay dead next to their lodge and one hundred and three other Indians were sprawled dead or dying in the foot-deep snow.

In the heat of the battle, it was hard to distinguish women and children from men, consequently those who ran or resisted were shot. A few had escaped, but others, all women and children, were captured and herded into the center of the village.

Major Elliot, leading a group of nineteen calvarymen, disappeared downstream on the trail of some of the fleeing survivors. After trailing them only a few miles, they stumbled upon a large Kiowa village, and before they could retreat they were surrounded and pinned down by hundreds of Kiowa warriors who had been alerted by the sound of battle upriver. Elliot and his men were quickly overrun and killed.

On this day, Colonel Custer was very lucky. What he failed to realize was that many different tribes had picked this area of the Washita River as their winter campground, and thousands of Indians were camped along a twenty mile stretch of the valley. Had the different tribes mobilized and struck, or if Custer had continued his march downstream, his force would have been massacred. However, that was not to be the case, and to the disgust of many of his officers, after only a token search for Major Elliot, Custer ordered the lodges of the Cheyennes to be burned, the seven hundred captured horses shot and the troop ordered back to Camp Supply, driving their fifty-three captives before them.

Less than a day's ride from the battlefield, Jim Cole and Ned Armstrong were busy with morning chores, unaware that the first of many clashes between the army and the Indians had taken place. And in the deep canyon of the Red River, Quanah's tribe, protected from the blast of the winter storm, rested contentedly in their tipis, telling tales of past buffalo hunts and successful battles against their enemies.

26

The winter campaign of 1868-1869 accomplished one thing for General Sheridan. All of the tribes, except the Kwahadi and Kotso- teka Comanches, decided it would be better and safer to make the reservations their headquarters, if not their home. The braves con- tinued to slip away to the *Llano Estacado* on hunting forays, and on numerous occasions, would make raiding parties on the hapless Texas settlers who were slowly encroaching northward into the his- toric hunting grounds of the Plains tribes.

The two Comanche chiefs,Quanah of the Kwahadis and Coy- ote Droppings of the Kotsoteka refused to go to the reservations and remained on the plains, living their life of freedom, roaming the broad prairies and living off the land. Even with most of the tribes living on the reservations, 1869, 1870 and 1871 became three of the bloodiest years along the Texas frontier. And even though much of the raiding and pillaging was done by the Kiowas, who were led by the vicious chiefs Satanta and Satank; Quanah and the Comanches who refused to live on the reservations were blamed.

The absence of the Indians from the northern plains resulted in a tremendous increase in the slaughter of the buffalo herds north of the Canadian river. Not only were the herds being hunted commer- cially for their hides, eastern gentry were riding the rails to Dodge City and making hunting expeditions onto the plains for sport. The herds, which had been estimated to contain as many as fifty million head in 1850, were being slaughtered by the tens of thousands, and

each year the pickings north of the Canadian became harder to come by. The buffalo slaughter only added fuel to the fire, giving the red man more incentive to raid and plunder.

Even with all of the killing and raiding to the south, the tribes continued to respect the friendship of One-Arm and his friends at Ceebara, stopping on occasion to visit and exchange gifts as well as to trade horses.

General Sheridan and General Sherman, perplexed at their inability to establish peace on the plains, began to lay plans for an all-out campaign which would wipe the Comanches from the *Llano Estacado* forever -- and the buffalo hunters were the center of their plans.

By spring of 1869, life at Ceebara had settled down to that of a typical frontier ranch. Many battles were waged between ranch hands in their efforts to win the favors of Jaunita, the fiery daughter of Maria and Ramon. Although she flirted with them all, her heart was set for Slim and her beauty soon prevailed. The Colonel performed another wedding and Slim and Jaunita set up housekeeping in a small sod and log cabin built below the bunkhouse on the edge of the spring-fed stream. New life on the plains was evident as the sounds of a new-born baby girl could be heard coming from the small cabin.

Each fall, for the next four years, the cattle, fat from the summer grazing, were brought down from the plains and the steers which had grown to the proper size were trailed northward up the Ceebara Trail to Dodge City. The heifers were kept for brood stock and soon the Ceebara herd had grown to over ten thousand mother cows. Ceebara trail-hands became well known in the frontier town, in the saloons as well as in sheriff Masterson's jail. They won most of their fights and were successful in courting some of the prettiest of the saloon ladies, marrying them and taking them back to the ranch in Texas.

The sound of children became a familiar noise in the ranch compound, as the Ceebara family continued to grow. Young Cole Armstrong, sporting the red hair of his mother and the strong body of his father was growing into a fine ranchhand, tutored by his doting grandparents, Jim and Belle, in the art of horsemanship. On his sixth birthday, Jim presented his grandson with the pick of the huge horse remuda, a dark chestnut gelding with dappled white spots on his rump which was the result of the mating of the Virginia mare and Ned's buckskin stallion.

Slim had patiently broken the fiery chestnut, turning him into the best and gentlest cow horse on the ranch. They all watched as the six year-old climbed into the saddle and proudly rode him around the corral, his wide-brimmed felt hat pulled tightly down to his ears. "Watch, Grandpa!" he shouted as he kicked the chestnut into a lope around the perimeter of the pen.

"What'll you name, him, son," Jim asked as horse and rider pulled up in a cloud of dust next to the fence where the family sat watching. Without hesitation, the six year-old answered, "Comanche!" as he kicked the horse into a lope and headed out the gate of the corral and down the trail to the creek. Horse and boy would be as inseparable in the coming years as grandfather and his black stallion had been during the past.

The huge herds of buffalo, although dwindling in numbers, continued their migrations, going north in the spring and returning south in the fall. The *Llano Estacado* south of the Canadian, void of all white men except those at Ceebara, became a haven for the shaggy animals. But that was to cease the spring of '73 when Billy Dixon returned with his crew of skinners and stopped at the gates of the Ceebara headquarters.

Jim's greeting was understandably cool. He would not easily forget his experience with those first buffalo hunters, whose scar he still carried above his heart, and their abuse on his lovely Belle would always be in his memory.

He did not ask Dixon to dismount, nor did he invite him into the ranch house. Standing with his left hand resting on his gun butt, he spoke tersely, "Buffalo hunters are not welcome on Ceebara land, Dixon. I warned you before and I tell you again, this land and everything on it belongs to me. If you don't want to end up as buzzard bait like the last bunch of hide-hunters who trespassed on my land, you'd best turn them wagons around and get the hell back north of the river."

Billy Dixon, taken aback by Jim's greeting, spat a brown stream of tobacco juice and nervously wiped his mouth with the back of his sleeve before responding. "Hell, Cole, I don't know what you're all fired up about. We ain't been hunting on your land and don't intend to. We're just on our way up west by old Bent's fort. Them buffaler herds been trailing acrost the river just north of them old 'dobe ruins and we thought we'd catch 'em as they climb the slopes on the other side. Just thought we'd stop and say howdy to you

folks and didn't 'spect as how we'd be breaking no laws just riding acrost your land."

Belle came out of the ranch house and walked across the yard to the gate where the two were talking. "Howdy, Miss Belle," Dixon said, removing his dusty hat from his grimy hair. Belle nodded and smiled. Turning to Jim and placing her hand on his which was resting on the butt of his gun, she said, "Jim, you know Billy had nothing to do with our run in with those hunters. He's no more responsible than you or I or anyone else as to what happened. That's over and done with. Now where's your manners, ask Billy to come in and set awhile, I've got the coffee brewing."

Jim looked at her, then at Dixon, "Reckon she's right, Billy. But we've had us a bad experience with buffalo hunters and you might as well know that I ain't about to forget it nor forgive it. Light off of that horse and come on in and set awhile."

Dixon dismounted lightly, handed the reins to one of his riders, and proceeded to knock some of the trail dust off of his buckskins with his hat as they walked towards the ranch house. Jim spoke to Maria who had appeared on the front porch, "Fetch those boys some coffee, Maria, and some of those fancy cookies you're famous for."

Ned rode up, dismounted and tied his mount to the hitching post and joined them as they entered the house.

"Now, what's this about a run-in with buffaler hunters, Jim. Seems to me it must have been tolerable bad to get you so rilled up," Dixon said as they sat down at the huge dining table.

Jim related the story and Dixon listened astounded. "No wonder you nearly drew on me when I rode up, Jim. I couldn't have blamed you if you'd have shot me in my tracks, but I hope you don't think me and my crew is part of that mangy lot. Although I got to admit, they's a lot of 'em that's just as mean," he said as he sipped his coffee.

Looking at Jim, then at Ned and back to Jim, then gazing intently into his steaming coffee, Dixon nervously spoke again. "Jim, you ain't going to like what I'm fixing to say, but its got to be said, it's the main reason I came this way so's you'd know what to expect."

Looking up, he continued. "General Sheridan's on the warpath. Seems your friend Quanah and his braves don't cotton to that reservation life and refuse to follow the General's orders. Also, they's lots

of stealing and murdering going on down south that they're getting blamed for. Sheridan says the best way to beat the injuns is to destroy their commissary and he's sent out word from Fort Dodge that the buffaler on the *Llano* are open game to anyone that wants to take 'em, and he's promised if the Comanches give any problems, he'll send in his cavalry to protect the hunters. There's hundreds of 'em getting outfitted in Dodge now, including a bunch of eastern city slickers and you can bet your hat they're going to be heading this way soon; if not this summer, they sure as hell will be here next spring."

"Damn!" Jim said as he stood and paced around the room. "The grass of these plains will be soaked red, not only with the blood of the buffalo but with the blood of the red man and the blood of good soldier boys. Why in tarnation can't the army leave the plains and the buffalo to the Indians."

Pounding his fist on the table, he almost shouted. "I'll never forget what Chief Black Kettle told me when I went to warn him just a few months before he and his tribe were slaughtered on the Washita. He couldn't understand why the army wanted them to go to the reservations and farm. He said his people didn't know anything about the white man's ways. They only knew how to hunt food, not grow it."

"Why limit us to certain boundaries, beyond which we cannot follow the herds," he said. "If you want the land for settlement, come and settle them. We will not disturb you. You may farm and we will hunt. You love the one and we love the other. Let us live together in peace, but let us each respect the other's rights."

"The old chief was right, you know," Jim added, angrily, "and now it comes to this. Because the damn politicians and the military say the Indian has to live by our rules and our standards, this country is going to be washed in a blood bath just as certain as we're standing here! Sure, the Indian will lose, but there will be no winners. Can you imagine what this country will be like with the great buffalo herds destroyed, the grass plowed, and the noble red man forced into a welfare state where he can only beg for what he needs?"

Jim stopped his pacing, looked at Billy Dixon and said, "Well, you can tell your damned buffalo hunters to come ahead if they've got the guts, I know I can't stop them, but I owe it to my friend Quanah to let him know what's going to take place. And I don't

take no responsibility on what he and the other Indians are going to do about it, and you can tell General Sherman that I'll be doing everything I can to keep them off of Ceebara land."

"Can't say as I blame you none, Jim, but if'n I was you, I'd get my family packed up and head my tail back to civilization until this all blows over. Them redskins may be your friends today but anybody that's got white skin ain't going to have a chance in hell if they go on the warpath."

After camping the night on Red Deer Creek, Billy Dixon and his crew of skinners headed west the next morning, seeking the herds as they crossed the Canadian. Jim and Ned, mounted and leading a pack mule, left at daybreak, climbed the buffalo trail to the cut in the caprock and headed southwest in search of Quanah and his tribe. Jim figured that they would find the Comanche village somewhere between headquarters and the big canyon at the head of the Red River.

Although they picked up lots of sign where the Indians had dressed out buffalo, they found no camp. Late afternoon of the second day, they spotted a small dust cloud rising from the prairie floor three or four miles to the west, and Jim, looking through his binoculars, could see several horses which were drawing travois loaded with hides and meat. They were being led by squaws, apparently returning to camp after dressing out the days kill by the braves.

As he watched, the small party vanished, disappeared as if they had been swallowed up by some unseen giant on the flat prairie floor. Jim and Ned kicked their mounts into a run and headed for the point where they had last seen the Indians. Suddenly, there before them, yawned the debths of the big canyon, sliced deeply through the flat prairie grass, and the dim trail which led into a small cut in the caprock.

Riding to the rim, they looked down to see the small band of women slowly traversing the canyon walls along the narrow trail, and a half mile below, nestled along the banks of a sparkling stream was the Comanche village. Hundreds of triangular tipis pushed upward from the canyon floor, their tan buffalo skins, bleached nearly white from the sun, stretched tightly around the slender lodge poles. The camp was a beehive of activity, meat was being sliced into small strips and strung on drying poles above smoking fires, hides were stretched out on the grass and old women and children

were busy scrapping every particle of meat from the surface.

A large herd of ponies were grazing a quarter of a mile farther down stream and were being tended by a group of teenage boys. Towards the center of the village, a group of old, grey haired warriors sat around the simmering coals of a small campfire, heating and chipping away at flint, fashioning the points for the arrows which would be used by the braves on another day.

A group of older squaws were busy getting their fires just right to begin cooking the evening meal. Most of the braves, fatigued from the days hunt, were sitting and lying in the shade of the many cottonwood trees which lined the creek's banks. A thin haze of blue smoke hovered over the camp and left a smell of burned mesquite and cedar in the air.

Jim and Ned urged their horses to the small cut in the canyon's rim, and started descending to the canyon's floor. They were halfway down before the alarm was sounded in the camp that intruders were approaching. Braves jumped quickly to their feet, grabbed their bows and rifles and rushed to the edge of the camp; however, when Quanah saw the black stallion and the empty sleeve where Jim's right arm was missing, he recognized his friends from nearly a half mile away and ordered his warriors to lower their weapons.

Like children, the Indians gathered around the two horsemen as they rode into camp, laughing excitedly at this unexpected visit by the only white men whom they trusted. Jim rode up to Quanah who stood straight and proud with his arms folded across his broad chest. Holding his hand up, palm out, in the Indians' sign of peace, Quanah welcomed his friends. They returned his greeting then offered their hands for the white man's handshake which Quanah accepted.

"Welcome to the village of the Kwahadis," Quanah said. Speaking in the Comanche dialect, Jim replied, "It is good to see you, my brother."

Other braves and sub-chiefs crowded around and Jim and Ned made a point to speak to each, calling them by name, and offering their hands in greetings. There was Man Who Walks Like Dog, Spotted Antelope, Wounded Eagle, White Horse, Howling Wolf and Buffalo Calf, who had led the first herd of Ceebara steers to the railhead at Dodge City. And standing silently behind the group of braves were the squaws, with the raven-haired Morning Star smiling happily at the sight of One Arm whom she had nursed back to

health from the stab wound which had nearly taken his life. At a signal from Quanah, a young boy appeared at his side, about seven years old which Jim recognized as his name sake. The Comanche chief proudly pushed the boy forward and Jim squatted on his heels, reached out and took the boy's hand.

"This must be Jim Bold Eagle," Jim said, looking the boy in the eye. "A fine warrior to be carrying my name."

The boy smiled broadly and stuck out his chest at this compliment from such a noted man as One Arm. Both Quanah and Morning Star also smiled proudly.

The Comanche chief led the way to the center of the village, where a large cottonwood cast its shade on many brightly colored blankets. Quanah stood before one of the blankets as Morning Star disappeared inside a nearby tipi and quickly reappeared, carrying the long headdress of white and black eagle feathers which she placed on his head. The other sub-chiefs took their places in a semi-circle, facing Quanah, who had placed Ned on his left and Jim on his right. At his signal, they all sat down on the blankets and crossed their legs.

The pipe of peace was lit and Quanah held it straight out from his mouth and took a deep, slow draw, filling his mouth with smoke. He held it for a moment, then exhaled through tightly drawn lips. The strong, acrid smoke curled upward.

With both hands, he ceremoniously handed the pipe to Jim who took it, and with his left hand, held it straight in front of his mouth and took an equally slow, long draw. As he exhaled he handed the pipe to Ned who did the same, this time with no sign of coughing or gasping. Quanah smiled, remembering how Ned had choked the first time they had smoked the pipe of peace together.

Each of the other chiefs took their turn at the pipe, and when it had made the circle, Quanah handed it to Morning Star who stood quietly to his rear.

"To what do we owe the honor of your visit to our lodge, One Arm?" he asked in broken English.

"I carry news which I felt you must have, Chief Quanah," Jim replied. "You will not be glad to hear that many white buffalo hunters are planning to come to this land of the Comanches to take hides. And they come at the request of General Sheridan who has promised to send many horse soldiers to help them if there is trou-

ble with the tribes. I come to warn you as a friend that if you try to stop them, they will kill you and all of your people. I hope that you will move your tribe to the reservation until the hunters and the soldiers leave."

"We will never leave the land of the buffalo," Quanah replied bitterly. "And we will not allow the white hunters to slaughter the buffalo and leave the meat for the coyotes and buzzards. If the long-knives come, they will also find our arrows straight and true, and many of them will die."

"I cannot blame you for your bravery, my brother," Jim replied. "I, too, do not wish to see the buffalo slaughtered, but I do not wish to see my friend and his people killed in a war which they cannot win. I know the Comanches are great warriors and that your arrows are straight but there are too many of the horse soldiers. For each brave you send into battle there will be a hundred long-knives sent to meet you. Take your squaws and your children back to the reservation if you must fight, at least they will be safe from the horse soldiers' bullets."

"No, we will keep our families with us, and we will all fight," Quanah replied. "I will call together the Kiowas, the Cheyennes and the Apaches and we will fight as one. The buffalo belong to the Indian, and if the buffalo is gone, we will starve, so it is better to die fighting than to starve."

After the pow-wow, Jim and Ned were led to an empty tipi where their packs had been stowed, rolled out their bedrolls and slept soundly until morning. Packed and saddled, they left the next morning for Ceebara, taking with them heavy hearts, knowing that the determination of the army and the Comanches, and the invasion of the hide-hunters, would probably spell doom for their friends, the Kwahadi Comanches.

Quanah watched as they climbed the canyon walls, he too, with heavy heart, knowing that at some time in the future these two white men might become his enemies in a war which neither wanted nor had any power to prevent.

Jim and Ned turned their horses to the northeast after reaching the top of the canyon, hoping to find Billy Dixon and ask him to intercede with General Sheridan to stop this invasion of the buffalo hunters. By mid-afternoon, they were nearing the breaks which bordered the Canadian River and at the same time, had intersected a huge, migrating herd of shaggy buffalo. They saw the dust and

heard the steady thunder of the moving hooves as they slowly grazed northward before they actually saw the animals.

As they topped a small rise in the prairie, they were astounded to see a massive black blob of gyrating bodies stretched as far as the eye could see to the east, and two to three miles across. It was as if someone had taken a brush and painted a black sea on the prairie canvas. The animals were moving slowly to the northwest, and the lead animals were no more than a mile to the east of the two riders.

"We best hurry and get past their line of travel, Ned," Jim said as they watched the herd moving in their direction. "If we don't get to the north of them before they get here, we may have to wait until dark for them to pass."

"I think you're right Colonel," Ned answered. "From the looks of that herd, we might be here a week before they all get past, they must be fifty thousand head in that bunch!"

As Ned was speaking, a loud crack was heard above the steady grind of the hooves and Jim recognized the sound immediately as that of a fifty caliber Sharps rifle, fired somewhere towards the rear of the herd. Immediately the black ocean began to move and sway as the herd stampeded across the flat prairie, coming directly towards the two riders.

"Let's get the hell out of here, boy!" Jim shouted as he gave the stallion the reins. Ned didn't have to be told twice, as he released the rope on the pack horse and followed the Colonel to the north.

Their horses were fast, but not fast enough! The stampeding herd was now within a half mile of them and they still hadn't reached the northern edge of the boiling mass. Jim turned his horse to the west, traveling in the same direction as the herd, hoping that the leaders would either stop from fatigue or would turn one way or another. But the herd continued to come, and seemed to be gaining ground on the two riders. Ned thought he could feel the hot breath of the leaders on the back of his neck as he dug his spurs in the buckskins side to get a little more speed.

When it appeared that they were going to be caught up in the middle of the stampeding herd, the prairie suddenly dropped off into a small playa lake, which was no more than three hundred yards across and no deeper than two feet at its deepest point! Jim never slowed the black as he hit the edge of the water in a full run, with Ned close behind. The horses faltered and nearly stumbled, but regained their balance and thrashed and splashed to the middle

of the lake, bogging in the soft mud which covered the bottom.

The buffalo herd split as it reached the playa shores, with half of the herd going right and the other half going left, continuing to move in their fast, awkward gait. Jim and Ned sat in their saddles for more than two hours watching as the black, shaggy animals surrounded the lake and disappeared over the rise to the west, continuing to run as fast as their short legs would carry them, each with its mouth open and long black tongue dangling out. There was a continual steady roar, as the last of the herd disappeared in a dust cloud over the western horizon.

The Colonel and Ned rode out of the lake to the eastern shore, and headed their horses back across the trampled grass in the direction from which they had come, searching for the lost packhorse. They came across numerous buffalo calves which had been trampled in the stampede, and soon spotted the hapless pack animal, which lay dead only a short distance from where Ned had released him three hours before, his body cut and bruised by the sharp hooves of the stampeding herd.

Most of the supplies had been ruined and they were only able to salvage a few of the cooking utensils and a little food which was under the dead horse's body. As they retrieved what could be used, Ned wiped his forehead and said, "I don't know about you Colonel, but that just about scairt hell out of me. I can tell you for certain, I thought we was gonners!"

"I 'spect you was right, son. if that lake hadn't sprouted when it did, we'd be buzzard bait just like this pore packhorse. The good Lord must have been watching over us today," Jim replied.

They mounted up and continued to travel east down the buffalo trail, searching for the person or persons who had fired the shot and stampeded the herd. However, darkness soon overtook them and they were forced to make a dry camp for the night.

They hobbled the horses and turned them loose to graze, rolled out their bedrolls and stretched out under the stars using their saddles for pillows. The coyotes had already started yapping in the distance, feeding on the packhorse and the dead calves. Other than that, the only sound that could be heard was an occasional soft whinny from one of the horses to be answered by the other. The moon had not yet risen, and Ned was concentrating on the brightness of the stars and the blackness of the night as his mind wandered back through the eight years since he and the Colonel had

met on the battlefield in Virginia; eight years which seemed like an eternity.

He had grown from a green kid, still wet-behind-the-ears, to a strong, muscular, frontiersman. His long blond hair, which was bleached nearly golden from the sun and wind, was now kept trimmed by Kate about halfway to his shoulders. A flowing mustache, somewhat darker, dropped from beneath his nose to each side of his mouth, leaving the impression that he was always smiling. Dark wrinkles trailed away from each corner of his eyes, caused from too much squinting in the bright Texas sunlight. He could ride and rope as well as the best cowhand, and had gained the respect of the older cowboys.

Not only had he grown in stature and looks, but through practice, he had learned to use the Colt revolver as well as his tutor, the Colonel. He had always been a marksman with a rifle, and now he could do as well with the revolver, drawing and firing as quickly as the blink of an eye and knocking down a running jackrabbit at fifty paces. The Colonel's Colt and the Bowie knife were as much a part of his dress as was the large straight-brimmed felt hat which he wore, pulled low in front, both summer and winter. He was quiet and easy going, slow to temper but a battler when the chips were down. When Belle asked Jim about Ned's maturity, he proudly replied, "He'll do!"

"Colonel?" Ned asked softly, thinking Jim might have already fallen asleep.

"Yeah,?" Jim responded sleepily.

"I was just thinking, you never did tell me what took place when you was inside the Alamo."

"Ain't much to tell, boy," Jim responded. "When Colonel Travis, Davy Crockett, Jim Bowie and the others heard Santa Anna was coming, they thought the best place to hold him off and give General Houston time to get his troops organized was inside that old church. It had walls thick enough to turn cannon shot," he paused for a moment as if thinking, then continued. "Wasn't no one looking to be a hero. It just looked like the thing to do at the time. We had a bird's eye view of everything around it from our shooting positions on top of the wall and we picked them Mexican soldier boys off like ducks on a pond every time they tried to rush our positions."

"I guess at first we never thought about having to get out of that

old coffin, I know I didn't. I thought we'd stay there, holding off old Santa Anna until our food run out, then we'd up and slip out at night or fight our way out and join General Houston wherever he was. But when them ten thousand Mexicans surrounded us, I saw right quick that there wasn't going to be no escape for all of us. I guess the others really thought that we could hold 'em off until the General could put together an army and come rescue us, I just don't know. I do know one thing, though. There weren't no regrets from any of those Texans. They came to fight and that they did!"

"What about Davy Crockett, I heard back in Kaintuck that he stayed drunk most of the time, is that right?" Ned asked.

"I don't know what he was before I met him, but I can tell you he wasn't no drunk in '36. Oh, he could drink with the best of them but he knew when to put the jug down. He was a gentleman, for sure, and folks in Texas respected him. I'll bet my hat he'd have been President of Texas someday, right along with the General, if he'd have gotten out of that war alive," Jim said.

"Now, Bowie," he continued, "was another story. He'd rather fight than eat and was always sharpening that big old frog-sticker when there wasn't nothing else to do. And he didn't have to find much of an excuse to break out the jug. The only thing he liked better was a good bar room fight and a joust with the women. I don't recollect ever seeing him staggering drunk, but he sure as hell liked to drink."

"I've thought about it a lot, boy, since me and you came out here to the plains. This is what that whole crew was fightin' for even though they never seen it. They wanted to be free, and didn't want to be crowded in. If they'd of made it out of the Alamo, I'd lay my life that most of 'em would be right up here with us, helping tame this wild country."

Ned could tell that the Colonel was reliving those days with his old friends, and asked, "Why'd they choose you to carry the message to General Houston when there was men in there with a lot more experience."

"I've asked myself that question a thousand times, son, and I guess I won't ever know. Maybe it was because they felt they needed the men inside to fight much more than they needed a green horn kid like me," Jim said. Reflecting back, he added. "And then, maybe it was because I was the smallest, could ride the fastest, and dodge the most bullets. I just don't know --- but I do know one

thing for sure, it's a miracle that I got through those lines without catching a ball between my eyes, There was Mexicans ten deep everyplace I turned. I had a good fast horse, and what he couldn't out run, he jumped over. By daylight the walls of that old mission was thirty miles behind me."

Looking up at the stars through half closed eyes, Ned said, "I'm mighty proud you made it, Colonel," as he dropped off to sleep.

They were already saddled, mounted and on the trail when the sun broke the horizon the next morning and had ridden only a short distance when they came across the carcasses of nineteen buffalo scattered in an area covering about two hundred yards. Four of the large bulls had their heads cut off just above the shoulders, the other fifteen were untouched except where the coyotes had ripped them to pieces and picked at the flesh.

"Why would anyone want to kill a buffalo and take only the head?" Ned asked as they looked down on the remains.

"Sport hunters, Son. Looks like we've already got some of those eastern *gentry* that Billy was talking about. They just want the thrill of the hunt and want to carry a trophy back to Philadelphia that they can hang on the wall. It's a good thing that Quanah and his braves don't see this, they'd hunt them down and lift a few eastern scalps to hang on their lodgepoles," Jim replied.

Jim kicked his horse into a trot following a single set of wagon tracks which led away from the carnage to the northeast. Ned's buckskin fell in beside the black stallion, and they rode in silence for most of the morning.

The terrain became rougher as the flat prairie fell off into the rolling hills and canyons which rose from the wide valley cut out by the Canadian River. A thin curl of smoke rose from the floor of the valley two or three miles ahead, but the source of the smoke was obscured by a butte and the wagon tracks led towards that smoke. Red and brown cliffs marked the northern slope across the river, and now and then the thin blue snake of the Canadian could be seen winding its way below the cliffs. As they topped the last hill above the river, they could see the wagon parked next to the adobe remains of old Bent's Fort across the river. Several men were standing around the fire, drinking coffee and chewing on the remains of a buffalo steak dinner. Two men were hitching the team to the wagon, and two more were saddling the other six horses.

They all looked surprised as Jim and Ned rode up. One of the

men who was hitching the team walked a few paces to meet them. It was apparent that he was the boss of the outfit.

"Howdy," he said. "Looks like you boys could use a hot cup of coffee." Glancing at the Winchesters which both Jim and Ned carried in their saddle holsters, he added with a smile, "You ain't going to knock down very many buffaler with them pea-shooters. Names Shadler, Ike Shadler," he said as Jim and Ned dismounted. He stuck out a big, calloused hand which Jim took in his.

"Jim Cole," he said, "and this is my pardner, Ned Armstrong." Ned stepped forward and shook Shadler's hand. The rest of the group continued to stand around the smoking campfire, looking inquisitively at the new arrivals. There were four of them and Jim could tell by the way they were dressed that they were a long way from home. They had on black denim trousers with their pant's legs tucked into the tops of nearly new black riding boots. Their buckskin coats appeared to be straight out of a mercantile, with hardly a spot of dirt or grease to be seen. Each one was sporting a large brimmed black felt hat, held down with a buckskin thong tied under the chin. They were clearly dudes from the east. Four long barreled, new Sharp's fifty calibers stood butt down, barrels propped against each other bivouac-style, a short distance from the campfire.

Ike Shadler spoke again, turning and pointing to the man who had just finished hooking the last trace chain to the doubletree on the wagon, "That's my brother Shorty, and those two fellers over by the horses is Sam Smith and Frenchy. They work for me." Nodding towards the men standing by the fire, he said," Those gents are from back east in Pennsylvany. Bankers, they be, and they had a hankerin' to kill a shaggy so me and Shorty hired out to oblige 'em."

Jim nodded to them in acknowledgement of the short introduction.

"Cole? Jim Cole! Why you're that feller that brings them 'horns into Dodge every fall, ain't you. I heard you had a spread somewhere in these parts. Billy Dixon told me about you, but I didn't know you was this far south," Ike said in recognition.

Jim tied his horse to the back of the wagon and walked to the fire where a blackened coffee pot was spouting steam over the hot coals. He picked up a dirty cup, blew the ashes out of its bottom, and poured it full.

Turning back to Shadler, he said, "Dixon told you about me,

did he? That's who we were looking for; said he was going to be hunting up here around the old fort. Don't reckon you've seen him?"

"Haven't seen him but we seen his sign," Shadler answered. "Looks like he might have camped here before heading north, fresh wagon tracks lead off up in the hills. What you need Dixon for?"

"To carry a message back to Dodge, to General Sheridan," Jim replied.

"Maybe I can oblige you," Shadler said. "We're breaking camp and going to head back north. These gents got all the hunting they want, and some damn good trophies to carry back to Philadelphy to brag about. We should be pulling into Dodge in three or four days."

"You ain't going to like the message I'm sending, seeing as how you're in the business of killing the Indians' buffalo," Jim said, looking Shadler in the eye. "Dixon told me about the General's encouraging hunters to start taking hides south of the Canadian, and I imagine that's the reason you brought these bankers this far south. You're lucky you didn't lose your scalps yesterday, even if you are here with the General's blessings. The only reason you didn't is because the Indians haven't run across your trail. The Comanche's are still out here on the plains, and they take offense at white people who slaughter the buffalo just for its hide or head. The chief of the Comanches told me a couple of days ago that he'll kill anyone he catches on the *Llano Estacado*. You'd best be thankful that he didn't catch you!"

It was apparent that the Shadler brothers, Frenchy and Sam Smith didn't appreciate what Jim had said. The other three stopped their work and walked to Ike's side, hands resting on the gun butts which hung from their belts.

"You talk like a squaw man, to me," Ike said. "If the Comanches are so damned mean, why ain't you lost your scalp if you're out here living amongst them?"

When Frenchy moved to draw on Jim, Ned's Colt was pointing at his chest before the gun ever broke leather. The hunter dropped the gun back in its holster and moved his hand to the front and nervously hitched his thumb in his gun belt.

Ned swung the barrel around, covering all eight men. "I'd just listen to the Colonel, boys, if you want to get back to Dodge with all your hairs still in place," Ned said slowly. The bankers continued

to stand silently by the fire, the blood draining out of their faces leaving them as white as a wagon sheet. They certainly hadn't bargained for a gunfight and didn't intend to buy one now.

"We don't want any trouble with you, Shadler," Jim said. "Take your trophies and your trophy hunters back to Dodge and when you get there, tell everybody that's got a hankerin' to kill a buffalo, whether its for a hide or a head, that they better do it north of the Canadian or they may end up being a trophy themselves, hanging on a lodge pole in some Comanche's tipi. And pass the word to General Sheridan that the tribes are already having a council to protect the *Llano Estacado* from hunters. If the hunters come, it will be all-out war as far as the tribes are concerned."

Turning, he walked to the wagon and untied their horses while Ned continued to hold his Colt on the group. Jim mounted, and drew his gun, which he rested loosely on the saddlehorn while Ned pulled himself into the saddle.

"I wouldn't tary if I was you men, the Comanches may be just over that rise right now, looking for the hombres that killed them nineteen buffalo and left their carcasses to rot," Jim said as they kicked their horses into a gallop out of camp.

27

When Ike Shadler drove into Dodge City in July of 1873, his wagon loaded with some of the finest trophies to be brought in all year, he found the frontier town alive with activity. A scrawny herd of longhorns had arrived the day before from central Texas, having been brought up by Bob McKnight on the Chisholm Trail. The trail-hands were soaking up the saloon's fare, servicing the painted ladies and brawling in the middle of the dirt street.

Dodge City had grown into a wild, unruly frontier town, cattle delivery point and hide capital of the plains. Cowboys, hide hunters, cattle buyers and sod busters filled the streets, the mercantiles and the saloons.

Front Street extended for two blocks along the railroad and was lined with permanent buildings -- Rath and Company's General Store, the Longbranch Saloon, F.C. Zimmerman's Hardware, Kelley's Saloon, Webster's Grocery and Dry Goods, and James Hanrahan's Saloon. A total of eight saloons dominated the businesses and each was well stocked with whiskey, gamblers and women. Hardly an hour went by without the sound of gunshots being heard somewhere in the town.

Hide hunters and easterners who had come over a thousand miles to participate in the sport of buffalo hunting, gathered around the wagon as Ike pulled up to Jim Hanrahan's saloon. His clientele, the four bankers from Pennsylvania, dismounted and

proudly pointed to their fine trophies, telling the crowd of the huge herds which were moving across the plains.

"We put up our stand in a shallow depression not over a quarter of a mile from the herd which was moving northwest," one of the bankers told a crowd which had gathered around him, "and for over four hours we watched as buffalo over a mile wide moved by. We waited until the tail end of the herd arrived, and shot about twenty before they stampeded out of sight!". He emphasized his tale by sighting down an imaginary rifle barrel.

Ike Shadler was telling sheriff Bat Masterson about his run-in with Jim Cole and Ned Armstrong. "They's thousands of shaggies south of the Canadian, just waiting for the taking, but I don't know that I want to go back anytimes soon," he said. "Cole said the Comanches know that hunters are coming and they are getting all of the tribes organized to kill anyone caught taking hides."

"What about Billy Dixon?" Masterson asked, "He left here in May with a bunch of wagons and skinners and said he was going down around old Bent's Fort on the Canadian for hides. Don't reckon you run into him anywheres."

"Didn't see him but saw his sign just a few days ahead of us at the ruins. His trail led off to the north of the river, 'spect he figured it was safer to stay north of the river, seein' as how he had talked to Cole about the injuns," Ike said.

One of the persons gathered around the wagon listening to the buffalo hunters stories was Colonel Nelson Miles, from Fort Dodge, and heard Shadler mention the Indians' council. Walking over to Shadler, he inquired, "Did I understand you to say you had been south of the Canadian and the tribes are on the warpath?"

"You heard right, Colonel," Shadler responded, "One-armed feller by the name of Cole told us that he had talked to Chief Quanah of the Comanches just a few days before and that they intend to scalp anyone caught on the plains south of the river; said they was planning a pow-wow with the other tribes to get them organized."

Colonel Miles turned on his heel and hurriedly mounted his horse, heading for the fort.

That night, the saloons of Dodge City were abuzz with Shadlers' news of Indians on the high-plains south of the Canadian River. Many of the *head-hunters* who had come west looking for a trophy were having second thoughts of hunting south of the river. Even though the temptation of three dollars a hide promised imme-

diate wealth, the buffalo hunters themselves were talking of keeping their hunting parties north of the Cimarron for the remainder of the year, unless the army sent troops onto the *Llano Estacado* for protection.

The following day, a group of hunters petitioned a meeting with General Sheridan to ask for the army's protection. They were ushered into the General's office at Fort Dodge, where Colonel Miles had already briefed the General on the news which Shadler had brought from Adobe Walls.

Shadler acted as spokesman of the group, since he had first-hand information on the situation. "General," he said, "they's thousands of buffaler south of the Canadian just waitin' for the takin', but we ain't hankerin to leave our scalps down there just for a few hides. You been telling us you wanted the shaggies thinned out, and you'd give us protection if'n the tribes give us trouble. We just want your word that you'll send a troop down there to keep them off'n our backs."

"We have no verification that the Indians have counciled, Mr. Shadler," Sheridan said. "In fact, this is highly unlikely, because most of the tribes have remained on the reservations for the past two years, giving little or no trouble. However, I am dispatching scouts to Camp Supply and Fort Sill to determine if any of the tribes have moved off the reservations. I can promise you no help before next spring, but if we determine that there is increased Indian activity on the plains, we will do whatever is necessary to push the tribes back on the reservations and to protect any of our citizens who might wish to take hides on the *Llano Estacado*."

The buffalo hunters left the fort disgruntled but resigned to stay north of the Canadian until the following spring. There were still small herds to be found between the Cimarron and the Arkansas which would offer worthwhile hunting for the easterners, and enough hides to service the buyers from the European markets.

The additional time would give the hunters time to organize and be better prepared in case the Indians did make an effort to keep them off the *Llano Estacado*. Plans were made to establish a trading post at the site of Bent's old post. Hanrahan agreed to build a saloon and Rath and Wright, general merchandisers, agreed to put up a store and stock it with supplies as well as to buy any hides brought in. Myers and Leonard also agreed to build a mercantile and Thomas O'Keefe said he would put in a blacksmith where the

hunters could shoe their horses and repair their wagons.

Meanwhile, Quanah was making plans to organize the tribes. He sent scouts to the reservations, spreading the word that the white hunters would be invading the last buffalo lands and asking for all tribes to prepare for war the following spring to push the whites back from their lands. He called for a council away from the reservations at the junction of Elk Creek and the North Fork of the Red River in June, which was the time that he expected the buffalo hunters to arrive on the plains.

At Ceebara, an equal amount of activity was taking place. Jim was concerned that if war did erupt, as Billy Dixon had warned, no whites would be safe on the plains. He wasn't concerned about the Kwahadi Comanches, but he recognized that the other tribes only accepted Ceebara because of their respect for Quanah, and if there was an invasion of white hunters, that acceptance could disappear overnight.

He instructed Slim to bring all of the ranch hands in from duty at line camps around the summer grazing range, and when they had all arrived he brought them together for a meeting under the huge cottonwood which shaded the ranch house.

Belle, with her long red curls tied into a neat ponytail and dressed in her standard soft buckskin skirt and denim blouse had set up a table under the tree which was covered with sweets from Maria's kitchen for the cowboys to enjoy. Kate, who was dressed in a bright gingham dress which she had purchased in Dodge City on the last cattle drive, poured their cups full of steaming black coffee.

"Folks, I'm concerned about recent developments which could place us all in danger," Jim said, as he slowly moved his eyes around the crowd. "Our association with Chief Quanah has been the one factor which has established us as friends with all of the tribes. but that could change if the hunters start taking buffalo from the *Llano Estacado*. So far, there has been no evidence that Ceebara range has been a target of the hunters, but they have already hit the herds just west and south of the old 'dobe ruins on the Canadian. Billy Dixon is hunting now just north of the ruins, and it's just a matter of time before others will be coming to hit the big herds on the *Llano*."

He paused, choosing his words carefully, then continued. "Ned and I came onto a hunting party from Dodge City which wanted nothing but the heads to put on their walls. They killed nineteen, cut off the heads of four, and left the rest for the coyotes and buzz-

ards. Now you know how the Indians would react if they found that kind of waste. The buffalo is sacred to them, sent by the Great Spirit to provide food, clothing and shelter. They'd kill and scalp everyone who they suspected of being involved. Some of 'em might even think we were responsible, especially some of Satanta's hot-headed Kiowas or Stone Calf's Cheyenne braves."

There was a murmur of agreement around the group as the Colonel's words began to make an impression.

"I wish I could tell you that the buffalo hunters won't come, or that we'll be able to keep them off of Ceebara but I'd be lying to you if I did. They'll be here, and they'll be anywhere they can find buffalo, including Ceebara, and there's probably more buffalo on Ceebara range than any place on the plains," Jim emphasized.

Pausing, he looked around at the concern registered on the faces of his people, then continued. "Dixon says that General Sheridan's encouraging the hunters to move south. He wants the herds destroyed so he can keep the tribes on the reservations; he knows without the meat and hides of the buffalo the Indians would starve and freeze and he's using the hunters to do his dirty work. You know what that means, the plains is fixin' to erupt in a war that we can't stop, and we're going to be caught in the middle!"

The cowboys nodded their agreement, but none interrupted the Colonel.

"I figure there won't be any trouble before next spring," Jim continued. "I think we put a scare into that bunch we caught up at the ruins and they'll spread the word once they get back to Dodge. But the scare will have wore off by spring and they'll be coming, with hides worth three dollars a piece and tongues a dollar, they'll be willing to gamble a few scalps. The tribes know they're coming, so they'll get ready this fall and winter and the army's already made a commitment, they'll do whatever it takes to protect the hunters.

"That's why we've got to start making our plans now. Anybody who feels its too risky to stay around is free to go. Maybe it's time to start thinking about sending the women and children to Dodge City until this thing gets settled --."

Before he could finish the sentence, he noticed heads being shaken "no", not only by the men but by the women and children.

Slim spoke for the others. "Ceebara's our home too, Colonel," he said. "And besides, our women folk are just as good with a rifle as we are, and you may need all the guns you can muster if this

thing breaks wide open. We appreciate the offer, but we'll take our chances right along with you. You just tell us what to do, and we'll get it done."

"Thanks, Slim," Jim said, then looking at the faces of the rest of the crew, he asked, "Is that the way you all feel?"

They all spoke as one, "Yes sir, we're staying!"

"We've got work to do, then," Jim replied. "We need to extend the rock wall far enough that we can keep all of the horses inside the compound. Hay needs to be put up so we'll have plenty to feed them if we get penned in for awhile. With the spring, we won't have to worry about water, but we need to make certain we've got enough food and ammunition. We can take a lesson from the Indians and dry plenty of buffalo meat into jerky. We'll send a wagon to Dodge City and bring back a load of flour, sugar, coffee, lead and gunpowder."

Turning to Ned, he said, "Give some thought as to how we can improve the defenses around the compound, son. We want to make certain that if we are attacked that we can hold 'em off to hell freezes over!"

Ned nodded in agreement.

Speaking to all of the group, Jim said, "From now on, when you are riding range, gathering wood, moving cattle or whatever, I want one man along just as lookout; if you see any Indians, never drop your guard. Don't shoot unless they fire on you first, but always be prepared. If you see a group that looks hostile, head for home first, and ask questions later.

"We'll bring the cattle down to winter pastures early, Slim. And bring them down in small bunches, keeping the hands together at all times, so that if you are attacked, you'll have enough guns to protect yourselves. There'll be no cattle delivered to the railroad this year, we've too much work to do."

With that, he dismissed the crew.

In March of 1874, the first wagons from Dodge City arrived at Adobe Walls on the Canadian River. The old walls were the remains of the once active Bent's Trading Post which had been established by William Bent in 1843 for the purpose of trading with the Cheyenne Indians. Bent, who was married to two of the Cheyenne medicine man's daughters, was able to remain in the Indian country by supplying guns, blankets and whiskey in exchange for hides and stolen horses and mules. But after about five years he moved out

when the Indians accused him of cheating. The years had reduced the post to nothing but deteriorating walls of adobe bricks which became a landmark in a country of no landmarks.

The Shadler brothers accompanied Fred Leonard, Thomas O'Keefe, Jim Hanrahan, Billy Dixon, former sheriff Bat Masterson, and several other buffalo hunters to the prairie outpost where they hoped to start a town which would serve as a trading center for hunters who would be trailing the buffalo herds onto the *Llano Estacado.*

Fred Leonard and his partner, Charlie Myers, began work on a picket house in which to store their wagon load of supplies for their mercantile. Jim Hanrahan decided to make a sod house in which to set up his saloon and Tom O'Keefe, the big Irishman, built a small picket house where he set up his anvil and forge for his blacksmith business. The hunters pitched in and helped and soon the semblance of a small community took place.

Leonard, because of fear of an Indian attack, built a pole stockade around his mercantile, and dug a water well in the middle. Later, Rath and Wright, merchants from Dodge City sent a wagonload of supplies with instructions for Billy Olds and his wife to open their store at the outpost.

The buffalo hunters began to scout the country south of the river for early arriving herds, and soon they were bringing hides in to trade for liquor and supplies. Hunters continued to arrive during April and May and by the middle of June, over two hundred hidehunters had spread across the plains south of the Canadian, slaughtering the migrating herds by the thousands.

A good hunter, accompanied by three or four skinners could take up to one hundred and fifty hides a day which would bring him three dollars each after they were stretched and dried -- pretty good pay for five men when the average Texas cowhand was receiving less than a dollar a day.

In early June, the tribes met for council on Elk Creek. Chief Quanah, whose tribe had spent the winter camped in the big canyon, brought word of the slaughter which was taking place on the plains. He told of a hunting party he had surprised on Chicken Creek and another on the Salt Fork of the Red River where they had killed four men who were poaching on the buffalo herds. He held the bloody scalps high for all to see. The other tribes who had wintered on the reservations were furious, and were easily incited to

take the warpath. After the pipe was passed around, each chief representing the different tribes, was allowed to speak and voice his anger at the whites for broken treaties, mistreatment and misrepresentation. Besides Quanah and Coyote Droppings of the Comanches, there was Stone Calf of the Cheyennes, Lone Wolf and Satanta of the Kiowas, joined by Grey Beard, Big Bow, White Shield, White Horse, Mow-way, and Howling Wolf. Altogether, they brought over a thousand warriors to drive the white hunters from their ranges.

Satanta told of the two years of mistreatment in the Texas prison where he had been confined for leading a raiding party into Texas and slaughtering seven men in a wagon train. He shouted revenge for the death of his friend Satank, at the hands of the white-eyes.

Stone Calf told of his people's hunger the previous winter on the reservation when the army failed to supply them with promised beef and beans. His tribe was forced to kill most of their horses and mules just to keep from starving, he said, and vowed that his warriors would never return to the reservation.

The prairies echoed back the sound of the war dance which lasted throughout the night. The glistening, gyrating bodies cast eerie shadows from the huge fire which burned in the center of the council grounds. The medicine men, led by Coyote Droppings, performed their magic and whipped the braves into a frenzy. Cheap Comanchero whiskey warmed their bellies and dulled their brains as they drank and danced and whooped throughout the night.

The war party, leaving their women and children camped on Elk Creek, hit the trail the next morning over a thousand strong, their painted horses and their feathered headdresses shining in the early morning sun, they headed for Adobe Walls where Chief Quanah said they would kill many whites and steal their supplies.

The population at Adobe Walls had swelled to twenty-nine persons by Saturday night of June 26. Several hunters who had heard of the massacre on Chicken Creek had come to the Walls seeking protection. Amos Chapman, a white hunter who had married an Indian squaw, had also come in to buy whiskey. In private, he told Jim Hanrahan that the Indians had been bragging around Fort Supply that they intended to attack the outpost at Adobe Walls and kill all of the white intruders and had picked Sunday, June 27 for the raid.

Hanrahan was visibly upset, but had some doubt to the authen-

ticity of the squaw-man's story and did not tell the others of the danger for fear the hunters would all pull out and leave the settlement unprotected. However, his doubt was soon to turn to legitimate concern.

Just before dusk, a lone horseman was seen descending the slopes south of the river. The huge black horse which was carrying him splashed across the shallow water and loped up to the saloon, sweat dripping from his black coat. A worried look creased the brow of Jim Cole as he dismounted and tied the black to the cottonwood rail outside the saloon door.

Most of the hunters were gathered outside the buildings enjoying the evening warmth and resting after a hard day of hide stretching. The Shadler brothers had pulled their wagon up next to Myers and Leonard's Store and were feeding their horses. Billy Ogg, who had been picketing his horse in a nearby thicket, walked up as Jim dismounted. Billy Dixon was sitting on a log bench outside the saloon cleaning his new Sharps, and Bat Masterson was inside, playing cards with William Olds, the proprietor of Rath and Wright's Merchantile.

Dixon, recognizing Jim, leaned his rifle against the sod wall and walked out to greet him. "Well, howdy, Jim, I wouldn't a thought of you for a hundred dollars. What in hell brings you out to these diggin's slumming with us buffaler hunters?" he said with a grin.

"Howdy, Billy," Jim answered, returning the grin with a scowl.

Not waiting for an answer to his question, Billy said, "Boys, this is Jim Cole -- Colonel Jim Cole. He's the feller that owns most of the grass the other side of the river, and he don't cotton too much for buffaler hunters -- for good reason, I might add."

The men crowded around to shake Jim's hand and to introduce themselves, all except the Shadlers who remained next to their horses, noticeably disturbed at the sight of the Colonel. Bat Masterson, hearing Jim's name, appeared at the door of the saloon and gave a limber-wrist salute to the new arrival.

"Welcome to civilization, Colonel," he said as he shook Jim's hand. Smiling, he added, "We ain't got no painted ladies, yet, but Hanrahan's got a wagon load of good whiskey. I'd be honored to buy you a drink, if you got no objection to drinking with a retired 'sheriff turned buffalo hunter'."

Jim seemed surprised to see Masterson, especially dressed in his hunter's garb rather than in the long black coat, white shirt and

string tie which had become his trademark in Dodge City. The twin Colts, however still hung loosely from each hip. Through the years, he and Bat had become good friends, enjoying each other's company when Jim came to town on his annual cattle drive.

"Howdy, sheriff," Jim said, as he returned the handshake. "A drink's what I need to wash this prairie dust out of my throat." He removed his hat as they walked into the dim light of the sod saloon, and wiped the sweat and dirt from his forehead with the back of his hand.

The other men followed them inside and stood around quietly, waiting for Jim to give some clue as to why he had ridden in on a horse which showed to have been pushed too hard all day.

Billy Dixon was the first to speak after the drinks had been poured. "Jim, looks to me as if you got a heap of worry on your mind. I know you don't like buffaler hunters, but them ain't exactly hate marks in the corner of your mouth, looks more like scairt, to me."

"You're right, Billy, and if you'd seen what I saw this morning, you'd have a few worry lines, yourself," Jim answered. "Ned and me and the boys was doing some cattle moving over to the Salt Fork of the Red River and we came onto a hunter's camp that Indians had visited before we did. What was left of those hunters wasn't much. They was tied to wagon wheels, scalped, castrated and had their eyes cut out. The Indians used them for target practice before they left and there must have been twenty arrows stuck in each body."

Looking around at the group, he continued, "That wasn't just a band of whiskeyed-up braves out looking to get a few horses and guns, it was a war party. They was mad as hell at what they had seen on the prairies, the same thing we saw. Hundreds of bloated, naked, buffalo carcasses scattered across the plains. They rode off to the northeast but they'll be back, and they won't rest until every white man is either dead or run off of their land. Like you said, Billy, I don't like buffalo hunters any better than they do but you're still my kind, and I felt I had to warn you before you got caught here with your pants down."

Hanrahan interrupted. "How long you reckon since it happened, Colonel?" he asked Jim.

"We figured it must have been three or four days ago. There's been talk of a big pow-wow planned for all of the tribes, and I expect they was going to the council when they came on the hunters. I

ain't saying they'll be coming here after you, but I'd bet my hat they're going to hit somewheres. They know you're here, there's Indian sign all over the place across the river," Jim replied.

"How come you came to warn us instead of going to warn your own people?" Hanrahan asked, rather unbelieving.

"I sent Ned and my boys back to the ranch with orders to stay there with the women and kids until they hear from me," Jim replied. "I got friends in the tribes, but there won't be any mercy to any white folks, including mine, once they go on the warpath.

Turning up the glass he downed its contents in one swallow and held it out for Hanrahan to refill, looked Billy Dixon in the eye and continued. "Ned brought back word from Dodge about your plans to make the Walls headquarters for the hunters and figured the least I could do was warn you about what's fixin' to take place, and figured you wouldn't listen to anybody but me. "

The other hunters started talking excitedly amongst themselves, questioning their intelligence for thinking they could take hides so far away from the safety of any army post. Some of them left the saloon to pack their belongings and get ready to head back to Dodge City.

"I 'spect I'd best spend the night with you boys," Jim told Billy. "My horse has had about all the running he can take for one day. I'd best rest him up and leave in the morning."

"You're right Colonel," Billy said. "Ain't no use in riding back into that hornet's nest on a winded horse. I'll fetch some feed and show you where to put him up for the night."

Jim followed Dixon out the door, untied the black from the hitching rail and led him to a corral behind Rath and Wright's Merchantile. He fed and watered the stallion and returned to the saloon where Hanrahan had laid out a buffalo roast on the bar. The men were standing around chewing on chunks which they had cut with their skinning knives. Jim cut a large slice, paid for a bottle of whiskey, and carried both to one of the rough tables in the corner. Dixon and Masterson joined him.

"What about the army," Jim asked after they were seated and drinks had been poured, "do they intend to take any action to look after the scalps of these hunters?"

Masterson answered, "Didn't appear that they were making any plans to send troops down when we left Dodge City back in April. Colonel Miles told me that if any trouble developed, to send word

and he'd dispatch a troop as soon as possible. I guess they figure that two hundred buffalo hunters ought to be able to take care of themselves."

"Two hundred! You mean there's two hundred hunters scattered over the plains already?" Jim blurted out.

"That's right, Jim," Dixon said. "They've come through here and spent a day or two and then gone on south. If the Indians found those two on the Red, they've probably found more, no telling how many of them are out there minus their scalps. We'll send word out tomorrow and warn as many as we can find."

"Most of 'em plan on bringing their hides back here, anyways," added Masterson. "If we can get them to come back in before the tribes decide to run us out, we'll have enough Sharps to start our own army. There's enough ammunition in Rath and Wright's store to hold 'em off forever."

The hunters began to drift out of the saloon, fetching their bedrolls from the wagons and rolling them out under the stars as close to the four buildings as possible. Ike and Shorty Shadler, keeping their distance from Jim, slept in their wagon. Jim, Dixon, Masterson, Shepherd and Welsh rolled their beds out on the dirt floor of the saloon and soon all were snoring soundly. Jim planned on leaving by daylight to return to Ceebara to wait out the impending war which he was certain would erupt.

Jim Hanrahan was too worried to sleep. He remembered what the squaw man had told him about the Indians plans to raid the Walls on June 27, which was tomorrow, and couldn't put the thought of a surprise attack out of his mind. About three o'clock the next morning he was still awake and was aware of some different sounds coming from the ordinarily quiet prairie night. There seemed to be too many coyotes yipping and too many birds calling in the middle of the night. He wanted to wake the hunters, but realized how stupid he would look if there was no danger. Still, he wanted everybody to be alert just in case Chapman was telling the truth.

He pulled his Colt from its holster which he had laid on the bar, quietly pulled the hammer back, pointed it towards the sod roof and pulled the trigger. The sound was deafening and dirt and dust filled the air. "Clear out, the ridgepole is breaking!" Hanrahan shouted as the men jumped from their bedrolls.

All six of the men headed for the door, Welsh and Shepherd

dressed only in their longjohns. Jim, Dixon and Masterson had crawled into bed without undressing.

The men who had been sleeping soundly outside were also awakened, all except the Shadler brothers who were unaware of the excitement. Soon, they were all milling around outside the saloon, waiting for the roof to cave in. Finally, Hanrahan suggested they get a forked tree limb from the woodpile and use it as a prop on the supposedly-cracked ridgepole. The limb was propped into place under the ridgepole and Hanrahan offered a free round of drinks to all of the hunters for their help.

As they enjoyed the free whiskey, Masterson looked up at the ridgepole and commented to no one in particular, "They ain't no crack in that ridgepole. As loud as it popped, there ought to be a crack."

Billy Dixon agreed, saying, "It sounded more like a Sharps going off than a log cracking." They both turned their gaze from the ridgepole to Hanrahan who was wiping glasses behind the bar. Hanrahan smiled and continued to wipe the glass, saying nothing.

Billy Ogg, put his empty glass down, hitched his gunbelt and started for the door. "Hell, it's too late to go back to bed," he said, looking back. "I'm going to fetch my horse and get ready to head out. I ain't going to hang around here and wait for some redskin to lay claim to my hair." He disappeared out the door into the early morning light.

After a few minutes, Billy Dixon turned to Masterson and said, "I guess Ogg was right, it's too late to go back to bed. We might as well get our horses and see if we can't locate some of those other hunters and get 'em warned." He walked outside, and a small movement on the horizon caught his eye. At first he thought it was deer, then through the mists, he saw several more moving objects, standing upright and walking on two legs!

About the same time he yelled "Indians!" there was the high pitched notes of a cavalry bugle sounding *charge* in the distance. The early morning light exploded with Indians, both afoot and horseback, yelling their war cry and charging down on the outpost.

With a hail of bullets and arrows pounding into the saloon around him, Billy Dixon crashed through the door just as a heavy object hit him from behind. It was Billy Ogg, who had walked right into the midst of the Indians when he went to saddle his horse. Incredibly, he outran the Indians and dodged their bullets as he

streaked back to the saloon, never slowing his pace until he crashed into Billy Dixon at the door. They both fell in a heap on the dirt floor.

All of the hunters were able to make it inside one of the four buildings except the Shadler brothers. They awoke to see the painted faces of the redskins looking down on them in the wagon, and before they could reach for their guns the sharp knives of the warriors were imbedded in their hearts and their scalps were added to the trophy belts of two Cheyenne braves.

By the time Jim and the others had knocked out the windows of the saloon in order to see to shoot, Indians were swarming around the buildings and some could be heard on top. They piled bags of flour and grain around the windows and steadied their buffalo guns on the bags as they calmly sighted down on the speeding Indians. Methodically, they pulled the triggers, each time knocking an Indian from his horse.

Once again, the high-pitched sound of a bugle rang out and immediately the Indians retreated to regroup.

"What in hell is that sound?" Masterson asked, turning to Jim.

"It's a cavalry bugle," replied Jim. "And there ain't any Indian can sound *charge* and *retreat* like that. It's got to be a soldier."

No sooner had he made the statement than the hills echoed back the sound of *charge,* and the Indians resumed the attack. "Here they come, again," Jim said when he recognized the call.

It was now light enough for them to see the Indians at a greater distance, and the big buffalo guns at the hands of the best marksmen in the country took their toll. Indians disappeared from horse's backs by the dozens, painting the grass red where they fell.

All morning long, the attack continued. When it appeared that those in the saloon might run out of ammunition, Jim volunteered to run to the Rath and Wright store to get more. Bullets kicked up little geysers of sand at his feet and he could hear the swish of others as they passed over his head as he dashed across the thirty yards of open space between the buildings. When it looked as if he were going to make it, a galloping horse with a painted rider appeared from behind the store and bore down on him. The Indian held a tomahawk high, intending to part Jim's skull as he rode by.

Jim was carrying his revolver in his hand, turned and fired, catching the horse between the eyes. Its legs folded under it and horse and rider plunged to the ground. Jim was knocked backwards

as the Indian crashed into him. He dropped the Colt as he fell, and as the two rolled on the ground in the dust, Jim pulled the Bowie knife from his belt and slashed at the Indian who was flailing a tomahawk at his head which caught him above the ear with a glancing blow, taking a chunk of hide and hair from his head at the same time that the Bowie knife sank deep into the Indian's shoulder.

They rolled away from each other, blood covering Jim's face and neck from his head wound, and the Indian's arm and chest from the shoulder wound. Rising to his knees, Jim, dazed, raised his arm to bring the knife blade down hard in the Indians chest but stopped it in mid-air. A startled look appeared on the Indian's face, as he too, stopped the swing of his tomahawk halfway to Jim's head. It was Quanah who looked back at Jim, and neither could complete their swing.

They stared at each other for a few seconds, neither speaking, then Quanah lowered his tomahawk and slowly rose to his feet, disgust plainly visible on his face as he trotted to the rear of the building and disappeared. Jim, still dazed, staggered to the door of the store which was opened by William Olds who had witnessed the entire affair from the window. He was pulled inside and the door was quickly closed and bolted.

The battle raged until four in the afternoon, with the bugle sounding charge and retreat for the Indians. But the accuracy of the buffalo guns soon discouraged the charges, and the Indians began to drift away from the field of battle. When it appeared that the battle was over, William Olds, who had climbed into the loft of the store for a better position, slipped and accidentally shot and killed himself while descending the ladder.

The hunters counted only four dead including Olds. The Shadler brother's big Newfoundland dog was also killed and scalped when it tried to defend its masters. All of the horses and mules were either dead or run off except Jim's big black stallion which remained penned in the picket corral behind the mercantile. A few of the horses which had strayed, returned by nightfall and were caught and penned inside the stockade walls of Myers and Leonard's general store.

Many of the Indians remained in the foothills above the trading post, sporadically exchanging shots with the hunters for the next two days, effectively keeping them from riding for help. On the third day, Billy Dixon noticed a small group of warriors setting as-

tride their horses on top of a butte nearly a mile away from the saloon. Turning to Masterson, he said, "Betcha four-bits I can drop one of those bucks."

Bat glanced at the butte and replied, "Easiest four-bits I ever made. That's nigh onto a mile away," as he reached into his pocket and pulled out a half-dollar.

Billy took out a half-dollar and placed it with Bat's on the top of the hitching post, rested the barrel of the big Sharps on the cross-member and carefully sighted down on one of the braves. He squeezed the trigger slowly, making certain that he did not pull the barrel the least bit. As the sound of the shot echoed back from the hills, Bat smiled and reached for the money since it was apparent that Billy had missed. Then his hand froze as the Indian fell from his horse. The other Indians quickly retrieved the body and disappeared behind the butte. This was too much for the remaining warriors to take. They were seen crossing the river about a mile downstream and heading south, leaving the hunters the task of burying their dead.

"I'll be damned," Bat said, looking with disbelief at the spot where the Indian had fallen. Billy reached over and took the two fifty-cent pieces from the post, smiled, and put them into his pocket.

The Indians lost over 80 warriors and countless horses in the battle. Jim later learned that the bugler was, in fact, a black cavalry-man who had deserted and joined the Indians, taking a squaw as his wife.

Word spread quickly to the other buffalo camps across the plains and by the end of the week the population of Adobe Walls had swelled to over two hundred. Billy Dixon carried a message to Fort Dodge about the raid, and General Sheridan made immediate plans to implement his Indian campaign to push the tribes back on the reservations.

When it was apparent that the Indians had all departed, Jim saddled his horse, crossed the river and rode east, anxious to learn what was happening at Ceebara. He made the forty miles by nightfall, and was relieved to find that none of the tribes had attacked the ranch.

Belle greeted him tearfully as he dismounted inside the compound, unable to hold back the emotions of her relief at seeing him safely home. He held her tightly for several minutes, oblivious of the rest of his family who had gathered around to welcome him

back.

When Belle had wiped the tears from her eyes, she was shocked to see the bruised swelling of the entire left side of Jim's face and head. His left eye was black and nearly swollen shut. The tomahawk wound was covered by a bloody bandage which Mrs. Olds had tied before he left the Walls, but the ride had covered it with dust and had caused the cut to reopen and bleed. It looked much worse than it actually was, and Belle would accept none of his assurances that it was only a scratch. She pushed him inside and forced him to sit down while she and Kate poured hot water and set about the task of cleaning and dressing the wound.

Ned poured a large drink of whiskey as the others crowded into the room to hear what had happened. Handing Jim the drink, Ned, with a touch of humor in his voice, said, "Colonel, it appears to me you got tangled up with a mountain lion and he about tore your ear off."

"That's right, son, only this mountain lion was carrying a toma-hawk and was wearing Comanche feathers," Jim replied as Belle be-gan to tenderly wash the dirt and dried blood from his head. He flinched as she poured a sizable amount of the whiskey onto the cut and it began to sting. Young Cole had quietly slipped to Jim's side and tears welled up in his eyes when he saw his grandpa's pain. Jim put his arm around the boy's shoulders and squeezed, as if to say everything was alright.

As Kate wrapped a clean white bandage around his head, he told the group about the ordeal at Adobe Walls and how he and Quanah had nearly killed each other. "I reckon that will be the end of our friendship with the Comanches," he said. "Quanah will prob-ably believe that I'm responsible for the buffalo hunters coming and will seek revenge, so we best prepare for the worst and hope for the best!"

"Everything's ready for the worst they can throw, Colonel," Slim said. Every gun on the place is loaded, plenty of ammunition is stored at each gun port, the stock are all in the new corrals and we got plenty of meat salted down. If they come, they'll get more than they bargained for."

Ned told Jim they had been extremely concerned about his safety because, returning from the site of the Red River massacre, they had intersected the huge war party just west of the ranch headquarters. "We near about ran smack into the middle of 'em,

Colonel," he said excitedly. "We was high-tailing it home and just before we dropped off the cap, we seen their dust down below. Must have been a thousand or more. We hid our horses behind some cedars and watched as they went by no more'n a half a mile away heading up Red Deer Creek. I suspect Quanah must have brought 'em in above the ranch house so there wouldn't be any trouble."

After the battle at Adobe Walls, the war party spread across the plains, searching out the buffalo hunters who failed to seek the protection of the small outpost, and killed one hundred and ninety within the next two months. The hunters on the open plains were helpless to defend themselves against such numbers, and the slaughter raged as the Indians gained more and more confidence.

Ceebara was secure with no indication of the slaughter that was taking place to the south and west. Jim could not understand why there had been no sign of the army, fully expecting General Sheridan to put forth an all-out campaign to push the tribes back on the reservations.

What he didn't know was that Sheridan was laying elaborate plans to put a stop to the Indian problem once and for all. He had dispatched scouts to Fort Sill, Fort Richardson, Fort Union and Fort Concho, with plans for a systematic advance on the *Llano Estacado,* cutting off all escape routes from the plains.

Colonel Miles was instructed to begin the campaign from Fort Dodge in early August, hitting the Ceebara area of the Canadian, Washita, Sweetwater, and North Fork of the Red River. He would be joined by Major Price who was instructed to drive across the plains from Fort Union to the east. Colonel McKenzie would bring his Fourth Calvary up from Fort Concho and sweep the plains from the south, while Colonel Davidson would march westward from Fort Sill and Colonel Buell would advance westward out of Fort Richardson.

As the army prepared for this major campaign, the slaughter on the plains continued. On August 3, squaw-man Amos Chapman was leading a party of buffalo hunters on the upper reaches of the Washita when they were surprised by about three hundred Comanches. Leaving their wagons and hides behind, Amos and the three skinners made a run to the north, hoping to outdistance the Indians to Ceebara headquarters. The three skinners were overtaken and killed before they had gotten out of the Washita valley.

Amos, riding a long-legged dappled gelding, was able to stay just ahead of the shouting warriors. When they topped the ridge south of Red Deer Creek, the Indians had closed in enough to wound Amos in the back with an arrow. He continued to spur his horse, however, and he splashed across the shallow creekbed and made a run for the gate into the Ceebara compound. Sonny, who had been acting as lookout high on the cliff's face saw their dust and shouted the alarm. The squaw-man raced into the compound amidst a rain of arrows as the Indians pulled up two hundred yards away from the wall.

Slim and the other cowboys took their places along the wall, ready to fire if the Indians attacked. The Comanches spread out in a line along the wall of the compound, their painted bodies and bright feathers glistening in the hot August sun as they sat astride their winded, sweating ponies.

Quanah rode out of the crowd a few paces, held his Winchester high above his head and shouted, "One Arm, we talk!"

Jim removed his gunbelt, mounted his stallion and instructed the men to open the gate. He rode slowly towards Quanah, as the warriors shook their bows and rifles above their heads and shouted their war cries.

The knife wound in Quanah's shoulder had healed, leaving a nasty looking scar. There was no sign of peace extended as Jim rode up, only a look of displeasure on Quanah's face.

"Send us Amos Chapman, Jim Cole," Quanah said. "We want his scalp for killing buffalo and leaving them to feed the coyotes and buzzards. He is no different than all the other hunters who kill only for gold."

Jim, with a look of sadness in his eyes, said, "I cannot do that, Quanah. I do not like it that the hunters have come and that they are killing your buffalo, but it is as I told you, the white chief of the army has spoken and promised them his protection. I cannot stop them, and you cannot stop them. They are too many and too powerful and soon they will come with their big guns and their fast guns and kill you and your braves. I ask, as your friend, to stop this war which cannot be won before your braves, your women and your children are killed."

But Jim could see that Quanah was not listening, he had changed. No longer was there the look of respect in his eyes for his white friend. No longer was there a feeling of trust. The friendship

had been replaced by hatred, Jim was now only another white who could not be trusted, another white who wished to kill the buffalo and push the Indians back onto the hated reservation.

"You are not my friend, One Arm. You speak with forked tongue. You fought with the hunters and killed many of my braves," Quanah replied. Placing his finger on the shoulder scar, he said, "The blood which made us brothers was spilled by your knife. If you do not give us the squaw-man, you will die."

"There are thirty buffalo guns behind that wall, Quanah, and each one is pointed at your heart. If you or your braves harm me, you will be the first to die. Go in peace and let us remain brothers," Jim said as he turned the black and rode slowly back to the gate, the longest ride he had ever made in his life.

Quanah turned his horse and motioned for his braves to move back, knowing full well that Jim meant what he said and knowing that not only he, but half of his war party would fall before they reached the shelter of the trees.

"They'll be back," he told Ned, as he dismounted. "Tell the men to keep their places and to fire at the first sign of an attack. The peace is over."

28

Regrouping in the protection of the cottonwoods below the ranch house, Quanah split his war party into two units, instructing one to ride west a half a mile before circling to the cliffs base, the other was instructed to ride east an equal distance, circling back to the base of the cliff. Upon the sound of his rifle shot, each was to mount an attack on the compound, riding in as closely as possible to the rock wall from the east and the west to escape the fire of the riflemen behind the wall.

After waiting thirty minutes, Quanah fired his rifle and the attack began. His logic was well planned, for those behind the wall were unable to direct their fire directly east or west, however, Quanah did not realize that four protected gun emplacements had been dug high on the cliff's face and each was occupied by two marksmen. Their positions allowed them to look directly down on the charging warriors.

Waiting until the Indians were close enough for the repeating Winchester's range, the cowboys began firing, knocking most of the leading braves from their horses. The others faltered, swerved their horses away from the wall where they were met by another hail of bullets as they came within vision of those who were firing from the gun slots in the wall. Quanah watched from the trees as brave after brave fell before the barrage.

Forty of the three hundred attacking Comanches lay dead and

not one had been able to climb the wall.

As they regrouped, preparing for a second onslaught, the shrill sound of a bugle was heard in the distance, and looking back down the valley, Quanah could see a company of cavalry splashing across the river, charging in his direction. He motioned for his warriors to retreat upstream, and they scattered through the cottonwood and hackberry trees with the cavalry in close pursuit. After a five mile chase, however, the troops lost them in the foothills and headed back to the ranch headquarters.

The Ceebara crew had already started dragging off the dead Indians and horses to a spot several hundred yards below the ranch house when the cavalry returned. Lieutenant Baldwin, commander of the troop, instructed Sergeant Major O'Shanon to help with the burial, as he and his two scouts rode into the ranch compound.

Billy Dixon and Bat Masterson had carried word of the Indian uprisings to Fort Dodge and had then hired on as scouts with Colonel Miles cavalry command. The Colonel had dispatched them with Lieutenant Baldwin's troop to Adobe Walls to determine if the buffalo hunters needed help, with instructions to rejoin him west of Antelope Hills. They had found over two hundred hunters camped around the walls, fully enough to protect themselves, Baldwin determined. Dixon, anxious to see if the ranch was under siege, had then led them across the prairie to Red Deer Creek.

"You're a sight for sore eyes, Billy," Jim said as he, Masterson and Lieutenant Baldwin dismounted inside the compound. "I never thought I'd be glad to see a buffalo hunter."

"Ain't no buffaler hunter, Jim, Bat and me got us a job scouting for the army. We figured it was safer than having to look over our shoulder every time we knocked a shaggie down to see if some damned Comanche was going to try to take our scalps in exchange."

Jim laughed, shook his hand and then Bat's. "Sheriff, seems to me you're having a hard time keeping a job, guess the pay wasn't good enough killing buffalo," he joked.

"Oh, the pay was fine, Colonel, it was them feathered benefits that I didn't like," Bat replied.

"Jim, this is Lieutenant Baldwin, commander of A troop. Lieutenant; Colonel Jim Cole, confederate army, retired," Dixon said as he made the introductions.

"Right pleased to meet you, Colonel," Baldwin said. "I've heard

a lot about you at the Fort. You've either got a lot of guts or awful damned stupid to try to build a ranch out here amongst the hostiles."

"The pleasure's mine, lieutenant," Jim responded as they shook hands. He smiled and added, thoughtfully, "I guess it was a little of both."

Jim introduced the others -- Ned, Slim, Belle and Kate, then instructed Slim to show the soldiers where they could pen their horses for the night and make their bivouac inside the compound.

The arrow had only penetrated the skin of Amos Chapman's back, and Maria had removed it and placed a clean bandage over the wound. Amos joined them as they walked to the house, telling Billy and Bat about the wild chase from the Washita.

Chairs were brought to the large open veranda surrounding the ranch house, where a cool breeze was blowing, and they all sat down. Belle and Kate brought hot coffee and sweet rolls.

"Lieutenant," Jim said, "I trust you're not the extent of the U.S. Army that has been sent to put down this uprising."

"No sir, Colonel. We're just a small part of it. Colonel Miles has the rest of the 6th Cavalry over on the Washita east of here. General Sheridan has ordered in the Fourth Cavalry from Fort Concho, and troops are coming from Fort Union, Fort Sill and Fort Richardson. He intends to put an end to this Indian problem, once and for all," Baldwin said.

"Jim, I know you was right about the buffaler hunters causing the uprising, and I know you got friends on both sides of the fence," Dixon said. "But you can see the war has started and the army ain't going to quit until every Indian is either dead or back on the reservations, and the Indians are going to fight to the last to remain free unless someone changes their minds. Whether you like it or not, you're caught in the middle. Indian blood has already been let on your property, and they ain't likely to forget it any time soon."

Looking at Belle and Kate and back to Jim, Dixon continued. "The sooner it's over, the sooner your folks will be safe, and until all of the tribes, including Quanah's, is back on the reservations, ain't no one's life here at Ceebara goin' to be worth a plugged nickel."

"I know that, Billy," Jim replied. "But there's not anything I can do to stop it."

Dixon stood, walked to the edge of the veranda, thoughtfully

looking towards the troop which was burying the dead below the ranch house, turned, and said, "Maybe not, but you can sure help to get it over with in a hurry."

Belle had walked behind Jim's chair and rested her hand on his shoulder. Ned was listening attentively to the conversation, saying nothing.

"What do you mean?" Jim asked.

"Ain't no one knows these plains like you and Ned and the other cowboys," Dixon replied. "Me and Bat knows it a little along the Canadian, but the injuns is going to hide south and west of the Canadian. The army's going to need your help in finding them, quick like."

"I 'spect you're right, Billy. Quanah would have killed me and all of my kin if he could have gotten past our wall today. He believes I've betrayed him, and like a dog backed into the corner, he'll bite his best friend. I'll do all I can, not to help the hunters or the army, but to prevent the slaughter of my friends."

"Colonel," Ned interrupted. "This is my battle, too. I know every draw, creek and buffalo wallow between here and the big canyon. I'll go with Billy and Bat and the Lieutenant and help track. Quanah may be back to try again and if he does, you need to be here to try to reason with him."

Jim, nodding his head in agreement, replied, "I think you're probably right, son. You could do a better job on the trail than me, and I could handle Quanah better if he does return." Turning to the cavalry officer, he continued. "You can tell Colonel Miles that I am at his service if he needs me, otherwise I will remain here until I receive his word."

"Colonel, there's no more than two hours of daylight left, with your permission we will bivouac here tonight and leave at first light tomorrow," Baldwin said as he stood to leave.

"Certainly, Lieutenant," Jim replied. "Instruct your men to set up camp inside our compound. You never can tell about those Comanches, they'd as soon take a scalp at night as during the day."

Amos Chapman, who had listened intently to the conversation, addressed the Lieutenant as he started to leave.

"Lieutenant, it appears buffaler hunting is done and finished with until we can corral the injuns back on the reservations, so if'n you'd like another scout what knows this country like the back of his hand, I'd be obliged to hire on."

"I'm sure Colonel Miles could use you, Mr. Chapman, providing that arrow wound is not too bad." Baldwin replied. "You're welcome to ride along in the morning, if you wish."

Moving his arm to show there was no damage, Amos answered, "Ain't nothing but a scratch, Lieutenant. I'll be ready."

Ned tied his bedroll and slicker to his saddle, filled his saddlebags with extra ammunition, tied a leather pouch filled with dried jerky to the horn, loaded and holstered his Winchester, mounted his buckskin and joined the Lieutenant at the head of the troop as they rode out of the compound at daylight. Kate, with little Cole at her side, stood on the veranda and waved as he disappeared out the gate, wiping a tear from her eye as she watched him go.

Lieutenant Baldwin told Ned that he expected to find Miles' column and wagon train somewhere along the Washita, so Ned headed the buckskin southeast across the rolling hills with Billy Dixon at his side, taking a point a mile ahead of the column. Masterson was instructed to take the right scouting position, a half mile to the right of the column and a mile to the front. Chapman took a point equal distance to the left. They crossed the valley of the Washita before turning due east, riding along the southern ridge of the foothills that rose above the small stream-bed. No more than three hours out, they spotted a whiff of smoke and a dust cloud on the eastern horizon at about the same time the faint sounds of rifle fire could be heard. The smoke billowed into a white cloud and bright orange flames could be seen at its base.

Stopping the troop on a high point where Ned and Billy were waiting, Lieutenant Baldwin scoured the area through his binoculars, saying under his breath, "Those red bastards have set fire to the prairie to cut off the Colonel!"

The orange flame continued to snake across the prairie behind a mounted Indian who was dragging a burning buffalo hide which had been soaked in grease. Although it was nearly four miles away, Baldwin's binoculars enlarged the battle area and brought the entire scene graphically into view.

Talking to no one in particular, he said, "The wind's whipping the fire towards the troops and the wagons. They've had to turn back to the river, and the Indians are escaping to the southwest."

"They're heading for the Sweetwater, Lieutenant," Ned said. "It's no more'n twenty miles to the southwest."

"Looks to be about five hundred of 'em," Baldwin said. "With

the fire between them and the Colonel, there's no way we can head them off, too many for us to handle. We'll wait until the fire dies down, and join the Colonel."

The fire raged for two hours before it burned itself out along the banks of the Washita, and Baldwin was able to rejoin his unit.

Baldwin reported his activities during the preceding three days, with a nod of approval from the Colonel. "You did well by not trying to engage this band," Miles said.

Ned and Chapman were introduced to the Colonel and he welcomed them, saying, "We can damn well use your help -- the hostiles are heading for a country we know nothing about."

Baldwin's troop was ordered to take the point, with half of the remaining troopers leading the thirty-six wagons and the other half bringing up the rear. Baldwin dispatched his scouts and they moved out across the burned-out prairie, kicking up clouds of black ashes. The August sun began to heat the prairie air, and small dust devils began to swirl across the burned-out prairie, licking the black ashes into tall twisting black snakes towards the cloudless sky.

Climbing to the slight divide between the Washita and Sweetwater, they then descended to the cottonwood and willow banks of the Sweetwater where they discovered a plainly marked trail where the Cheyennes had discarded articles to lighten their loads in their haste to put distance between themselves and the pursuing cavalry. Darkness was upon them, so Colonel Miles decided to bivouac till morning, camping on the Sweetwater at the spot where Ned had carved the brand on the huge cottonwood, nine years before. The "C-Bar-A" scar in the tree's bark could be seen plainly, having grown as the ranch had grown through the years.

Miles, anxious to speed up his movement, ordered the wagons to be left behind with a small contingent of troops as protection, and at daylight, continued the pursuit at a faster pace. Ned followed the trail, paralleling the one which he had followed when they brought the herd up from Waco, bearing ever closer to the rising buttes of the caprock.

He crossed the North Fork of the Red River, and reached the Salt Fork by dark the following day, where they camped for the night along its sandy banks. Miles doubled his guard, recognizing that the Cheyennes were only a few hours ahead.

The trail led along the bluffs of the caprock, where it intersected the Prairie Dog Town Fork of the Red River which led into the

valley of the deep canyon. As Ned led Lieutenant Baldwin's troop towards a break in the bluffs, he detected a slight movement above him and three hundred yards ahead. As he stopped the buckskin for a better look, he saw a small whiff of smoke rise from the spot where he had detected the movement, then heard the sound of the rifle crack as the bullet ricocheted from a rock next to his head.

He turned the buckskin and kicked him into a run back down the rock strewn path, as rifle fire broke out all along the rim of the caprock. Reaching the head of the column, which was climbing out of a dry arroyo, Ned pulled up and reported the position of the Cheyennes.

"They've strung out along the base of the caprock, Lieutenant," he said as he pointed towards the direction of the ambush.

Baldwin spread his column along the banks of the arroyo and returned the fire, while he waited for Colonel Miles to advance to his position with the remainder of the troops. They removed the Gatling guns from the backs of the two pack mules, and soon the hot, dry air was filled with the chatter of the automatic weapons. This was too much for the Cheyennes, even though they had a tactical advantage with positions high up on the ridge. They began a progressive retreat, taking cover occasionally and firing, then moving on up the canyon.

At the head of the small canyon, which intersected the big canyon, the Indians climbed out onto the flat plains above on a well used trail which had been cut through the rocks. Reaching the *Llano Estacado* they spread out and disappeared, the prairie swallowing them as if they were ghosts.

Ned led the cavalry on the largest of the trails across the flat grasslands, which soon vanished as the Indians broke away in smaller and smaller bands. Colonel Miles called a halt to the chase after realizing that the Indians had reached their sanctuary, the thousands of square miles of endless prairies.

They retraced their trail to rejoin Captain Lyman and the wagons on Sweetwater Creek, nearly two weeks after leaving them to pursue the hostiles. Colonel Miles dispatched Lieutenant Baldwin and Bat Masterson to Camp Supply to report his recent engagements with the Cheyennes and to request supplies to be sent to Oasis Creek, where Captain Lyman would meet them with his now empty wagons.

Anxious to make contact with the hostiles once again, Colonel

Miles called his scouts into his field headquarters tent to seek their advice on where the Comanches might be hiding.

Drawing a rough sketch of the area along the headwaters of the Red River tributaries, Ned said, "Colonel, it's getting late in year and Quanah will either be about here," he placed his finger on the map on the south tributary of the North Fork, "where there's fresh water and lots of buffalo. Or --," he traced his finger nearly due west to the mark indicating the northernmost end of the big canyon, "here!"

Holding his index finger on the spot, he continued, "This is his winter camp ground, the upper end of the big canyon fork of the Red River, the Indians call it the Prairie Dog Town Fork. The canyon where the Cheyennes ambushed us is probably forty or fifty miles downstream, about here -- ", his finger moved down the map to the confluence of the Red River and Tule Creek.

"It wouldn't surprise me none if the Cheyennes circled back and joined up with Quanah somewhere in that vicinity, either on top of the plains or in the canyon," Ned said.

"We'll leave at daybreak," Colonel Miles said, pointing to the map. "I want you to lead us up the North Fork, and if we don't make contact we'll cut south to the head of this tributary," his finger found a point where Ned had indicated a creek, "and come downstream. If we don't find them in that area, we will wait for Lyman's wagons where this creek joins the North Fork," his finger traced its way downstream to the confluence of the North Fork and McClellan Creek. Miles was still apprehensive about taking his troops across the plains, and chose to remain below the caprock where he would have protection and landmarks.

For seven days they searched in vain, finding many fresh trails, the remains of a few buffalo which had been skinned and stripped of their meat, but no Comanches. Finally, they made camp in a large cottonwood grove on the banks of the North Fork, and having received no word from Baldwin or Lyman, Miles dispatched Ned, Billy Dixon, Amos Chapman and four enlisted men to Camp Supply to determine what had happened, instructing them to ride at night and sleep during daylight hours to avoid any contact with the hostiles.

In the early dawn of the second day, the seven men were riding hard trying to reach the shelter of the Washita to hide, when they rode into the middle of a war party of about one hundred and

twenty-five Kiowa and Comanche braves. Realizing they were surrounded, Ned shouted for the men to dismount and stand back to back. Private Smith was given the responsibility of holding the horses, as the Indians prepared to charge. He was cut down in the first exchange of fire and the horses bolted, taking with them canteens, blankets and extra ammunition.

The now helpless men, kneeling back to back, were able to repel attack after attack, although taking several bullets themselves. Ned had been hit in the shoulder and Billy Dixon had caught a slug in the calf of his leg, both only superficial wounds. Amos Chapman was down with a busted knee, and Private Smith lay dead on the prairie.

"I guess I've been in worst predicaments," Billy said jokingly, as the Indians prepared for another rush, "but right now, I can't rightly recollect when it was!"

Ned, smiled as he squeezed the trigger of his Winchester and watched another Indian fall from his horse.

"Seems to me if you want to live long enough to remember when that was, you'd better start thinking up a way to get us out of here, Billy," Ned responded as he reloaded. "We ain't nothing but ducks in a shootin' gallery standing here in the open!"

"If'n I had my trusty Sharp's fifty caliber, it might even up the odds a little better," Billy quipped.

The accuracy of their carbines had caused the Indians to move back and regroup, giving the besieged captives a chance to look around for a more favorable fighting position. The prairie was a blackened, barren void, having been burned off by the Indians three weeks previous. A small depression, no more than ten feet in diameter, could be seen about a hundred yards away which had been made by buffalo pawing and rolling around in an effort to escape the summer heat. Ned instructed the men to make a run for it, one at a time as the others covered them with a protective barrage of shots. Amos, with a busted knee, tried but was unable to make the run.

Using their Bowie knives, the men dug furiously to deepen the buffalo wallow, pushing the dirt out, making a protective rampart to deflect the Indian's shots. After trying unsuccessfully several times to reach Amos and drag him into the wallow, each time to be turned back by a volley of bullets, Billy and Ned were finally able to pull him off the prairie.

As the day wore on, it was apparent that the Indians were play-ing a game with the wounded men, riding in circles and shouting obscenities. They knew Amos Chapman well, since he had lived with them and had taken one of their squaws as his wife.

"Amos! Amos!," they shouted in the Kiowa dialect. "We've got you now, Amos, you yellow dog!"

By mid-afternoon, a circle of dead horses and dead Indians sur-rounded their position, an indication of the accuracy of their rifles. It also had caused the Indians to become more wary, remaining farther away from the deadly aim of the buffalo hunters.

When it appeared they could not hold out much longer, the weather suddenly changed. A mild cold front blew in from the north, mixing with the hot September air, sending forth lightning and thunder and a hard downpour of cool rain. Private Rath, sens-ing that the Indians were concentrating on the thunderstorm, rushed from the pit and retrieved Private Smith's rifle, revolver and ammunition belt. To his surprise, Smith was still alive. He shouted for help, and Billy Dixon rushed out and helped drag him into the wallow.

Although the thunderstorm probably saved their lives, their protective wallow had filled up with rain water. They were soaked to the skin and were crouching in six inches of nearly freezing wa-ter. As darkness settled over the shivering group, they watched the Indians, bundled in their blankets, disappear in the direction of the Washita River bottom where they could build fires and dry out.

Ned could see his buckskin grazing near a mesquite flat about three hundred yards away. "Soon as it gets a little darker, I'm going to make a run for my horse, Billy, and go for help," he said as he pointed towards the mesquite flat.

"Good luck," Billy said as Ned crept silently out of the wallow and headed for his horse. Apparently all of the Indians had left and Ned was able to reach his horse undetected. The buckskin stood quietly as he approached, glad to see its master again. He mounted and struck off to the southwest, hoping that Colonel Miles had come in search of his lost wagons.

During the night, Private Smith died and Dixon and Chapman rolled him out of the wallow onto the prairie. The other enlisted men were severely wounded, and Billy doubted that they would last until morning. However, daylight found them all still alive with no Indians in sight.

"I'm going to scout around and see if there's any sign of Ned, Amos," Billy said to Chapman. "Keep your eyes open, them red devils could come back any time."

He too, headed southwest, and had been gone no more than an hour when he spotted a large military contingent in the distance headed north. He fired his pistol twice, attracting their attention. The column, hearing his shots, turned and came to his aid.

It was four companies of the Eighth Cavalry from New Mexico under the command of Major Price. Price had been scouting the plains from the west, unsuccessful in finding any hostiles, but having lost his supply wagons which were supposed to be somewhere in the vicinity. Price placed the wounded Dixon on a spare horse and followed him back to the buffalo wallow where his surgeon examined the men and announced there was nothing he could do for them, they needed an ambulance and Major Price had none.

Some of the soldiers of the Eighth tossed them some uncooked buffalo meat as Price ordered the cavalry to continue its search for his wagons, unbelievably leaving the wounded men to fare for themselves.

Billy made the wounded men as comfortable as possible and stood watch throughout the day, hoping that the Kiowas would not return. The day was passed cursing Major Price for leaving them to die, and swearing to get even if they got out alive. Darkness once again settled on the buffalo wallow, as Billy and Amos discussed the fate of Ned.

"He's Comanche bait somewhere, I'll bet my hat," Amos said. "He should've been back by now."

"I ain't givin' up on him, yet, Amos," Billy replied. "That boy is as close to being an injun as Quanah Parker, hisself. If anyone can slip through them devils its him, that's for damn sure!"

Billy didn't really believe what he was saying, but he wanted to give the wounded men some hope that they would be rescued.

About midnight, they heard the sound of horses approaching, first believing it was the Indians returning, then hearing Ned's voice calling out in the darkness. Billy stood and fired his pistol in the air as all of the wounded men began to shout at the top of their lungs.

Ned rode up, leading Colonel Miles and his column. The surgeon gave the men proper medical attention as Billy Dixon reported on Major Price's lack of concern for the wounded men.

Camp was made and the next morning Private Smith's body

was buried, wrapped in a blanket, in the middle of the buffalo wallow. The wounded men were helped onto horses and the troop headed northeast in search of Captain Lyman and the wagons. They had hardly crossed the Washita when the first of the wagons appeared on the horizon, coming in their direction.

Captain Lyman rode up to the Colonel and briskly saluted. Miles was noticeably disturbed as he said, "Where the hell you been, Captain. You should have been back a week ago."

"My apologies, sir!" Lyman said, standing at attention. "We were delayed by 400 Kiowas, Cheyennes and Comanches who attacked our wagons, surrounded us and held us in a corral for five days. Scout Schmalsle successfully made it to Camp Supply with news of our plight and returned with troops which arrived only last night. I am sorry to report the loss of two men and three wounded."

Colonel Miles, embarrassed at his shortness and loss of temper, responded, "Only two killed and three wounded. My God man, you're lucky you didn't lose the whole troop. My apologies to you, sir, and congratulations on a job well done."

Lyman relaxed and smiled, "It was because I had good troops, sir," he said as he handed Colonel Miles a dispatch from General Sheridan which Scout Schmalsle had received at Camp Supply.

"Colonel Miles; Colonel Mackenzie has left Fort Concho on August 23, 1874, with his Fourth Cavalry and five companies of the Tenth Infantry. He will traverse the area along the headwaters of the Brazos until reaching the Red River. He plans to turn west at the Red River, and scour the plains for hostiles. He should arrive at the Red River where it flows off of the plains approximately September 25. It will be necessary for you to enter the plains south of the Canadian and block the escape of any hostiles which he pushes your way. I am placing Major Price and the Eighth Cavalry under your command. Colonel Davidson has left Fort Sill on September 10, and will march due east to the Sweetwater, where I have instructed him to meet with you. You should instruct him to secure the area below the caprock from the North Fork of the Red River to the Salt Fork. Colonel Buell will arrive with his Tenth Cavalry on the Salt Fork and will block any escape from there to the South Fork. Good luck! -- Phillip Sheridan, General of the Army."

After resting his troops and animals for four days, Colonel Miles gave the order to move out, with Ned and Billy Dixon lead-

ing the way once again back to the Sweetwater where a command post would be established for the remainder of the campaign. They reached the creek before nightfall, making camp along its banks. Colonel Davidson arrived the next day with his black cavalry and infantry and after only a day's rest, proceeded south to the Red River.

Calling Ned and Billy Dixon into his tent, Colonel Miles told them of the plans sent down by General Sheridan. "It's important for Mackenzie to know that we will be positioned to help him as he makes his sweep across the plains. I want you to carry a message to him, telling of the General's plans. Ned, do you know that country below the Red River?"

"Yes, sir," responded Ned. "Colonel Cole and me brought our herd up along the headwaters of the Brazos. If we keep to high ground, we should be able to see for twenty-five, thirty miles. We'll find him if he's in that part of the country."

"Fine," Colonel Miles replied. "I'll expect you to be in the saddle at daybreak."

The ride south was uneventful until they reached the South Fork of the Red River. Topping a rise along the rough terrain, they surprised a hunting party of twelve Cheyennes no more than a hundred yards ahead, coming directly towards them.

Ned quickly drew his Colt and before the Indians had time to react knocked three from their horses. Billy shouldered his carbine and dropped two more before they disappeared down a dry arroyo.

"I 'spect we better hightail it out of here, Ned," Billy said. "Their main party may be around close-by."

"You ain't waitin' for me," responded Ned as he dug his spurs into the buckskin's side.

They rode hard for the next hour, keeping to the high ground where they could see for miles in every direction. When they determined they were not being followed, they slowed their horses to a fast walk, continuing south.

That night, they made a dry camp with no fires, picketing their horses beneath a high, overhanging cliff. As the darkest part of the night descended, just before the moon appeared on the eastern horizon, Ned spotted the campfires. He estimated them to be five or six miles south and east of their present position, and the number of fires suggested that it was a large cavalry contingent -- Mackenzie's Fourth!

"No need to go on tonight, they'll be coming our way tomorrow," Dixon said.

"You're right," replied Ned. "Let's get a good night's rest and join up with them in the morning."

They slept easier, knowing that Mackenzie's large column would have scared any stray Indians away from the area.

29

Ned and Billy intersected the Fourth's line of march the next morning, along the banks of the Blanco River, presenting themselves to colonel Ranald Mackenzie. Ned handed Mackenzie the dispatch which had been sent by Miles and waited as he read.

"Pleased to have you join us, Mr. Armstrong -- Mr. Dixon," Mackenzie said as he finished reading, glancing first at Ned, then at Billy. "It appears that Miles has been raising hell up north with the hostiles and has pushed them towards us. Apparently, from his dispatch, he believes you can help us locate them. I'd appreciate a detailed report of the area where you think they might be hiding," he said.

Ned, clearing a spot of grass with the sole of his boot, drew a rough sketch of the area in the sand. "Billy and me jumped a band of Cheyennes here," he said as he pointed with a broken mesquite limb to a spot indicating the confluence of the caprock and the South Fork of the Red River. "I'll bet my hat the main Cheyenne party was around close by. I 'spect the balance of the Kiowas and Comanches are holed up in the big canyon at the mouth of the river -- here," and he moved the point of the stick upstream.

Bringing the stick back to the area indicating their present position, Ned traced a trail along the caprock then up a small canyon below the Red River and onto the *Llano Estacado*. "This is the canyon where we chased the hostiles out onto the plains, Colonel, and

if'n I was you, I'd take my troops up on top -- here -- then head out across the plains and come up on the west side of the canyon, here -- " as he dug the stick into the sand indicating the rim of the big canyon at the head of the river.

Colonel Mackenzie watched intently as Ned laid out his plans, then asked, "Assuming that we find the hostiles in the canyon, how do you suggest we descend from the top of the prairie to the bottom of the canyon without being detected.?"

"The Indians have several trails entering the canyon," Ned replied, "which are wide enough to lead a horse down, single file. If we approach the rim at first light at a point downstream from the lodges, we should have most of the troops to the bottom before the camp is awake."

"Sounds reasonable, Mr. Armstrong. I hope you're right, because if they spot us before we reach the bottom, we'll be at their mercy on the side of that canyon wall," Mackenzie responded. "You and Mr. Dixon take the point and we'll move out immediately."

Ned and Billy swung into their saddles and kicked their horses into a fast jog, heading north along the base of the caprock, as the troops of the Fourth Cavalry, in columns of four, followed, with the wagons and infantry bringing up the rear.

The weather turned sour by mid-afternoon, with rain falling in sheets as a cold front passed over. By nightfall the contingent of five hundred troopers and thirty-six wagons reached the protection of Tule Canyon during a driving thunderstorm, exhausted from pushing and pulling the wagons through mud and rocks. As Ned had predicted, the main body of Cheyennes were camped nearby and during the night, attacked in an effort to steal the horses and mules. Mackenzie, however, was expecting trouble and had posted one-third of his troops as guards while the remainder rested, and the Cheyenne's were driven back down the canyon.

Upon reaching the top of the caprock the next day, Mackenzie, realizing that the Cheyennes continued to observe their progress, ordered Ned to lead the troops southwest across the prairie, away from their actual planned route in an effort to fool any scouts who might be following. After satisfying himself that the Indians had remained in the canyon, he ordered a change in direction and darkness found them headed due north towards the suspected campground of the main body of hostiles.

Riding ahead, Ned and Billy outdistanced the slow moving

troops and scouted the rim of the canyon by the light of the full moon until they located the Indian camp, nestled safely on the canyon floor. All was quiet as the village slept, and the Indians felt so secure from attack that no guards were posted along the top of the canyon. Ned and Billy continued to search until they located a well-used trail descending from the rim which wound along the canyon wall and ended at a spot well below the Indian camp. While Billy remained at the trail's head, Ned returned to report to Colonel Mackenzie.

As the first light of dawn broke over the eastern rim of the canyon, Ned dismounted and led his buckskin down the narrow trail, to be followed by Billy and the five hundred cavalrymen, each leading his mount.

Over four hundred of the troops reached safety on the canyon's floor before a lone Indian, having walked into the brush to relieve himself, discovered their presence. He was quickly killed, but the shots alerted the sleeping camp, and soon all hell broke loose as half naked Indians ran from their tipis, firing into the semi-darkness at the approaching cavalry. As the battle progressed, squaws and children ran from the village, clutching small bundles of possessions and disappeared into nearby arroyos. The braves continued to fire rapidly as they retreated to the canyon walls where they set up firing positions behind boulders and trees.

Quanah, hearing the first shots, rushed from his tipi and began firing his repeating Winchester at the charging cavalry, shouting for Morning Star to take what necessities she could carry, and run with little Jim Bold Eagle for protection in a nearby cut in the canyon wall. As she ran from the shelter of the tipi, dragging her son by his hand, she was shocked to see Quanah fall backward, blood gushing from a nasty wound in his scalp. Dropping the small bundle which she was carrying, she rushed back to where Quanah lay unconscious in a heap, with his face and chest covered with blood from the wound.

Dragging him back inside the tipi, she pulled a strip of calico from a deer-horn hook which was tied to the lodge pole, and wrapped it tightly around his head, stopping the flow of blood. She was sitting with his head in her lap, sobbing quietly, when the dark form of cavalryman appeared in the doorway of the tipi. Little Jim Bold Eagle stood fearlessly in front of his mother and father, as if to protect them from the soldier's gun. The soldier pointed his rifle at

the wounded brave, hesitated as he looked at Morning Star and the boy, then turned and dashed from the tipi, rejoining the troops as they pursued the retreating warriors up the canyon.

The battle raged all morning, with the cavalry slowly pushing the Indians upstream and away from the campground. Mackenzie, realizing that to try to rout the Indians from their protected hiding places would mean many casualties to his troops, determined instead to retreat back to the village and destroy the camp and take all of their horses and mules captive, leaving the Indians to face the approaching winter with no food, shelter or horses. Such a situation, he believed, would force the tribes to return to the reservations where food and shelter could be found.

Several of the squaws, old men and children were huddled in the middle of the village, with a half dozen soldiers guarding them when Mackenzie returned to the camp.

"Colonel," Sergeant-Major Douglas shouted, "there's a wounded brave over here with his squaw and young 'un. You want me to finish him off?"

The sergeant had found Quanah just as Mackenzie rode back into the village. As the Colonel dismounted, little Jim Bold Eagle attacked -- kicking, scratching and biting the huge cavalryman in an effort to protect his parents. The sergeant pinned his arms behind his back and held him as Mackenzie stepped into the tipi to inspect the wounded Indian.

Quanah, his face and chest covered with blood, began to regain consciousness, and was attempting to stand as the Colonel looked on. "This buck will live, throw him in with the other captives and burn the lodge," Mackenzie instructed. "We're not making this another Sand Creek."

Although only four braves were counted as dead in the raid on the village, all of their possessions were destroyed and their horse herd, numbering over fourteen hundred, was captured. Fourty-four prisoners were taken, including Quanah, although he was not recognized as being the notorious Comanche chief. Only one cavalryman was wounded, having been shot in the stomach, a miracle after such a long and fierce battle.

The prisoners were herded up the trail leading out of the canyon, followed by the huge horse herd and the weary troopers. By four o'clock in the afternoon everyone was out of the canyon and reassembled on the plains. Mackenzie allowed no rest however, and

ordered the men to continue back to the head of Tule Canyon, where the wagons and infantry were waiting. The captives were placed on Indian ponies in order to make better time.

Ned was exhausted when he reached the wagons eight hours later. He had been in the saddle for thirty-four hours and had not eaten anything other than some dried jerky for forty-eight hours. He and Billy dismounted, removed the saddles from their equally exhausted horses, placed their bedrolls under a wagon and fell quickly to sleep.

Their sleep was interrupted at sunup by gunfire coming from the direction of the horse remuda. Ned grabbed his Winchester and rushed towards the sound of the shots, fully expecting that the Indians were attacking and were stampeding the horses. He stopped, spellbound, at the scene unfolding before his eyes when he reached the herd.

A team of infantrymen were methodically shooting the Indian ponies which had been herded into a corral formed by the supply wagons. Colonel Mackenzie, remembering the previous year when the Comanches had recaptured several hundred head of Indian ponies which his troops had taken captive, had ordered the ponies killed to make certain that there would be no chance of it happening again.

All day the slaughter continued as shot after shot echoed eerily back from the canyon walls, now and then the whinny of a wounded pony could be heard coming from the ever growing pile of dead animals. By mid-afternoon, one thousand and forty-eight animals had been killed, with only a few of the better quality animals being kept for use by the scouts and troops.

As Ned walked away from the slaughter, sick at his stomach, he noticed the group of Indian captives, tied to two of the wagons. His heart raced when he recognized the dirty, disheveled figure of Morning Star, standing proudly over the prostrate body of a wounded brave whose head was wrapped tightly with a bloody bandage, lying on the grass. If she recognized him, she showed no emotion, as she stooped to minister to the wounded man. Little Jim Bold Eagle sat passively at the wounded man's head, staring blankly into space.

"Quanah!" Ned thought. "The wounded brave must be Quanah!"

Throughout the day he wrestled with the problem of what to

do. If he told Colonel Mackenzie that Quanah was one of the captives, he would probably be shot on the spot. On the other hand, if he said or did nothing, Quanah might die from the head wound. These were his friends, he reasoned, and Quanah his blood brother. No matter if they were Comanches, and no matter what they may have done in an effort to protect their land, he felt obligated to try to help them.

By the time darkness had fallen over the camp, he had made his decision. He saddled his buckskin and two of the captured Indian ponies which had been saved from slaughter and led them to a clump of mesquite, three hundred yards to the west of the camp, where he tied them. Returning to camp, he crept silently up to the sleeping Indians and gently touched Morning Star's hand. She opened her eyes to see his finger over his lips, cautioning her to remain quiet.

Ned slipped his Bowie knife from its scabbard and quickly cut the ropes which bound her wrists and ankles to the wagon. Then he cut those holding Quanah and the boy and motioned for her to help him lift Quanah to his feet.

Although he was only semi-conscious, Quanah did his best to stand and walk. As the stench of the dead Indian ponies permeated the heavy night air, they slipped quietly away from the wagons to the mesquite trees where he had tied the horses. Lifting Quanah to the back of one and Morning Star and the boy to the other, Ned mounted his buckskin and they disappeared quickly into the blackness of the night, riding towards the North star.

The prairie was silent, with only the rustling of the tall grass as the horses jogged sure-footedly through the blackness. A faint orange glow on the eastern horizon soon announced the rising of a full moon. Suddenly, as if by magic, the moon broke the horizon and burst into a large round ball of silvery light. As the light appeared, the flatness of the land could be seen disappearing in the distance, offering no hint of landmarks on the horizon, only a slight change of shades of gray where the sky dipped to the earth's surface.

Ned kept his eyes on the North Star, keeping the buckskin on a course which would intersect the deep canyon at the very head of the river. Morning Star and the boy rode in silence at Quanah's side, helping to steady him in the saddle when it appeared that he might fall.

At one time, they rode through a herd of four or five hundred

head of buffalo which were bedded down in the tall grass, and the animals continued to lie quietly, chewing their cud, refusing to be disturbed by this intrusion.

As dawn broke brightly the next morning, Ned could see that they were dropping into a wide, flat-bottomed valley which was dissected by a small stream that meandered to the east. This would be the headwaters of the Prairie Dog Town Fork of the Red River, above the big canyon, Ned reasoned.

He paralleled the stream to the east until they came to a small stand of cottonwoods which nestled on the creek's banks. Stopping the buckskin, he turned to Morning Star and spoke to her in Comanche. "We will rest here for awhile."

Untieing his bedroll, he threw it on the ground next to the trunk of one of the larger trees and helped Quanah from the horse and onto the blankets. Morning Star removed the bloody bandage from his head and washed it in the clear waters of the small stream, then began to bathe the wound.

As the cool water began to sooth the pain and cool his head, Quanah became rational and attempted to stand, only to fall back because of his weakness. Ned walked to his side, and like a wounded animal, Quanah lashed out, not understanding that Ned had rescued him from the soldiers.

Morning Star quickly told him what had happened, how he had been shot and taken captive, and how Ned had freed him during the night.

"Quanah, my brother," Ned said as he stood over him. "I know that you are angry because I have ridden with the soldiers. I did so only because I believed it would save your people. It is my wish that the buffalo hunters and the soldiers would have never come, and that we could have continued to live in peace, but it cannot be. It has happened. Now we must look to tomorrow and at what will happen to you and your people. As Colonel Cole warned, the army is too strong and too many for you to win a war, and if you continue to fight, all of your braves, all of your women and all of your children will be killed. Only you can save them from this end. The army will continue to hunt you like the coyote, until there will be no more Comanches unless you return to the reservation."

The hatred in Quanah's eyes was beginning to fade as he listened to Ned, realizing that he was speaking the truth.

"Only a few of your people were killed in the battle," Ned said,

243

"but your lodges, your horses, your food and your buffalo robes were destroyed by the army. What will your people do with nothing to protect them from the winter's storms and no horses with which to chase the buffalo? They will die from starvation and the cold if they do not return to the reservation."

Kneeling beside his friend, Ned asked. "Do you know where your people have gone? We must find them."

Quanah, sitting up, replied, "Yes, I told them where to go if we were attacked. But I will not tell you so you can lead the yellow-legs to their place."

Ned, angered by the remark, said, "I did not rescue you from the soldiers just to have them capture you again. " He turned and walked to his horse, saying as he went, "I leave you to die with your people. The soldiers will find you, no matter where you hide, and the next time they will take no prisoners."

Quanah, glaring after him, held up his arm to stop him. "Wait! You are right. It is time to talk. Help me and I will take you to my people."

They rode northeast out of the small valley and traveled across the broad ocean of grass for several hours, with only an occasional playa lake breaking the flat monotony. With only an hour of sunlight left, the prairie began to drop into a small valley which Ned recognized as McClellen Creek, a tributary of the Salt Fork of the Red River, where he and the Colonel had fought and killed Huereto and his band of cutthroats and freed the Mexican girls.

Smoke could be seen rising from a small stand of cottonwoods, the only indication that there was life in the valley. As they approached the smoke, several figures could be seen scurrying about. A large mule deer was hung in a tree and three squaws were busy skinning it and cutting off chunks of meat. Suddenly, thirty or forty Indian braves who had been hidden behind the creek bank appeared and pointed rifles and arrows at the four approaching horsebackers, but Morning Star galloped ahead of Ned and identified herself. The braves put down their weapons and rushed to help their wounded chief.

There were over five hundred men, women and children in the party huddled under the trees. They had no tipis or horses and only a few of the basic necessities of survival. The deer would make only a small meal for such a large number of empty bellies.

Although weak and hardly able to talk, Quanah called a pow-

wow under the spreading branches of the largest tree and related to the other chiefs how he had been taken captive and how Ned had rescued him and his family from the soldiers. There were rumblings of dissension when he told of his decision to follow Ned to the ranch headquarters and later to try to return to the reservation, but they all knew that it would be virtually impossible to remain on the plains during the winter with no food or shelter.

"We cannot escape the long-knives without horses, nor can we chase the buffalo," Quanah told them. "On the reservation perhaps we can live to fight another day."

And so the decision was made. The next morning Ned led them out of McClellan Creek and back onto the flat plains, heading due north to avoid any troops which might be searching the breaks along the caprock. He was only hours ahead of Lieutenant Baldwin's "A Troop", which had bivouaced for the night ten miles downstream from the Comanche camp.

Colonel Mackenzie, after resting his troops, instructed the infantry and wagons to return to the Blanco River and set up a supply camp while he led the cavalry along the dim trail left by Ned and Quanah to the head of the big canyon, believing that Ned had been taken captive by the Indians. However, after crossing the head of the Prairie Dog Town Fork where Ned had rested, he found a fresh trail which had been left by several members of the Cheyenne tribe, and followed it around the east side of the canyon and back towards his supply camp below the caprock. The Cheyennes eluded him, as did the Kiowas and Apaches, who were making their way back to the reservations as fast as possible.

Ned was forced to stop for rest several times as they moved across the endless prairie with little or no water. The old and wounded lagged behind and Quanah continued to lapse into semiconsciousness as a result of the hot sun beating down on his head wound. On several occasions he fell from his horse and had to be helped back into the saddle. After traveling north for four hours, Ned turned east and reached the big playa lake before sundown where he stopped for the night.

A small herd of Ceebara longhorns, which had been missed when the herd was gathered for winter pasture, were bedded down on the north shore of the lake. Two of them were shot and butchered for the evening meal.

The following day, Ned led the weary tribe down the cut in the

caprock, across the creek and to the Ceebara ranch house. The muzzles of many rifles could be seen in the gun slots along the wall as Ned motioned for Quanah and Morning Star to follow him inside.

Kate, followed closely by young Cole, rushed to meet him as he came through the gate. Before the buckskin had stopped, Ned slide from the saddle and took the two in his arms, trying unsuccessfully to hold back the tears of joy at being home.

The entire Ceebara family were soon crowding around, eager to welcome him home and receive news of the Indian wars. Jim and Belle helped Quanah from the saddle and into the ranch house, where he was placed in one of the bedrooms. Hot water and towels were immediately brought in and Belle began cleaning the nasty looking wound as Morning Star, exhausted from the journey, looked on.

"Glad to have you safely home, son," Jim said as they walked from the bedroom. "How'd you come to be with Quanah's tribe, last word I had, you'd been dispatched to Colonel Mackenzie's outfit?"

"That's right, Colonel," Ned replied, and then reviewed the events that had taken place after he and Billy had joined Mackenzie's Fourth.

"As far as I was concerned, the war was over when I saw Morning Star and little Jim Bold Eagle tied up and Quanah nigh onto dead," he continued. "I 'spect the army ain't going to cotton too much to me takin' off like I did but I just couldn't set still for Quanah to either die or be hung without trying to do something about it."

"You're right, son," Jim replied. "I'd have done the same. Not only do we owe Quanah, but the Indians are going to need him even more than ever to look out for their rights on the reservation after they lay down their weapons."

"What are we going to do about getting them back to the reservation, Colonel? The army's out there waiting to catch them as they come in and I heard talk when I was with Colonel Miles that any of the chiefs that aren't killed will be tried and sent to prison in Florida," Ned said.

"We'll have to wait until Quanah is able to talk, son, but if he's in agreement, I'll ride in with him and do what I can to convince the authorities that they're going to need him just as much as the tribes will need him. There's going to be an awful lot of unhappy Indians

penned in and they're going to need a strong leader. Right now, we'd best do something about those five hundred hungry Comanches outside the gates that need immediate attention," Jim said, as he walked out into the October sun.

Slim joined the Colonel and Ned as they mounted their horses and rode out the gate. The Indians were waiting in disarray under the cottonwoods, trying to act strong but reflecting a feeling of helplessness with no horses and no chief and few possessions.

Jim rode through their midst, stopping at a group of braves who seemed to be the designated leaders. Howling Wolf and Spotted Antelope, who had helped with the cattle drive to Dodge City, were in the group. Remaining on the stallion, Jim spoke, recognizing each by his name.

"Chief Quanah is very sick and my people are using strong medicine to make him well but it may be many days before he can once again lead his people. You know that One Arm has always spoke the truth with you. I tell you now, that the army will not harm you if you remain here until he is well. I want you to make your camp along the base of the cliff," and he motioned towards the east where the trees grew almost up to the cliff's base.

"We have buffalo skins which you can use to make tipi's, and tools to cut lodge poles. I will give you ponies which you can use to hunt the buffalo for food and robes," Jim said, then pointing to a small herd of longhorns grazing near the creek, added, "Take what you need of those beeves to feed your people."

Turning to Slim, Jim said, "Take five of these braves to the remuda and give them ponies," then to Ned he said, "Fetch some axes from the tool shed and have the boys bring out all of the hides that are stored in the loft."

Spotted Antelope and Howling Wolf gave the squaws orders to start making camp,then with three other braves, followed Slim to the horse corrals.

Although weak, Quanah was able to rejoin his tribe in less than a week, and under his direction, a comfortable camp materialized, with enough lean-tos and tipis stretched below the cliff to offer protection for the tribe during the threatening inclement weather. The hunters returned daily with additional buffalo, antelope and deer and the squaws were kept busy smoking and drying the meat and curing the hides.

Jim and Ned spent many hours visiting with Quanah while he

was recuperating, convincing him of the need to return to the reservation and make a new life for his people.

"Chief," Jim said, "the buffalo will soon be no more and you and your people must rely on white men's methods and white men's ways to survive. Where buffalo have lived, cattle will live. And Indians can own cattle the same as they can own horses. You can take what you need of our herd to start your own."

Quanah listened intently to the suggestion, then answered. "You are right, One Arm. The Comanches are proud people and we do not wish to depend on the *white-eyes* for food and clothing, we will have our own."

"Many of the Chief's of the Kiowas, Cheyennes and Apaches will be sent to prison," Jim said, " and those tribes will have no leaders. They followed you in war and they will look to you for leadership in peace. You have proven yourself a great warrior, now you must prove yourself as a great peacemaker."

"We will go to the white man's reservation," Quanah said, "but we will go as a proud nation, not as prisoners or whipped dogs. We will remain here until the army leaves our land, then we will ride in as warriors, not as crying squaws."

"That is as it should be," Jim said. "You are welcome to stay here at Ceebara until your people are well and once again strong."

The winds of winter began to blow as November approached. The first snow piled deep around the ranch house and the makeshift lodges and tipis of the Comanches, as it did around the tents of the troops which continued to scour the plains for any recalcitrants which had not returned to the reservations. The Cheyennes, Kiowas and Apaches slipped quietly back to their reservations, and only Quanah and his Kwahadi Comanches remained hidden from the soldiers. The movement of the troops became so limited and difficult , while contact with hostiles was non-existent, that Colonel Mackenzie called the troops back into the forts.

Not until mid-February did he send Lieutenant Baldwin's troops back on a final swing across the plains in search of the missing Kwahadis. After a fruitless two-week search of the canyons along the caprock, Baldwin turned his troops towards Ceebara, remembering that Quanah had been a friend of Colonel Cole and Ned Armstrong. Perhaps, he reasoned, the Colonel could give him some information concerning Quanah's whereabouts.

A Comanche hunting party, returning from a hunt in the foot

deep snow, observed Baldwin's troops moving eastward down Red Deer Creek, no more than five miles upstream from the ranch house. Dumping the two large mule deer which they had killed, and remaining hidden from the soldier's view, the Indians kicked their ponies into a run back to Ceebara, arriving an hour ahead of the slow moving troops.

Hearing the news, Jim ordered all of the ranch crew to form a line between the approaching cavalry and the Indian camp, with Ned and himself stationed two hundred yards in front of his cowboys. Quanah was instructed to keep his braves behind the cowboys, but prepared to defend themselves if attacked.

Although Jim instructed Belle and Kate to remain inside the compound with the other women, they refused and rode out to station themselves close behind their men.

Quanah and his braves formed a line behind the protection of the cottonwoods, but in front of the village, each with a rifle pointed in the direction of the approaching cavalry.

Lieutenant Baldwin was dumbfounded at the scene before him as he and his troops splashed across the frozen steam. There was the ranch house, peacefully nestled against the cliff's base, and no more than two hundred yards to the east was over a hundred newly erected tipis scattered through the trees with smoke curling upward from many campfires.

Then he was aware of the Colonel, Ned, Belle and Kate, mounted and sitting quietly in their saddles between him and the Indian village. As he approached, Baldwin could see the line of cowboys setting their horses under the trees with Winchesters resting loosely across the saddle horns, and behind them, the armed Indians!

Not knowing what to expect, Lieutenant Baldwin gave the order to halt, then quickly ordered a battle line to be formed. The sounds of the bugle echoed shrilly down the small valley, as the troops moved quickly into battle formation.

Jim kicked the big black stallion into a trot and approached the troop, holding his hand up in a sign of peace. Baldwin rode out to meet him, and before the two horses had stopped, nose to nose, Baldwin demanded, "What the hell's the meaning of this Cole?"

"Now don't go gettin' your dandruff up, Lieutenant," Jim said. "We're just making sure that no one goes off half-cocked and someone gets hurt before we have a chance to talk."

"Have a chance to talk about what, Cole?" Baldwin said angrily. "My orders were to find the Comanches, disarm them and bring them in or kill them, and that's exactly what I intend to do. We've been all over hell and half of Texas trying to find Quanah and his savages, and I don't -- ."

"Like I said, Lieutenant," Jim interrupted, "you'd best not be going off half-cocked. You're on private property talking to the legal owner of this land. This is Texas and those boys behind me happen to be citizens of the sovereign state of Texas and have orders to keep any trespassers off of my property. They've never disobeyed my orders before and I don't 'spect they will be inclined to do so now."

Looking back and motioning towards the line of braves and the women and children behind them, he continued. "As far as those Indians are concerned, they're guests of mine and are making no trouble for anyone. I have promised to protect them, and that I intend to do. If we're forced to fight to see that no harm comes to them on Ceebara property, we'll do so!"

"Cole, you know damn well you don't stand a chance against my troops if you try to stop us. And to defend those hostiles will be considered treason against your own government. We'd have legitimate right to shoot you on the spot right along with those Comanches," Baldwin said, his voice breaking slightly, indicating his nervousness.

"Perhaps you're right, Lieutenant," Jim said, then glancing over his shoulder at Bell and Kate who sat with their rifles pointed in the direction of the troopers, added, "but are you prepared to kill white women and children? That's what you're going to have to do if you don't listen me out."

In a more reasonable tone, Jim continued. "Chief Quanah has promised me he will go to the reservation, but only under his terms and as a free man. I can assure you he will die, as will all of his people, before they will go in as prisoners. And if you try to force him to go in now as a prisoner, there'll be many of your troops who will die along with him. Do you think it's worth the gamble?"

Baldwin, good soldier that he was, realized that this was an impasse. He was not afraid to commit his troops into a battle which might mean that some of them would be killed, that was to be expected. But he wasn't about to order his troops to attack these Texans who stood firm in their commitment to defend their friends, the Comanches. And the thought of Belle and Kate being killed be-

cause of his orders was unacceptable.

"Alright Cole, you win!" he said. "But I must have your word and Quanah's word that they will come in on their own."

Looking to Ned, Jim said, "Fetch the chief, son."

Ned loped his horse to the rear and asked Quanah to join him. Quanah, with his bright headdress of turkey and eagle feathers flowing down his back, mounted his tall chestnut gelding which had been a gift from the Colonel, and rode out to join Jim and the Lieutenant.

"The Lieutenant wishes your word that you will bring your people in to the reservation if he leaves us in peace," Jim said as Quanah pulled his horse to a stop.

"I have given One Arm my word that we will come," Quanah said, "but only as free men, not as prisoners of the *white-eyes.*"

"I have always heard that Quanah speaks with a straight tongue," Baldwin replied, looking Quanah in the eye. "I will take your promise back to Fort Sill."

Jim interrupted, "They will not be in before spring, Lieutenant. Quanah has told me that when he comes, they will ride, not walk. Which means that they must capture many more of those horses which have escaped during the battles. They also need many more buffalo hides and meat. Some of them don't even have moccasins for their feet. The buffalo herds will be coming back in the spring, and once they have killed all they need, I promise they'll come in."

As an afterthought, and looking at Quanah, he said, "You can tell McKenzie that if they are not on the reservation by July, he can come after them with my blessings."

The buffalo herds began their northerly migration in April and the Comanche squaws were kept busy skinning the many animals killed by the men of the tribe. The meat was sliced and hung to dry and the hides cured for robes and tipis. Many horses were located and captured, some bearing the US brand of the cavalry, horses which had escaped during the heat of battle. The Comanches once again became mobile, and able to hunt greater distances from the ranch.

In May, 1875, having heard no more from the army, Jim and Ned decided to ride to Fort Sill to intercede for Quanah and the Comanches, to make certain that if they came in, they would not be punished.

Reaching the fort, they were ushered into Colonel Mackenzie's

office, who had been given command of the fort as well as the responsibility of all the tribes which were on the reservations.

Recognizing Ned, Mackenzie looked astonished. "My God, Armstrong, I thought you were dead. When those Comanches escaped and you was missing, I supposed that they must have taken you captive. We trailed you to the head of the canyon, but lost the trail along Prairie Dog Town Fork. At any rate, I'm glad to see that you're still alive."

"Thanks, Colonel," Ned replied, and did not offer any explanation of the episode.

Jim, changing the subject, got right to the point. "Colonel, I have convinced Chief Quanah and the Kwahadi Comanches that it is senseless to continue to fight and remain off the reservation. They are ready to come in if they can be assured that there will be no reprisals against them, and if they are allowed to come in under their own initiative, not as captives of the army."

"I know, Cole," Mackenzie replied. "I received Lieutenant Baldwin's report to that effect."

"As you know, Colonel, Chief Quanah is my friend," responded Jim. "For years we were able to live in peace on the *Llano Estacado* with his tribe, the Kwahadis. He has respected our presence and we have respected his. We grow our longhorns and they hunt their buffalo. Not until the buffalo hunters came and began the slaughter was there any problems between us. I have talked with him and convinced him it is now time to put an end to all of this bloodshed. He realizes that he cannot win, but he also recognizes he cannot win the peace unless you will agree to allow him to continue to set as chief of his tribe."

"I don't know that I can do that, Cole," Mackenzie replied. "Many of the chief's have already been tried and sentenced to prison in Florida -- Big Bow, Lone Wolf, Wild Horse, Grey Beard and Poor Buffalo. They all have broken treaties in the past and must be punished for their deeds."

"Quanah has never broken a treaty, Colonel," Jim said, "because he has never signed a treaty. Your records will show that the Kwahadis have never attended any of the peace conferences nor have they ever agreed to live on the reservations, they have always maintained that the *Llano* was their land, and they have fought hard, even though sometimes viciously, to protect that land from encroachment by the whites."

Mackenzie was thoughtful as he rubbed his chin. "I did not know that, Cole." he said. "What you are saying is that this man Quanah is not guilty of breaking any laws or agreements, he has only fought long and bravely to save *his* country from invasion by a foreign government, no less than you or I would do."

"That is correct, Colonel, and I can assure you that if you allow him to remain as head of his tribe when he comes in, he will make your job of governing these people much easier," Jim answered.

Mackenzie, standing, walked from behind his desk and extended his hand to Jim, who took it awkwardly in his left. "You have my word, Cole; Chief Quanah will receive all the respect of my office and I will see that he remains here on the reservation, helping me to establish a decent life for these poor souls."

"Thank you, Colonel," Jim said as he turned to leave.

Ned, who had stood silently during the conversation, opened the door for Jim and followed him out. He was stopped by Colonel Mackenzie's parting words, "Armstrong, you will be proud to learn that Colonel Miles has recommended you, Billy Dixon and the other members of the buffalo wallow fight for the Congressional Medal of Honor. To my knowledge, this is the first time in history that every member of a battle was so honored. Congratulations!"

Ned was astonished, he had never really considered any of his deeds during the Indian wars as bravery, but only as a part of his duty as scout. "Thanks, Colonel," he stammered in disbelief.

Jim put his arm around Ned's shoulder and squeezed, saying, "I'm proud of you, son!"

As they mounted their horses, Mackenzie added, "By the way, Armstrong, you never told me how that wounded Comanche and his squaw and kid was able to overpower you and take you prisoner."

Looking back, Ned could see a slight grin on Mackenzie's face and a twinkle in his eye. He stopped, turned to face Mackenzie, and said solemnly, "They slipped up on my blind side, Colonel," as he flipped a quick salute to the brim of his hat and kicked the buckskin into a trot.

30

"What I need is a bottle of Red-Eye and a painted-up lady settin' on my lap," the grizzled hunter said as he threw another hide off the wagon. "I've had about all of this stinking hide business I can stand without a little rest and ree-laxation."

"Ain't no way you're ever going to get no painted-up lady on your lap, Pete, as dirty and stinking as you are!" his partner said as he stacked the hide on the growing pile next to the creek.

For nearly a half a mile along the creek's banks, wagons loaded with buffalo hides were being unloaded by sweating hunters and skinners. Stacks of the black, hairy remains of thousands of buffalo had turned the green prairie into a black, fly-infested jungle. Poles had been cut from the willows along the creek bank and used to make lean-to's and tipis which were covered with hides for shelter. *Hidetown* was the name coined by the hunters and in a matter of only a few weeks, like a gold-boom mining town, it had become a center of commerce on the plains.

Word spread across the plains and in Dodge City that Hidetown on the banks of the Sweetwater Creek was the place to do hide business now that Adobe Walls had been abandoned. Freight wagons drawn by mules and oxen traveled the Ceebara Trail to the Canadian, then crossed the river and followed the wagon tracks left by Colonel Miles troops to the Sweetwater. While hunters unloaded their hides for drying, the freighters struck deals to buy the cured hides from others, loaded them and headed back north to the rail-

road at Dodge City.

The only sign that civilization had penetrated the area before the first load of hides was stacked along the stream was a deep scar cut in the largest tree that cast its shadow on the sweating hunters, "C - Bar - A - East Line - 1865."

Unloading and stacking hides was a hot, stinking and dirty job and as the sun reached its apex the hide-hunters began to look for coolness in the shade of the cottonwood trees. Dick Bussell wasn't sleepy and was sick of buffalo roast, buffalo steak and buffalo ribs. Thinking that the small stream might harbor a fish or two, he pulled a fish line from his saddle bag, cut a willow pole, and slipped quietly up to a deep pool at a bend in the creek. Sticking a grasshopper on his hook, he dropped the line into the clear creek water. After only a few minutes, his fishing effort was interrupted by a strange sound coming from just over the hill to the east. At first he thought it was Indians coming and he shouted a warning to the sleeping inhabitants of Hidetown. They grabbed their rifles and took cover. However, when no Indians appeared, they crept quietly to the top of the knoll above the creek and peered over to the flat which lay on the other side. There to their surprise was a large contingent of soldiers erecting tents, unloading supply wagons and unharnessing teams. Off to the right of the soldiers camp was another group of six wagons, camp followers, who were also busily setting up their camp.

"My God," Pete, the grizzled old hide-hunter shouted, "would you look at that? Them's painted-up ladies or my old eyes is a-lyin' to me!"

As they watched in astonishment the camp followers erected a large tent and hung a sign over the door-flap which read *Saloon.*

The soldiers, all black except for the officers, were members of the Sixth Cavalry under the command of Major James Biddle and had been dispatched from Fort Supply to establish an army post between the *Llano Estacado* and the Indian Nations for the purpose of keeping the Indians from returning to their hunting grounds. Major Biddle had determined that here, along the banks of the Sweetwater was the best location for the post. It was coincidental that he had chosen a site which was only half a mile from the newly erected center of commerce, Hidetown, and just across the creek from the east boundary of Ceebara!

Old Pete and the other hide-hunters rushed back to the creek,

shed their filthy clothes, washed some of the grime and blood from their bodies in the creek and put on their cleanest dirty buckskins then headed for the saloon. Pete rolled his eyes heavenward as he stepped into the large tent and smelled the whiskey from the bar and the perfume of the ladies. "Thankee, Lord! My prayers has been answered!" he said.

In just a matter of days, the population of the Hidetown community had increased ten-fold, with over four hundred soldiers and the twenty-odd camp followers establishing residence. Picket buildings of sharpened cottonwood posts driven into the ground and covered with adobe and sod sprang up, replacing many of the army and civilian tents. Lee and Reynolds, a Dodge City mercantile company, had come with the army as a sutler and opened a trading post, buying hides and selling supplies. But as would be expected, the saloon received the most traffic of both soldiers and hide-hunters.

When news that the last of the tribes had been cleared from the plains and that a new army fort on the Sweetwater was established to keep the Indians corralled, the buffalo hunters swarmed south of the Canadian where the last of the huge herds still roamed.

Hidetown brought with it the first signs of civilization, such as it was, to the plains. Streets were laid out and businesses, mostly saloons, were built. With buffalo hides bringing three dollars each, a lot of money was exchanging hands in the frontier town, and with the money came the gamblers, outlaws, renegades and saloon ladies from all over the west. With no organized law, Hidetown's reputation as the toughest town in Texas soon spread, and the soldiers at the fort spent most of their time trying to keep some semblance of law and order rather than Indian watching.

The Ceebara cowboys, unaware of the population explosion on the Sweetwater, had moved the huge herd of longhorns to the Washita and Red Deer Creek in late March, just prior to the birth of Hidetown, and started pushing them out on the plains in late May and early June. They kept the herd together until they reached the big playa lake, where they split it into ten smaller herds, numbering almost a thousand head each. Three cowboys took each of the herds in a different direction from the lake, allowing them to graze leisurely as they moved them out to other water holes. Sonny, Miguel and Curley, the three youngest members of the Ceebara crew, headed their herd to the south and would leave them along

the head of the North Fork of the Red River, a four day drive at the grazing pace.

Sonny had grown into a tall, muscular young man with deep set blue eyes. The sun and wind of the Texas high plains had etched deep wrinkles along the outer edges of his eyes, leaving the impression that he was always about to burst into laughter. His face was covered with freckles, and his long reddish-blonde hair protruding below his wide-brimmed hat was held in a ponytail at the back of his head with a thin, rawhide strap. A large turkey feather dangled in the sweatband of his hat.

Miguel, on the other hand, was as dark as any of Quanah's braves, with flowing black hair and sparkling brown eyes. About the same size as Sonny, he inherited his mother's fine, Mexican features and his father's energy. The two of them had grown into the best cowhands on the ranch. Jim was as proud of them as he was of Ned, and treated them as his own sons.

"We'll expect you back at the ranch no later than a week," Jim said to Sonny, as he helped them head the herd to the southwest. "You know the rules, if you run into trouble, leave the herd and hightail it for home."

"Yes. sir," Sonny replied, as he dug his spurs into the paint's side to head a calf which had broken from the herd.

For the next two days, they passed close to several large herds of shaggies which paid little attention to the cattle and cowboys. However, on the evening of the second day, the herd topped a rise at about the same time the blast of a heavy Sharps buffalo rifle shattered the peaceful quiet. The gunshot spooked the cattle and they stampeded down the slope into the midst of a milling herd of buffalo. The hunter had taken a stand downwind from the herd of shaggies, expecting to down thirty or forty before they became excited and bolted.

His second shot was the last he got off, with two of the larger cows laying in the grass as witness to his accuracy. The stampeding longhorns were joined by the startled buffalo herd, and both groups headed to the southwest, away from the hunter's stand.

Sonny knew that there was no way to stop the herd, and that they would eventually run themselves down and stop on their own. He pulled his horse up next to the two dead shaggies and waited as the hunter appeared in a small depression about two hundred yards downwind. A quarter of a mile behind him appeared three freight

wagons and a chuck wagon accompanied by two mounted horsemen.

The hunter was cursing as he approached. "Damn you! I been stalking that herd for six hours, waiting for the right time to pull down on 'em, and just when I did, you jackasses messed it up," he shouted, shaking his fist at Sonny. He was a big, raw-boned half-breed looking man with a long flowing coal-black beard, which was broken by a prominent crescent-shaped scar reaching from the right cheek bone down to his chin. Mean black eyes stared from beneath long shaggy eyebrows, making Sonny think of a rattlesnake staring out, ready to strike at the least movement.

His attitude didn't set too well with Sonny, who said, "Now wait a minute, mister! You got no right to go cussing at me when you're hunting on our ranch property. The best thing I 'spect you can do is keep heading west for about a day until you're off Ceebara grass before you decide to do any more poaching!"

"Poaching! Ceebara grass! Like hell!" the hunter shouted. "We're nine thousand miles from nowhere and you want me to believe that this grass is your'n and that I'm poaching!"

The wagons pulled to a stop behind the hunter just as his hands reached for the Colt which hung at his hip. Curley, who had been setting his horse about six feet to Sonny's rear, seeing the movement, reached for his gun but was never able to clear leather as one of the men in the wagon cut him down with a blast from a Winchester which he had been holding in his lap. Curley fell to the grass with a round hole gushing blood from his chest.

"I wouldn't do that, young feller," the hunter said as he pointed his Colt at Sonny's head. Sonny wisely moved his hand away from his gun and back to the horn of his saddle. Miguel, surprised at the events, never made a move for his gun, and instead, stared helplessly at Curley who lay dying in the grass.

The three horsemen unlooped lariats from their saddles, rode behind Sonny and Miguel and threw the loops around their shoulders pinning their arms to their sides, jerking them from their horses. They kicked their horses into a gallop and made a wide circle around the two dead buffalo dragging the cowboys, before pulling up in front of the hunter. The skinners who were in the wagons whooped and hollered as Sonny and Miguel bounced along the prairie, enjoying this turn of events.

One of the skinners jumped from the wagon and ran to where

Sonny and Miguel lay prostrate in the grass, bent over and grabbed Sonny by his hair and pulled him to his knees. Looking up at the hunter, he said excitedly, "These here bucks is young and got lots of muscle, Mick. Ain't no use in shootin' 'em till we finish our hunt. Me and Sid 'ul see to it that they's kept busy loadin' hides."

Mick, the big hunter, smiled, nodded his head and holstered his gun. "I guess you boys can use a breather. Put 'em to skinnin them two cows and when they finish, tie 'em to the back of the wagon and make them walk a ways, and make damn sure you keep a gun on 'em all the time. If they even act like they want to git away, shoot 'em!", he said as he rode off in the direction of the stampeded herd.

The skinners took the gunbelts from Sonny and Miguel, removed the ropes and shoved them towards the two dead shaggies, throwing a couple of skinning knives into the grass next to the animals. "You heard Mick, start skinnin'," the one called Turk said.

When the skinning was finished, salt was sprinkled over the hides and they were rolled into a tight bundle and thrown onto the first wagon. The lariats were once again looped around the cowboy's necks and tied to the back of the freight wagon and Sonny and Miguel were forced to walk as the wagons moved out on the trail of the hunter. Their horses were tied to the rear of the chuck wagon and followed along as they moved out. Curley's body was left lying where he had fallen, and would be coyote bait before morning.

During the night, a strong thunder storm blew in, dumping over two inches of rain on the prairie which erased any sign of the trail which had been left by the cattle and the hunters, only the carcasses of the two buffalos and Curley's body were evidence that the bushwhacking had taken place.

For the next five days, Sonny and Miguel were slaves to the hide-hunters, skinning and loading over forty hides a day. The regular skinners spent most of their time lying in the shade of the wagons, prodding and threatening the two young men. When the wagons would hold no more, Mick turned them around and headed for Hidetown, forcing Sonny and Miguel to walk, once again with the ropes around their necks and tied to the rear of the wagon.

"Ain't no sense in killin' good help," Mick said, laughing cruelly at the boys as they stumbled along behind the wagon. "There'll be plenty of time for that after we get these hides unloaded and dried at Hidetown."

When the boys failed to show up at the ranch after eight days, the Colonel told Belle he was going looking for them. "Probably ain't nothing to worry about, but they should have been in before now," he said as he strapped on his gun belt.

"I'm going too," Belle said. Although she hadn't indicated her concern, she had felt strongly for three days that her son was in some kind of trouble. "Woman's intuition," she confided in Maria, who was also worried about her son, Miguel.

Without saying a word, Ned saddled his buckskin and joined the Colonel and Belle as they rode out the gate of the ranch compound. Each carried a bedroll behind the saddle and a loaded Winchester in the rifle boot strapped to the front. A sack of jerky was hung on each saddle horn.

"Shouldn't be no problem in finding a thousand head of longhorns," Jim said to Belle and Ned as they rode out onto the plains after climbing to the top of the caprock through the cut above the ranch house. "And when we find the cattle, we should find the boys."

Riding southwest towards the head of the Salt Fork of the Red River, they found the cattle scattered over an area several miles short of the pasture where Jim had instructed Sonny to leave them. For the first time since they had left the ranch house Jim was visibly worried.

After circling the herd and finding no sign of the boys, the trio headed back down the trail left by the cattle. Darkness forced them to stop for the night because the dim trail was impossible to follow, even for Ned's sharp eyes.

At daylight they were mounted and searching for anything that would give them a clue to what might have happened to the boys.

"Keep a sharp eye out for anything that looks different," Jim instructed Ned and Belle. Soon the trail became less and less visible as a result of the thunderstorm and Jim was about ready to send Belle in one direction, Ned another and he another, when they came across the carcasses of thirty freshly skinned-out shaggies lying in the trail left by the cattle, and deep ruts made since the rain by three heavily loaded wagons.

"Probably no more than three or four days ago," Jim said as he examined the carcasses.

Searching the area around the carcasses, Belle was first to spot a turkey feather tied by a piece of rawhide to an ear of one of the

bloated bodies.

"Jim," she screamed, "it's the feather Sonny wore on his hat!"

"You're right," Jim exclaimed as he dismounted and pulled the feather loose from the rawhide thong.

Looking at it thoughtfully, he added, "Sonny's trying to tell us he's in trouble. Let's just hope we're not too late to help."

Ned had already kicked his buckskin into a gallop down the wagon trail as Jim mounted up and followed Belle who was close behind.

The trail bore in an easterly direction and dissected the caprock about ten miles from the Sweetwater where Ned had carved the "C-Bar-A East Line 1865" in the cottonwood tree. Several other wagon trails joined at a cut in the caprock making a well marked wagon road into the Hidetown trading center.

Ned pulled up on the lip of the caprock and pointed in the direction of the Sweetwater. Several thin strings of smoke could be seen curling up from the area, too much for just one buffalo hunters camp. "Peers to me there's quiet a gathering down there, Colonel," he said as he pulled his glass out of the saddlebag and lifted it to his eyes.

"I'll be damned, Colonel, there's a whole passle of hunters camped along the creek with hides stacked everywhere and there seems to be a bunch of army tents about a half mile the other side!" he said as he handed the glass to Jim.

Jim looked intently at the scene and muttered under his breath, not believing that what appeared to be a small community had sprung up on his property since they had gathered the cattle in March.

"The horses are beat," he said as he dismounted. "We'll camp here for the night and ride in in the morning. No use in riding good horse flesh to death, besides, it would be way after dark before we could make it to the creek, and we might be biting off more than we can chew. If Sonny and the boys are still alright tonight, there's no reason to believe that they won't be in the morning."

Ned pointed to the northeast at a large black mass that seemed to be moving slowly to the south. "Must be a couple thousand head of shaggies grazing towards the Sweetwater, Colonel. Guess they're just as surprised as us that someone has taken over their watering hole."

The sun was beginning to drop below the horizon to the west as

they made a cold camp along the edge of the caprock. As darkness settled in, the small, flickering lights of the campfires from Hidetown glowed like a hundred fireflies in the distance. The eastern horizon began to turn a deep orange color and soon the darkness was shattered by the outlines of a bright orange ball as the moon slipped silently out of the space which marked the end of the earth and the beginning of the sky. The flickering specks of the campfires below were joined by the light of thousands of flickering stars above as Jim, Belle and Ned stretched out on their bedrolls, each lost in their thoughts about the fate of Sonny, Miguel and Curley and what might be in store for them tomorrow.

About three miles behind the grazing herd of buffalo, another camp was being made. Quanah had brought his braves out along the Washita for a last hunt and chase before leaving for the reservation. They had picked up the trail of the huge herd, and were camping for the night, excited about the prospects of a great hunt tomorrow.

* * * * * * * *

Jim, Ned and Belle were on the trail by daylight, descending down the alluvial slope below the caprock. After reaching the bottom, they kicked their horses into a slow easy trot down the well marked wagon road, and held that pace for the next two hours. By mid-morning, they rode into the stinking outskirts of Hidetown.

They rode slowly along the edge of the camps, virtually unnoticed as skinners unloaded wagons, unrolled hides and stretched them in the sun to dry. Hunters were walking back and forth, giving orders, horses and mules milled around the camps grazing on the short trampled grass, and cooks were busy cleaning up after the morning breakfast. A haze of fine dust filled the air over the small valley kicked up by all of the activity. Suddenly Ned pulled the buckskin to a stop and motioned for Jim and Belle to do the same. In the next camp, which was approximately a hundred and fifty yards downstream and the other side of a plum thicket, he could see Sonny's paint, tied to the back of a wagon. Near the paint he spotted Sonny and Miguel, shirtless, unloading hides from a huge freight wagon. Two men were watching with Winchesters hung loosely from the crook of their arms. Another man sat listlessly on the seat of the wagon rolling a smoke. The hunter was bending over

the coals of a campfire, pouring steaming coffee into a tin cup.

The legs of a fifth man could be seen behind the chuck wagon and two more were approaching the campfire, carrying water from the creek. All were well armed with revolvers strapped to their hips and a half dozen rifles were leaning against the tongue of the chuck wagon.

After watching the activity for a couple of minutes, it was plain to Jim that the boys were being held captive and forced to do the work against their will. He thought it was odd that Curley was no where in sight. Motioning to Ned and Belle, he turned his horse and rode into the shaded cover of a cottonwood grove along the creek's bank, dismounted and watched the activity taking place in the buffalo hunters' camp.

"Looks like the boys is in a heap of trouble," he said to Belle and Ned as they dismounted. "Near as I can tell, they's at least seven hide hunters in that group, all itching for a fight. We got surprise on our side, though, and we can probably take them before they realize we're around, it's them coyotes on either side of their camp that I'm worried about. Looks to be about ten or twelve in the camp upstream and another dozen in the camp downstream. There must be another hundred or more scattered along the creek, they ain't apt to take too kindly to someone riding in shootin' up their neighbors."

Ned nodded in agreement as he surveyed the situation. "Colonel, it 'pears to me our best chance of getting to the boys and getting out in a hurry is to ride right through their camp, cross the creek and hightail it for the army camp over the ridge. If we try to go upstream or downstream, we ain't got a chance to get by them other hide hunters without gettin' shot all to hell."

Jim thought for a moment about Ned's plan before nodding agreement. "Those two hombres with the guns on the boys is our first priority, we don't want to give them a chance to pull down on the boys before we can get them mounted up and headed out," he said.

"Belle, me and Ned will ride in and take those two skinners first, you get to Sonny and Miguel and see that they get mounted on that paint pronto. If you spot Curley, mount him behind your saddle and skeedaddle. Keep your eye on that hombre behind the chuck wagon and the one settin' on the freight wagon, they'll probably come out shooting when the excitement starts," he added.

Belle calmly pulled her Winchester from its holster and levered

a shell into the chamber as she nodded agreement. These men were mistreating her son and she was ready to do whatever was necessary to rescue him from his situation.

"I'll take the hombre who's drinking coffee and you handle the other two," Jim said to Ned as they remounted. He tied the bridal reins together and looped them around his left hand, which held his Colt revolver. "Let's just ride in slowly so's they don't suspect anything until we're ready," he added as he turned the big black back towards the hunter's camp.

Belle pulled up to his right side and Ned joined him on the left. Walking their horses, they rode into camp.

They were within twenty feet of the wagon before Sonny and Miguel looked up from their work and recognized them. They dropped their hides and started to speak when Belle put her fingers to her lips and motioned them towards Sonny's horse, keeping her eyes on the dirty skinner resting on the wagon seat.

The two men with the rifles, who had been discussing their escapades the night before with the dance hall girls, looked up as Sonny and Miguel headed for the paint. "What the hell you think you're doing?", one of them said as he raised his rifle. The other glanced in the direction of the trio riding into camp and raised his rifle as if to stop them.

It was the last move he would ever make as Jim's Colt spit lead and he was knocked backward as the bullet found his heart.

Almost as one, the sound of Ned's pistol joined that of Jim's, and the other skinner who was sighting down on Sonny's back, dropped the rifle and fell forward, a round hole appearing between his eyes.

Turning her attention from the men around the campfire, Belle could see the skinner on the wagon reaching for his gun. With one hand, she turned the rifle towards him and pulled the trigger, and quickly levered in another shell. The force of the slug lifted the skinner off the wagon seat and threw him to the ground on the other side. From the corner of her eye she could see Sonny and Miguel leaping on the back of the paint and the outline of a man holding a pistol appear from the back of the chuck wagon. She swung the rifle barrel around and automatically pulled the trigger as she saw flames spit from the end of the pistol barrel. She felt a burning sensation along her cheek and just below the ear as the bullet grazed her skin, and at the same time she saw the pistol drop from the cook's hand

as he grabbed his shoulder and screamed with pain.

"Where's Curley," she shouted.

"Dead!", responded Sonny as the two boys vaulted onto the bare back of the paint. She turned her mare towards the creek and splashed across.

The men around the campfire went down as one, with their guns only halfway out of leather as Ned and Jim swung their guns from the two guards to the surprised trio. The buffalo hunter fell face down in the glowing embers of the campfire from Jim's lead as the other two were knocked backwards by Ned's.

The big black and Ned's buckskin leaped over the fallen trio as they spurred them towards the creek. As they reached the opposite bank, gunfire could be heard coming from the two adjoining camps and lead whistled over their heads.

But a new sound was joining that of the crack of rifles, the sound of rolling thunder, but there were no clouds in the sky.

Looking to the rear, Jim could see the black, shaggy forms of thousands of buffalo as they stampeded down the valley, overrunning the hunter's camps along the banks of the creek. He shouted for the others to hold up as he pulled his horse to a stop, turned and watched as all hell broke loose in the place called Hidetown.

Along the edge of the buffalo herd he could see the naked forms of Quanah's braves as they held their rifles high, firing in the air and keeping the huge shaggy animals heading downstream. Over the thundering sound of the thousands of hooves and the shots from the rifles he could hear the excited whoops and yells of the braves as they screamed their delight at the havoc they were causing.

Wagons, stacked hides, stretched hides, campsites and hide-tents disappeared as the huge herd lumbered through in their relentless efforts to escape from the Indians. Buffalo hunters and skinners, like a bunch of disoriented ants, were seen running in all directions, climbing trees and wagons in an effort to escape the stampeding herd. Many of them never made it and were trampled beneath the sharp hooves of the animals which they had come to kill. The hunters had fallen victim to the hunted.

As Quanah rode by, Jim spurred his horse alongside, smiling as he too began firing over the heads of the buffalo. Ned, Belle and the two boys followed behind.

After the herd had crashed through the camp and continued

their run downstream, Jim motioned for Quanah to pull up.

"Get your braves and head back to the ranch," he shouted. "There's an army camp just over the ridge and they'll be coming after you as soon as they realize what has happened."

Turning his horse, he headed back upstream, motioning for Ned and the others to follow. They left the creek-bed and disappeared over the hill, riding hard for the protection of the ranch. Looking back he could see Quanah and his braves regrouping and following on their trail.

The entire episode had taken less than ten minutes, and he knew that the total surprise of the hunters and the army commander would require several hours before they would be able to organize and pick up their trail. They would have plenty of time to reach the safety of the ranch compound.

31

Although they prepared and waited, the soldiers never came. The trail had been lost because the buffalo herd had turned, circled back around Hidetown and headed for their grazing lands along the upper Washita, following the trail left by Jim and Quanah and the others. The soldiers returned to the fort to help bury the dead, although there was not much left to bury behind the sharp hooves of thousands of head of plains buffalo. However, over one hundred new unmarked graves scarred the slope above the Sweetwater creek, graves of hunters who had fallen victim of the hunted.

By the first of June, the Kwahadis were ready, their lodges had been rebuilt, new buckskins and moccasins covered their bodies, much jerky filled their bags, turkey and eagle feathers adorned their war-bonnets, and their horse remuda was large enough that even the squaws could ride. Once again they were the *Lords of the Plains*.

Quanah, sad at heart facing the realization that a way of life for him and his tribe was ending, asked Jim and Ned to accompany him on a final trip to the big playa lake on the *Llano Estacado* before he led his people to the reservation. He wanted to look once again at the herds of buffalo and antelope which he would be able to hunt no more.

The sun was rising in the east when the three riders reached the top of the caprock. They paused and looked out over the broad ex-

panse of the valley formed by Red Deer Creek which was obscured in places by an early morning fog. Off to the left they could see smoke rising from the ranch house and Indian campground, but the cottonwood trees hid the buildings and tipis from view. The three sat their horses in silence for several minutes, savoring the beauty and tranquility of the scene. Without a word, Quanah turned his horse and headed west. Jim and Ned followed.

They had ridden no more than two hours when they came upon the carcasses of over a hundred buffalo, freshly skinned by hide hunters. The bloated, tongueless and hideless bodies sparkled grotesquely in the green grass of the prairie, a dark reddish-black stain coloring the grass where their life blood had been drained by the fifty caliber slugs of the buffalo guns. The coyotes had feasted on some of the carcasses the night before, but most of them had been left for the buzzards which were pulling and tearing at the exposed flesh when the riders approached. The stench of death was permeating the air as they rode through the desecration and Jim could see the muscles in Quanah's jaws tighten as he looked from one naked animal to the other.

Quanah finally spoke, "The white man kills the Indian to get the buffalo. Then he kills the buffalo only for his hide and leaves the rest to rot and feed the buzzards. Soon the buffalo will be no more, then where will the white man go? What good is the grass without buffalo? The white man will also starve, just as the Indian will starve on the white man's reservation."

Jim had no answer for his friend, Quanah. He could only look with sadness and nod his head in agreement. Reflecting, Jim thought, "*this has been the story since the first whites landed in the east; push the Indians back, kill all of the game, cut all the trees, plow all the grass, then move further west and start the cycle all over again, never content to learn to live with the Indians nor to keep the land as it had been for millions of years. But now there will be no place else to go, the Llano Estacado is the last place where millions of animals still roam across a sea of grass. There will be no more land which can be taken from the Indians, there will be no more great herds of game on which to satisfy our greed.*"

"I wish to go no further," Quanah said sadly. "We will only see more dead buffalo and smell the air of death, I do not wish to remember my land this way."

They turned and rode silently back to the caprock, and just as

they began the descent to the valley below, a huge old bull buffalo appeared on the horizon to the right, and no more than twenty paces to his left stood a massive longhorn bull, each chewing its cud while passively watching the three riders.

Jim pulled the big black stallion to a stop and pointed towards the two animals."The Indian's buffalo with its short horns and the white man's cow with its long horns have learned to live together in peace, maybe someday we will learn to do the same," he said.

"Yes," Quanah replied wisely, "But only on white man's terms."

Sitting the chestnut gelding, Quanah, holding both arms upward and turning towards the huge old bull, chanted in the Comanche dialect, "Goodbye, great-grandfather Buffalo, your children leave your land forever, never to share the hunt again."

The old buffalo pawed the grass, raised his head and bellowed sadly, as if to say in response to Quanah's farewell, "I too, leave this land of grass to the white man and his cattle." Turning, he disappeared down the trail, leaving the massive longhorn bull standing majestically alone.

The next day the Comanche camp was dismantled and Quanah led the tribe sadly, but proudly, across Red Deer Creek and turned eastward towards the Indian Nations, fulfilling his promise to One Arm to leave *the Llano Estacado* forever and to live on the reservation in peace.

Within two years, all of the buffalo except for a small herd protected by the Colonel were slaughtered and the hunters either left or took up other occupations. Ceebara grew, as did Mobeetie and the Anglo population. Soon other towns sprang up, Saint's Roost and Tascosa, and the buffalo were replaced by millions of head of longhorn cattle as other ranches were born -- the JA, the Frying Pan, the Matador and the XIT.

Colonel Jim Cole and Ned Armstrong would face many more battles before Ceebara was finished, battles with the state, with other ranches, barbed wire, rustlers and the railroad.

But then, that's another story!

ABOUT THE AUTHOR

Gerald McCathern is a native of the Texas Panhandle, born in 1926 he has lived most of his life in the area around Amarillo. As a boy during the "dirty thirties" he lived on ranches and farms in Roberts and Wheeler counties where he searched the countryside for Indian artifacts left by past inhabitants of the area.

These artifacts instilled in him a keen interest in the history of the area, an interest which resulted in the writing of this novel, *Horns.*

After serving in the Aviation Engineers during WW II, he returned to Pampa, Texas and worked in the oil fields for a short time before enrolling in Texas Tech under the G.I. Bill. It was there that he met and married his wife, Bonnie Traweek. He graduated from Tech with a degree in Petroleum Geology and worked on wild cat oil wells in the Permian Basin for a short time before moving to Hereford, Texas to begin a farming and ranching career which lasted for forty-four years.

During those years he continued his love for writing, editing and publishing his own nationally circulated newsletter, *The Agriculture Watchdog.* He also wrote and published four books, *From the White House to the Hoosegow, Gentle Rebels, To Kill the Goose,* and *Line of Succession.*

He retired from farming in 1996 and is now pursuing a full time writing career.

Gerald and Bonnie have three children and eight grandchildren. They reside at their home in Hereford, Texas.